BRITISH MUSEUM

OCCASIONAL PAPER NUMBER 50

2000 YEARS OF
ZINC AND BRASS

Revised edition
Edited by P.T. Craddock

BRITISH MUSEUM OCCASIONAL PAPERS

Publishers: The British Museum
 Great Russell Street
 London WC1B 3DG

Production Editor: Josephine Turquet

Distributors: British Museum Press
 46 Bloomsbury Street
 London WC1B 3QQ

Occasional Paper No. 50, revised edition 1998 (first published 1990)
2000 Years of Zinc and Brass
Edited by P.T. Craddock

ISBN 0 86159 124 0
ISSN 0142 4815

Front cover: An excavated bank of medieval zinc smelting furnaces from Zawar, India; the far two still containing their last charge of retorts. See 'Zinc in India' pp.27-72. (Photo P.T. Craddock, British Museum)

For a complete catalogue giving information on the full range of available Occasional Papers please write to:
The Marketing Assistant
British Museum Press
46 Bloomsbury Street
London WC1B 3QQ

Printed and bound in the UK by Short Run Press Limited

CONTENTS

INTRODUCTION TO FIRST EDITION

This volume is the first comprehensive technical history of the production of zinc and brass. This is somewhat surprising because the two metals are amongst the most familiar of modern materials, and because the production processes have always been at the forefront of man's technical development and thus of some intrinsic interest in themselves. Indeed the production of zinc by high temperature distillation in India, and afterwards in China, were probably the first instances of purely scientific methods and apparatus applied to industrial production.

This book arose out of a weekend meeting occasioned by the recent discoveries in India and the continuing research and excavation in Bristol. The meeting was held at the Extra Mural Department of Bristol University in 1985, organised by the Department together with Joan Day and the author. It became clear at that meeting that there was a need for a general work on brass and zinc as existing papers on specialised topics or periods were very dispersed throughout the literature.

Many more of the processes have apparently never been described in the literature at all, and certainly there has never previously been an attempt to link the developments of the various periods and places into a comprehensive whole. This is especially true of the apparent divide between the so-called traditional ancient processes and the more recent industrial processes of Europe and North America. This volume shows that the technical developments were in fact continuous and consciously related from the ancient to the modern world. It is an attempt to bring together something of the long history of the two metals produced by experts in the various periods and places.

The problems of condensing the highly volatile zinc into a metal, or alternatively making brass directly from copper metal and zinc ore, were some of the most challenging tasks of the ancient world. The rewards were great - brass was an acceptable alternative to bronze - but the difficulties of working with a vapour at high temperatures and rigorously excluding air required new methods and apparatus. The possible routes by which the cementation process of brass making was evolved are quite fascinating, and it would be interesting to learn of the intermediate developments preceding the sophisticated multi-retort zinc furnaces at Zawar in India. The paper by S.W.K. Morgan, which concludes this volume, is especially important in this context as here we have the innovator's own story of the problems encountered in translating an idea into a viable industrial process.

Technical innovation and mass production had been developing slowly but surely over much of the world. It is becoming clear that the application of sophisticated techniques and apparatus to the problems of an industrial scale production of advanced materials had been in progress for well over a thousand years at centres throughout the Old World. As examples, aspects of textile production in Medieval Europe, especially in Italy, ceramic production in China, and zinc production in India all used complex technologies and evolved into major industries at an early date. These industries and others like them provided the technical basis for the period of intense industrialization and capital investment known as the Industrial Revolution. Economic historians and industrial archaeologists have hitherto taken rather too narrow a view of the real origins of industrialization; possibly this volume is an indication of things to come.

Boundaries and starting points are notoriously difficult to establish. But the big expansion in international deep water trade from the sixteenth century on, which exposed Europe to a whole range of new materials from raw materials to sophisticated manufactured products together with a whole range of challenging ideas and processes from the rest of the world, could be taken as a base line for the Industrial Revolution, at least during the historically brief phase of European supremacy in rapid technical innovation and industrialization.

Zinc forms a not unimportant and certainly highly typical part in that story. It was made by a very sophisticated process in the East and was then shipped to Europe as a finished commodity where its nature and production aroused considerable curiosity - especially after it was realised that it originated from the widely available calamine deposits already used in brass making. Finally the technology for producing zinc was also acquired in Europe, although the European processes rapidly evolved away from the principles of downward distillation, and even Champion's first furnace bears little resemblance to the Indian furnaces. The rapid evolution of the zinc smelting process over the last two centuries is one of the most interesting chapters not just in this book but in the whole of metallurgy.

The British Museum gratefully acknowledges financial assistance from Mr A. Haas and Mr and Mrs M.D. Schwarz of the USA, and also from Australian Mining and Smelting (Europe), Avonmouth towards the production of this book.

INTRODUCTION TO REVISED EDITION

The first edition of this book having been sold out, the opportunity has been taken to correct and update the contributions for a second edition. Continuing research into subjects such as the early processes of the treatment of the zinc ores at Zawar in India; Islamic brasses; and field work recording the still operating traditional Chinese processes have resulted in important new information which is now incorporated here. Other developments, ranging from the earliest excavated brasses (c. 1350 BC, see p.8), and the discovery of finds of metallic zinc from Roman Age sites in Europe (p.5) to the latest installation of a blast furnace process zinc smelter in India (p.53) are also reported. The chapter on 'Brass and Zinc from the Middle Ages until the Nineteenth Century', has been expanded to include sections on zinc sheet and on galvanised iron. Perhaps the most surprising discovery are the Spanish references to zinc in the fourteenth century (Somers 1997). Hitherto the earliest use of the word zinc (*zincken*) has always been ascribed to Paracelus (1493-1541), utilising a Carinthian word. The first printed reference, to *zincum* seems to be in the revised edition of Agricola's *Bermannus* of 1558 (de Ruette 1995). However Somers has drawn attention to the earlier references published in Ferrer Navarro (1977), in which the modern Catalan and Spanish word for zinc, *cinc*, is used. These are references to several *calderas de cinc*, exported from Valencia in 1381-2, and to a *mortaro de cinc*, weighing 8 lb, exported in 1384. These vessels would almost certainly have been of brass, rather than zinc, but the use of the word at such an early date is very interesting.

Thus there has been a considerable all-round expansion in the information contained in the volume, but the purpose remains as closely defined as before, namely to describe the inception, and technical development of the processes by which zinc and brass were made at various centres around the world, together with typical compositions of the resulting brasses. This closely focussed approach has largely omitted discussion of the economic history, and almost totally omitted the social significance of the metals on the societies which made and used them. In doing this we very consciously flew in the face of the current philosophies of the study of ancient technology, which favours a much broader holistic approach. For this we were roundly castigated by one reviewer (Geselowitz 1993), who proclaimed that ' those of us trained as archaeologists insist that history and archaeology are two complimentary approaches which must be used interactively to reconstruct a story of past technology in its social environment.', and latterly that 'The volume is virtually a monograph on the history of brass/zinc technology'. To deal with the last quote first, that was *exactly* what was intended, neither more nor less. Surely before one can begin to place a relatively unknown technology in its social environment it is necessary to accurately describe that technology in its physical and chemical dimensions. Archaeology deals with the reality of physical remains, and on a different level pyro-technical processes can ultimately only exist as physical and chemical reality. Geselowitz, at the conclusion of his review, makes the point 'that institutions which seem superficially similar or even "generically" related, may be falsely assumed to operate in similar fashions' and thus for example 'to suggest economic relationships in first century BC Rome functioned like ours is ... to see Cicero as Patrick Henry in a toga'. These are the very dangers of dealing with the intangible that we have sought to avoid. Zinc melted at 419°C and boiled at 907°C in ancient Rome , as it did in ancient India, and latterly in China, through to the present day. Working strictly within the axioms of physical reality *does* allow for greater intercomparisons to be made between the otherwise very different social and cultural groupings. This is surely the basis upon which the questions of how and why discoveries were first made, and how processes which achieve the same end, such as the production of zinc and brass, could be so very different, yet each be viable in its own time and place, can be studied.

The production of zinc and of brass was a challenge wherever it was attempted and the interaction between the various production methods adopted at different times and places and the local scientific/industrial practise is important. Similarly the economic impact of the rapidly growing supplies of the new metals, first brass about 2,000 years ago, and then zinc in the Post-medieval world, is clearly important. However before these objectives can be realistically attempted it surely necessary to know when, where and above how the metals were produced.

These are the questions we sought to address in the first edition of this work; the second edition provides more evidence of the global technical history of these most interesting processes.

Paul Craddock

References

Ferrer Naverro, R., 1977. *La Exportación Valenciana en el Siglio XIV.*

Geselowitz, M.N., 1993. Scientific Archaeology and the Formalist/Substantivist Debate: A Review of *2,000 Years of Zinc and Brass*, *Archaeomaterials* **7**, 167-71.

de Ruette, M. 1995. 'From *Counterfrei* and *Speauter* to zinc', in *Trade and Discovery*, ed. D.R. Hook and D.R.M. Gaimster, British Museum Occasional Paper 109, London 105-203.

Somers, J. 1997. Quoted in issue 36 of the *Newsletter of the Historical Metallurgy Society*, p.2.

ZINC IN CLASSICAL ANTIQUITY

P.T. Craddock

Department of Scientific Research, The British Museum, London WC1B 3DG

INTRODUCTION

The origins of the production of metallic zinc are even more confused and incomplete than for brass. As yet there is no coherent picture of the development before the emergence of zinc smelting as a fully-fledged industrial process in north west India, probably about a 1,000 years ago (see Chapter 3). Instead we have for the most part a variety of generally unrelated evidence, sometimes of dubious value, from all over the ancient world that zinc was known and produced, admittedly on a small scale, many centuries before it came into regular production. This very long period when zinc was little more than a scientific curiosity, creates problems in elucidating the early history of the metal. The problem is confounded by the perception that the relative chemical reactivity of the metal will ensure that any zinc buried in the ground will inevitably have long since corroded away (and thus pieces that are found cannot be ancient), and the frequent misidentification of pieces that have survived as being of tin or of lead.

Zinc is one of the more abundant metallic elements in the earth's crust, but it is very reactive and thus never occurs as a native metal. Zinc ores are common and easily recognised and they are regularly found with other metals, notably lead, in deposits which were worked in antiquity. Why then does it appear so late in the archaeological record, millennia after lead, copper, tin or silver? The reduction of the ores present no insuperable problem thermodynamically in the simple shaft furnaces used all over the world for metal smelting. The problem lay, of course, in the extreme volatility of the metal, it boils at 907°C which is below the temperature at which it would be smelted. Thus instead of a molten metal descending to form an ingot at the base of the furnace, zinc as a vapour would rise and promptly reoxidise in the upper part of the furnace and be lost in the fume.

However during the smelting of zinc-rich lead ores in early times it is not impossible that a very little zinc escaped reoxidation and condensed in the flue as certainly happened in the more recent past. For example, zinc was recovered from the flues of the smelting furnaces of Swansea in the nineteenth and early twentieth century by the workmen and made into spelter toys for their children (Peter Hutchinson *pers comm.*).

Several instances of supposedly ancient artefacts made from zinc have been reported over the years and these must be considered now.

REPORTED DISCOVERIES OF EARLY ZINC ARTEFACTS

Davies (1935, 60), followed by Caley (1964, 13) listed several reports of early zinc artefacts. Davies accepted several of the items including some pieces from northern Italy purporting to be of Iron Age date, but Caley was much more cautious. Their lists included excavated items such as bracelets from tombs on Cameiros on Rhodes, or a bell found in excavations at Castelvenere near Trieste, where the identification of the metal seems to be based on little more than visual appearance, and the objects can no longer be traced, or artefacts such as a Dacian (?) idol from Tordos in Transylvania, which although undoubtedly of zinc, was just a surface find with no archaeological context, indeed no real provenance or date. The only specimen included by Caley to have come from an archaeological context and to have been proven to be zinc was a small sheet of the metal from the Athenian Agora which is discussed in detail below.

Since Caley's publication other finds of ancient metallic zinc have been reported. These include two pieces from excavations both in Scotland and purporting to date from the Iron Age (McKie 1974, 172). The pieces were both included along with other finds from the two sites, and no comment was made on their significance. This reticence was probably just as well as they have more recently been examined by E. Slater of Glasgow University who reports (*pers comm.*) that the two pieces are not of zinc but fragments of galvanized iron, and their relatively uncorroded condition strongly suggests they are modern. This conclusion has been fully accepted by their excavator who noted that their position could have made a modern intrusion possible.

The possibility of Medieval zinc was raised by the publication of two conjoining and corroded fragments of zinc, which appear to be part of a large base, possibly ecclesiastical in function, decorated in a Romanesque style (Brownsword 1988). The zinc contained about 0.7% of lead and a trace of copper. The pieces were found at Pipe Aston, near Ludlow in Shropshire in the bed of a stream below the water line and thus unfortunately have no dateable context and could very well be Victorian or even later.

A small inscribed tablet of zinc has been published (Fellmann 1991, Rehren 1996) purporting to come from a known Gallo-Roman sanctuary near Berne. The inscription is in a Celtic language and is formed of Greek capital characters stippled onto the cast tablet. The metal was apparently cast in an iron mould, which are otherwise unattested in the Roman period, and the zinc is rather impure for freshly distilled zinc, containing 1.06% of lead, 0.287% of iron, 0.109% of cadmium and 0.07% of tin. The iron content is especially high, reminiscent of the zinc from a modern galvanising bath. However the cadmium content is somewhat high for zinc produced by any modern differential distillation process.

Some years ago the existence of a zinc statuette of Hellenistic type from the Athenian Agora was mentioned to the author by T. Stech (reported in Craddock 1978). The statuette was unstratified but was said to have come from the same area as the more well-known sheet of zinc from the Athenian Agora, mentioned above and to be discussed in detail below. Since then the author has had the opportunity to examine the statuette, and it certainly is of zinc, but it is completely uncorroded and has a flash lines and mould marks showing that it was cast in a two piece mould, as part of a batch of many identical pieces. This and the lack of corrosion suggest it is modern.

The only piece of worked zinc to come from stratified excavations and which still exists for study, and thus to be generally accepted, is the now famous small sheet of zinc from the Athenian Agora. This was intelligently and comprehensively published by Farnsworth, Smith and Rodda in 1949. The discovery was made ten years earlier by Dr Arthur Parsons who in the 1949 paper described the circumstances of its discovery thus:

> The fragment of zinc was found in Section OA on May 13, 1939, at the base of the cliff on the north slope of the Acropolis, at a point about 7.0m east of the ancient fountain house, the Klepsydra, and directly below the cave sanctuary of Pan. The pottery and the coins with which it was found were chiefly of the fourth and third

centuries BC; there was nothing later than the early second century BC. It may be regarded as certain that the zinc got there no later. The deposit appears to have been formed by a winter torrent which washed the material down from the ledges above.

The piece was a roughly rectangular plate originally about 6.6 by 4cm, and about 0.05cm thick over most of its area but tapering away at the edges. This was probably due to corrosion, which in places had pitted right through the metal. When the object was first uncovered it was heavily patinated, and in the belief that it was lead it was completely stripped in chromic acid to reveal any possible inscription. This of course made any study of the patination impossible, but at least it establishes that the piece was originally corroded. Forbes (1971, 272) questioned the antiquity of the piece specifically on the grounds that it was uncorroded.

Once it was recognised as zinc, the plate was divided and one half carefully studied. A quantitative analysis by emission spectography showed the sheet to be of zinc with 1.3% of lead 0.06% of cadmium, 0.0055% of copper, 0.0016% of iron, 0.00025% of manganese and slightly under 0.0005% of magnesium, in addition, very faint traces of tin, silver, and silicon were also detected, along with chromium which probably came from the acid used to clean the plate. According to the authors, one of whom was a metallurgist with the New Jersey Zinc Co., the lead, iron and cadmium contents were typical of modern zinc, but that there were otherwise a greater variety of trace elements than was usually encountered. Of course some of the extra trace elements could well have been picked up during burial (of whatever duration) as corroded bronze coins were found in the same layer. The iron, lead and cadmium are fairly typical of unrefined zinc produced by the now obsolete retort process used in the nineteenth and twentieth centuries. Most of the zinc was refined but some was sold untreated. Comparisons with zinc produced earlier are given below (see p.3).

The metallographic structure proved most interesting. The piece had been moderately worked by hammering as shown by random elongation of the lead globules. If the metal had been rolled then the elongation would have been uniform in the direction of the rolling. This observation was confirmed by the absence of any preferential orientation in the distortion of the granular structure of the sheet. Zinc is very difficult to work cold, but in 1805 only a few years after it began to be regularly smelted in Europe it was discovered that zinc could be perfectly

satisfactorily rolled at temperatures between 100-250°C and a large manufacture of rolled zinc sheet grew as a consequence of this discovery (see Day p.152, in this volume). Thus modern zinc was either cast or hot rolled, but rarely if ever hammered. This suggested to Farnsworth *et al.* that the sheet was not modern, quite apart from the purely archaeological considerations. They were however unhappy at the relatively uncorroded state of the piece and hinted very obliquely at the possibility of oriental zinc in the form of linings of tea chests (but then, confusingly, killed this idea by pointing out that tea chests were in fact lined with a tin/lead alloy, not zinc at all). However the damage was done, and this almost chance remark was taken up by Forbes (1971, 272), who in turn was followed by Needham (1974, 148) who quite unreasonably equated the possibility of zinc in classical Greece as being as likely as aluminium in Han China!

As this piece was unique there was nothing with which to compare the state of corrosion (although it should be pointed out that the late medieval zinc coins found in India seem to regularly survive half a millennia of burial without serious damage, and now Roman-period pieces are known to survived burial (p.5). The same problem of lack of comparative material is encountered with the composition. Bishop Watson gave what are probably the earliest published comparative compositions in his *Chemical Essays* (1786 IV, 41), derived from the densities. There he states that 'a cubic foot of Indian zinc weighs 7240 oz. the same bulk of Goslar zinc, taking the medium of 3 specimens gave 7210 oz., the Goslar zinc which I examined gave only 6953 oz. to a cubic foot, a cubic foot of English zinc, from Bristol, weighs 7028 oz. and hence if the lightness of zinc be a criterion of its purity, our English zinc is preferable to the Indian, and nearly equal to the German Zinc.'

Assuming that lead was the only significant impurity in the zinc then from these figures it is possible to deduce that the Indian zinc had about 5% of lead, the zinc (collected from the flues of lead smelters) at Goslar in Germany about 1%, and the zinc smelted by Champion in his vertical metal process about 2%. By contrast ingots of zinc from the wreck of a vessel of the East India Company en route from Canton to Sweden in 1745 recovered in this century were found to contain 0.765% of iron and 0.45% of antimony, and lead could not be detected (Carsus 1960, 3). The absence of lead is rather surprising, but probably the upward distillation method used by the Chinese (see p.115) rather than the downward method adopted in both India and

Britain significantly reduced the denser lead fraction. Note, however that a recent analysis of a fragment of zinc adhering to the floor of a furnace at Zawar contained only about 0.35% lead (see Chapter 3, p.53), rather suggesting that the metal was subsequently adulterated with lead. From these figures, especially for lead, it does seem that an Indian or Chinese source for the Agora piece is unlikely, but that a source similar to the Goslar zinc, is supported. The significance of this is discussed below.

Thus the antiquity of the Agora piece would seem to be supported both on archaeological and metallurgical considerations. This conclusion poses the questions of why zinc was apparently so rare in the classical world and how this particular specimen came to be made. For this it is necessary to turn to the contemporary literature.

ANCIENT DOCUMENTARY SOURCES FOR ZINC IN THE WEST

There is a small but coherent literature on brass from quite early times, and the alloy had a specific name in Greek, *oreichalkos* (literally 'copper of the mountain'), which changed over the years to the Latin *aurichalcum* (literally 'golden copper'). For zinc there is but one contemporary classical reference and even then the metal does not have a name, it is just 'mock silver.'

This reference occurs in Strabo's *Geography* (Book XIII sec. 56) (Jones 1928, vol.6, 115), but was taken from the now lost *Philippica* by Theopompus of Chios, written in the fourth century BC. The passage has been frequently translated and discussed, but probably the most accurate translation is that given by Caley (1964, 18-25): 'There is a stone near Andeira which yields iron when burnt. After being treated in a furnace with a certain earth it yields drops of false silver. This, added to copper, forms the mixture which some call *oreichalkos*'.

Andeira was a city in Phrygia (north-west Anatolia) which figures large in the history of brass. Near where Andeira lay are deposits of argentiferous lead/zinc pyrites which show evidence of early work (Lones n.d.). This is at Balya Maden in the modern Turkish province of Balkesir. The ore is described (de Jesus 1980, 270; Anon 1972, 81) as being of galena, sphalerite, pyrite with some chalcopyrite and arsenopyrite. In more recent times the mine was worked from 1880 to 1935 with an annual production of approximately 7.3 thousand tons of lead, 2 tons of silver and 55kg of gold. After smelting the lead contained about 600ppm silver. No attempt

was made to recover the zinc. The remains of the ancient smelting activities, which seem to have been mainly for silver, have been surveyed by Pernicka *et al.* (1984), with results which are significant for the present discussion (see below).

There are descriptions in the sixteenth-eighteenth centuries of the smelting of similar pyritic ores rich in silver, copper, lead and zinc together with a host of other metals such as arsenic and antimony, in central Europe – especially at the famous mine of Rammelsberg near Goslar in the Harz Mountains.

In the sixteenth century Agricola in his *De Natura Fossilum* (discussed by Hoover and Hoover 1912 in the more familiar *De Re Metallica*, 408) stated that 'if pyrites are smelted the first to flow from the furnace into the forehearths as may be seen at Goslar is a white molten substance, injurious and noxious to silver for it consumes it'. Then in the glossary he continues that there is a second substance *conterfei* which was found on the walls of the flue. Both of these substances can be readily identified. The first is *speiss*, a mixed iron arsenide/antimonide, the particular composition, depending, of course on the ores. Speiss is formed during the smelting of ores rich in iron, and arsenic or antimony, and it readily absorbs silver. When solid it is dense, very hard and with a silvery-white, very metallic fracture. Its high iron content means that it readily rusts in air, and, in fact, it was often confused with iron. For example cannon balls cast from speiss by the Turks have been found at Palaia Kavala in northern Greece (Photos *et al.* 1989). At Rio Tinto, in the south of Spain, speiss was described in the seventeenth century as a metal suitable for casting into cannon balls, bullets, coins or even to replace the tin in church bells (Salkield 1987, 144). As late as 1966 the locals collected bagfuls of the speiss from the Roman slag heaps, mistaking them for metal (information from John Hunt, the then Mine Secretary).

The smelting of the zinc-rich ores at Goslar caused the deposition of large quantities of zinc oxide on the furnace walls, which was collected (as recorded and illustrated by Ercker (Sisco and Smith 1951, 271-2, Fig. 36). The droplets of *conterfei* or mock silver, as it was also called, collected from flues of the Goslar furnace were, of course, the very small amount of metallic zinc which had condensed and solidified before they had chance to reoxidise. Initially they were only collected if anyone expressed an interest, but later zinc began to command a high price and cool chambers were set into the flue walls to encourage droplets of zinc to condense and drip down into charcoal below.

Watson (1786 IV, 40) noted that 'At Goslar in Germany they smelt an ore which contains lead, silver, and copper and iron and zinc in the same mass; the ore is smelted for procuring the lead and silver and by a particular contrivance in the furnace.... they obtain a portion of zinc.' Swedenborg (1734) recorded the quantities produced by this method at Rammelsberg as 'being no more than 'between 140 and 155 hundredweight per annum' (between 7 and 8 tonnes). The zinc so produced was used in the manufacture of top quality brass.

Armed with this background information it is possible to interpret the Theopompus quotation with some confidence.

The mixed silver-bearing pyrites ore mined near Andeira when smelted would have yielded an iron-rich speiss which with its very metallic appearance, could easily have been mistaken for iron itself – as it was in the recent past. The recent survey of the ancient slag heaps at Balya Maden by Pernicka *et al.* (1984) has shown that they do indeed contain speiss. Meanwhile some of the zinc in the ores would have been reduced to zinc metal in the vapour phase which would inevitably have been carried up the flue where the vast majority would have reoxidised to zinc oxide. Just a tiny proportion would however have been condensed as droplets of metallic zinc on the flue walls. This was the *conterfei* or 'mock silver', after all what else does one call a silvery-white metal found in a silver mine, but which is not silver? This zinc when added to copper gave *oreichalkos* or brass. By the fourth century BC at the latest there can be no serious doubt than *oreichalkos* was brass (and absolute certainty by the time of Strabo), and the only metal one can add to copper to make brass is zinc. Percy (1861, 519) had also suggested the zinc could have been recovered from the flues of furnaces used for smelting other metals, and noted that zinc metal had been collected from cracks near the tuyere of a blast furnace of the Ebbw Vale Ironworks in Wales when zinciferous ores were smelted.

There is a possibility that this phenomena was known and exploited in Medieval Europe. In the *Book of Minerals*, compiled in the thirteenth century AD by Albert Magnus (Wyckoff 1967, 250), it states that *tutty* (that is zinc oxide, see Chapter 4) was the white smoke collected from the furnace flues, but that there was another, darker variety, called *Indian tutty* which sank to the bottom when the ordinary *tutty* was washed. This sounds very like the droplets of relatively dense, metallic zinc found at Rammelsberg etc.

This hypothesis for the interpretation of the Andeira droplets has been boosted by the recent discoveries of small lumps of zinc metal from excavated sites of the Roman period in both Poland and in Britain. Stos-Gale (1993, esp. p.115) has reported a small piece of zinc from deposits excavated in a metalworking shop at Jakuszowice, 50 km north east of Krakow in southern Poland, contemporary with the late Roman period. The piece was an irregular lump of zinc with about 5% of lead. The site lies about one hundred km from the Olkusz lead/zinc ore field, and Stos-Gale believed the piece to have formed in the flues of a lead smelting furnace, although there was no evidence of primary extractive metallurgy at the site, suggesting the piece may have been deliberately collected and brought to the site. The second piece was excavated from Roman contexts of the first century AD at the lead mine of Charterhouse on Mendip, Somerset in England (Todd 1993, and 1996). The lead ore at Charterhouse contains some zinc, and smelting was carried on at the mine. This small piece of zinc had almost certainly formed in the upper parts of the lead smelting furnace, but as it was unused it may well not have been deliberately collected or even recognised as being of metal. These two finds do however show that zinc metal could be produced in the small lead smelting furnaces of classical antiquity.

SUMMARY

Thus we would seem to have a fourth century BC reference to the collection of zinc as a by-product of silver smelting. The process is not recorded at mines elsewhere in Classical antiquity, but similar ores were smelted at Laurion in Greece. At Laurion, zinc oxide was carefully recovered from the walls of the furnace flues for medicinal purposes - the basis of the familiar zinc ointment. Pliny (Natural History 34.182, Rackham 1952, v.9, 225) refers to it as *lauriotis*. Thus it seems quite likely that droplets of zinc similar to those found at Andeira would have been encountered and even collected at other mines, but were not recorded. This is now confirmed by the finds of zinc at mines and metal working sites. Even so it is clear that if this was the only way of recovering zinc then it must have been a rare metal, and if this zinc was the only source for brass-making before the discovery of the cementation process, using zinc oxides directly, then perforce brass itself must also have been a very expensive metal. This could explain the great value put on brass by Plato

and others. It would also explain why so little zinc has survived from antiquity, and why it had no separate name beyond 'mocksilver'. It was a rare metal and its importance was as a component of brass. Once brass production by the cementation process had begun, there would have been no further economic interest in zinc and by Roman times no contemporary mention is made of it, Strabo's quote coming from a work written several hundred years previously. The fragment found recently at Charterhouse on Mendip from a Roman context had clearly been discarded. Some additional support is provided by Watson's figures where the lead content of the Agora piece seems similar to that at Goslar, produced by a similar process millennia before.

Thus we have the rather unexpected scenario for the early manufacture of brass and zinc. Some time in the first millennium BC smiths at the lead-silver mines recognized that the droplets of white metal (mocksilver) which collected in the furnace flues could be added to copper to give *oreichalkos*, or copper of the mountain, a golden copper alloy of great rarity which had hither to been obtained from natural mixed copper/zinc ores (see Chapter 2). Even so brass was still very costly and was to remain so until by the end of the second century BC at the very latest, probably in western Anatolia, *oreichalkos* or brass began to be made by the cementation process, as exemplified by the first brass coinage minted in Pontus, Phrygia, and Bithynia. The zinc ore may possibly have come at least in part from the mines of Andeira. Once the cementation process was established zinc metal was no longer needed for brass production and in the west its significance dwindled until by the time of Strabo it was already no more than an historic curiosity culled from a work written centuries before.

REFERENCES

Anon, 1972. *Lead, Copper and Zinc Deposits in Turkey*. Mineral Research and Exploration Institute of Turkey. Ankara.

Brownsword, R. 1988 A possible Romanesque object made from zinc. *Journal of the Historical Metallurgy Society* **22** 2, 102-3.

Caley, E.R. 1964. *Orechalcum and Related Ancient Alloys*. American Numismatic Society. Notes and Monographs no. 151. New York.

Carsus, H.O. 1960. Historical background. in *Zinc*. (ed. C.H. Mathewson). American Chemical Society, New York.

Craddock, P.T. 1978. The composition of the copper alloys used by the Greek, Etruscan and Roman civilisations. 3: The origins and early use of brass. *Journal of Archaeological Science* **5**, 1-16.

Davies, O. 1935. *Roman Mines in Europe*. Oxford University Press, Oxford.

de Jesus, P.S. 1980. *The Development of Prehistoric Mining and Metallurgy in Anatolia*. B.A.R. International Series **74**, Oxford.

Farnsworth, M., Smith, C.S., and Rodda, J.L. 1949. Metallographic examination of a sample of metallic zinc from ancient Athens. *Hesperia*, (Supplement 8), 126-9.

Fellmann, R. 1991. Die Zinktafel von Bern-Thormebodenwald und ihre inschrift. *Archäologische der Schweiz* **14**, 270-3.

Forbes, R.J. 1971. *Studies in Ancient Technology* **8**. 2nd ed. Brill, Leiden.

Hoover, H.C. and Hoover, L.H. (trans. and ed.) 1912. *Agricola: De re Metallica*. The Mining Magazine, London.

Jones, T.L. 1928. *Strabo: Geography*. Book **XIII**,1, 56 (Loeb Classical Library). Heinemann, London.

Lones, T.E. n.d. *Zinc*. Pitmans Commercial Services, London.

McKie, E. 1974. *Dun Mor Vaul: an Iron Age Broch on Tiree*. University of Glasgow Press, Glasgow.

Needham, J. 1974. *Science and Civilization in China* **V**,2. Cambridge University Press, Cambridge.

Percy, J. 1861 *Metallurgy: Fuel; Fireclays; Copper; Zinc and Brass*. John Murray, London.

Pernicka, E., Seeliger T.C., Wagner, G.A., Begemann, F., Schmitt-Strecker, Eibner C., Öztunali, O., and Baranyi, I. 1984. Archaömetallurgische Untersuchungen in Nordwestanatolien. *Jahrbuch des Römisch-Germanischen Zentral Museums* **31**, 533-600, esp. table 2 p.544.

Photos, E., Koukouli-Chrysanthaki, C., Tylecote, R.F. and Gialoglou, G. 1989. Precious Metals Extraction in Palaia Kavala, in *Old World Archaeometallurgy* ed. A. Hauptmann, E. Pernicka and G.A. Wagner. Deutsches Bergbau-Museums, Bochum. 179-190.

Rackham, H. (trans. and ed.) 1952. *Pliny: The Natural History* 9 (Loeb Classical Library). Heinemann, London.

Rehren, Th. 1996. A Roman zinc tablet from Bern, Switzerland: reconstruction of the manufacture. in *Archaeometry 94* ed. Ş. Demirci, A.M. Özer and G.D Summers, Tübitak, Ankara. 35-45.

Salkield, L.U. 1987. The Roman and pre-Roman slags at Rio Tinto, Spain. In *Early Pyrotechnology*, eds. T.A. and S.F. Wertime. Smithsonian Institution Press, Washington DC.

Sisco, A.G and Smith, C.S. 1951. *Ercker: Treatise on Ores and Assaying*. University of Chicago Press, Chicago.

Stos-Gale, Z. 1993. The origin of Metals from the Roman-Period Levels of a Site in Southern Poland, *Journal of European Archaeology* **1** 2, 101-30.

Swedenborg, E. 1734. *de Cupro* (English translation A.H. Searle, British Non-Ferrous Metals Association, Misc. Pubs. **333**. 1938, London.

Todd, M. 1993. Charterhouse on Mendip: An interim report on the survey and excavation 1993. *Proceedings of the Somerset Archaeological and Natural History Society* **137**, 59-67.

Todd, M. 1996. *Pretia victoriae?* Roman Lead and Silver mining in the Mendip Hills, Somerset, England. *Münstersche Beiträge fur antiken Handelsgeschichte* **15**,1, 1-18.

Watson, R. 1786. *Chemical Essays* **IV**. Evans, London.

Wyckoff, D. (trans.) 1967. *Albert Magnus: The Book of Minerals*, Clarendon Press. Oxford.

THE PRODUCTION OF BRASS IN ANTIQUITY WITH PARTICULAR REFERENCE TO ROMAN BRITAIN

Justine Bayley

Ancient Monuments Laboratory, English Heritage, 23 Savile Row, London W1X 1AB

INTRODUCTION

Archaeologists tend to call all objects made from copper alloys 'bronze' and refer to their manufacture as bronze-working. To a certain extent this is understandable as until recently most objects that had been analysed were of Bronze Age date and were indeed made of bronze, that is of copper alloyed with tin. The expectation therefore was that the only copper alloy used in antiquity was bronze. A couple of Roman fittings analysed by Gowland at the beginning of this century should have sounded a warning as he showed them to be brasses containing nearly 19% zinc with no detectable tin (Fox and St. John Hope 1901). However the universal use of bronze as a descriptive term, and by implication a metal composition, continued. Somewhat later Smythe (1938) showed a range of different copper alloys had been used for small objects from sites along Hadrian's Wall and Tylecote (1962) interpreted these results as showing the widespread introduction of zinc into the copper alloys used in Roman Britain.

It was not only to Britain that the Romans introduced the use of brass; it had come into general use in many parts of the Roman world in the first century BC. Brass was not completely unknown before then but was not produced in quantity on any regular basis. These earlier occurrences are discussed below.

Although there has been confusion in the names used to describe copper alloys in relatively recent times (Dr Johnson's dictionary defined brass as bronze!), the Romans clearly differentiated between the various copper alloys that they used. Pliny describes a whole range in his *Historia Naturalis* (Bailey 1932) but even he has inconsistencies in his terminology. Most of the alloys are varieties of *aes* which is usually translated as 'bronze' though it also has the generic meaning of 'copper alloy'. *Aurichalcum* was the specific term equating to 'brass' which derived from the Greek word *oreichalkos*.

Given this history of confusion and uncertainty, it would perhaps be useful to define the terms that will be used here to describe copper alloys. In Roman and later times copper was alloyed with one or more of the elements tin, zinc and lead. Other elements were often present in minor or trace amounts but this was normally unintentional. An alloy that contains mainly copper and zinc is a brass, bronze is mainly copper and tin, while copper alloyed with significant amounts of both tin and zinc is known as a gunmetal. Any of these alloys may also contain lead, and are then known as leaded bronze etc. There are no hard and fast divisions between the different alloys, the name used depends on the relative amounts of the various elements present. The relationship between alloy name and composition is demonstrated in the ternary diagram (Fig. 1) where the closer you get to a corner, the higher is the proportion of that element present. Analysis of Romano-British metalwork has shown that brasses generally contain 10-25% zinc, bronzes 5-15% tin, and gunmetals at least several per cent of both tin and zinc. Leaded alloys are those with over about 4% lead though most contain over 10% and some in excess of 20%. Significantly the zinc content tends to be inversely proportional to that of the tin suggesting deliberate or accidental mixing of brass and bronze scrap (Bayley *et al.* 1980, fig. 4; Craddock 1978, fig. 7).

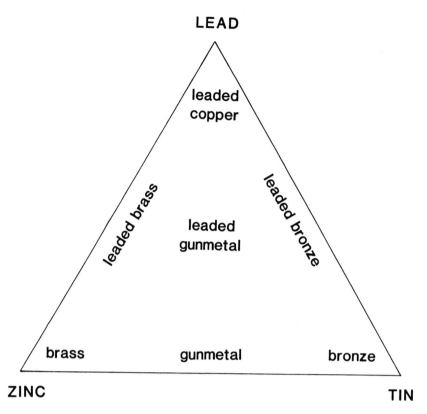

Fig. 1 Ternary diagram showing the relationship between alloy name and composition for copper alloys

THE ORIGINS OF BRASS IN THE MEDITERRANEAN WORLD

Modern analyses have detected significant amounts of zinc in an increasing number of early objects which pre-date the general introduction of brass. These all provide some indication of the local accidents and experimentation which culminated in the introduction of the large scale use of brass in the first century BC.

The earliest zinc-rich copper alloys noted in the literature are those from the Early Bronze Age site of Vounous Belapais in Cyprus (Stewart and Stewart 1950, analysed by Desch) though more recent work has shown the results to be incorrect; the objects are in fact mainly arsenical coppers (Craddock 1981). However, the mechanism proposed by Craddock (1978), i.e. the smelting of zinc-rich copper ores, could indeed produce natural brasses containing several percent of zinc. This may explain the occurrence of objects containing a small amount of zinc, usually in addition to the expected alloying elements. Several examples are quoted by Craddock (1978), for example the seventh century BC fibulae from the Phrygian tombs at Gordion in Asia Minor. Before these examples were known Halleux (1973) had already made the fascinating suggestion that perhaps naturally occurring zinc-rich copper ores

gave the metal referred to as 'copper of the mountains' in a number of Assyrian cuneiform tablets of the eighth-seventh centuries BC. This metal was clearly quite distinct from ordinary copper and much more expensive. At the same time we get the first Greek references to *oreichalkos* - which is literally translated as copper of the mountain.

As well as the objects with low but significant zinc contents there are a number with rather more zinc, in the range 6-12%, a high enough level to be described as brass. Craddock (1978) mentions some and to these can be added a bowl in the British Museum from Nimrud which contained 6% zinc (Hughes *et al.* 1988) and a finger ring from Ugarit of the thirteenth century BC with 12% zinc (Schaeffer-Forrer *et al.* 1982).

Since the first edition of this work other examples of early brass have been discovered. Probably the most significant are two rings excavated many years ago at Nuzi in northern Iraq, from levels dating to shortly before a general destruction that is dated to *c.* 1350 BC. The metalwork is currently being studied by Christine Bedore, of the Department of Archaeology at Boston University, to whom I am extremely grateful for permission to publish this information in advance of her own report. Quantitative analysis by INAA/ICP found 14.4% zinc together with 4.7% lead and 0.49% tin in one

ring and 12.2% zinc together with 3.3% lead and 6.3% tin in the other. These are currently the earliest brasses known.

Many of these zinc-rich objects came from Asia Minor so it is not perhaps surprising that the classical authors who wrote about the production or use of *oreichalkos* always mentioned this area when they gave any geographical location. These texts have been discussed at some length by Forbes (1964), Caley (1964), Craddock (1978) and Craddock *et al.* (1980) among others, who generally accept that *oreichalkos* should be identified as brass and that it was a rare and precious metal until the first century BC.

The zinc content of this early *oreichalkos* suggests it was not made by the cementation process which normally produces brass with over 20% zinc (see next column). There is no real evidence of how the metal was made, though it could have been by careful reduction of zinc-rich copper ores or possibly even by alloying zinc metal with copper. Metallic zinc was known in Hellenistic Greece (see Chapter 1 and Craddock 1978) and Strabo quotes Theopompus (who wrote in the fourth century BC) as saying that, after being treated in a furnace, a certain stone from near Andeira (in north-west Asia Minor) yielded droplets of false silver which, when added to copper, formed *oreichalkos* (p.3). If this is a description of zinc condensing in the cooler parts of a furnace and being recovered as has been suggested (Craddock 1978), the inefficiency of the process might explain the rarity of the resulting *oreichalkos*. The whole question of early zinc in the West is examined in greater detail by Craddock (see p.1).

It is Asia Minor again which provides the first evidence of mass-produced brass. A selection of first century BC coins from Phrygia and Bithynia (Pl. 1) were analysed and nearly half were shown to be brasses with an average zinc content of nearly 22% (Craddock *et al.* 1980). Zinc at these levels is typical of brass made by cementation and it was the development of this process which made the widespread use of brass a practical proposition. These coins seem to be the direct ancestors, via the Augustan C series issued in the East in 29 BC, of the well-known brass *dupondii* and *sestertii* of the major central reformed coinage of 23 BC (Burnett *et al.* 1982).

THE CEMENTATION PROCESS

Copper, tin and lead were all available as metals in antiquity so their alloys could be made by melting the copper, adding the tin and/or lead and stirring the melt to homogenise it. Brass could not be made in this way because metallic zinc was not generally available as it could only be obtained from its ores by distillation. Instead, brass was made by the cementation process which remained the standard European method of manufacture until the beginning of the nineteenth century (see chapter 6).

To produce brass by cementation, finely divided copper metal is mixed with zinc oxide or carbonate (calamine) and charcoal and put into closed crucibles. These are then heated, the zinc ore is reduced to metallic zinc (in the form of a vapour) which diffuses into the copper, forming brass. The temperature has to be carefully regulated as zinc does not vaporise below 907°C and pure copper melts at 1083°C. As zinc diffuses into copper the melting point of the metal falls and is below 1000°C by the time it contains about 30% zinc. At the end of the process the temperature is increased and the metal melted to homogenise it. Once this happens there is little further uptake of zinc as the surface area of metal exposed to the zinc vapour is drastically reduced.

Werner (1970) has reported laboratory experiments by Haedecke (1973) that reproduce this process and which demonstrate that the maximum zinc content to be expected at a working temperature of 1000°C is 28%. This figure represents equilibrium between the metallic zinc (vapour) in the sealed crucible and the zinc dissolved in the copper. Craddock (1978) mentions seventeenth century experiments which managed to get a maximum zinc concentration of 33.3% by cementation and certainly this figure was usual in the eighteenth and nineteenth centuries (Percy 1861) so values up to this level must be considered possible in Roman times though normally the maximum would have been between 22% and 28%. These high-zinc brasses normally contain a maximum of only a few per cent of additions such as tin or lead as higher levels of them in the copper used for cementation would lower the melting point of the metal and directly reduce the amount of zinc that could be absorbed.

While we know from modern analyses that brass was widely used in Roman and medieval times and that it was made by the cementation process, there is relatively little archaeological evidence for its manufacture. In the same way that Theopompus' description may indicate the small scale production of metallic zinc, other passages in the classical authors can be used as supporting evidence for cementation. Dioscorides, writing in the first century BC, is among those who mention calamine ore and its uses.

The translation quoted here is the only one into English and, as can be seen from its archaic language, dates from the seventeenth century. He describes the various sources of *cadmia* (zinc oxide or carbonate) and its medicinal uses and says:

> The best of ye Cadmia is ye Cyprian ... but Cadmia also comes from brass red-hot in a furnace, the soot sticking to the sides, and to ye top of the furnaces. Now [rods] of iron, of a great bigness, called by ye metal-men Acestides are joined together at ye top to ye end that ye bodies that are carried up from the brass, may be held and settled there; which also sticking ye more, grow into a body

Galen, writing in the third century AD, also mentions calamine in a medicinal context, made from pyrite on a fire; again Cyprus is his source.

Dioscorides' reference to brass as a source of calamine may seem an unhelpful reversal of the process for which evidence is sought. What it does however indicate is that the relationship between calamine and brass was known. The process being described was probably a method for purifying zinc ores to give calamine or zinc oxide that could then be used either medicinally or metallurgically. Condensing refined calamine on iron bars is also documented in Persia, although at a rather later period, when Marco Polo recorded it in the course of his travels (Latham 1972 and below p.74).

In cementation this refining step would be essential if zinc sulphide rather than oxide or carbonate ores were being used. It has the added advantage of separating the zinc from any contaminants such as iron or lead minerals which are often found together with those of zinc. In Europe the common zinc mineral used in antiquity was calamine so this refining step was often omitted; the result is an iron content of up to 0.5% in the resulting brass (Craddock 1985a). In the Middle East the sulphide ore, sphalerite, was used from an early date and the brass typically has a lower iron content because the ore was roasted, though it often contains a little lead from the mixed sulphide ores.

Pliny, who wrote his *Historia Naturalis* in the first century AD, is another author who mentions *cadmea*, a term which he uses to refer to both zinc-rich ores and the volatilised products obtained from roasting them. He also mentions the production of brass from copper and cadmea. Of the different sources of copper available, he says that Marian copper absorbs *cadmea* most readily and then looks like *aurichalcum* and is used to make *sestertii* and *dupondii*.

The earliest full description of making brass by the cementation process is that given by Theophilus in his *De diversis artibus* (Hawthorne and Smith 1963). Although this treatise is dated to around the twelfth century AD, many of the processes described were of considerable antiquity even then, illustrating the conservatism of craftsmen. His description can therefore be taken as a reasonable approximation of the process used in Roman times and on into the Middle Ages.

> And when the crucibles are red-hot take some calamine, ... that has been [calcined and] ground up very fine with charcoal, and put it into each of the crucibles until they are about one-sixth full, then fill them up completely with ... copper, and cover them with charcoal. ... When it is all thoroughly melted ... pour it out.

Taken together, the documentary records of ancient brass-making are fairly helpful and do at least confirm the use of the cementation process in antiquity. Archaeology has recently begun to provide some extra information but little is known of where and when brass was made and the way the industry was organised and controlled. Brass was very likely made in Etruria, and in northern Europe the area round what is now Aachen was also a centre. Calamine ore was discovered there in 74-77 AD and the industry flourished in the period 150-300 AD but declined in the fourth century. The fifth century marked a revival which set the scene for the later medieval industrial pre-eminence of this area (Forbes 1956). Apart from some evidence of Roman calamine mining (Willers 1907) there is little surviving material evidence for ancient metallurgy here; presumably the long period of working has effectively destroyed the earliest remains. However, excavations in 1979 just to the north at Xanten discovered hundreds of very small, lidded brass-making crucibles dating to the mid first century AD (Rehren 1996), while a minimum of 272 large, crudely-lidded vessels from Lyon, in eastern France, dating to the end of the first century AD, are also thought to have been used for making brass by cementation (Picon *et al.* 1995).

BRASSWORKING IN BRITAIN

In Britain there were abundant zinc ores in the Mendips but there is no evidence that the Romans exploited them though they certainly did mine argentiferous lead in the same region. Recent archaeological excavations have however produced a small body of evidence for brass manufacture by the cementation process in the early Roman period (Bayley 1984a). In both Colchester and Canterbury fragments of small, lidded crucibles were found, of a

form and fabric so far unparalleled in Romano-British metal melting crucibles (Pl. 2). Analysis detected unusually high levels of zinc on their inner surfaces so the sherds have been interpreted as parts of brass-making crucibles. A handled crucible of similar appearance has more recently been found at Ribchester, though it lacks a lid. Those from Colchester were found inside the fortress in layers dating to within a few years of its foundation in 43/4 AD (Crummy 1992, 55) while the earliest of those from Canterbury are from contexts pre-dating from c. 60 AD (Frere et al. 1987, 299. The small size of these vessels has led to some questioning of the interpretation placed on them, though Rehren (1996) has identified even smaller brass-making crucibles from Xanten. The British finds are very distinctive; the fabric is very friable so, once broken, they do not survive well. It is quite likely that similar but larger vessels were also used though none have yet been found and identified; they may have been pulverised to recover metals prills trapped in their walls. Lidded crucibles of similar form have been found in a context of 60-75 AD at Verulamium (Bayley 1991, Frere 1972, Figs 141, 2 and 3) and in a second century context in Germany (Bachmann 1976), though analyses suggested they were used to melt brasses and mixed copper alloys (gunmetals) respectively. In the latter case Zwicker et al. (1985) suggest the lid may have acted to limit the loss of zinc from the melt and even allowed zinc to be added to the melt in the form of an ore (a semi-cementation process). Certainly, on the basis of the limited evidence we have in Britain and on the Continent, lids seems to be necessary on Roman brass-making crucibles and may also have been used on some brass-melting crucibles, though there are many of these that clearly never had lids.

At Sheepen, near Colchester, there was an industrial site where metal working was carried on in the period between the Roman conquest in 43 AD and the Boudiccan uprising in 61 AD (Niblett 1985). Finds from there included metal-melting crucibles, fragments of clay moulds and scrap metal; a variety of alloys including brasses were represented (Bayley 1985a). One notable find was a large brass sheet 910 x 150 x 5mm (Musty 1975) which was presumably intended as raw material for the metal working industry. This was analysed by Paul Craddock and shown to be a high zinc brass (copper with 26.8% Zn, 0.14% Fe and only traces of other elements), typical of primary production by cementation. Other objects from the site have also been analysed and include a high proportion of brasses (see Fig. 7).

Excavations at Claydon Pike in the upper Thames valley have produced a bun ingot which cannot be closely dated but is definitely Roman. It has been analysed by Peter Northover and shown to be a brass with 20.6% Zn, 0.4% Fe and 0.9% Pb and is thought to be an import to the site. Ingots of this form are also known from a first century AD wreck off Corsica; their composition closely mirrors that of the Sheepen sheet (Paul Craddock and Nigel Meeks, personal communication). Rectangular plano-convex brass ingots, about 130mm long, which had been broken from a casting of a strip of them have been found in Gloucester. One from a probable second century pit at 1, Alvin Street was analysed by Duncan Hook and shown to have 20.3% Zn and 0.3% Sn, while part of another from Coppice Corner analysed by Nigel Blades had 18.9% Zn, 0.2% Pb, 0.2% Fe but no detectable tin.

In the century or two before the Claudian conquest in 43 AD, Iron Age Britain had a strong metalworking tradition (Stead 1984) as finds from a number of sites have shown, although there is little evidence for metal production as opposed to use. Gussage All Saints, Dorset, produced large quantities of crucibles and moulds (Spratling 1979, Foster 1980) while finds from South Cadbury (Spratling 1970) included a fine selection of tools and other workshop debris. These are not unique sites, just ones that have been published, in part at least. Crucible fragments are the most commonly found indicator of metalworking, and analyses have been made of the metal-rich deposits on a considerable number of them from sites in the Midlands and southern England. These crucibles are all triangular in plan, some like those from Thetford are deep (Gregory 1991) while others are shallow (Spratling 1979), and the metal on them is always copper or bronze (or occasionally gold); no significant amounts of zinc have been detected. This demonstrates that the native British metalworking tradition did not include brass making or melting.

This digression backwards into the Iron Age reinforces the point made above that it was the Romans who apparently introduced brass to Britain. It is perhaps worth stressing that the evidence presented for brass working above all comes from sites occupied very soon after the Conquest, and in Colchester at least there are possible military connections. For the later Roman period, crucibles of a variety of forms which were used to melt brass or zinc-containing alloys are now known from a considerable number of other sites across the whole country (Bayley 1992a).

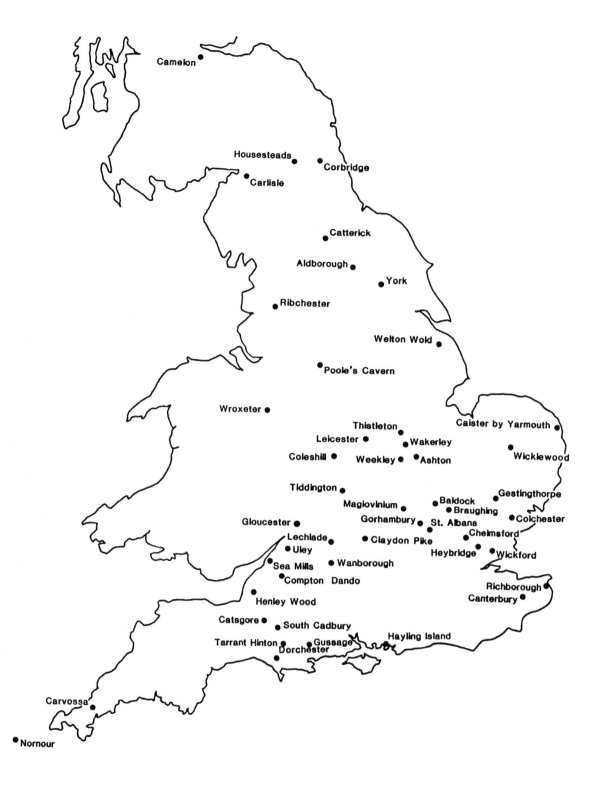

Fig. 2 Map showing location of sites mentioned in the text and many of those which provided objects for analysis

THE USE OF BRASS

Having identified brass among the alloys worked in Roman Britain it is worth considering what it was used for. It is well known that the Romans had a brass coinage (for example, Caley 1964) but the degree to which the metal was used for other objects is less well documented. Were specific alloys selected for different types of objects or different methods of manufacture, or was any metal that came to hand used indiscriminately? Did date or place of manufacture also affect the alloys used? Where did the metals come from? In an attempt to answer at least some of these questions a large programme of analyses has been carried out at the Ancient Monuments Laboratory since the mid 1970s. A total of over 4000 late Iron Age and Roman objects from over 100 sites all over Britain have been analysed, some 1100 quantitatively by atomic absorption and the rest qualitatively by energy dispersive X-ray fluorescence (XRF). Figure 2 shows the location of many of these sites and others mentioned in the text.

The first stage of the project was the analysis of all the 450 or so brooches from Richborough Fort in Kent. The site was one of the major ports of entry to Britain from 43 AD to the end of the Roman occupation in the early fifth century. About a third of these brooches were shown to be brass while the remainder were a mixture of bronzes and gunmetals containing very variable amounts of lead (Bayley *et al.* 1980). The distribution of alloys was not random; individual brooch types tended to be made of one specific alloy and alloy usage was positively correlated with date, the majority of the brass brooches being first century AD types (Bayley and Butcher 1981).

Brooches were initially selected for analysis as they have a well developed typology that has been extensively studied so they can be dated fairly precisely even when their find contexts are not themselves well dated. Later, a mixture of other decorative and utilitarian objects were also analysed to see if their compositions reflected the patterns emerging from the brooch analyses.

The results of some of the brooch analyses are summarised in Figure 3. In general the types at the top of the figure are early and the lower ones later; where more than one type has been grouped together each one has a similar range of compositions. Examples of some of the brooch types are shown in Plate 3 and a wider selection is illustrated by Collingwood and Richmond (1969). The six shadings used in Figure 3 (and Figs 6 and 7) denote bronze, leaded bronze, leaded gunmetal,

gunmetal, brass and other copper alloys. This last category includes those few objects made of nearly pure copper or base silver and also those where the XRF results could not be unambiguously interpreted.

An alternative method of displaying the analyses is on ternary diagrams like Figure 1. Each quantitative analysis can be represented by a point on the diagram which corresponds to its composition. This is particularly useful with objects of mixed alloys as clustering and/or dispersion of results can be seen more clearly than would be the case if only the coarse divisions into a few alloy groups were used.

THE BROOCH ANALYSES

Many of the brooch types found in Britain were also in use on the Continent. In some cases where the continental examples are far more numerous and of earlier date it can fairly safely be concluded that the British examples are imports. In other cases, generally similar brooches are found on both sides of the English Channel, but sufficient specific details allow British and Continental examples to be separated so the two metalworking traditions can be isolated. It may be that both groups derive from the same prototypes or that one is based on the other. Britain was on the fringes of the Roman Empire so some fashions survived here long after they had ceased to be current elsewhere. There are some native British brooch types which are common here but are found only occasionally on the Continent, examples of exports rather than imports.

Some brooches were cast but other types were wrought, either from roughly formed blanks or from metal stock such as rods, bars or sheet. While almost any copper alloy can be cast more or less easily, objects that are to be hammered to shape must be made from low lead or lead-free alloys as heavily leaded metal cannot be worked in this way. Some forms of surface decoration, e.g. mercury gilding, are also constraints in the choice of alloy (Bayley and Butcher 1997).

It can be seen from Figure 3 that, for the earlier types at least, each brooch type (each bar on the figure) has a single preferred alloy. The one-piece La Tène III brooches with an open catchplate which date to the late first century BC and the early first century AD are, with two exceptions, all bronzes. These brooches are relatively rare in this country so it is tempting to see them as imports although the bronze of which most are made was the normal alloy for wrought metalwork here at that time so they

could well have been made here. Certainly they would have been within the technical competence of the craftsmen.

Nauheim derivative brooches are a long-lived group and examples are known both on sites occupied before the Conquest and where occupation did not begin until later although they are rare on pre-Conquest sites. They are simple one-piece brooches with solid catch plates and the bow can be a simple round or square sectioned wire, a narrow strip or sometimes a more elaborate design. 60% of them are bronzes, 25% brasses and the rest mainly gunmetals. The variation in composition does not seem to have a geographical or chronological basis as all the sites which produced more than 20 examples, whether they began pre- or post-Conquest, had some of each alloy. On sites where typological sub-groups have been suggested these sometimes do seem to have some correlation with metal composition. Work by Adrian Olivier (personal communication)

suggests that the brasses may be variants more closely related to continental examples and possibly even imports.

The other major types in use in the early and mid-first century are represented by the next four bars on Figure 3. The brooches have been grouped together on the basis of the way the pin was attached to the brooch. First are the Langton Down, Rosette and Thistle brooches where the cylindrical head encloses the coiled spring which is attached to the pin. These types are almost certainly imports from the Continent and mainly reached Britain before the Conquest, most are brasses (Fig. 8). Very few Continental brooches have been analysed but all but one of a small group from Argentomagus were brasses (Guerra et al. 1990) as was a Rosette brooch from Alesia; it came from a part of the settlement where there was extensive evidence for metalworking, including brass working, in the earlier first century AD (Rabeisen and Menu 1985).

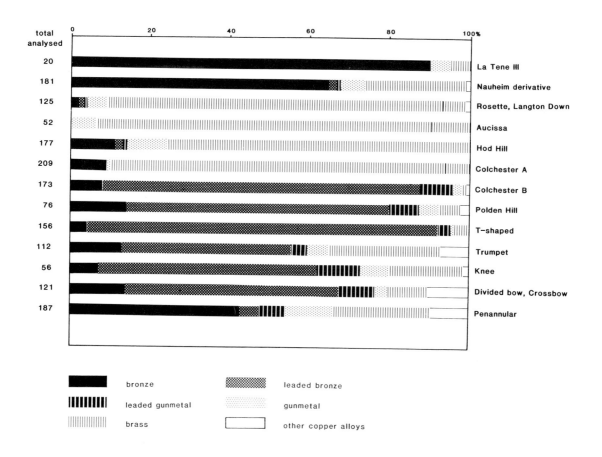

Fig. 3 Frequency of alloy use for various brooch types: summary of data

14

The next two bars represents the brooches where the pin was hinged on an axis bar held in position by rolling the head of the brooch forward around it. They are also thought to be imports to Britain but, unlike the Rosettes etc. are mainly found on post-Conquest sites. The Aucissas are almost without exception brasses (see Fig. 4). Ten examples of this type from Masada, in Israel, have almost identical compositions (cf. Table 1; Ponting and Segal 1998) suggesting an Empire-wide distribution from a single or limited number of sources. In contrast, about 70% of the Hod Hills are brasses with the rest fairly evenly divided between bronzes and gunmetals. There seems to be no correlation between the typological variants and the different alloys used. It is perhaps worth noting that 14 of the 55 non-brass Hod Hills come from a single post-Conquest site, Richborough. The analytical results for these types are plotted in Figure 4 which shows how they differ from each other.

The one-piece Colchester brooches are, like the Nauheim derivatives, made from a single piece of metal, the spring/pin assembly being an integral part of the brooch. They are widely distributed both in Britain and on the Continent in the years on both sides of the Conquest. Some of the variants found in Britain closely resemble types common on the Continent while others are found almost exclusively on this side of the Channel and so are thought to be of British manufacture. The discovery of three unfinished blanks for this type of brooch at Baldock (Stead and Rigby 1986) reinforces the case for local manufacture. Over 90% of all varieties are brass and again it is Richborough that has produced 9 of the 24 non-brass examples. This is the first brooch type for which manufacture in brass in Britain is likely. Seeing many of these brooches pre-date the Conquest, this raises interesting points which will be discussed below.

A distinct difference can be seen between the alloys used for the one-piece (A) and two-piece (B) Colchester brooches which are common in mid to late first century contexts (Fig. 5). Over 80% of the Colchester B brooches are leaded bronzes with the rest mainly leaded gunmetals though there are also a few unleaded bronzes. Unlike the one-piece Colchester brooches they have the pin/spring assembly made separately and then attached to the main casting. This was necessary as the alloy used for the brooch normally contained too much lead to produce a satisfactory spring. One can speculate which came first - the use of a cheaper, leaded alloy which forced the change in design, or the new design which then allowed leaded alloys to be used (Bayley 1985b).

Of similar composition to the two-piece Colchester brooches are types derived from it, including those known as Polden Hill brooches. They show slightly more variation in alloy type; only about 65% are leaded bronzes. More closely matching the Colchester Bs in composition are the various T-shaped brooches, which are common in the late first and early second century; over 80% of them are leaded bronzes (Bayley and Butcher 1981, fig. 4). The T-shaped brooches were always thought to have been made in south-western Britain as so many have been found there. Recent excavations at Compton Dando in the Mendips have supplied confirmation of this in the form of hundreds of fragments of decorated piece moulds for a variety of these brooches, as well as some crucibles.

In contrast to these last three groups are the Trumpet brooches which are thought to be of a similar date range and are also thought to be of British manufacture. Nearly half of these are leaded bronzes and over a quarter brasses - a catholic selection when compared with those types already discussed. This variety is not as random as it might seem as there is a high correlation between typological variants and composition (Bayley and Butcher 1997).

The Knee, Divided Bow and Crossbow brooches, which mainly date to the third and fourth centuries, are represented by the next two bars in Figure 3. Like the Trumpet brooches they show a wide range of alloys, but a higher proportion of them are leaded. Again there is correlation with typological sub-groups and types of applied decoration, patterns clarified when more analyses became available (*ibid.*).

The final bar in Figure 3 is that for penannular brooches. These small, mainly plain, brooches are not well dated and not surprisingly they are found in a range of alloys. Many appear to be wrought rather than cast which restricts the range of alloys which can be used to those containing little or no lead. The 'other alloys' section here is mainly fairly pure copper; this is the only brooch type that is normally made of unalloyed metal.

Decorative plate brooches were also used in Roman Britain but their compositions have recently been discussed elsewhere (Bayley and Butcher 1991). About a quarter are made of brass or zinc-rich gunmetals and many of these brasses are first century types. Bayley and Butcher have also published a discussion of the alloys used to make a wider range of brooch types (1995) and a full publication of all the data from their extensive study of Roman brooches is in an advanced state of preparation.

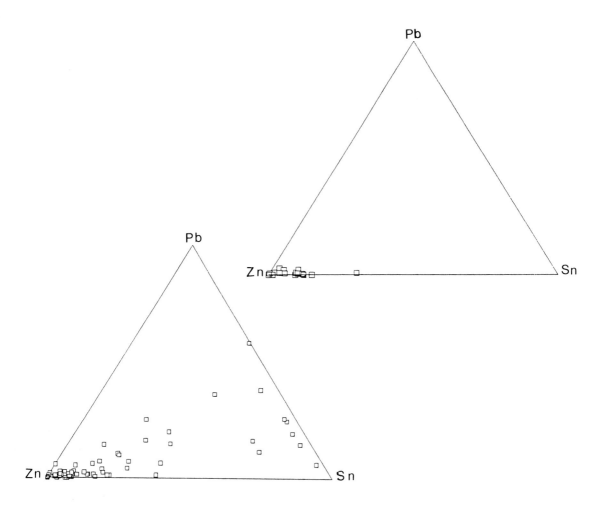

Fig. 4 Ternary diagrams showing the compositions of some Aucissa brooches (above) and Hod Hill brooches (below)

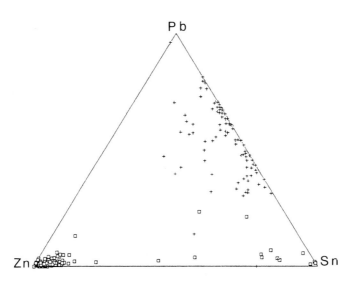

Fig. 5 Ternary diagram showing the composition of some Colchester A (boxes) and Colchester B (crosses) brooches

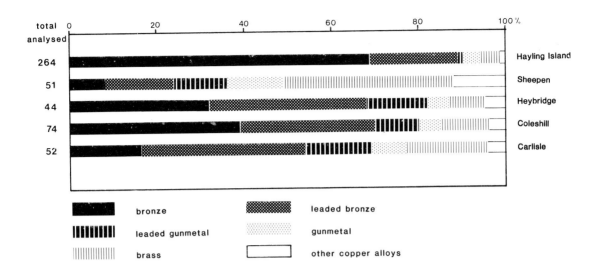

Fig. 6 Frequency of alloy use for objects other than brooches from five sites

OTHER ANALYTICAL RESULTS

As a control to compare with the brooches, groups of other objects from a number of sites were also analysed. The breakdown into alloy types is presented in Figure 6 in the same way as for the brooches. The similarities and differences between the individual groups can be explained by considering the date and nature of the sites.

Hayling Island was the site of a temple from late Iron Age on into Roman times. The majority of the finds are thought to be pre-Conquest and 70% are bronzes with leaded bronzes making up the bulk of the remainder. About 10% of the finds are of zinc-containing alloys though less than half are true brasses. These objects are either typologically Roman or are thought to have some ritual significance.

A completely different picture is presented by the Sheepen finds which are dated to 44–61 AD. Nearly 40% of them were brass (Bayley 1985c) but many of these were military fittings, like those analysed by Gowland mentioned above (p.7). Although brass was frequently used at this period for brooches, it is as likely to have been the military nature of the objects as much as their date which determined the alloys used to make them. Military fittings of a range of dates have been shown to be brass. Other examples from this country include finds from Fremington Hagg (Craddock et al. 1973) and Ribchester (Jackson and Craddock 1995) while a group from Xanten, on the lower Rhine, have also been published (Craddock and Lambert 1985).

The other three groups of analyses shown in Figure 6 are from sites in different parts of the country and all cover virtually the whole of the Roman occupation from the later first to the fourth century. The finds from two of the sites were sub-divided into shorter time periods but there seemed to be no significant variation of alloy usage with time, unlike the results from Gorhambury where larger numbers of analyses suggested an increase in the use of mixed alloys at later periods (Bayley 1994). The most striking thing about these three groups is their similarity; perhaps they represent the normal frequency of alloy usage to expect for small everyday objects (excluding brooches) in Roman Britain. Craddock (1978) has suggested that about a third of Roman copper alloy objects deliberately contained zinc and 30% of the objects from these three sites do contain significant amounts of zinc. However, only 12% are true brasses.

It is instructive to compare the analytical results for these other objects with those for the brooches from the same sites (Fig. 7). There is clearly a lack of similarity in the patterns of alloy usage. Each pair of bars presumably represent the same time span so date can be ignored as a possible factor. Therefore either the different types of objects were coming from different workshops with access to different alloys, or the criteria applied to the selection of alloys for making brooches were different from those for other objects. The differences are most noticeable on the first century sites (Hayling Island and Sheepen) which belong to the period when wearing brooches was most common (Mackreth 1973) and when brass was the commonest alloy used for making them (Fig. 3).

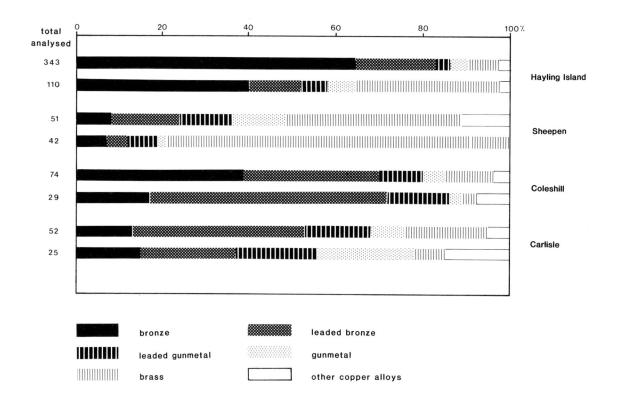

total analysed

343

110

51

42

74

29

52

25

Hayling Island

Sheepen

Coleshill

Carlisle

■■■ bronze ▦ leaded bronze

▐▐▐ leaded gunmetal gunmetal

|||||| brass □ other copper alloys

Fig. 7 Frequency of alloy use for non-brooches (upper bar of each pair) and brooches (lower bar) for four sites

DISCUSSION

The evidence presented above is part of the overall pattern of usage of brass in Britain in antiquity. It is necessary to consider not only brass, the binary copper-zinc alloy, but other alloys that contain zinc in significant amounts. Craddock (1978) uses the term brass to cover all these zinc-rich alloys, but here, as has already been explained, it is preferred to differentiate true brasses from gunmetals. There is of course no absolute divide between the two alloys as any proportions of copper, zinc and tin will mix, but it is normally possible to assign individual objects to one group or the other.

Craddock (1978) suggests that about 70% of brooches are likely to be brasses or gunmetals as they belong in his decorative metalwork category. Figure 7 shows the proportion varies from 20% to 90% with an average value for the four sites of about 55%. The 1645 brooch analyses summarised in Figure 3 show a similar proportion of alloys containing significant amounts of zinc (52%) while 35% are true brasses.

Even among those objects that are unequivocally brass there is some variation in composition. Some are relatively pure and contain well under a percent of tin or lead while others have several percent of additions. This can be illustrated by comparing the compositions of the predominantly brass brooch types (Table 1). The Aucissa brooches (Fig. 4) are high zinc brasses with minor amounts of tin. The Colchester A brasses (Fig. 5) show similar zinc and tin ranges but have lead levels which while still low are significantly higher than for the Aucissas. The Rosettes and Langton Downs (Fig. 8) are less pure brass with lower zinc and higher tin and lead levels. It is in some of the more extreme of these cases that the name gunmetal has to be considered. Some of the Hod Hill brooches (Fig. 4) are definitely not brasses; there is no tight grouping but just a clustering towards one end of the brass-gunmetal-bronze continuum. This is reflected in the figures in Table 1, in particular in the high standard deviation on the zinc figure, even after the low-zinc brooches (i.e. bronzes) have been excluded.

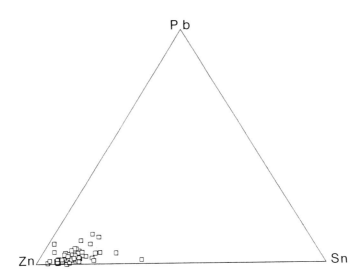

Fig. 8 Ternary diagram showing the composition of some Langton Down and Rosette brooches

Table 1 Means and standard deviation for the major alloying elements in some brass brooch types

Brooch type	sample size	Zinc %	Tin %	Lead %
Aucissa	16	19.54 ± 2.56	1.72 ± 1.83	0.15 ± 0.18
Colchester A	89	17.99 ± 6.74	2.62 ± 3.42	0.34 ± 0.36
Colchester A★	78	20.10 ± 3.28	1.61 ± 1.59	0.29 ± 0.21
Rosette etc	57	17.88 ± 2.94	2.62 ± 1.26	0.87 ± 1.00
Hod Hill	62	13.50 ± 7.21	3.58 ± 3.27	1.47 ± 2.26
Hod Hill★	51	16.25 ± 4.53	2.36 ± 1.94	0.90 ± 1.28

The rows marked ★ exclude those brooches with zinc contents under 2%

CONCLUSIONS

The analyses summarised above show that brass was used selectively in Roman times, for coinage, for military fittings and in the first century for brooches. The uniformity of metal use across the country suggests some sort of centralised, perhaps Imperial control which may have been exercised by the army. Interestingly the atypical compositions - e.g. the non-brass Colchester A brooches - cluster at just a few sites, suggesting much more localised production or trade in these non-standard brooches. The low proportion of other objects made of brass (just over 10% of the total) suggests it was not widely available.

The non-brass alloys were not used at random but were carefully selected so the metal was generally well suited to the manufacturing method and type of object being made.

When considering the source of brass in the earlier first century AD, all indications are that it came from those areas of the Continent which were already part of the Roman Empire. There is no evidence for pre-Conquest making or even melting of brass in Britain, and as many of the brass brooches found here are of types well known on the Continent the British finds are most probably imports. It is tempting to see all early brass brooches as imports, perhaps with the non-brass examples as copies made here in locally

available bronze but there is some evidence to cast doubt on this total correlation of brass with imports.

First there is the group of three brooch blanks from Baldock which must be considered as good evidence for brass brooch making in Britain. Most of the finds on that site came from secondary deposits such as pits and ditch fills and the dates assigned to these features indicate when they were filled so at least some of the material they contain will be earlier (Stead and Rigby 1986). The brooch blanks come from contexts dated *c.* 25-50, 50-70 and 70-90 AD respectively. A pre-Conquest date for them is therefore likely as the type was no longer current by the end of the first century; at least the one in the latest context must be residual. There is further evidence for metal working, including brass melting, at Baldock (Bayley 1986), but the earliest of these finds date to 70-90 AD and most come from second century or later contexts and so are unlikely to be related to the brooch making.

The other main argument against all brass brooches being imports relies on the existence of brooches found in Britain which, while being of the general one-piece Colchester type, are variants which are unknown or very rare on the Continent. They could be explained as being the products of local craftsmen working from imported blanks such as those found at Baldock - but why have a trade in blanks rather than finished brooches? Perhaps future excavations will provide further evidence which will allow a more definitive interpretation. Meanwhile, it is accepted that the metal of these British brooches may well be of Continental origin but the brooches themselves must have been made in Britain, whether from blanks or some other, less specific form of metal stock.

Whatever the exact position before the Roman conquest, it can now be said that in the decade or so following it there is positive evidence for brass making, brass melting and the use of brass in the Romanised parts of Britain, with at least some of it associated with a military presence. Brass continued to be used after the first century but on a reduced scale and for a less restricted range of objects.

While widespread use of brass in the earlier first century AD is noteworthy, so too is its rapid disappearance as the preferred brooch alloy in the third quarter of the century (Fig. 5). The change from brass brooches is contemporary with changes in the composition of the brass coinage. Analyses have shown that the zinc content of brass coins dropped gradually from the middle of the first century AD. Each time brass coins are melted down and re-struck they loose up to 10% of the zinc in the alloy (Caley 1964) which suggests that from this time new brass ceased to be so readily available and the existing metal stock was being re-cycled. Dungworth (1996) has shown that recycling on its own does not produce the pattern of zinc-decline seen, and suggests deliberate debasement may have affected the composition of the brass coinage. Whatever the reasons for the reduction in the zinc content of the coins, the change suggests reduced availability of brass; the disappearance of large amounts of the metal from the civilian market suggests that its use, like that of precious metals, was an imperial monopoly and that it was being called in for official use.

If it was indeed official action which restricted the availability of brass in the later first century, then the chicken and egg question of the change from one-piece to two-piece Colchester brooches can be resolved. Brass ceased to be widely available and alternative alloys were therefore used for a design that was still popular. Modifications were made to the design and it continued in use in this altered form, but now made of leaded bronze. The few bronze and gunmetal examples may date to the changeover period as examples in both designs are known (Fig. 5).

POSTSCRIPT

There is a gap of nearly a millennium between the end of the Roman occupation of Britain and the High Middle Ages when the use of brass and zinc-rich gunmetal are again well known. Relatively little analytical work has been done on finds from the earlier part of this period but what there is suggests that most copper alloy metalwork was made of mixed alloys, gunmetals and leaded gunmetals, though some brasses and bronzes were still used (e.g. Mortimer *et al.* 1986, Blades 1995). By the late Saxon and Viking period brass is again appearing quite regularly both in this country (Bayley 1984b and 1992b, Caple 1986 and White 1982) and on the Continent at sites such as Hedeby where tin is virtually unknown in the copper alloys which contain only zinc and/or lead (Hans Drescher, personal communication). Craddock (1985b) also notes the prevalence of zinc over tin in the copper alloys of the medieval period.

Evidence for brass manufacture is even more elusive in medieval times than at earlier periods. The only positively identified finds are a very large group of crucibles from Dortmund, in Germany, which probably date to around 1000 AD and certainly predate the city wall built in 1200 AD (Rehren *et al.* 1993). They are thought to have been used for

making brass though they are open, like those described by Theophilus (Hawthorne and Smith 1963), rather than closed like the Roman examples described above. Rehren (personal communication) suggests the calamine was placed in red-hot crucibles and covered with copper and then charcoal, so the zinc vapour rose through the liquifying metal. If so, it was probably a less effective method than using lidded crucibles as no equilibrium state would exist and there would be no build up of zinc vapour pressure, forcing it to diffuse into the copper metal.

ACKNOWLEDGEMENTS

Sarnia Butcher has supplied typological identifications for all the brooches analysed and has most helpfully discussed the interpretation of the results obtained. Leo Biek has read and commented on draft versions of this paper as has Paul Craddock who suggested numerous additions, particularly to the section dealing with the origins of brass. I would like to thank them all for their help. Judith Dobie of the English Heritage Archaeological Drawing Office drew the brooches in Plate 3.

REFERENCES

Bachmann, H-G. 1976. Crucibles from a Roman settlement in Germany. *Historical Metallurgy* **10**(1), 34-5.

Bailey, K.C. 1932. *The elder Pliny's chapters on chemical subjects*, Part II. Edward Arnold, London.

Bayley, J. 1984a. Roman brass-making in Britain. *Historical Metallurgy* **18**(1), 42-3.

Bayley, J. 1984b. Metalworking evidence. In *Excavations in Thetford 1948-59 and 1973-80*, A. Rogerson and C. Dallas. Gressenhall, Norfolk Archaeological Unit (East Anglian Archaeology No. 22), 107-8.

Bayley, J. 1985a. The technological finds. In *Sheepen: an early Roman industrial site at Camulodunum*, R. Niblett. Council for British Archaeology (Research Report 57), London. Fiche 3: D11-E13.

Bayley, J. 1985b. Brass and brooches in Roman Britain. *MASCA Journal* **3**(6), 189-91.

Bayley, J. 1985c. The analysis of copper alloy objects. In *Sheepen: an early Roman industrial site at Camulodunum*, R. Niblett. Council for British Archaeology (Research Report 57), London, 115.

Bayley, J. 1986. Metallurgical analyses, sections A-F. In *Baldock: the excavation of a Roman and pre-Roman settlement, 1968-72*, I.M. Stead and V. Rigby. Society for the Promotion of Roman Studies (Britannia Monograph No 7), London. 380-7.

Bayley, J. 1991. Analytical results for metal and glass-working crucibles from Frere's excavations at Verulamium. Ancient Monuments Laboratory Report 68/91.

Bayley, J. 1992a. *Non-ferrous metalworking in England: late Iron Age to early medieval.* Unpublished PhD thesis, University of London.

Bayley, J. 1992b. *Anglo-Scandinavian non-ferrous metalworking from 16-22 Coppergate.* Council for British Archaeology (Archaeology of York 17/7) London.

Bayley, J. 1994. Use of copper alloys in Roman Britain. *Conservation Bulletin Science and Technology supplement* No **3**, 11-12.

Bayley, J. and Butcher, S. 1981. Variations in alloy composition of Roman brooches. *Revue d'Archéométrie* supplement, 29-36.

Bayley, J. and Butcher, S. 1991. Romano-British plate brooches: composition and decoration. *Jewellery Studies* **3**, 25-32.

Bayley, J. and Butcher, S. 1995. The composition of Roman brooches found in Britain. In *Acta of the 12th International Congress on Ancient bronzes, Nijmegen 1992* eds. S.T.A.M. Mols, A.M. Gerhartl-Witteveen, H. Kars, A. Koster, W.J.Th. Peters and W.J.H. Willems. Provinciaal Museum G.M. Kam, Nijmegen. 113-19.

Bayley, J. and Butcher S. 1997. The composition and decoration of Roman brooches. In *Archaeological Sciences 1995*, eds A.G.M. Sinclair, E.A. Slater and J.A.J. Gowlett, Oxbow, Oxford, 101-6.

Bayley, J., Butcher S. and Cross I. 1980. The analysis of some Roman brooches from Richborough Fort, Kent. In *Proceedings of the 16th International Symposium on Archaeometry and Archaeological Prospection*, eds. E.A. Slater and J.O. Tate. National Museum of Antiquities of Scotland, Edinburgh, 239-47.

Blades, N.W. 1995. *Copper alloys from English archaeological sites 400-1600 AD: an analytical study using ICP-AES.* Unpublished PhD thesis, University of London.

Burnett, A., Craddock, P.T. and Preston, K. 1982. New light on the origins of *orichalcum*. In *Proceedings of the 9th International Congress of Numismatists*, eds. T. Hackens and R. Weiller. Association Internationale des Numismatistes Professionals (Publication No 6), 263-8.

Caley, E.R. 1964. *Orichalcum and related ancient alloys.* American Numismatic Society, New York.

Caple, C. 1986. *An analytical appraisal of copper alloy pin production 1400-1600 AD.* Unpublished Ph.D thesis, University of Bradford.

Collingwood, R.G. and Richmond, I.A. 1969. *The Archaeology of Roman Britain.* London.

Craddock, P.T. 1978. The composition of the copper alloys used by the Greek, Etruscan and Roman civilizations 3: The origins and early use of brass. *Journal of Archaeological Science* **5**, 1-16.

Craddock, P.T. 1981. Report on the composition of metal tools and weapons from Ayia Paraskevi, Vounous and Evereti, Cyprus, in Birmingham Museum. In *Cypriot antiquities in Birmingham Museum and Art Gallery*, E. Peltenberg. Birmingham Museum, 77-8.

Craddock, P.T. 1985a. A history of the distillation of metals. *Bulletin of the Metals Museum of the Japanese Institute of Metals* **10**, 3-25.

Craddock, P.T. 1985b. Three thousand years of copper alloys: from the bronze age to the industrial revolution. In *Application of science in the examination of works of art*, eds P.A. England and L. van Zelst. Museum of Fine Arts, Boston, 59-67

Craddock, P.T., Burnett, A.M. and Preston, K. 1980. Hellenistic copper-base coinage and the origins of brass. In *Scientific Studies in Numismatics* ed. W.A. Oddy. British Museum (Occasional Paper No. **18**), London, 53-64.

Craddock, P.T. and J. Lambert 1985. The composition of the trappings. In A group of silvered-bronze horse-trappings from Xanten (Castra Vetera). *Britannia* **15**, 141-64.

Craddock, P.T., Lang, J. and Painter, K.S. 1973. Roman horse-trappings from Fremington Hagg, Reeth, Yorkshire. *British Museum Quarterly* **37**, 9-18.

Crummy, P. 1992. *Excavations at Culver Street, the Grilberd School, and other sites in Colchester 1971-85*. Colchester Archaeological Report 6, Colchester.

Dioscorides *Materia Medica*. Translated in 1655 by John Goodyer; reissued and edited by Gunter 1934. OUP, Oxford.

Dungworth, D. 1996. Caley's 'zinc decline' reconsidered. *Numismatic Chronicle* **156**, 228-34.

Forbes, R.J. 1956. Metallurgy. In *A History of Technology* Vol **2**, eds C. Singer *et al.* Clarendon Press, Oxford. 41-80.

Forbes, R.J. 1964. *Studies in Ancient Technology* Vol **8**. Brill, Leiden.

Foster, J. 1980. *The Iron Age moulds from Gussage All Saints*. British Museum Occasional Paper No **12**, London.

Fox, G.E. and St John Hope, W.H. 1901. Excavations on the site of the Roman city at Silchester, Hants, in 1900. *Archaeologia* **59**(2), 229-51.

Frere, S.S., Bennett, P., Rady, J. and Stow, S. 1987. *Canterbury excavations: intra- and extra-mural sites, 1949-55 and 1980-84*. Kent Archaeological Society (Archaeology of Canterbury VIII), Maidstone.

Gregory, T. 1991. *Excavations in Thetford, 1980-1982, Fison Way*. Gressenhall, Norfolk Archaeological Unit (East Anglian Archaeology **53**).

Guerra, M.F., Beauchesne, F., Fauduet, I. and Barrandon, J.N. 1990. Characterisation par activation neutronique des fibules d'Argentomagus. *Revue d'Archéométrie* **14**, 99-107.

Haedecke, K. 1973. Gleichgewichtsverhältnisse bei der Messingherstellung nach dem Galmeiverfahren. *Erzmetall* **26**, 229-33.

Halleux, R. 1973. L'orichalque et le laiton. *Antique Classique* **42**, 64-81.

Hawthorne, J. and Smith, C.S. 1963. *Theophilus on divers arts*. University of Chicago Press, Chicago.

Hughes, M.J, Lang, J.R.S., Leese, M.N. and Curtis J.E. 1988. The evidence of scientific analysis: a case study of the Nimrud Bowls in *Bronzeworking Centres of Western Asia c.1000-589 B.C.* ed. J. Curtis. Kegan Paul, London. 311-16.

Jackson, R.P. and Craddock, P.T., 1995. The Ribchester Hoard: A Descriptive and Technical Study. In *Sites and Sights of the Iron Age* ed. B. Raftery. Oxbow Books, Oxford (Monograph No 56), 75-102.

Latham, R.E. 1972. Translation of *The Travels of Marco Polo*. Pelican Books, London.

Mackreth, D. 1973. *Roman brooches*. Salisbury and South Wiltshire Museum, Salisbury.

Mortimer, C., Pollard A.M. and Scull, C. 1986. XRF analyses of some Anglo-Saxon copper alloy finds from Watchfield, Oxfordshire. *Historical Metallurgy* **20**(1), 36-42.

Musty, J. 1975. A brass sheet of first century AD date from Colchester (Camulodunum). *Antiquaries Journal* **55**(2), 409-11.

Niblett, R. 1985. *Sheepen: an early Roman industrial site at Camulodunum*. Council for British Archaeology (Research Report **57**), London.

Percy, J. 1861. *Metallurgy. Vol I Fuel: fire-clays; copper; zinc; brass*. John Murray, London.

Picon, M., Le Nezet-Celestin, M. and Desbat, A. 1995. Un type particulier de grands récipients en terre réfractaire utilisés pour la fabrication du laiton par cémentation. *Actes du Congrès de Rouen de la Société Française d'Étude de la Ceramique Antique en Gaule*, 207-215.

Ponting, M. and Segal, I. 1998. Inductively coupled plasma-atomic emission spectroscopy analyses of Roman military copper-alloy artefacts from the excavations at Masada, Israel. *Archaeometry* **40**(i), 109-27.

Rabeisen, E. and M. Menu 1985. Metaux et alliages des bronziers d' Alesia. In *Recherches gallo-romaines*, 1. Editions de la Réunion des Museés Nationaux, Paris. 141-81.

Rehren, T. 1996. Large scale - small size production: Roman brass making crucibles. Papers presented at the International Symposium on Archaeometry, May 1996, Urbana, Illinois. Publication forthcoming in *Journal of Archaeological Science*.

Rehren, T., Lietz, E., Hauptmann, A. and Deutmann, K.H. 1993. Schlacken und Tiegel aus dem Adlerturm in Dortmund: Zeugen einer mittelalterlichen Messingproduktion. In *Montanarchäologie in Europa*, eds. H. Steuer and U. Zimmermann. Jan Thorbecke, Sigmaringen. 303-14.

Schaeffer-Forrer, C.F.A., Zwicker, U. and Nigge, K. 1982. Untersuchungen an metallischen Werkstoffen und Schlacken aus dem Berich von Ugarit (Ras Shamra, Syrien). *Mikrochimica Acta* [Vienna] **1**, 35-61.

Smythe, J.A. 1938. Roman objects of copper and iron from the north of England. *Proceedings University of Durham Philosophical Society* **9**(6), 382-405.

Spratling, M. 1970. The smiths of South Cadbury. *Current Archaeology* **2**, 188-90.

Spratling, M. 1979. The debris of metalworking. In *Gussage All Saints: an Iron Age settlement in Dorset*, G.W. Wainwright. HMSO, London, 125-49.

Stead, I.M. 1984. Some notes on imported metalwork in Iron Age Britain. In *Cross-Channel trade between Gaul and Britain in the pre-Roman Iron Age*, eds S. Macready and F.H. Thompson. Society of Antiquaries, London, 43-66.

Stead, I.M. and Rigby, V. 1986. *Baldock: the excavation of a Roman and pre-Roman settlement, 1968-72*. Society for the Promotion of Roman Studies (Britannia Monograph No 7), London .

Stewart, E. and Stewart, J. 1950. *Vounous Belapais 1937/8*. Lund.

Strabo *Geography*: Book **13**. Translated by T.L. Jones, 1968. Loeb edition, Heinemann, London.

Tylecote, R.F. 1962. *Metallurgy in Archaeology*. Edward Arnold, London.

Werner, O. 1970. Über das Vorkommen von Zink und Messing in Altertum und im Mittelalter. *Erzmetall* **23**, 259-69.

White, R. 1982. *Non-ferrous metalworking on Flaxengate, Lincoln, from the 9th-11th centuries*. Unpublished dissertation for Diploma in Conservation, Institute of Archaeology, London.

Willers, H.W. 1907. *Neue Untersuchungen über die römische Bronzeindustrie von Capua und von Niedergermanien*. Leipzig.

Zwicker, U., Greiner, H., Hofmann, K-H. and Reithinger, M. 1985. Smelting, refining and alloying of copper and copper alloys in crucible furnaces. In *Furnaces and smelting technology in antiquity*, eds. P.T. Craddock and M.J. Hughes. British Museum (Occasional Paper **48**), London, 103-15.

The following excavation reports include some larger groups of analyses of brooches and other objects. Those marked with an asterisk include some of the data presented in Figures 6 and 7:

Blockley, K. 1989. *Prestatyn 1984-5. An Iron Age farmstead and Romano-British industrial settlement in North Wales*. British Archaeological Reports (British Series 210), Oxford.

Jackson, R. 1990. *Camerton: the late Iron Age and early Roman metalwork*. British Museum Publications, London.

Leech, R. 1982. *Excavations at Catsgore. 1970-1973 - A Romano-British Village*. Western Archaeological Trust (Monograph No 2), Bristol.

★ McCarthy, M.R. 1990. *A Roman, Anglian and Medieval site at Blackfriars Street, Carlisle: Excavations 1977-9*. Cumberland and Westmorland Antiquarian and Archaeological Society (Research Series No 4), Kendal.

Neal, D.S., Wardle, A. and Hunn, J. 1990. *Excavation of the Iron Age, Roman and medieval settlement at Gorhambury, St. Albans*. English Heritage (Archaeological Report **14**), London.

★ Niblett, R. 1985. *Sheepen: an early Roman industrial site at Camulodunum*. Council for British Archaeology (Research Report 57), London.

Potter, T.W. and Trow, S.D. 1988. Puckeridge-Braughing, Hertfordshire: The Ermine Street Excavations, 1971-1972. *Hertfordshire Archaeology* **10**.

Stead, I.M. and Rigby, V. 1986. *Baldock: the excavation of a Roman and pre-Roman settlement. 1968-72*. Society for the Promotion of Roman Studies (Britannia Monograph Series No 7), London.

Stead, I.M. and Rigby, V. 1989. *Verulamium: the King Harry Lane site*. English Heritage (Archaeological Report **12**), London.

★ Wickenden, N. 1986. Prehistoric settlement and the Romano-British 'small town' at Heybridge, Essex. *Essex Archaeology and History* **17**, 7-68.

Woodward, A. and Leach, P. 1993. *The Uley shrines, excavation of a ritual complex on West Hill, Uley, Gloucestershire: 1977-9*. English Heritage (Archaeological Report **17**), London.

Analytical results for brooches from other sites are available in the Ancient Monuments Laboratory Report Series.

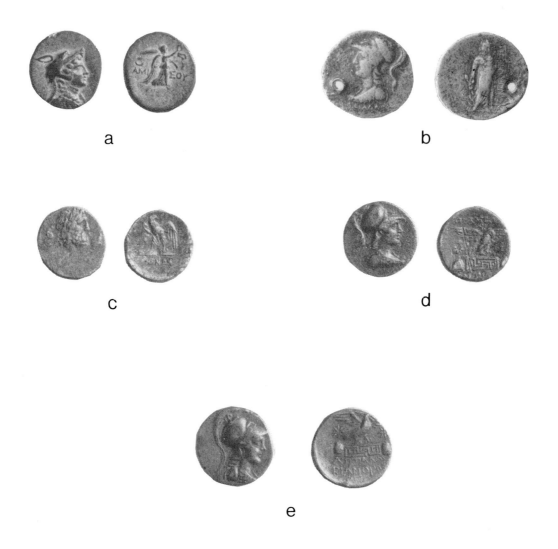

Plate 1 Some of the earliest brass coins from Asia Minor:
a) Mithradates VI, mint of Amisus (90-75 BC) BMC 79 b) and c) Pergamum (mid first century BC) BMC 130 and 14‹
d) and e) Apamea, Phrygia (70-60 BC and 56 BC) BMC 85 and 59

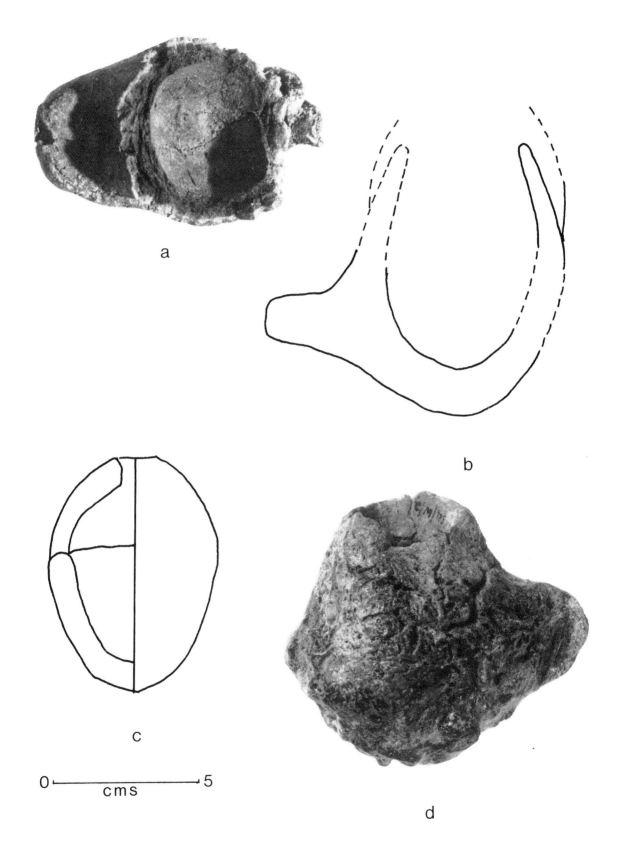

a

b

c

d

Plate 2 Early Roman cementation crucibles:
a) and b) base and reconstruction of complete vessel from Colchester
c) sketch section of complete crucible from Palace Street, Canterbury d) possible cementation crucible from Ribchester.

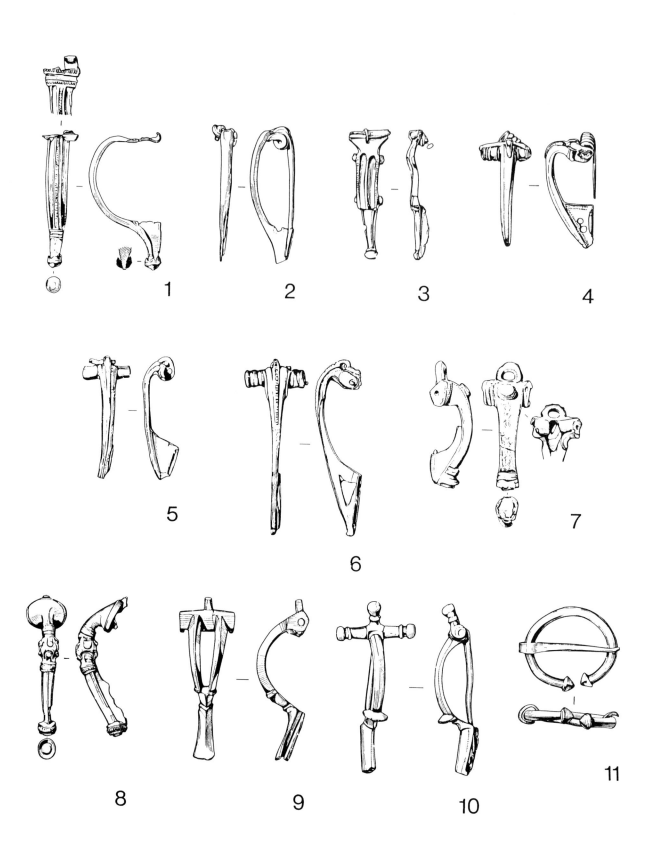

Plate 3 Examples of Romano-British brooches (scale approx. 2:3):
1) Aucissa 2) Nauheim derivative 3) Hod Hill 4) Colchester A 5) Colchester B 6) Polden Hill
7) Headstud 8) Trumpet 9) Divided bow 10) Crossbow 11) Penannular.

ZINC IN INDIA

P.T. Craddock[1], I.C. Freestone[1], L.K. Gurjar[2], A.P. Middleton[1] and L. Willies[3]

1 Department of Scientific Research, The British Museum, London, WClB 3DG
2 Hindustan Zinc Ltd., Yashad Bhawan, Udaipur 313001, India
3 Peak District Mining Museum, Matlock Bath, Derbyshire

TEXTUAL EVIDENCE FOR BRASS AND ZINC IN INDIA

The earliest evidence for brass and zinc in the East, particularly from the Indian subcontinent, is almost all textual, little relevant material evidence having yet been uncovered or scientifically examined. Some exceptions to this are the brasses from the excavations at Atrañjikhera, Uttar Pradesh from levels dated to between 1200 and 600 BC (Gaur 1983, 483-90). Of the four pieces analysed one contained 6.28% zinc and another 16.2% of zinc, both also contained tin. In the later part of the first millennium BC brass usage may have become more frequent as exemplified by the vessels of leaded brass excavated at Begram in the Kabul Valley in Afghanistan, dating from the second century BC (L.P.H. Hurtel and F. Tissot, reported at the 'Crossroads of Asia' conference, Madingley Hall, Cambridge 6th October, 1992), which join those already published from Taxila, now in northern Pakistan (Marshall 1951, 567-69), which suggest that brass was available from at least the fourth century BC. It may have been introduced by the Hellenistic invaders from the West as the word ārakūta appears in the contemporary *Arthaśāstra* (2.12.23, 2.17.14 & 4.1.35, Kangle II, 1972), where it is regarded as a recent loan word derived from the Greek *oreichalkos* (see also Biswas 1996 I, 361 for further discussion of this term). Some of the brass may well have been made by the addition of zinc metal to copper as the zinc content exceeds the limits set by the cementation process (see p.9 and Craddock 1981). There is, however, a wealth of documentary evidence. Many texts list zinc as a metal quite separate from tin or lead, some specifying it as a metal made by distillation, and others giving quite detailed descriptions of how this distillation was to be carried out. The problem lies not in identifying the subject of any particular text but its date. Most early Indian texts suffer from this problem, the authors, where stated, are usually otherwise unknown and there are few references to external dateable events. None of the extant manuscripts are more than a few centuries old, and are thus often far removed from the originals

in time with all the problems of copyists' mistakes and interpolation that this entails. Thus, for example, zinc is apparently mentioned in some translations of literature originating from the Vedic period, and thus claims have been made that zinc was in use in India many thousands of years ago which is patently not so. However, by careful study and some educated guesswork backed up by a small but increasing body of archaeological evidence, it is possible to arrive at some sort of progression for the development of zinc production. The following sections are based on the translations from the Sanskrit originals by L.K. Gurjar, ahead of his own publication in the main Zawar excavation report and in Paliwal *et al.* (1986), and on the translations given in Ray (1956). For the identification of plant names Gamble (1902) and Tewari (1992) have been used. We are very grateful to Caroline Cartwright for guidance in this matter.

From the texts it seems certain that brass was in use in the later part of the first millennium BC, and that zinc was also known. During the first millennium AD reference is made in the literature to the production of brass by the cementation process and also to the distillation of zinc. The last reference to cementation is probably no later than the twelfth century AD in sources which also give detailed descriptions of the production of metallic zinc by processes which seem very close to the remains of zinc-making on an industrial scale excavated at Zawar in Rajasthan, which are fully described below.

The earliest reference to a metal which could be identified as zinc occurs in the *Charaka Samhita*, a medical treatise compiled in the early Buddhist period no later than about 500 BC and certainly incorporating earlier material (Ray 1956, 60). In chapter 26 there is a description of how *pushpanjan*, the basis for a salve for the treatment of eyes and open wounds, is to be prepared by heating a metal in air. The identification with zinc seems certain as no other metal would react in air to produce an oxide suitable for this type of medicinal purpose (Falk 1991). *Pushpanjan* is also mentioned slightly later in the *Sushruta Samhita*.

One of the few early works of Indian literature with an identified and historically known author is

the *Arthasāstra* which is ascribed to Kauṭilya, who was one of the principal ministers of the Mauryan Emperor, Chandra Gupta (*c.* 321-296 BC). However there are later interpolations such that it is not certain how much of the work, if any, certainly belongs to the fourth century BC. The text used here is that of Kangle (text I 1969, 55-7, translation II 1972, 106-7) but the translation, unless otherwise attributed, is that of Gurjar. Recent work on the silver-lead deposits in Rajasthan suggest they were first extensively worked at about this time and they are almost certainly one of the sources of the silver used in the first Indian coinage issued by the Mauryans, as well as of the zinc minerals used for making cementation brass and possibly metallic zinc itself even at this early date. Thus it is appropriate to quote Kauṭilya's comments on the silver-lead ores in full:

Silver ores (2.12.2)

These ores have the colours of a conch shell, camphor, butter, a pigeon, turtle-dove (*vimalak*) or the neck of a peacock. They are as resplendent as opal, agate, cane and grain sugar and have the colours of *kovidara* flowers, lotus, patali, (*Stereospermum suaveolens*), *kayla* (a type of *Phaseolus* bean) or of flax. These are associated with lead (*nag*) and zinc (*anjan*). They smell of raw meat and on breaking show black or white spots and lines, and which on roasting do not split but effloresce and emit smoke. The heavier the mineral the higher the metal content.

Lead ores (2.12.13)

The earth which is black like a crow, grey like a pigeon or *gorchana*, marked with white lines and smells like raw meat. This is the place where lead ores can be found.

The reference to black and grey colours (Gurjar forthcoming), iridescent materials, and the smell, all suggest galena and mixed galena/sphalerite deposits generally. The deposits at Zawar and at Dariba, some 85 km north-east of Udaipur, are also marked with white lines and spots of native silver. They could be the actual deposits Kauṭilya had in mind when compiling his book.

The greatest of the early Indian scientists was Nagarjuna who probably lived sometime in the second to fourth centuries AD somewhere in northern India. His main works are contained in the *Rasaratnakara*. In its present form this was probably compiled in the seventh or eighth centuries AD. It refers to the cementation process of making brass and gives the first description of zinc-making by distillation.

The reference to the cementation process is as follows: 'What a wonder is it that zinc ore,... roasted three times with copper converts the latter to gold.' (Ray 1956, 129)

This would imply that a secondary, oxidised ore such as the carbonate, smithsonite was being used.

The zinc-making process is called *stav padan*, literally extract or distillation process, and is as follows:

Rasak (zinc ore) should be treated with *dhanyamia* (a fermented spirit similar to paddy), alkalis and ghee (clarified butter) and then mixed with wool, lac, *harad* (or *harra*) (*Terminalia chebula*), *kenchua* (earthworm) and *suhaga* (borax). Upon heating it yields an extract which is white, shining like tin of this there is no doubt.

All the processes include similar lists of exotic materials, some of which seem unnecessary, even unlikely ingredients, but in fact they do seem to have had some real function, and where feasible they have been identified in the surviving retorts. The organic materials served two functions: to bind the ground-up ore into small sticky balls and – upon the application of heat – they would have charred and provide the necessary reducing agent. Alkalis and common salt were certainly added to increase the yield in the retort processes developed independently(?) in Europe during the nineteenth century (Almond *pers comm.* and Smith 1918, 101).

Another important work containing descriptions of the zinc making process is the *Rasarnavam Rastantram*. Once again opinions differ on the date of this work, Triparthi (1978, 6) would date it between 600-100 BC, but Ray (1956, 118) suggests a date in the twelfth century AD. The emphasis on processes involving mercury suggests a Tantric origin for the work which would favour the later dating, although there is evidence that it has been compiled from pre-existing works. As well as mentioning the cementation process of brass making and a detailed description of zinc making there is also a description of the various types of zinc ore. These types are described as follows:

Mratica rasak, which is said to be 'of the best quality and like yellow coloured soil'. (This is probably calamine (smithsonite), $ZnCO_3$, or just possibly zincite, ZnO.)

Gud (jaggary) rasak is said to be 'of medium quality and the colour of treacle'. (This is probably sphalerite, ZnS).

Pashan rasak which is 'of the poorest quality and is hard like stone'. This could be hemimorphite, $Zn_4Si_2O_7$ (OH)$_2$. H_2O, the silicate (identification suggested by Gurjar).

The ores were treated as follows:

The *rasak* powdered by the wise *vaidhya* and put in a cloth bag is dipped into a container of women's urine for seven nights. The soaked powder is then treated with juices of yellow and red flowers (saffron, acacia, catechu, lac tree, *Terminalia chebula* and *dhak* (*Butea frondosa*), and then treated repeatedly with alkaline, neutral and acidic solutions respectively. Then wool, lac, tumeric (*Curcuma roxob*), *harra* (*Terminalia chebula*), *kenchua* (earthworms) *suhaga* (borax) and *grahdhoom* (soot?) are mixed together and added to the treated ore. The product is then placed in the *mook musha* (closed crucible or more likely, retort) and heated strongly. The extract released on heating has a diamond-like shine which is undoubtedly zinc. (VII 33-36)

The account of the different zinc ores is especially interesting as it would seem to be the earliest known detailed description of the different minerals of zinc. Note, that where zinc ores are mentioned in the Sanskrit texts they are today normally automatically translated as calamine, the carbonate, but there is no real justification for this. Calamine deposits are quite rare in India; some may have existed at Agucha in Rajasthan where the top three or four metres of an enormous surface deposit have been mined away at some time in the distant past. The missing portion could have been calamine, but the remaining ore is sphalerite (Tiwari and Kavada 1984). Otherwise all the exploited deposits in India, notably Dariba and Zawar, also in Rajasthan, were apparently exclusively of sphalerite (ZnS), which would have required roasting or some treatment to remove the sulphur before it was added to the retort. It should be noted that limited occurrences of gossanised material, in which smithsonite could have once existed, are found at both Zawar and Dariba. In Chapter 4 the Islamic processes by which sulphidic or pyritic ores were burnt and the zinc vapour so produced oxidised and collected on pegs of iron or of clay suspended over the fire in the furnace are described (p.74-5). There is no surviving evidence for anything like this at Zawar, in the form of spent clay pegs such as are found in great heaps at various sites in Iran for example (Barnes 1973), but some roasting process must have taken place (see below pp.35,52). The treatment with urine for seven nights described above in the *Rasarnavam* would have been insufficient to oxidise the sulphides. However it is not specified which type of *rasak* was meant, possibly it was the *mratica rasak* or calamine.

The *Rasakalpa*, also probably compiled in the twelfth or thirteenth century AD, describes how *rasak* is to be enclosed in fourfold pieces of cloth and

steamed for a period of five months. This could well have oxidised finely powdered sphalerite but it seems an inordinately long and cumbersome process and would be more likely to produce the sulphate than the oxide. The description then goes on to state that: 'the product is to be ground in a mortar and mixed with treacle, soot and the other ingredients and made into balls. These are then to be placed in a crucible (retort) and strongly heated. The essence possessing the lustre of tin is thereby obtained.' (Ray 1956, 157)

The *Rasaprakasasudhakara* of Yasodhara, also of the twelfth to thirteenth century gives a detailed description of the distillation process which is repeated almost verbatim in the slightly later *Rasaratnasamuchchaya* as follows:

Extraction of Zinc:- Rub calamine with turmeric, the marking-nut tree, *bhilawa* (*chebulic myrobalans*), resin, the salts, soot, borax, and one-fourth its weight of *Semicarpus anacardium*, and the acid juices. Smear the inside of a tubular crucible with the above mixture and dry it in the sun and close its mouth with another inverted over it, and apply heat; when the flame issued from the molten calamine changes from blue to white, the crucible is caught hold of by means of a pair of tongs and its mouth held downwards and it is thrown on the ground, care being taken not to break its tubular end. The essence possessing the lustre of tin, which is dropped, is collected for use. (Ray 1956, 171)

The warning given about protecting the tubular end fits in well with evidence from Zawar, where the contemporary and later excavated retorts have a long thin and fragile tubular clay condenser luted on to the open retort (Fig. 2, Pls 6,7). The description given above suggests the condenser end was open and the carbon monoxide formed during the reaction burnt off giving a characteristic blue flame, together with some of the zinc itself which also burns with a blue flame. Thus, when the flame turned white this indicated that zinc was no longer coming over and the process was complete. Almost identical observations are made in European manuals of zinc smelting by the horizontal retort process written in this century, and in the descriptions of the traditional Chinese process given in the paper by Xu Li in this volume (p.122).

In the contemporary *Rasachintamani* of Madananta-deva, the instructions are slightly different. There the process was judged to be complete as soon as white fumes appear. Possibly if the carbon in the retort ran out before the zinc ore was exhausted this could be signalled by the appearance of clouds of white zinc oxide where the zinc vapour had oxidised whilst still

in the condenser without the characteristic blue flame at the retort end.

Finally there are the accounts of the iatro chemists who flourished during the thirteenth to seventeenth centuries AD. Their works are rather more practical than the preceding more philosophical works, dealing with the preparation of medicine and salves, and contain a great deal of information on chemistry and metallurgy, including the production of zinc. The *Rasaratnasamuchchaya*, probably compiled in the late thirteenth or early fourteenth century AD, is probably the most familiar of the works of the iatro chemists. Some of the processes already covered in the Tantric works such as those described by *Yasodhara* given above are repeated, but many new techniques, with far more detail than hitherto, are also included. There is also a separate section on apparatus which again almost certainly contains descriptions taken from earlier works, notably the *Rasendrachudamani* of Somadeva, a Tantric work probably compiled in the twelfth or thirteenth century AD. The description of apparatus such as the *vrantak moosha*, a covered crucible or retort used for preparing zinc, are especially interesting as they tally exactly with the retorts found at Zawar of approximately the same date (Pl. 1).

> Prepare a *brinjal* (aubergine) -shaped crucible or retort of clay, and put onto it a tube eight or twelve *anguls* (inches) long, which opens out like a thorn apple flower (*datura stramonium*) at one end. The tube should be hollow and have a circumference at the expanded end of eight *anguls*. Such crucibles are known as *vrantak moosha* and are used for the distillation of *kharpar* (zinc ore) etc. (See also Ray 1956, 191.)

The description of the zinc smelting process is as follows:

> Take equal parts of lac, bark of the pipal tree, *hara*, myrobalans (*Terminalia chebula*), tumeric *haldi* (*Curcuma longa*), treacle, resin, rock salt, *suhaga* (borax) and *kharpar* (zinc ore). Bind them together and bake with cow's milk and ghee (clarified butter). Then make into balls and put into a *vrantak moosha* (crucible or retort) and heat strongly. The contents are then poured onto a slab of stone -the essence of *kharpar* of the appearance of tin is to be used. (See also Ray 1956, 172.)

Or, alternatively, having prepared the retort and its charge as described above and fitted the *datura* condenser

> Dig a hole in bottom of a *koshthi* (distillation furnace) and place inside a water-filled vessel with a perforated plate or saucer over its mouth. Then fix the *vrantak moosha* in an inverted position over the perforated plate or saucer. Put charcoal of the *jujube* tree (*Ziziphus*

jububa) over and around the *vrantak moosha* and heat strongly with the help of bellows. On heating the zinc, extract descends and is collected in the vessel bottom.

This description fits the process uncovered at Zawar very well, although there is no hint in these written descriptions of the multiple units actually found there.

The earliest external reference to zinc production in India is to be found in the *al-risalat althaiya* compiled in Iran in the tenth century AD by Abu Dulaf (Allan, 1979, 44). There he describes the various varieties of zinc oxide and concludes that the best variety is the Indian which was prepared from the vapour of 'tin'. Whilst metallic zinc was unknown outside India it was often referred to as 'Indian tin'. The earliest European reference to Indian zinc may be contained in Albert Magnus' *On Minerals*, compiled in the thirteenth century AD (Wyckoff 1967, 250). There *tutty* is described as the white smoke collected from furnace flues, but there was a special sort which sank to the bottom on washing and this was known as *Indian tutty*. Was this metallic zinc collected as described in Chapter 1 (p.4)?

ZINC PRODUCTION AT ZAWAR

From these ever more detailed descriptions it is clear that the production of zinc by distillation has a long history in India. Surprisingly the physical remains of the process seem confined to just one site, Zawar which lies about 45 km south of Udaipur in the state of Rajasthan in north-west India (Fig. 1). None of the chemical or medical treatises discussed in the previous section mention Zawar, but we do have one early reference to zinc making there and that is in the *Ā-Īn-I Akbañ*, of Abū L-Fazl Allāmī (Blochmann ed. Phillott 1989), completed in 1596. This work, extolling the great Mughal emperor Akbar and his dominions, has compendious lists of the materials made in each part of the Empire. Amongst these are *jast* which was subsequently the word for zinc. The entry reads:

> *jast*, according to some is *ruh-i-tutiya* (the metal of *tutiya*, the Persian word for zinc oxide) and resembles lead, it is nowhere mentioned in the philosophical books (this is true of Persian and other Islamic works, but is certainly not true of the Indian works in Sanskrit as demonstrated above), but there is a mine of it in Hindustan in the territory of Jālor which is a dependency of the Sūba of Ajmir. (Blochmann 1989 I, 42-3);

and more specifically: 'In the village of Jāwar, one of the dependencies of Chainpur, is a zinc (*jast*) mine.' (Blochmann 1989, II, 273)

Zawar would have lain in the vicinity of Jālor (Habib 1982, 20).

Various mining engineers and geologists who visited Zawar in the 1940s and 50s in connection with the re-opening of the mines were struck by the immense heaps of spent retorts especially when re-used as hollow bricks for building houses, etc. and brief descriptions and even photographs of the early remains at Zawar appeared in a number of technical journals and books (Carsus 1960, Werner 1972, Morgan 1976 & 1985, and Straczkk and Srikantan 1967).

These reports, reinforced by the early literature on zinc smelting in India, suggested the remains at Zawar were possibly extremely important not only for the history of zinc but for science and technology in general.

Geology

The Zawar deposits are located in the Aravalli Hills that run north-east/south-west through several hundred kilometres of Rajasthan. The local rocks are made up of a succession of calcareous, arenaceous and argillaceous meta-sediments forming parts of the Aravalli Supergroup of middle Pre-Cambrian age. A detailed description is given in Straczkk and Srikantan (1967, especially Table 1).

Structure

The present structural disposition of the area is the manifestation of two distinct major periods of tectonic activity, each of which was characterised by intense folding and faulting. The first tectonic cycle folded the rocks into a north-south trending, northerly-plunging tight isoclinal fold. The second tectonic cycle refolded the structures of the first. This induced a totally different trend giving rise to west-plunging east-west trending isoclinal folds resulting in a cross fold structure. The north and south limbs of the cross fold are represented by Mochia-Balaria hills and by Bohua Magra respectively; Baroi and Zawar Mala on the other hand represents the north-south

trending, northerly plunging first generation fold system (Fig. 1). The area is also affected by a number of low angle folded thrust faults of the first and high angle longitudinal faults of the second tectonic cycle.

Mineralization

The principal rock types are greywackes, phyllites, slates, dolomites and quarzites showing a wide range of variation in grain size and mineral constituents.

Base metal sulphide deposits at Zawar are confined exclusively to the dolomitic horizon of the Baroi Magra formation (Fig. 1).

Both structural and lithological controls of mineralization are evident. Ore localization is controlled by shear fractures and tensional fractures related to fold patterns and by fault contacts, and occurs as veins, veinlets, brecciated zones and disseminations forming lenticular bodies, which are solely confined to the dolomite. The ore body generally exhibits parallelism with the host formations except in Balaria, where the lenses in the south zone are very askew; in this area the lenses are disposed in echelon fashion with sinistral shift. The average strike length of lenses is 100-300 metres and their widths range between 2-45 metres; few of the ancient workings extend more than 100 metres below the surface.

Sphalerite is the principal economic mineral and occurs as veins, veinlets and stringers. The second most abundant is pyrite which occurs as thick veins and stringers, with and without sphalerite and galena. Galena is more locally concentrated in the form of coarse crystalline patches in sphalerite and pyrite and as veins and stringers. Cadmium and silver are present in solid solution with sphalerite and galena. Average ratios between Zn-Pb, Zn-Cd and Pb-Ag are 3:1, 1:40-45ppm and 1:40ppm respectively. In most of the area galena and sphalerite can be easily separated by hand picking, a factor of great importance in the establishment of zinc smelting at Zawar rather than at the other mines in the region.

Crude mineral zoning is apparent in some lenses, with richer mineralization occurring in the central portions. Pyrite usually increases towards the tips of lenses and is indicative of pinching.

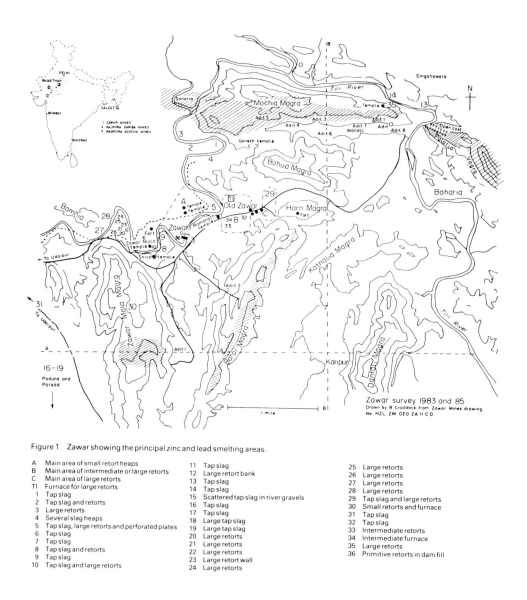

Figure 1 Zawar showing the principal zinc and lead smelting areas.

A	Main area of small retort heaps	11	Tap slag	25	Large retorts
B	Main area of intermediate or large retorts	12	Large retort bank	26	Large retorts
C	Main area of large retorts	13	Tap slag	27	Large retorts
TI	Furnace for large retorts	14	Tap slag	28	Large retorts
1	Tap slag	15	Scattered tap slag in river gravels	29	Tap slag and large retorts
2	Tap slag and retorts	16	Tap slag	30	Small retorts and furnace
3	Large retorts	17	Tap slag	31	Tap slag
4	Several slag heaps	18	Large tap slag	32	Tap slag
5	Tap slag, large retorts and perforated plates	19	Large tap slag	33	Intermediate retorts
6	Tap slag	20	Large retorts	34	Intermediate furnace
7	Tap slag	21	Large retorts	35	Large retorts
8	Tap slag and retorts	22	Large retorts	36	Primitive retorts in dam fill
9	Tap slag	23	Large retort wall		
10	Tap slag and large retorts	24	Large retorts		

Fig. 1 Contour plan of Zawar district, showing principal sites discussed in the text

ZAWAR MALA MAGRA

Of the four areas exploited in antiquity at Zawar only Zawar Mala Magra has been surveyed archaeologically and dated in any detail and thus the detailed geological descriptions will be confined here to that mine.

The rocks form part of the Manoli, Baroi and Zawar formation of the Tiri Series of the Aravalli Supergroup.

Stratigraphy

Upper phyllite
Quartzite
Carbonaceous phyllites and dolomite
Dolomite
Lower phyllite

Grey phyllites and slates
Fine to medium grained quartzite
Carbonaceous phyllites with inter-bedded marly slates and dolomite bands.
Variants of dolomite, ie siliceous, arkosic and sericitic dolomite with intercalations of quartzite (host rock).
Gritty, locally conglomeratic greywacke, with intercalations of phyllites.

Mineralization

Sulphide mineralization occurs throughout the dolomite horizon and is confined to structural openings, i.e. shears and tensional fractures. The principal sulphide minerals in order of abundance are pyrite, sphalerite and galena with a minor amount of pyrrhotite and traces of chalcopyrite. From the point

of view of economic significance sphalerite is the predominant mineral and next in abundance is galena. Exploratory mining has revealed the presence of an apparent zonation from high zinc in the eastern part to lead-zinc in the central part and zinc-pyrite in the western part. Early mining seems to have been concentrated in the zinc-rich areas.

The sphalerite is fine to medium grained and occurs as veins and veinlets and stringers with or without galena and is of two colours, honey yellow and dark brown. The dark brown variety has an affinity with pyrite.

Galena occurs generally as fine-grained veins but coarse grained crystalline patches occur locally. The veins are continuous along the strike of the lode, while crystalline galena restricts itself to open fractures, voids and quartz. The dimensions vary from a few centimetres to tens of metres. There are small occurrences of stains of native silver, especially in the upper part of the deposit.

Mining

This aspect of the Zawar project has been directed by L. Willies and his team from the Peak District Mining Museum with considerable assistance from L.K. Gurjar and the Geology Department of Hindustan Zinc. The investigations of the mines at Zawar were not complete at the time this report was made, but it is already obvious that major mining systems were developed in the latter half of the first millennium BC at both Mochia Magra and Zawar Mala Magra. The absence of either later working or collapse at the latter mine has resulted in the virtual intact survival of one of the most extensive and sophisticated ancient mining systems known anywhere (Willies *et al.* 1984 and Willies 1987).

Due to the intense folding discussed in the Geology section, the ore bodies usually lie at a steep angle, and were followed down by the miners from where they outcrop on the top of the steep ridges, some 300 metres above the valley floor. Traces of early mining are visible along a total of at least 12 km of the ridges, including major excavations which form the tops of stopes, shafts for ventilation, access and haulage routes leading down vertically to intersect the inclined stopes, and also great opencast mines on Mochia and Balaria. The ore bodies were often several metres thick and many metres wide and thus great stopes developed following the ore down for a hundred metres and sometimes more into the hills (Pl. 2). We have found no evidence for adits going into the hillside to intersect the ore bodies lower down, although these would have been a considerable help in both access to and draining of the mines. Perhaps this reflects the general reluctance of early miners to dig in anything but ore unless forced to (although the Roman mines at Rio Tinto had several adits over a kilometre in length cut through barren rock to drain their mines (Salkield 1987, 10 & 40).

Our survey showed that the mining was very largely carried forward by firesetting, except at Pratap Khan in Zawar Mala where weaknesses in the iron oxide-filled rock joints were exploited. Elsewhere firesetting was evidenced by the very rounded profiles of the galleries and supporting pillars (Pl. 2), the smooth surface of the rock showing few pick or chisel marks. Some of the rock faces still bear traces of burning, everything is smoke blackened and the floors are buried deep in charcoal, ash and burnt rock. At some faces where mining was still being carried forward right up to the time when work ceased for ever, the method of firesetting could be observed. The main galleries were at a steep angle following the ore down and shallow elliptical pits between one and two metres long were observed in the plunging face where the last fires had burned fracturing the underlying and surrounding rock. Several fires would have been necessary to advance the whole of these broad faces. It might be thought that once lit the fires would have been unapproachable through the several hundred metres of smoke-filled tunnels laden with fumes of carbon and sulphur dioxides, thus rendering it impossible to douse these fires and crack the red hot rock face. But this is not certain as the stopes are often very tall and run straight to the surface. It is possible that the hot fumes hugged the roof whilst cool air was sucked in at floor level, allowing the miners access. This problem was overcome in Europe sometimes by judicious use of shuttering in the galleries to create a smoke-free passage. The debris on the floor in Zawar Mala contains many branches and twigs that are only partially burnt. Was this due to insufficient air, or is it evidence for having been doused? On the whole it seems likely that firesetting would have been done in rotation through the galleries being worked and that a gallery would have been evacuated while the fires burned until doused by a small team of miners. Then the remaining miners could re-enter and attack the shattered rock with hammers, chisels, hoes and, if necessary, picks. A selection of iron tools from the Mochia mine are illustrated in Plate 3. For further work on firesetting generally, but based on the Indian mines, see Craddock (1992), Willies (1992) and Willies (1994). The continued use of firesetting in

the stone quarries of southern India is described in Craddock (1996).

The stairways are sufficiently broad for two people to pass without difficulty. The obvious implication of this is that an almost continuous stream of workers moved both up and down these stairways carrying baskets of ore and debris (gangue) and pitchers of drainage water; remains of both types of container are quite common in the mines. Much of the rock debris (deads) was carefully stacked inside the galleries as they were worked out. Where the deads were stacked in the steeply sloping main stopes it was necessary to build retaining walls and stabilise with timbers set from floor to ceiling.

The absence of adits running from the hillside to meet the descending stopes meant that everything that left the mines had to come up the stairways to the surface, including drainage water. It is difficult to gauge how serious the problem of drainage was. Perhaps the very absence of adits suggests it was not that critical, as adits are the obvious answer to a serious flooding problem.

Inevitably the problem would have varied with the season. Our explorations were carried out some months after the cessation of the monsoons, but we still noted that just one small flow at the base of the major stope we surveyed in Zawar Mala was producing about a litre of water every two minutes. Each gallery has several small flows such as this and thus throughout the mine system this could culminate into thousands of litres per day even months after the monsoon had finished. The larger water clay pots found in the mine have a capacity of about five litres, and thus several hundred journeys up and down the ladderways would have been necessary each day in each gallery system just to drain the mines. The water running down the stopes was collected in channels and by launders hollowed from tree trunks, which survive in quantity throughout the mines (Pl. 4). With these much of the water was brought together for removal before it reached the bottom.

Amongst the many finds of pottery were many vessels with straight flared sides, rather resembling small pudding basins or bases of larger vessels trimmed down. These were probably lamps, and Mr H.V. Paliwal of HZL demonstrated how, when filled with cotton waste and soaked in vegetable oil, they give a good light for several hours. Preliminary tests by Dr John Evans of the North East Polytechnic College of London have confirmed that the clay walls of the vessel do contain vegetable oils which would seem to confirm their use as lamps.

We postulate that the mine developed in the following sequence. First a large number of small quarries and trial mines took out the richest and most accessible pockets of ore, then the steeply dipping main ore bodies were attacked by driving galleries down into them and extending laterally from them (underhand stopping). Pillars of ore were left at frequent intervals to support the roof but after the main operations had ceased most of these were removed together with the remainder of the ore as the miners worked back towards the surface (retreat mining). Probably the final stage in the mining were the extensive surface quarries to remove the easily accessible but low grade ore. Such opencast operations are found all along the top of Mochia Magra, and a very considerable body of material must have been removed. Dates for the first three phases of mining at Zawar Mala all lie in the range fourth-first centuries BC (Table 1), and the dates from the underground working at Mochia suggest a date in the fifth century BC, but the opencast working above could be much later, as suggested by the one carbon date of 390 ± 50, BM-2666, from the Mochia surface workings (Table 1). Modern mining has severely damaged the ancient underground system at Mochia, but it seems that, with modifications for the near-vertical deposits, it was broadly similar to Zawar Mala, but may have been even larger in scale (Straczkk and Srikantan 1967, 56). The mines of Balaria and Baroi have as yet not been exposed systematically, but one timber support from Balaria gave a post-medieval date (Table 1).

Beneficiation

Just outside the mine entrances are the usual heaps of spoil-rock fragments of all sizes from dust through to boulders. Still within a short distance of the mines (under a hundred metres) lie many more heaps of much more regular pea-sized rock fragments, and the very occasional hard stone pebble used as a hammerstone, these are the remains of the beneficiation process. The general absence of stone tools suggests that most of the hammers were of iron. The ore would have been broken up into pea-sized pieces and the good ore selected by hand-picking. There was apparently insufficient water up in the hills for any sort of water sorting even utilising the water from the mines, and there are no remains of launders or buddles anywhere. However at some early nineteenth century lead mines near Jaipur where streams were absent, large pits were filled with water and the ore washed in wooden tubs floating on the surface (Percy 1870, 294). Alternatively, a form of

winnowing could have been practised as in the nineteenth century at the tin workings of Hazaribargh and Ranchi in Bihar (Chakrabarti 1979). Washeries could have been located in the valleys but once again no remains have been identified. At Dariba we have located large mortars hollowed out of the local very hard and resilient calc-silicate rock for crushing ore; these are not found at Zawar, presumably because of the absence of suitably hard rock, but many small crushing hollows have formed on convenient flat rock surfaces where crushing has been performed (Pl. 5) (See Craddock 1995, 157-61 for a more general discussion of the formation of these small crushing hollows). Analysis of the gangue from beneficiation heaps show it is low in both lead and zinc, suggesting that right from the start of mining in the first millennium BC both lead and zinc were sought, unless the heaps were reworked later for which there is no evidence. As part of the beneficiation process, the ores must have been separated into lead and zinc at this stage. At Zawar the two minerals are not intimately mixed and separation by hand-picking is feasible. The low level of lead in the spent retort residues suggests it had been substantially removed mechanically at this stage.

Although no ancient concentrates have been found it is possible to predict the likely zinc content by comparison with the modern concentrates. Analysis of the non-volatile metals in the spent retort residues (lead, iron and silver) are uniform throughout the retort-filling (suggesting little was lost in the process) and are very comparable to the modern concentrates which typically contain about 50% of zinc.

The beneficiated ores were then brought down to the valley for smelting. This paper will concentrate on the production of zinc, although lead and silver were also produced at Zawar. The smelting of silver and lead ores at Zawar and the other major sites in the Aravallis is discussed in Craddock et al. (1989).

Smelting Zinc Metal

Before the zinc ore could be smelted it was necessary to drive off the sulphur, converting the sphalerite to the oxide. The long chemical treatment with urine described in some of the very early treatises seems ineffectual and would be totally inappropriate to the industrial scale of operations at Zawar. Sphalerite is one of the more difficult metal ores to de-sulphur, the temperature must be high, the lead content low and the sulphides given no chance to form sulphates which would merely convert back to sulphides at the reduction stage in the retort. In fact the sulphur levels in the retorts are very low (about 0.5%) which

suggests the roasting stage must have been very thorough.

As a first stage the ore could just have been roasted in heaps or in open stalls, the reaction:

$$2ZnS + 3O_2 \rightarrow 2ZnO + 2SO_2$$

is exothermic and so once combustion has commenced the majority of sulphur will burn itself off. This was the practice in Germany in the eighteenth century (Ingalls 1903, 66). However this would still leave about 8%, of sulphur, but the charge in the retort had to be almost free of sulphur. Thus the partially calcined ore would have had to be roasted in a furnace with fuel at about 900-950°C to complete the removal of sulphur down to about 0.5%. We have found no archaeological evidence for roasting furnaces. Just beyond the main retort heaps and settlements at Zawar are substantial heaps of white ashy material. In our first substantive report (Craddock et al. 1985) we identified these as the roasting places. However, excavation failed to locate any installation or even flat area for the roasting, and analysis of some of the white material has shown that it is not the debris of roasting, but is almost certainly the furnace ash from the distillation process (Freestone et al. 1985a). The lead, silver and iron contents are all much lower than in the ore or retort residue, which seems to rule out ash from the intermediate calcination process, but the cadmium content is much higher at about 200ppm compared to only about 10-20ppm in the retort residues. In the distillation process cadmium comes off first because it is even more volatile than zinc and could tend to condense in the lower chamber of the furnace amongst the ashes rather than with the zinc. The bulk of the ash heaps is made up of calcite, with abundant fragments of charcoal and crumbs of vitrified ceramic. This ash would have been both caustic and poisonous and it is no surprise that it was dumped well away from the settlement. Even there it may not have been rendered harmless, and indeed may explain the persistent local legend of the end of the old mining community (see below, p.46).

Preparing the Charge and Loading the Retorts
(Fig. 2, Pls 1,6,7)

The calcined ore appears to have been mixed with an inert carrier of dolomite and the reducing agents (Freestone et al. 1985b). The full list of organic ingredients given in the contemporary Indian literature listed above seems somewhat fanciful, and it must be confessed that many of the more exotic items do appear frequently in alchemists' recipes. However, the underlying principle is sound, and is

supported, where possible, by the evidence surviving in the retorts themselves.

Basically the recipes describe how the ore was to be mixed up with a variety of sticky organics and rolled into balls. These would tend to stick together in the retort giving a reasonably stable structure with plenty of space for the gases generated during the reaction to move around freely.

Examination of the contents of the large retorts, where the debris survives *in situ*, do show a nucleated, sintered structure suggesting the original charge could have been made up of balls about 1cm in diameter (Freestone *et al.* 1985b), although the intense heat has meant that little of the original structure survives.

The great heat also means that it is pointless to try and identify any of the organic material, or to check on some of the more exotic ingredients listed in the Sanskrit literature although small flecks of charcoal are visible throughout the charge. It is possible, however, to check on the inorganic ingredients. High lime and magnesia contents in the retorts suggest that crushed dolomite may have been mixed with the roasted ore as an inert carrier (Freestone *et al.* 1985a). The recipes make no mention of this but it was possibly taken as part of the 'ore' component, although both borax and salt are specified. Borax has been detected by emission spectroscopy, but in no greater concentrations than is found in the local clays. The glass phases in the residues can contain 1-2% of sodium chloride. This suggested that the charge was saturated in chloride, strongly suggesting that salt was deliberately added to the charge. Gurjar has suggested that ammonium chloride known locally as *nausadar*, may possibly have been the source of the chloride, as this is still widely used as a flux by local smiths. Alternatively both common salt and ammonium salts could have been introduced in the form of urine, mentioned in some of the early recipes. Small quantities of salt in the charge would have promoted the sintering of the dolomite. Clearly this sintering had to be carefully controlled; too little and the charge would just collapse as a powder once the organics had lost their binding power, too much and the charge would vitrify, sealing the reactants in a glass.

The addition of about 1% of salt to the smelting charge was regularly made in the European processes in more recent times. The salt certainly increased the yield of zinc. The reasons given were that the salt probably glazed the walls of the retort and prevented adsorption of zinc there, and also that the salt somehow suppressed the formation of the pernicious and intractable form of partially oxidised zinc known as 'blue powder' (Smith 1918, 101, and below p.200).

The particular organic ingredients listed in the Sanskrit manuals do seem unnecessarily exotic and expensive, and it is very likely that much cheaper and more familiar materials were used in the industrial process. The ubiquitous fuel and binding agent in use then and more recently was cow dung. Thus at the copper mines at Singhana-Khetri, about 600 km north of Zawar, in the nineteenth century the ground ore was rolled into sausages with cow dung and roasted before smelting, and further north in Sikkim the partially smelted copper was crushed and mixed with cow dung and rolled into small balls prior to roasting (Percy 1861, 389-91).

The retorts are the main surviving evidence of the smelting process, each one was used just once so there are now many millions of them in great heaps, spread over several square kilometres, concentrated around the old settlement but also occurring in outlying areas along the Tiri river for several more kilometres (Fig. 1). The retort walls are of clay with large inclusions of the local quartzite and phyllite. The heaps now contain several hundred thousand tonnes of used refractories, and Zawar must have been the centre of a major ceramics industry. There are no obvious sources of clay apart from the alluvium of the Tiri itself. During the monsoon large quantities of clay would be brought down and deposited behind the great dam built in the fifteenth century, and this could have been dug out during the following dry season. After Zawar was abandoned a huge deposit of clay and silt built up behind the dam, until the dam itself was breached and the river cut through the clay. The remnants of this bed are now left as banks several metres tall and running back several hundred metres from the dam.

Our investigations have discovered three principal sizes of retort, which we termed 'small', 'large', and 'intermediate'. In addition we have recently located fragments of retorts and condensers, which appear to be unusually small; no complete examples were located so their length is unknown, but their internal diameter was about 5.5cm. They were found in the earth fill of the Tiri dam. Thus the retorts in the fill must predate the dam, but by how much is impossible to know until they have been located *in situ*. All the retorts seem to be of the same general form, the contemporary account of them as being shaped like an aubergine describes them perfectly (Fig. 2, Pl. 1). Our 'small' retorts are approximately 16cm long and 8cm diameter, the 'large' retorts are

approximately 30cm long and about 12cm diameter, and the 'intermediate' retorts are approximately 25cm long and about 10cm diameter. (These are external dimensions, without the condenser in place. The figures in Craddock *et al.* (1985) were the external dimensions of combined retort and condenser.) The retort was an open, cylindrical aubergine-shaped vessel (Pl. 6) into which the prepared charge was placed around a wooden stick and the conical clay condenser was secured on to the end of the retort with a firm lute of clay. The central channel left by the stick through the retort charge survives in many spent retorts, and in one case combustion had been incomplete and the charred remains of the stick were still present. The stick and channel served several functions through the process. First the stick stopped the charge from falling out when the retort and condenser were inverted into the furnace. Then, as the heat built up so the stick would char and drop out, or be blown out by the gases generated within the retort, leaving an open central channel running through the charge into the condenser down which the zinc and carbon monoxide could escape.

Fig. 2 Idealised section through a small retort, as loaded into the furnace ready for firing

The condensers are shaped like a filter-funnel (or the thorn apple flower as the contemporary accounts accurately state) (Pl. 7). The small retort condensers are clearly handmade, often with finger fluting on the sides, whereas the later condensers on the large and intermediate retorts were pressed into polygonal moulds. They generally terminated in a long tube about 10cm in length and a centimetre in external

diameter although almost without exception they are now missing. The few fragmentary pieces which we found were full of zinc oxide, and minute globules of zinc coated with zinc oxide, known now as blue powder, and it seems likely that they were generally collected, broken up and returned to the smelting process to recover the zinc.

The retorts were now ready for firing. Upon heating, the organics in the charge would begin to char and dehydrate producing gases which would blow out the charred remains of the stick and open the central channel. As the temperature rose so the organics would lose their stickiness, but the dolomite would begin to sinter helped by the small amount of salt, thus preserving the open structure. The carbon remaining from the organics would form carbon monoxide and commence the reduction of the ore. The reaction is very strongly endothermic and all the heat was supplied through the retort wall. With the open structure heat could penetrate rapidly and uniformly by radiation, and to a lesser degree by convection, enabling the reaction to proceed simultaneously throughout the retort. If the reactants had been just packed in as a powder the heat would have had to penetrate by conduction, with the outer charge reacting before the inner regions, and it would also have been almost impossible for the reducing gases to circulate or for the zinc to escape.

The Furnaces (Figs. 3-6, Pls 8-20)

Before the excavation there was no knowledge of the shape of the furnaces at all. The early descriptions suggested a two-part furnace, known as a *koshthi*, separated by a perforated plate, which was used for the process of *tiryakpatana yantram* (distillation by descending) in the smelting of zinc. The fire was in the upper chamber around the retort with the neck of the condenser protruding through the hole in the plate into the cool chamber below, with the zinc dripping down and being collected under water. Note that the double chambered installations used in the preparation of potassium nitrate in the Ganges valley up until the early decades of the twentieth century were known as *kothi* (Marshall 1915, 47-9).

Our survey at Zawar soon revealed that intact remains of the furnaces had become buried in the retort heaps at numerous locations. We have excavated examples of the furnaces used for the small, large and intermediate retorts (Pls 8-12). Although we have not yet located remains of the furnaces associated with the retorts of dam fill, we did find fragments of primitive thin handmade perforated plates together with the retorts, suggesting the very

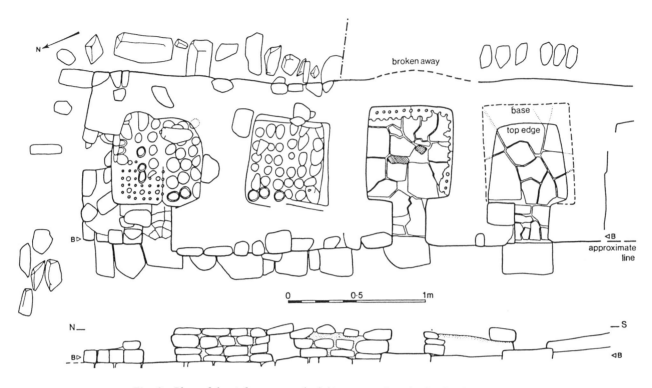

Fig. 3 Plan of the 4 furnaces or *koshthi* excavated in the bank of 7 at site 30

earliest furnaces were similar in principle at least to those we have excavated, and are presumably ancestral to them. The three examples we have excavated were all of very similar design, differing only in the size necessary to hold the same number of different sizes of retort (Pls 8-12). Of these the small retort furnace on Zawar Mala Magra, site 30, was the best preserved and will be described here.

The installation was a bank of seven furnaces, each containing 36 retorts (Pls 13,14). The individual furnaces or *koshthi* were square in plan and consisted of an upper furnace chamber in the form of a truncated pyramid in which the retorts sat, and a lower cool square chamber where the zinc was collected (Figs 3-5 and Pls 15,16). The external walls were of regularly coursed brick (Pl. 17) rising eight courses from the plinth of stone on which the furnaces stood. The area before the furnace was paved with large flat bricks, not unlike Roman *tegulae* in size and thickness. The interior of the furnace walls were much less regular, and often large gaps in the brickwork were just filled with clay and fragments of broken refractories. The inner face of the furnace and the chamber beneath were roughly plastered with about one or two centimetres thickness of clay. In each of the *koshthi* the lower chamber was approximately square in plan, being 66 by 69cm, the long side containing the entrance. The equivalent measurements in the large furnaces were

110cm and 73cm for the intermediate furnaces, both of theses dimensions are for the entrance side. Unfortunately they were not so well preserved as the small furnaces and it was not possible to determine whether the slight difference in dimensions also occurred in these furnaces.

The entrance to the chamber for all furnace sizes (Pl. 18) was no more than about 25cm wide and about 20cm high (three courses of brick) and this was the sole access to the lower chamber during the operation of the furnace. All three of the furnace banks excavated by us contained furnaces where the retorts were still in place, but the vessels where the zinc collected were missing, showing that it was not the practice to remove the retorts and perforated plates to get access to the lower chamber. This must have been done exclusively through the small entrance, presumably with long tongs.

The division between the two chambers was formed by four closely fitting perforated bricks or plates (Pl. 19, Fig. 5). Each brick was identical and had been made in a mould, hence the exactly similar dimensions of the furnaces – presumably the furnaces were built around sets of perforated bricks each coming from the same mould. Each brick has two straight edges which fitted flush against the edges of its neighbour, and two chamfered edges which fitted into sides of the *koshthi* supported from beneath on a projecting brick ledge. The chamfer was probably to

38

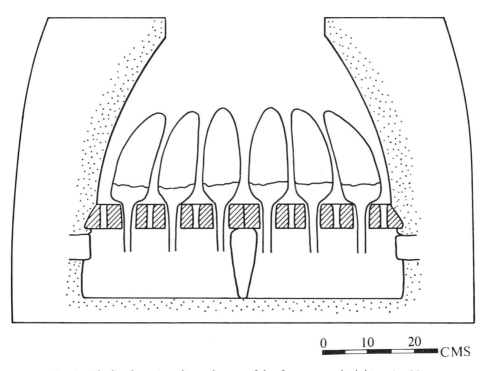

0 10 20
CMS

Fig. 4 Idealised section through one of the furnaces or *koshthi* at site 30

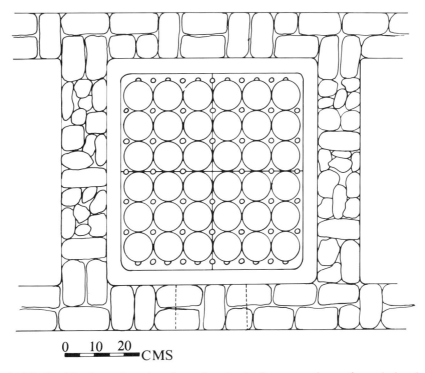

0 10 20
CMS

Fig. 5 Idealised horizontal section through a site 30 furnace at the perforated plate level

enable the bricks to be removed and replaced by levering them up without doing too much damage to the furnace lining. Judging from the number of heat fractured fragments of the plates in the heaps they disintegrated fairly frequently. All four plates were supported in the centre on one tapering pillar (Pl. 20). The tapering profile was necessitated by the overriding need not to restrict access to the rear of

the cool chamber from the small entrance. The pillar was sometimes luted to the floor with mud, but the perforated plates were not mortared to the pillar or to each other, once again facilitating individual replacement where necessary.

Each plate had nine large holes (35mm diameter) in a three by three arrangement to accommodate the condenser necks and 26 smaller holes (10mm

diameter) plus a further nine holes shared with the adjacent bricks. These smaller holes were for the passage of air into the furnace, and for fuel ash to drop through on to the floor of the lower chamber.

The retorts would have been loaded into the *koshthi* as shown in the artists reconstruction of site 30 (Fig. 6) with the condenser necks in the larger holes. The retorts were otherwise unsupported generally, although fragments of used retorts were sometimes used as spacers in the small *koshthi*, and in the large *koshthi* specially made clay wedges resembling segments of an orange were used to keep the retorts at a uniform separation where, and when this was judged necessary, to prevent them from slumping against each other during the firing. It was, of course, essential to try and ensure the heat to each retort was uniform from all sides.

The Operating Parameters of the *Tiryakpatana Yantram* Process

The scientific study of the semi-vitrified refractories and the spent retort residues can reveal many of the operating conditions, temperature, duration, reducing conditions, etc. This, coupled with some contemporary descriptions, and analogy with the experience of later European retort processes, enables us to reconstruct the operation with some confidence.

The fuel recommended in the *Rasaratnasamuchchaya* was charcoal, especially of the *jujube* tree (*Ziziphus jujuba*) a species still well represented in the Zawar area. Very little identifiable charcoal survived in the *koshthi* but one very hard dense piece was immediately recognised and confidently identified by the locals as being of the *nin* tree (Very probably the *neem* tree (*Azadirachta indica*). Dung cakes may well have been used as well (Hegde *et al.* 1986), but it is likely that the principal fuel was charcoal in order to reach the temperatures necessary in the rather confined spaces between the retorts for distillation to proceed. The air supply seems to have been almost wholly through the perforated plates. There is no evidence for fixed tuyeres in any of the furnaces. However it does seem likely that small hand-held bellows would have been used to encourage the fire locally where necessary to keep the operation proceeding uniformly. The vitrification on the retorts themselves is most pronounced in the central regions, lessening towards the condenser end, and very often the retort tip is unvitrified, suggesting the fire was mainly around the retorts rather than above them. This means that the depth of the fire bed cannot have been much more than about 20cm, and it has been suggested that this was too shallow to realise the temperatures required. However, Juleff's recent (1996) iron-smelting experiments had an even

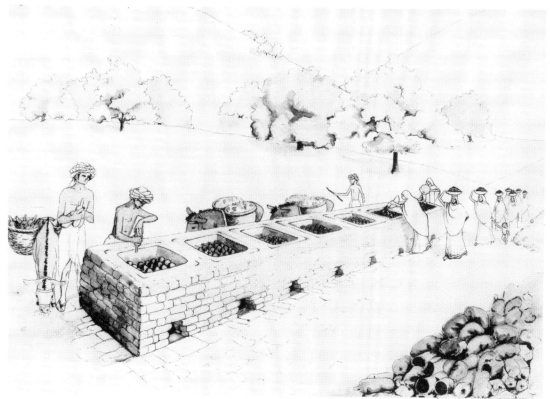

Fig. 6 Artist's reconstruction of the site 30 furnaces being loaded with retorts. (NB in reality the furnaces would almost certainly have been in some kind of roofed but open shelter.)

thinner fire bed but achieved higher temperatures than those used at Zawar. Hegde *et al.* (1986) and Hegde (1992, 75) believed that the furnace as excavated was incomplete, and proposed a dome-shaped upper portion. However in a number of places on the site 30 furnaces the top of the existing wall survived with the vitrification continuing up and over the present top of the furnace wall, strongly suggesting that this was the original top.

Comparative studies of the degree of vitrification of the retort walls by scanning electron microscope suggests the maximum temperatures reached were about 1200°C (Freestone *et al.* 1990). This is rather low compared to the later horizontal retort process as practised in Europe and America. Smith (1918, 93) states that 1400°C was the usual temperature and that reduction was very slow below about 1125°C, but, Smith did note that using soft coke or charcoal, zinc could be produced at just over 1000°C, and most certainly the cementation process worked perfectly well at about 1000°C.

These temperature estimates are supported by the mineralogical studies of Friedlander and Kangsoo Choo (1970). They noted that 'the presence of gahnite and willemite, and of clinohypersthene and hypersthene place the temperature of the smelting process around 1100°C.'

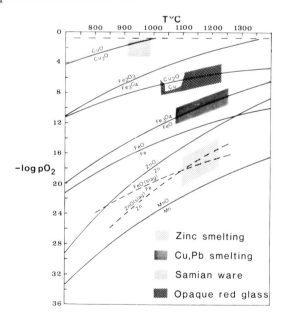

Fig. 7 Plot of the partial oxygen pressure versus temperature. The lightly stippled area represents the likely conditions within the retorts.

The conditions in the retort were necessarily intensely reducing. Figure 7 shows the typical conditions for the smelting and firing atmosphere of some other common metals and materials. At temperatures in the region of 1100°C a partial oxygen pressure (pO_2) of 10^{-16} is required to smelt the pure oxide. However, in the sintered and partially vitrified charge the pO_2 is likely to have been around 10^{-20} (Freestone *et al.* 1985b).

The duration of the process, as measured by the longest period of time the maximum temperature was attained, is estimated by studying the degree of penetration of the vitrification into the furnace walls. From these studies, we estimate that the maximum temperatures were held for about 4 to 6 hours. This agrees well with some contemporary statements. In the 1840s the mines at Zawar were investigated by Captain Brooke (1850), a political agent to the Mewar state, with a view to re-opening them. There he met the archetypal last inhabitant who offered to show him how the process worked. A demonstration before the Maharana failed, but the old man clearly remembered most of the process, and stated that the ore was fused in three or four hours which agrees well with our calculated value.

When the furnace reached maximum temperature, the organic material charred and carbon monoxide was produced by reaction with the initial oxygen and with carbon dioxide evolved from the breakdown of the dolomite, i.e.

$$2C + O_2 \rightarrow 2CO$$
$$CaMg(CO_3)_2 \text{ (dolomite)} \rightarrow CaO + MgO + 2CO_2$$
$$CO_2 + C \rightarrow 2CO$$
$$ZnO + CO \rightleftharpoons Zn + CO_2$$

The last reaction is reversible and predominance of carbon monoxide would have been necessary to keep the reaction to the right. Thus there will have been three gases moving into the condensers: carbon monoxide, carbon dioxide and zinc. The over-pressure of carbon monoxide also served to stop oxygen entering and re-oxidising the zinc before it had condensed.

There would have been a considerable temperature drop along the neck of the condenser, from about 1000°C at the top where it joined the retort to about 450°C at the bottom in the cool chamber), where the liquid zinc must have dripped down into the now missing collection vessels. The actual condensation range is much narrower than the 907°C boiling point and 419°C melting point would suggest. In practice, virtually no condensation takes place until the temperature falls below 550°C, but if the temperature drops below about 415°C, the zinc condenses as the partially oxidised blue powder which is almost useless (Smith 1918, 93), and would

anyway block the condenser end with catastrophic results. Thus in the space of 10cm the temperature had to be reduced by about 500°C to within the narrow range of about 420-550°C and held long enough for the zinc to condense to a liquid.

The over-pressure of carbon monoxide prevented the re-oxidisation of zinc in the condenser. As it issued from the condenser end it would burn together with some zinc with a distinctive blue-green flame and, as the early accounts state, when the flame changed to white, the charge was exhausted and the process over.

This simultaneous maintenance of several different temperature regimes, coupled with extraordinarily rigorous reduction conditions within the dynamic retort-condenser system - over 36 retorts in each of the 7 furnaces - demanded great care in the preparation of the charge and enormous skill and experience in the firing. With an operation of this complexity we have left behind the technology of the ancient world and look forward to modern science-based chemical industry. The significance of this and Zawar's place in the development of the Industrial Revolution is discussed below.

Scale of Production

The debris of zinc smelting covers the ground at Zawar for several square kilometres. Translating this into tonnes of zinc produced is fraught with assumptions and educated guesses. There are two stages: estimating the amount produced per retort, and the number of retorts likely to be present in the heaps. Estimating the amount produced per retort is the easier of the two. The concentration of some of the involatile metals - lead, iron, silver - in the retort residues is not dissimilar to that found in the modern concentrate (Freestone et al. 1990). Thus it is likely that the zinc concentration was similar. Thus by subtracting the amount of zinc typically remaining in the residues and retort walls we arrive at the amount of zinc which was produced and left.

Each large retort held about 1000gm of material of which about 500gm was zinc. Approximately 50gm were left in the residue or retort wall. However, more would certainly be lost in the condenser as blue dust, or burnt at the end of the condenser. The more modern European retort processes reckoned to lose 10-15% of the potential yield, and if losses of about 25% are assumed for the Zawar process, this should be erring on the side of caution. (Even though the blue powder and zinc oxide from the condenser tube was probably returned to the process it is still a loss for the purposes of this calculation). Thus about 300-

400gm were probably produced from each large retort. A small retort held about 300 gm, of which about 150gm were of zinc. This should have produced about 100gm of zinc per small retort.

These figures seem rather small, but are much more impressive for each furnace load of 36 retorts. The 3-5 hour heating suggests a daily routine. The furnaces holding the large retorts were in blocks of 3; assuming all were fired together, then this was 108 retorts, i.e. a production of about 30-50kg of zinc per day. For the small retort furnaces, in blocks of 7, then this is 252, i.e. about 25kg of zinc per furnace block. This is comparable to the overall production in the region of about 20 to 25kg per furnace of 36 retorts in the recent traditional Chinese process reported below in Chapter 5 (p.123). It is also most unlikely that only one furnace block would have been in operation at any one time. Thus, for example, the large retort furnace block of 3 furnaces was set in a small walled enclosure, with apparently identical enclosures also each holding blocks of 3 furnaces on each side, the whole forming an interrupted line of at least 9 furnaces set along the crest of a major retort dump.

Estimates of the amount of debris are very speculative. In some areas debris is no more than a surface scatter in the fields, in others the heaps are over 10 metres deep. Straczkk and Srikantan (1967, 52) estimated the zinc smelting debris to be about 200,000-250,000 tonnes, mainly concentrated in the village of Old Zawar. However our more recent 1983 survey found a number of major new areas of retort heaps. We would now estimate the total at being 400,000 tonnes at the very least. (In Freestone et al. 1985b, we assumed a figure of 600,000 tonnes of zinc smelting debris.) The zinc smelting debris is made up predominantly of spent retorts. A large retort weighs about 3kg with its spent charge, and this is estimated to have produced 300-400gm of zinc. If we assume that the heaps are predominantly of retort material, as our excavation suggested, then it is probably erring on the side of caution to equate 5kg of debris in the heaps for each 300-400gm of zinc. (This is allowing an extra 2kg of debris from the perforated plates, furnaces, and for the small retorts to have been less efficient in materials.) On this basis the zinc smelting debris could represent a production of about 24-32,000 tonnes, spread over about 400 years from 1400-1800. If production was maintained on a fairly regular basis then this works out at about 60-80 tonnes per year or about 200kg daily. As the maximum daily production per furnace block was calculated at about 30-50kg this means there must

have been a minimum of 4-8 furnaces operating at any one time, and obviously at peak times there must have been very many more. However it should be stressed again that these calculations are based on rather weak estimates and probably unjustified assumptions, but it does give an indication of the scale of activity, and the productivity of the individual furnace blocks and the overall production.

Dating (Table 1, Fig. 8)

Radiocarbon dating of charcoal from the heaps of smelting debris and piles of charcoal and wood from the mines has provided the main framework for the chronology, particularly for the early periods. So far there has been little historical study. However, there are some known historical references to Zawar, as well as some monuments in the area - especially the temples - whose dedicatory inscriptions are clearly dateable. Taken together these elements enable a reasonably coherent picture of the development of Zawar over two and a half millennia to be constructed.

The revised list of carbon dates available so far is given in Table 1. The results are calibrated using OxCal v2.18 (Bronk Ramsey 1995), and the calibration curve of Stuiver and Pearson (1986). References are to the original publication of the figures in the journal *Radiocarbon*. The carbon dates show that the deep mines of Zawar Mala and Mochia were worked predominantly more than 2000 years ago and are approximately contemporary with the Mauryan Empire. None of the remains of zinc smelting are that old, but several of the lead slag heaps are approximately contemporary. Further, the early slag heaps tend to have been formed away from the zinc smelting areas and the slags themselves have a relatively higher zinc content (10%) than the later slags which have a much lower zinc content (2%) and the iron content increased from about 10 to 25% to replace the zinc (Freestone *et al.* 1985a, fig. 7). At first sight, this would suggest that lead was the principal metal exploited 2000 years ago, and not the zinc. However, this impression should be considered against Zawar Mala where the enormous ore bodies were predominantly of sphalerite with no more than a few per cent of lead and virtually no silver. It seems unlikely that the many prodigious mining operations were carried forward, rejecting the predominant zinc ore, in order to recover a small amount of relatively worthless lead. Recent research (Eckstein *et al.* 1996 and addendum below) suggests that in the early stages the zinc ore mined at Zawar was roasted to produce zinc oxide which was the primary product, either to be used as a pharmaceutical, or as a component of brass made by the cementation process. The relatively small amount of lead ore recovered with the zinc would then have been separated, smelted, and, if rich enough to warrant it, de-silvered. The silver levels at Zawar are low generally and none of the slag heaps examined by us contained any evidence at all for silver production, unlike the contemporary mines of Agucha and Dariba, although there are records of silver production at Zawar in the seventeenth century AD (see below p.46).

About 2000 years ago the mine apparently ceased to be worked, possibly reflecting the collapse of the Mauryan Empire, and for centuries afterwards there was little evidence of activity at Zawar. One small slag heap is dated to the seventh century AD together with a small mine working inside one of the large ancient workings in Zawar Mala, and these are contemporary with the date of the earliest historical references to Zawar. This reference is on an inscription found at Sanoli, well to the south of Zawar, which refers to the arrival of a merchant who had a mine at Zawar, then known as Aranoyagire in an area called the 'hill of wells'. The surface of all the hills above the ore bodies at Zawar are covered with hundred of minor shafts, many leading down to galleries and stopes which carbon dating has shown are well over 2000 years old. The description 'hill of wells' is entirely appropriate.

The earliest evidence for zinc smelting is the carbon date of 840 ± 130 BP (PRL 935, Table 1) for one of the heaps of white ash removed from the zinc smelting *koshthi* furnaces. Also, fragments of relatively small and primitive retorts and perforated plates have been found in the earth fill of the great dam across the Tiri river, constructed in the fifteenth century, and may belong to the early period. They must at least predate the dam itself.

It would appear that the main expansion of zinc production began at Zawar some time in the fourteenth century AD. Traditionally Rana Lakha of Mewar, (1382-97), is credited with having established the mine at Zawar for the production of lead, zinc and silver (Tod 1978, I 222). This perhaps should now be seen as a refurbishment or expansion rather than a beginning, but it does fit in very well with the carbon dates for the beginning of large scale zinc production. The main period of temple building seems to belong to the late fourteenth to early sixteenth centuries, many dated by inscriptions and the dam across the Tiri and the massive fort on Harn Magra (Fig. 1), both date to the fifteenth century. Production of zinc on an industrial scale proceeded

for the next four centuries or more, with the inevitable periodic interruptions such as the wars between the Rajputs of Mewar and the Moghuls and Marathas. Due to an event in one of the wars, Zawar once again enters the historical record. The great hero of Rajputana's resistance to the Moghuls, Rana Pratap Singh (1572-1597), was forced to take refuge in the mines from the armies of Akbar (Tod 1978, I 272). One of the mines on Zawar Mala, known as Pratap Khan, is traditionally known his hiding place, and it does seem to have more substantial and elaborate stairways than the other mines we have explored, together with a large levelled platform in one of the ancient stopes.

The dating of the retort heaps is somewhat problematic as most of them are rather too recent for meaningful carbon dating. The small retorts, as evidenced by the dates from site 30 (530 ± 50, BM -2223N) and site 5 (500 ± 50, BM -2578) seem to have been in use in the fourteenth and early fifteenth century and probably continued into the sixteenth century. Unfortunately nowhere have we found a direct stratigraphical relation between the small and large retort heaps. Both the large and intermediate retort furnaces investigated by us sat on the crests of large heaps in old Zawar. The tip lines exposed in the section cut by the modern road (Pl. 20) suggest that the heaps formed very quickly and this is borne out by the dating evidence such as it is. one of the small temples, dated by inscription to the mid-15th century, is almost totally buried by the heaps of debris from the large retort process, strongly suggesting they began to grow there only some time after the construction of the temple. The best dating evidence so far discovered for the end of the large retorts was the discovery of a coin hoard in a clay pot buried in the fill covering a group of large retort furnaces, near to the temple and adjacent to the large furnaces excavated by us. The coins were 22 identical and uncirculated silver coins of Akbar minted at Ahemabad in 1592 AD. It is almost certain that these coins were deposited within a short time of minting, and this would suggest that smelting in the large retorts was mostly complete in that area of Old Zawar before 1600 at the latest (Paliwal et al. 1986), and that the whole massive heap had built up well inside the hundred years or so which separate the temple from the coin hoard.

The intermediate retorts are always found stratified above the large or small retort dumps. There is at present little dated mining activity contemporary with this surface activity. This is mainly a reflection on how little of this colossal system of mines we have

been able to explore. The single date we have from the Balaria system of mines suggest they are contemporary with the retort process and no dates are available from Baroi, but the ore there is much richer in lead and it may not have been extensively worked for zinc at any time. However, considerable later working is probable at both Zawar Mala and Mochia. Along the top of Mochia Magra there runs a very extensive system of open cast mines for several kilometres that are likely to represent the last phase of mining after all the rich ore had been removed by deep mining. There is only a single radiocarbon date from this system of workings. This is 390 ± 50 BM-2666 and was obtained on small twig charcoal, probably being the remains of firesetting, at the base of one of these trench mines at the east end of Mochia Magra. The whole system must have produced enormous quantities of zinc ore.

Site 30, which is dated to the early fifteenth century is right up in Zawar Mala within a few hundred metres of the mine shafts and it is hardly conceivable that zinc ore smelted there could have come from anywhere else. There is additional evidence that the mining took place in the area of site 30 no earlier than the smelter. The shallow valley in which the furnaces lie is thickly littered with the broken rock debris brought down from the nearby spoil dumps by flash floods during the monsoon season. But under the several square metres of paving beneath the furnaces not a single rock fragment was found. The implication clearly is that the furnaces were in place before the mine debris reached that part, and thus some further mining, later than the 2000 years-old galleries we have studied, must have occurred at Zawar Mala. There are a number of small heaps of lead slags, contemporary with the zinc smelting activity but from their small volume, this must be regarded as a by-product of the zinc production.

Thus we may say that the industrial phase of zinc smelting probably began some time around the twelfth century as evidenced by the single date from the white ash heap, and that production expanded considerably in the late fourteenth-early fifteenth centuries as evidenced by the large numbers of small retorts. The use of these probably continued into the sixteenth century by which time the large retorts were certainly in use. However, in the area of the main heaps, where the coin hoard was discovered at Old Zawar, production of zinc using the large retorts ceased before the end of the sixteenth century. The large retorts may have continued in use elsewhere on the site, but the intermediate retorts are always found

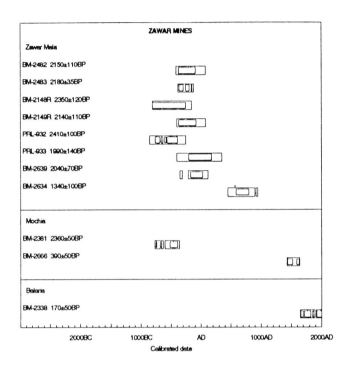

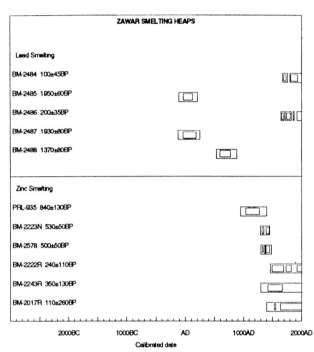

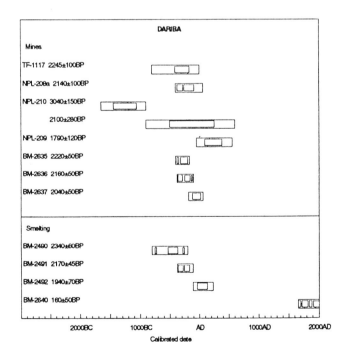

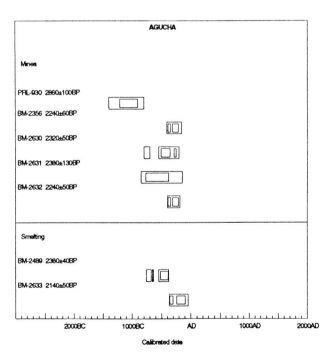

Fig. 8 Diagrammatic representation of the radiocarbon dates for the mines and surfaces sites at Zawar, Dariba and Agucha

on the top of heaps of large or small retorts and these may represent the usual form of retort in the seventeenth and eighteenth centuries up until production ceased in the early nineteenth century.

Zawar was singled out in the Ā-Īn-I-Akbarī (Blochmann, ed. Phillott 1989, II 273) in 1596 AD as the place where zinc was made, and Mewar State records now preserved in Udaipur show that lead, zinc and silver were produced in the seventeenth century AD. Thus in 1657 AD Murhot Nainsi, chief minister to the Maharaja Jaswat Singh reported that: 'In Zawar there is a silver mine, the income of which is 4-500 rupees per day and both zinc and silver are extracted from it'. (Gurjar trans.)

As late as the mid-eighteenth century the mines still produced 222,000 rupees of revenue per annum as recorded by Tod (1978, I, 399), the great historian of Rajasthan. He specifically stated (I, 222) that the zinc (or tin as he called it) contained little silver, so presumably in the late eighteenth century most of the revenue came from zinc. Tod also noted that 'the mines have long been abandoned and the protecting deities of the miners are unable to get even a flower placed on their shrines' (I, 222) and 'the miners are now dead the mines filled with water' (I, 399). The whole province of Mewar had been devastated by the Maratha wars in the late eighteenth and early nineteenth centuries and in 1812 the sufferings were compounded by prolonged drought, and the ensuing famine caused mass evacuation (Hamilton 1820, I, 547-52); it is quite possible that the mines closed then. A local legend ascribes the end at Zawar to a terrible dust cloud which poisoned the land. This is not as impossible as it might first appear. As described above the main heaps of debris at Zawar are surrounded by many smaller but still substantial heaps of highly toxic and caustic ash, which was quite deliberately dumped some way from the settlements. It is quite feasible that dust storms during a drought could have lifted much of the dry ash and spread it over the adjacent farmland creating yet more havoc in a land already beset by calamity.

As noted above (p.41) in the 1840s Colonel Brooke was able to find an old man who had witnessed the zinc distillation, suggesting once again that its extraction continued into the nineteenth century (Brooke 1850). By the 1860s the jungle had completely taken over and a highly picturesque account, which appeared in *The Indian Antiquary* (Anon. 1872), describes how the old mines were now the haunt of tigers. In the latter part of the nineteenth century several rather half-hearted attempts were made to reopen the mines, and their existence was noted in geological reports (Heron 1930, for example), but not until the Second World War was the re-opening of the mines seriously contemplated. The disruption of normal supplies of lead and zinc to India, specifically the capture of Burma and the Bawdwin mines by the Japanese, meant that India was forced back on its own resources. Exploration of the old Zawar mines by W.P. Cowen of the Mawchi mines in Burma and such of his staff who had escaped, showed that there was potential (Crookshank 1947). The war ended before the mines were brought back into production, but development work continued after the war (Fleming *et al.* 1949). Production began in the late 1940s, culminating in the present large scale undertaking run by Hindustan Zinc Ltd. Zinc ore is now also mined at Dariba and at Agucha in the Aravalli ore belt, as well as at Zawar. The ore is treated electrolytically at a plant near Udaipur and at a zinc-lead blast furnace plant (see Chapter 8), newly established at Chanderiya close to Chittaurgarh, and near to the Dariba mines (Mukherjee *et al.* 1991).

ZINC IN INDIA: MATERIALS AND PRODUCTION

As we have seen, metallic zinc was frequently referred to in the Indian technical literature over the last two thousand years and the remains at Zawar suggest very considerable quantities were produced. It is thus legitimate to speculate what it was used for. The major portion was probably always mixed with copper to make brass. The archaeological evidence suggests brass was widely used in India during the last two millennia and although some brass was made, undoubtedly by the direct cementation process, the last Indian reference to this process seems to be as early as the twelfth century. Few early artefacts of metallic zinc have yet been recognised, although many more may exist, wrongly labelled as being of lead or tin. Many coins of zinc are known from about the fourteenth century onwards. These are often found alongside identical contemporary coins of tin or lead, as exemplified by the locally-minted eighteenth century coins at the Portuguese settlement of Diu on the Gujarat coast (Yih and de Kreek 1993)

Apart from brass there are two other typically Indian materials which are both predominantly of zinc. These are zinc-mercury amalgams and bidri ware.

The zinc amalgams are very unusual and rare nowadays, but were frequently mentioned in the

early Indian literature. A few examples known to the authors can be given here. One is a plaque from a private collection standing about 15cm tall showing Tara with a kneeling donor in one corner, which should date to about the tenth century AD (Pl. 21). The other example is in the inlay of a nineteenth century box from Hoosiarpoor in the Punjab which was acquired soon after its manufacture by the Glasgow Art Gallery and Museum in 1888 at the Glasgow International Exhibition. The inlay was recently investigated by the conservation staff of the Glasgow Museum and found to contain an amalgam of copper, zinc and tin in the mercury. Powell (1872) describes similar boxes inlaid with tin foil amalgams produced in the Punjab.

Bidri ware, the other material predominantly of zinc, is much better documented, large amounts of it survive from previous centuries, and production still continues at least in the Deccan at Hyderabad, Aurangabad and Bidar, from which latter town bidri takes it name, and at Lucknow in Uttar Pradesh. Bidri has recently been the subject of two excellent monographs (Stronge 1985 and Lal 1991) and several detailed technical studies (Untracht 1968, 138-49; La Niece and Martin 1987 and Stronge and Craddock 1993), and will thus not be described in detail here. Bidri is an alloy, often utilised for vessels, cast from an alloy containing about 95% of zinc and 5% of copper. This is inlaid with silver and then chemically treated to produce a lustrous dense black body to contrast with the silver. The result is highly attractive and has always been a prized luxury material (Pl. 22).

The early history of the material is very obscure. Tradition states that it began in the Middle East and the craftsmen who have made it were and are always Moslem, but there is no real evidence for it outside India, especially as zinc seems to have been unknown in the Middle East at least until the time of the Mughals. A rather more specific tradition states that production began in Bidar at the instigation of the ruler Ala Uddin Bahmani II (1436-57 AD), and this seems more likely, although even at Bidar there is no firm evidence for production (Yazdani 1947, 20), or indeed anywhere else prior to the seventeenth century AD, and almost all the surviving pieces may be placed in the eighteenth or nineteenth centuries AD, with just a few from the late seventeenth century. Initially production does seem to have been centred on the Deccan but during the eighteenth century spread to other centres such as Lucknow in Uttar Pradesh, Murshidabad in West Bengal, and Purnea in Bihar, all in the Ganges valley. Bidri

production is notably absent from Western Indian, and there seems no evidence that it was ever produced at any centre near to Zawar, its absence at Udaipur, the nearby capital of Mewar, and a centre of the arts is especially striking.

This brings us to one of the most puzzling features of the zinc artefacts found in India - lead isotope studies on lead in the zinc of coins from the Punjab, and on the bidri ware show they do not come from Zawar, or indeed anywhere within the Aravalli hills. Major ores of zinc suitable for exploitation are rare within India, and most have been carefully studied by Hindustan Zinc. None contain any evidence of early zinc production as found at Zawar, even through the relative minor evidence of small scale lead and copper smelting was reported. Retort heaps of the size and appearance of those at Zawar are so distinctive that it seems most unlikely that major sites of early zinc distillation remain to be discovered within India. Even so, with the active help of the local Hindustan Zinc geologists based at Hyderabad and the Geological Survey of India (southern circuit) samples of lead ores were collected from several localities in the Deccan and south India, to ascertain if at least lead deposits existed there of similar geological age to that found in the Indian bidri which was produced in central/south India. Once again the lead isotope signature of these deposits proved totally different from that of the small amount of lead found in the bidri, and this strongly suggests the zinc used was not from India. A possible explanation is that the five pieces examined were all too recent to be of Zawar zinc. They date from between the late seventeenth and mid nineteenth centuries AD and imports of zinc metal into south India from China are documented from the mid-seventeenth century onwards, as exemplified by two ingots recently acquired by the British Museum (Reg. 1997, 2 - 2, 1 & 2) from the East India Company vessel *Diana* which sank in the South China Sea *en route* from China to Madras in 1816 (Ball 1995, 153).

The coins from the Punjab remain a problem, their dates range between the fourteenth to nineteenth centuries, which coincides almost exactly with the industrial phase of production at Zawar, yet here too, none of the metal of the coins examined had its source in the Aravalli hills. Clearly there must have been other operational sources, as yet unlocated, possibly in Afghanistan, where zinc sources are reported (Shareq *et al.* 1977, 136-46).

THE ORIGINS OF THE ZINC SMELTING PROCESS IN INDIA

The remains discovered at Zawar are unique. Not only has nothing remotely similar ever been found elsewhere but there are also no known immediate antecedents to the fully developed industrial process. The earliest remains of zinc smelting from Zawar already suggest a multiple retort arrangement similar to that found in the later furnaces.

Possible antecedents or rather inspirations can be found in the production of other metals with a low boiling point, notably mercury, and in other furnace designs, notably pottery kilns.

Mercury has a much longer history of production over much of the ancient world (Craddock 1986, Craddock 1995, 302-7). This is because, although like zinc it is produced as a vapour which must be condensed, the actual smelting conditions are much less rigorous and thermally much simpler. The ore, cinnabar, HgS, has merely to be heated to 6-700°C to bring about the decomposition, releasing mercury vapour. The process is described in the *Rasaratnakara*, compiled in the sixth-seventh century AD (Ray 1956, 131). The mercury ore was distilled in a *patana yantram* and collected in a vessel of water. The *patana* apparatus comprises two vessels, one inverted over the other; the material to be distilled was heated in the lower and the mercury condensed in the upper vessel. However, the method of collection of mercury underwater suggests an *adhaspatana yantram* may have been meant. This is basically similar, but the order is reversed. The material to be distilled was smeared on the inside of the upper vessel and heated from above, and the distillate then dripped down into the water on the lower vessel. This is the classic 'distillation by descending', or *tiryakpatana yantram* and in principal is very close to the Zawar process for distilling zinc. This method of mercury production was widespread and an excellent description of the process as carried out in sixteenth century Germany is given with illustration, by Agricola in his *De re Metallica* (Hoover and Hoover 1912, 427). The multiple retort arrangement shown in Figure 9 is similar in principal to the Zawar arrangement, and it is very likely that the commercial distillation of mercury suggested the basic principal of distillation by descending for the production of zinc. However zinc needs a much higher temperature and the vigorous exclusion of air and for this special apparatus had to be developed.

In appearance the closest parallel of the *koshthi* is the familiar updraught pottery kiln, such as that shown in Figure 10, as used in India from at least the fourth millennium BC up to the present day. The kiln is divided into an upper and lower chamber by a perforated clay floor or clay bars supported on a central plinth. The fire was in the lower section and the pots were stacked in the upper chamber above, heated by flames passing through the holes in the perforated floor. This is of course totally different from the arrangement for smelting zinc, but the *form* of the pottery kiln could well have been the inspiration for the successful development of a furnace to apply the age-old *principle* of distillation by descending, as used for mercury, for zinc. The latter required higher temperature and greater reducing conditions than had hitherto been attained in any distillation process.

ZINC PRODUCTION OUTSIDE INDIA

The Persian and other scholars who visited the Islamic Mughal Empire which extended over most of north and central India were astonished at the wealth, and intrigued by the numerous materials which were totally new to them. Zinc does seem to have been generally unknown in the Islamic world, with the exception of a small group of jewel-encrusted zinc vessels known significantly as *tutya*. They were clearly of great value and rarity and probably made for court use during the sixteenth century in eastern Iran or Afghanistan. It would be interesting to know the source of the zinc. Some pieces survive in the Topkapi collection (Istanbul) (Rogers and Ward 1988, 132-3; Atil *et al.* 1985, 28-9; this volume Pl. 1, p.113).

By the sixteenth century not only the Arabs and Persians were trading with India, but European vessels from Portugal, followed by those from the Netherlands and England began a direct commerce. Zinc began to be imported into Europe first as a curiosity but then on a considerable scale as the advantages of brass made with metallic zinc became more widely appreciated. The earliest reference to the import of Indian zinc into Europe is contained in a report made by an Italian living in London at the beginning of the sixteenth century. The report is now preserved in the Public Record Office in London (*Calendar of State Papers: Research in Foreign Archives, Italy 1509-19*, we are grateful to R. Homer and J. Somers for bringing this reference to our notice). The report warns that the English had better look to their tin trade as a Portuguese vessel had just arrived in London bearing amongst other things 200

A—Hearth. B—Poles. C—Hearth without fire in which the pots are placed.
D—Rocks. E—Rows of pots. F—Upper pots. G—Lower pots.

Fig. 9 Mercury distillation in sixteenth-century Germany as illustrated for Agricola in *De Re Metallica*. The principle, and even the arrangement of the retorts is very similar to the *koshthi* furnaces of Zawar (see Fig. 6).

Fig. 10 Section through a traditional updraught pottery kiln in Pakistan. The form of the furnace is similar to the *koshthi*.

pieces of 'Indian tin'. This has previously been taken at face value but India has very little tin and it has never featured in Indian foreign trade. However the usual term for zinc in the lands around India was 'Indian tin', and of course in Europe the word zinc had yet to become current. The influence of European trade on the later development of the Indian zinc industry has not yet been studied, but was probably considerable. At Zawar for instance production seems to have expanded dramatically at much the same time as European trade began and continued until the cessation of zinc shipments in the face of European and Chinese competition in the early years of the nineteenth century, when the Zawar mines closed down. It is beyond dispute that European vessels introduced zinc to the West in commercial quantities, but it is just possible that they were also responsible for introducing the metal to China and the Far East. It is sometimes forgotten that the Portuguese and latterly Dutch and English vessels did not just ply between India and Europe but also opened up the India-Far East country trade as well.

The history of brass and zinc in China is still very uncertain and requires detailed study. Brass does seem rare before the sixteenth century and zinc unknown (see the revised bibliography in Chapter 5 dealing with Chinese zinc production for recent studies). It is possible that brass, and by extension, the cementation process came to China from Northern India, about 2,000 years ago, overland with Buddhist monks along the Silk Route. However, the origins of zinc smelting seem much later and more indigenous.

Compendious encyclopaedias and scientific treatises written during the Ming dynasty up to the early sixteenth century make no mention of zinc or zinc making, but by the early seventeenth century the metal is mentioned. Thus the *Wakan Sanzai Zue* (1712) which contains Wang Chhi's *San Thsai Thu Hui* of 1609 states that:

> *Aen* (*ya chhien*), also called *totamu*, a word derived from some foreign language (clearly derived from the *tutenag* or *tutty* of the European traders, ultimately derived from the Persian). We really do not know quite what this (metal) is, but it belongs to the category (*lei*) of lead, wherefore it is called 'inferior lead' (*ya chhien*). It comes in plates over a foot long, five or six inches wide and less than an inch thick. It is obtained by smelting. There is also a kind called 'medicinal rubbings' (*yakuken*), which may be in appearance like flower petals (probably flakes).
> That which comes from Kuangtung province is best, while that from Pa-niu in Tung-ching (Indo-China) is less good in quality. Nowadays in the making of vessels of brass (*kara kane thang chin shinchū chen thou*) it is

indispensable to add *aen*, so this metal is very valuable. It is probably made by the transformation of calamine (*lu kan shih*) in furnaces.
> The pharmaceutical natural histories say that calamine ore was mixed with copper to make brass (*thou-shih*); there is no doubt of this, but we are not sure how it was done. (Needham 1974, 212-3)

From the above it seems that zinc was then a fairly new metal with which the authors had no great familiarity, and that brass making by mixing zinc and copper had only replaced the old cementation process within memory.

Recent analyses of Chinese coins (Bowman *et al.* 1989) have shown that the first brass coins appeared rather abruptly in the early sixteenth century and then rapidly become prevalent. Similarly, the zinc content of the metal rises steadily and already by the mid-16th century some coins have such a high zinc content that they must have been made by adding metallic zinc to the copper.

The earliest brass coins, although containing less zinc, were very probably also made by mixing the two metals rather than by cementation. This is indicated by the low iron content of these coins. Brass made by cementation of the zinc ore and copper usually has a much higher iron content. This accords well with a Chinese reference found by Bowman *et al.* which states that a different metal, described as 'good' or 'superior' tin, was added to some of the issues of Hong Zhi in 1505, the same year as the earliest brass issues, suggesting that the superior tin was in fact metallic zinc. (But see Zhou Weirong 1993 and 1996, where a date of the mid sixteenth century AD is postulated for the earliest zinc production in China).

Is it possible that zinc first came to the Far East in Portuguese vessels thereby stimulating local production in both Indo-China and China? Even if this could be demonstrated, the Chinese smelting technique was completely different from the Zawar method. The Chinese process was first described in the *Thien-Kung Khai-Wu* in 1637 (Fig. 11).

> Zinc (*wo-ch'ien*, lit. poor lead), a term of recent origin, does not appear in ancient books. It is extracted from smithsonite (calamine) and is produced primarily in the T'ai-hang Mountains of Shansi, followed by Ching-chou [in Hupei] and Heng-chou [in Hunan]. Fill each earthen jar [retort] with ten catties of smithsonite, then seal tightly with mud and let it dry slowly so to prevent cracking when heated. Then pile a number of these jars in alternate layers with coal and charcoal briquettes, with kindling on the bottom layer for starting the fire. When the jars become red-hot the smithsonite will melt into a mass. When cooled, the jars are broken

open and the substance thus obtained is zinc, with a twenty per cent loss in volume. This metal is easily burnt off by fire if not mixed with copper. Because it is similar to lead, yet more fierce in nature, it is called "Japanese Lead". (Sung Ying-Hsing, trans. Sun Jen I-Tu and Hsüeh-Chuan Sun 1966, 471).

Here again in the mid-seventeenth century the novelty of zinc is emphasised, and little detail is given of what is actually going on inside the retorts. However, traditional zinc distillation has continued in parts of China to this day. It is obvious from Xu Li's detailed description (Chapter 5) that the Chinese methods owe nothing to India but are clearly based on the principle of the traditional Mongolian still (Needham 1980, 62-81).

Fig. 11 Zinc smelting in seventeenth century China (from *Thien-Kung Khai-Wu*)

Some Indian zinc seems to have been going to Africa, for Antonio Gomes' 1648 account of the kingdom of Monomotapa states:

There is a great quantity of copper ... they make an alloy of this copper with a metal like tin, but somewhat

different which, if it were reckoned in carats would be better than tin, and which in India is called *calaim* (motaune) by the Kaffirs of Goa. (Fagan *et al.* 1969, 105).

Recent scientific examination of metal artefacts belonging to the historic period from East Africa has confirmed the presence of brass, together with other more specifically Indian products, notably crucible steel (Kusimba *et al.* 1994).

The trade with Europe is much better documented, and by the eighteenth century zinc was imported in considerable quantities although it seems that by this time zinc from the Far East dominated the international markets. It was in great demand for brass making, especially for scientific instruments and in the jewellery and trinket trade, such that by 1731 it commanded a price of £260 a ton on the London market. Calamine, by contrast sold for just £6 a ton, and by this time it was generally realised that this was the source of zinc. Thus it was inevitable that large-scale commercial zinc production would soon be introduced into Europe. Some small quantity of zinc was recovered from flues of the Goslar lead smelters (see Chapter 1), but the first to establish commercial zinc production was William Champion (see Day 1973 and Chapter 6 p.146). His zinc-making process was based on the principle of distillation by descending. About 6 large retorts were inverted in a furnace with the zinc condensing in iron and clay tubes protruding through holes in the furnace floor into a cooler chamber below. In broad outline the process followed the Zawar process very closely, although it was on a much larger scale and the design of the furnace was very different – Champion based his furnace on those of the local Bristol and Nailsea glass industry.

The Carinthian process developed in Hungary in the late eighteenth century (Ingalls 1903, 393, and below Chapter 7, p.179-80, Fig. 10) is much closer to the Zawar process in both appearance and principle. Large numbers of retorts, usually over a hundred, each about a metre long but only 10cm in diameter and tapering towards the open, lower end, were fired vertically. They terminated in a short tube which led through the floor of the furnace into a cool chamber below where the zinc collected on an iron floor. The furnaces were in groups of twos or fours and apart from the greater number of retorts per furnace, they must have had a striking resemblance to the Zawar furnaces, and also of course to the arrangements used for the smelting of mercury in central Europe (Fig. 9). Indeed it is more likely

that there was an independent translation of the principle of mercury smelting to zinc at Carinthia in the eighteenth century rather than that somehow knowledge of the discovery made centuries before at Zawar reached Carinthia.

SUMMARY

Both brass and zinc have a long history in India, reaching back almost certainly into the first millennium BC. Brass was produced principally by the cementation process up to the end of the first millennium AD, after which it soon ceased to be mentioned in the Indian technical literature. By this time zinc was already well known, and production on an industrial scale had commenced at Zawar.

The development of zinc production from an alchemist's curiosity to a commercial product seems to have taken place within India, such that by the fourteenth century detailed descriptions of the process could be made and the distillation units excavated at Zawar in Rajasthan, dating from the twelfth-nineteenth centuries, closely resemble these descriptions. The inspiration for the principle of zinc smelting by distillation probably came from the apparatus used in the preparation of mercury, but the form of the specialized furnace or *koshthi* probably derives from the humble pottery kiln.

Trade, in European vessels from the sixteenth century, carried Indian zinc to both East and West and when local production commenced the apparatus usually reflected, at least in part, the local traditions of distillation. China seems to have adopted the Mongolian still. In Britain, which had the closest links with India, the principle of Champion's process was probably derived, indirectly, from the Zawar process but here again the furnace was an adaptation taken from those used in the local glass industry. The inspiration of the Carinthian process is uncertain, but could be local. The other European processes, described elsewhere in this book, do by contrast have a well-documented link with Champion's process, even if they soon departed from it. Thus Zawar may claim not only to be the earliest centre of zinc production, but to be the direct ancestor to the processes of high temperature distillation developed in the nineteenth-twentieth centuries.

RECENT FIELDWORK AND RESEARCH

The results of the continuing research on the Zawar project have been included where appropriate in the general revision of the text; however the more significant new developments and discoveries made since the first edition can be summarised here.

The radiocarbon dates from all three major sites, Zawar, Dariba and Agucha have been augmented (Table 1). Amongst the most significance from Zawar are some mine dates. A major survey of the extensive open cast mines running for some kilometres along the top of Mochia Magra and Balaria has been conducted. Remains of firesetting operations survived above ground in the form of the platforms built of stone, on which the fires were set to attack the upper sides of the opencast. Similar platforms, dated to the post Medieval period have been found in the copper mines at Singhana-Khetri in the north of Rajasthan (Willies 1993). Limited excavations in opencasts at the east end of Mochia have located charcoal lying in situ from the firesetting operations. Radiocarbon dating on this charcoal gave a date of 390 ± 50 BP (BM 2639), which supports the original idea that much of the later mining activity was confined to the large opencast mines. Thus the majority of the deep mines would seem to belong to the early phase of working.

Charcoal from a small firehole which was sunk in the floor of a small chamber above the major gallery system in the ancient mine system which we previously investigated in Zawar Mala (Willies 1987), gave a radiocarbon date of 1340 ± 100 BP (BM-2634). This is contemporary with the small smelting site no. 7, which lies beneath Zawar Mala near to Old Zawar village, and together they represent the recommencement of activity at the mines after their abandonment at the beginning of the first millennium AD. Recent studies of the smelting debris at site 7 suggest that they were still primarily concerned with the production of zinc oxide rather than zinc metal (Eckstein *et al.* 1996 and below).

Previously one of the major areas of uncertainty centred on what was actually produced at Zawar in the early period. Of the possible materials, metallic zinc, zinc oxide, silver or lead, only metallic zinc seemed to be excluded by the absence of the appropriate production debris, namely retorts.

The remaining ore deposits at Zawar are predominantly of sphalerite, zinc sulphide, with a little lead. The silver contents are generally low, especially compared to the deposits worked at the sister mines of Dariba and Agucha. There is no

reason to believe that the deposits worked in antiquity were substantially different. The contemporary surface smelting evidence at Zawar is the small heaps of lead smelting slags, which are puny in relation to the heaps at Dariba and Agucha and also the scale of the underground workings at Zawar at this time. Materials from the Zawar heaps have now been scientifically studied and suggest the major activity was the production of zinc oxide (Eckstein *et al.* 1996). The slags have very low metal content, and a surprisingly low sulphur content, low compared both to the contemporary slags at Dariba and Agucha and to the later Zawar slags. They strongly suggest that the material smelted had been carefully roasted. Roasting would not have been necessary to smelt the ores for lead. In the heaps there were many fragments of furnace lining coated with zinc and lead oxides, which also suggested some stage in the process was strongly oxidising. The most distinctive material were flat crusts of zinc oxide with some lead oxide (now mainly the carbonate) which had a layered structure where they had condensed against a flat surface. From the surviving evidence of these finds it is suggested that the predominant sulphidic zinc ore was indeed the main mineral sought, and that it was first carefully roasted to produce zinc oxide. This was smelted in an open furnace with charcoal to produce zinc vapour which promptly reoxidised in the atmosphere above and could have been condensed on some putative flat surface supported above the furnace, recalling the arrangements for the production of zinc oxide described by both Classical (Chapter 2, pp.9-10) and Islamic authors (Chapter 4, p.74). The zinc oxide so produced could have been used medicinally or used for the production of brass by the cementation process. The slags themselves resulted from the smelting of the debris of the roasting operations in order to recover the minor quantities of lead which they would have contained. As noted above the metal content of these slags was very low such that no blebs of lead metal were found and consequently the silver content could not be determined. Hence it is not certain whether the lead was further treated to recover any silver present. The silver content of the Zawar ores is generally low, although there is historical evidence that some silver was recovered in the later period.

Some of the furnace residues from the small retort furnace, Site 30, have been examined. One piece from the floor of the cool chamber where it is believed the collecting vessels stood, was found to be of metallic zinc. Semi-quantitative analysis by energy dispersive X ray fluorescence showed the metal to be quite pure with 0.35% of lead as the only measurable impurity. The Indian zinc examined in England by Watson (Chapter 1, p.3) in the late eighteenth century had much more lead, this may have been due to the later, and hotter, large and intermediate retort processes incorporating more lead into the zinc, or more probably, adulteration of the zinc with lead after it had been made.

During the life of this project to study the origins of zinc production at Zawar the new zinc mine at Rampura-Agucha has been under development and a new smelter has been built at Chanderiya, near Chittaurgarh in Rajasthan (Mukherjee 1991). The blast furnace process was chosen because of its ability to deal with a range of ore compositions. This process, fully described in Chapter 8, was developed primarily at Avonmouth, just outside Bristol, where Champion developed the first European process, based on the Zawar process, thereby continuing the interaction of technical processes.

REFERENCES

Allan, J.W. 1979. *Persian Metal Technology*, Ithaca Press, London.

Anon. 1872. The mines of Mewar. In miscellany section of *The Indian Antiquary* Feb., 63-4.

Atil, E. Chase, T. and Jett, P. 1985. *Islamic Metalwork in the Freer Gallery*, Smithsonian Institution Press, Washington D.C.

Ball, D. 1995. *The Diana Adventure* , Malaysian Historical Salvors, Kuala Lumpur.

Barnes, J.W. 1973. Ancient clay furnace bars from Iran. *Bulletin of the Historical Metallurgy Group* 7 (2), 8-17.

Biswas, A.K., 1996. *Minerals and Metals in Ancient India*, DK Print World, New Delhi.

Blochmann, H., (trans., Phillott ed.) 1989. *The Ā-Īn-I Akbañ of Abū L- Fazl Allāmī*. originally republished 1927, reprinted Low Price Publications, New Delhi.

Bowman, S.G.E., Cowell, M.R. and Cribb, J. 1989. 2000 years of coinage in China: an analytical study. *Journal of the Historical Metallurgy Society* 23 (1), 25-30.

Bronk Ramsey, C. 1995. Radiocarbon and the analysis of stratigraphy: The OxCal program. *Radiocarbon* 37 2, 425-30.

Brooke, J.C. 1850. Notes on the zinc mines of Jawar. *Journal of the Asiatic Society of Bengal* 19, 212-15.

Carsus, H.D. 1960. Historical background. In *Zinc*, ed. C.H. Mathewson. New York, American Chemical Society. 1-8.

Chakrabarti, D.K. 1979. The problem of tin in ancient India, *Man and Environment* 3, 61-74.

Craddock, P.T. 1981. The copper alloys of Tibet and their background. In *Aspects of Tibetan Metallurgy*, eds.

W.A. Oddy and W. Zwalf. London, British Museum (Occasional Paper No. 15), 1-32.

Craddock, P.T. 1986. A history of the distillation of metals. *Bulletin of the Metals Museum* **10**, 3-25.

Craddock, P.T. 1992. A short history of firesetting, *Endeavour* **16** 3, 145-50.

Craddock, P.T. 1995. *Early Mining and Metal Production*. Edinburgh University Press, Edinburgh.

Craddock, P.T. 1996. The use of firesetting in the granite quarries of South India, *Mining History* **13** 1, 7-11.

Craddock, P.T., Freestone, I.C., Gurjar, L.K., Hegde, H.T.M. and Sonawane, V.H. 1985. Early zinc production in India. *The Mining Magazine* Jan, 45-51.

Craddock, P.T., Freestone, I.C., Gurjar, L.K., Middleton, A. and Willies, L. 1989. The production of lead, silver and zinc in early India. In *Old World Archaeometallurgy*, ed . A. Hauptmann, E. Pernicka and G.A. Wagner. Der Anschnitt, Bochum. 51-70.

Crookshank, H. 1947. Zawar Silver-Lead-Zinc Mines, *Indian Minerals* **2**, 22-7

Day, J. 1973. *Bristol Brass*. Newton Abbott, David and Charles.

Eckstein, K., Craddock, P.T. and Freestone, I.C. 1996. Frühe Bergbau- und Verhüttungsaktivitäten in Zawar, Dariba und Agucha (Nordwestindien) *Metalla* **3** 1, 11-26.

Fagan, B.M., Phillipson, D.W. and Daniels, S.G.H. 1969. *Iron Age cultures in Zambia* **2**. Chatto and Windus, London.

Falk, H. 1991. Silver, Lead and Zinc in Early Indian Literature, *South Asian Studies* **7**, 111-7.

Fleming, J., Robottom, H.H. and Narayanan, P.I.A. 1949. The Beneficiation of Lead-Zinc Ore from Zawar, *Transactions of the Mining, Geological and Metallurgical Institute of India*, **45** 1, 21-78.

Friedlaender, C.G.I. and Kangsoo Choo 1970. Mineralogical Observations on Slags from Zawar Mines, Rajasthan, *Indian Mineralogist* **11**, 1-10.

Freestone, I.C. Craddock, P.T., Gurjar, L.K. Hegde, K.T.M. and Paliwal, H.V. 1985a. Analytical approaches to the interpretation of medieval zinc smelting debris from Zawar, Rajasthan. *Journal of Archaeological Chemistry* **3**, 1-12.

Freestone, I.C., Craddock, P.T., Gurjar, L.K., Hegde, K.T.M. and Paliwal, H.V. 1985b. Zinc production at Zawar, Rajasthan. In *Furnaces and Smelting Technology in Antiquity*, eds. P.T. Craddock and M.J. Hughes. London, British Museum (Occasional Paper No. 48). 229-44.

Freestone, I.C., Middleton, A.P., Craddock, P.T., Gurjar, L.K. and Hook, D.R. 1991. Role of minerals analysis in the reconstruction of early metal extraction technology. In *Materials Issues in Art and Archaeology* II, eds. P.B. Vandiver, J. Druzik and G.S. Segan. M.R.S. Pittsburgh, 617-26.

Gamble, J.S 1902. *A Manual of Indian Trees*, Sampson Low, Marston and Co. London.

Gaur, R.C. 1983. *Excavations at Atranjikhera: Early Civilisations of the Upper Ganga Basin*, Aligararh Muslim University/Motil Banarsidass, New Delhi.

Habib, I. 1982. *An Atlas of the Mughal Empire*. Delhi.

Hamilton, W. 1820. *A Description of Hindostan*. John Murray, London.

Hegde, K.T.M., 1992. *An Introduction to Ancient Indian Metallurgy*. GSI. Bangalore.

Hegde, K.T.M., Craddock, P.T. and Sonawane, V.H. 1986. Zinc Distillation in Ancient India, in *Proceedings of the 24th International Archaeometry Symposium*, eds. J.S. Olin and M.J. Blackman. Smithsonian Press. Washington D.C. 249-58.

Heron, A.M. 1930. General Report for 1929, *Records of the Geological Survey of India*: Zinc mines of Zawar, Mewar, **63**, 79.

Hoover, L.H. and H.C. (trans. and ed.), 1912. *Agricola: De re Metallica* The Mining Magazine. London.

Ingalls, W.R. 1903. *The Metallurgy of Zinc and Cadmium*. The Engineering and Mining Journal. New York.

Juleff, G. 1996. An ancient wind-powered iron smelting technology, *Nature* **6560**, 60-2.

Kangle, R.P. 2nd ed. vol.I 1969, II 1972. *The Kauṭilya Arthaśāstra*. Motilal Banarsidass. Delhi.

Kusimba, C.M., Killick, D.J. and Cresswell, R.G. 1994. Indigenous and imported materials at Swahili sites on the coast of Kenya, in *Society, Culture and Technology*. ed. S.T. Childs, *MASCA* **11**, supplement. 63-77.

Lal, K. 1991. *National Museum Collection: Bidriware*. National Museum, New Delhi.

La Niece, S. and Martin, G. 1987. The technical examination of bidri ware. *Studies in Conservation* **32** 3, 97-101.

Marshall, A. 1915. *Explosives*. J.A. Churchill, London.

Marshall, J. 1951. *Taxila*. C.U.P., Cambridge.

Morgan, S.W.K. 1976. *Zinc and its alloys*. Macdonald and Evans, Plymouth.

Morgan, S.W.K. 1985. *Zinc*. Ellis Horwood, Chichester.

Mukherjee, A.P., Premkumar, G. and Dhana Sekaran, R. Jan 1991. Primary lead smelting at HZL, *Hindzinc Tech* **31**. 5-25.

Needham, J. 1974. *Science and Civilization in China* **5** (2). C.U.P. Cambridge.

Needham, J. 1980. *Science and Civilisation in China* **5** (4). C.U.P. Cambridge.

Paliwal, H.V., Gurjar, L.K. and Craddock, P.T. 1986. Zinc and brass in ancient India. *Bulletin of the Canadian Institute of Metals* **885**, 75-9.

Pearson, G.W. and Stuiver, M. 1986. High Precision Calibration of the Radiocarbon Time Scale, 500-2500 BC. *Radiocarbon* **28** 2B, 805-39.

Percy, J. 1861. *Metallurgy*. John Murray, London.

Percy, J. 1870. *Lead*. John Murray, London.

Powell, B. 1872. *Punjab manufactures: Handbook of the manufactures and arts of the Punjab*. Lahore.

Ray, P. 1956. *History of Chemistry in Ancient and Medieval India*. Indian Chemical Society, Calcutta.

Rogers, J.M. and Ward, R.M. 1988. *Süleyman the Magnificent*. BMP, London.

Salkield, L.V. 1987. *A technical history of the Rio Tinto mines*. Institute of Mining and Metallurgy, London.

Shareq, A., Chmyriou, V.M., Stazhilo-Alekseev, K.F., Drunov, V.I., Gannan, P.J., Rossovsky, L.N., Kafarsky, A. and Malyarov K.R. 1977. *Mineral Resources of Afghanistan*. United Nations Development Program.

Smith, E.A. 1918. *The Zinc Industry*. Longmans, London.

Straczkk, J.A. and Srikantan, B. 1967. Geology of Zawar lead-zinc area, Rajasthan. *GSI Memoir* **92**, 47-52.

Stronge, S. 1985. *Bidri ware*. Victoria and Albert Museum, London.

Stronge, S. and Craddock, P.T. 1993. Bidri ware of India in *Metal Plating and Patination* ed. S. La Niece and P.T. Craddock. Butterworth Heinemann, Oxford. 135-47.

Stuiver, M. and Pearson, G.W., 1986. High-precision calibration of the radiocarbon timescale, *Radiocarbon* **28** 2B, 805-38.

Sun Jen I-Tu and Hsüeh-Chuan Sun 1966. *Sung Ying-Hsing*: *T'ien-Kung k'ai-Wa*: *Chinese Technology in the 17th Century*. Pennsylvania University Press, Philadelphia.

Tewari, D.N. 1992. *Tropical Forestry in India*. International Book Distributors, Dehra Dun.

Tiwari, R.K. and Kavada, N.K. 1984. Ancient mining activities around Agucha village. *Man and Environment* **8**, 81-7.

Tod, J. 1978. *Annals and Antiquities of Rajputana*. Smith and Elder, London. Reprint of 1829 ed. by M.N. Publishers, New Delhi.

Tripathi, I.D. 1978. *Rasarnavam Rastantram* Chowkhambha Sanskrit Series. Varanasi.

Untracht, O. 1968. *Metal Technology for Craftsmen*. Doubleday, New York.

Werner, O. 1972. *Spectralanalytische und metallurgische Untersuchungen an Indischen Bronzen*. Brill, Leiden.

Willies, L. 1987. Ancient mining in Rajasthan. *Bulletin of the Peak District Mines Historical Society* **10** (2), 81-123.

Willies, L. 1992. Ancient and post-medieval mining sites in the Khetri copper belt and the Kolar gold field, India, *Bulletin of the Peak District Mines Historical Society* **11** 6, 81-124.

Willies, L. 1994. Firesetting technology, in *Mining before Powder*, ed. T.D Ford and L. Willies. HMS. London. 1-9.

Willies, L., Craddock P.T., Gurjar, L.K. and Hegde, K.T.M. 1984. Ancient lead and zinc mining in Rajasthan India. *World Archaeology* **16** (2), 223-33.

Wyckoff, D. (trans.) 1967. *Albertus Magnus: Book of Minerals*, Clarendon Press, Oxford.

Yazdani, G. 1947. *Bidar* Published under the authority of the Nizam. Hyderabad.

Yih, T.D. and de Kreek, J. 1993. Preliminary data on the metallic composition of some South East Asian coinages as revealed by XRF analysis, *Spink's Numismatic Chronicle* **101** 1. 7-9.

Zhou Weirong 1993. A New Study of the History of the Use of Zinc in China, *Bulletin of the Metals Museum of the Japan Institute of Metals* **19**, 49-53.

Zhou Weirong 1996. Chinese traditional Zinc Smelting Technology and the History of Zinc Production in China, *Bulletin of the Metals Museum of the Japan Institute of Metals* **25**, 36-47.

Table 1 Radiocarbon dates for Zawar, Dariba and Agucha, calibrated using OxCal v2.18 (Bronk Ramsey 1995) and the calibration curve of Pearson & Stuiver (1986). References are to the original publication of the figures in *Radicarbon*.

ZAWAR MINES

Zawar Mala Mine

	Material	Lab. number	Radiocarbon Result BP	Possible Calibrated Age Ranges Calendar Years		Ref
				68% confidence	95% confidence	
ZM/LW/85/13 from small chamber in main gallery	charcoal	BM-2481	modern			1989, **31(1)**,24
ZM/LW/85/14 from ladderway	wood	BM-2482	2150 ± 110	370 to 90 BC	410 BC to 80 AD	1989, **31(1)**,24
ZM/LW/85/8	wood	BM-2483	2180 ± 35	360 to 290 BC or 250 to 190 BC	380 to 160 BC or 140 to 120 BC	1989, **31(1)**,24
LW/82/2 from scaffold in escape stope	wood	BM-2148R	2350 ± 120	800 to 250 BC	800 to 150 BC	1985, **26(1)**,67
LW/82/1 from launder in escape stope	wood	BM-2149R	2140 ± 110	370 to 80 BC	400BC to 80 AD	1985, **26(1)**,67
470 MRL, RL 456 MRL	charcoal	PRL-932	2410 ± 100	760 to 680 BC or 660 to 630 BC or 600 to 580 BC or 560 to 390 BC	850 to 250 BC	
RL 566 MRL	charcoal	PRL-933	1990 ± 140	200 BC to 180 AD	400 BC to 350 AD	
ZW/LW/22 Pratap Khan mine, from fire near "Audience Chamber"	charcoal	BM-2639	2040 ± 70	170 BC to 30 AD	350 to 310 BC or 210 BC to 120 AD	1994, **36(1)**, 108
ZW/LW/87/26 from firehole in top chamber	charcoal	BM-2634	1340 ± 100	590 to 800 AD	450 to 900 AD or 920 to 950 AD	1994, **36(1)**, 108

Mochia Mine

Pit prop from gallery	wood *Terminalia* sp	BM-2381	2360 ± 50	750 to 740 BC or 520 to 390 BC	770 to 680 BC or 660 to 630 BC or 600 to 360 BC	1987, **29**(2). 189
ZM/LW/87/32, from loose heap of debris in opencast mine	charcoal	BM-2666	390 ± 50	1440 to 1520 AD or 1590 to 1630 AD	1430 to 1640 AD	1994, **36**(1), 108

Balaria Mine

10 West stope 415 MRL	wood *Terminalia* sp	BM-2338	170 ± 50	1660 to 1700 AD or 1720 to 1820 AD or 1850 to 1870 AD or 1920 AD to modern	1650 to 1890 AD or 1910 AD to modern	1987, **29**(2), 189

ZAWAR LEAD SMELTING SLAG HEAPS

Large slag heap, Site 5, layer 3	charcoal	BM-2484	100 ± 45	1690 to 1730 AD or 1810 to 1930 AD	1670 to 1755 AD or 1795 AD to modern	1989, **31**(1), 24
Large slag heap, Site 14, layer 3	charcoal	BM-2485	1950 ± 60	30 BC to 120 AD	110 BC to 210 AD	1989, **31**(1), 24
Small pit under layer of slag, Site 29, layer 2	charcoal	BM-2486	200 ± 35	1650 to 1680 AD or 1740 to 1800 AD	1640 to 1700 AD or 1720 to 1820 AD or 1850 to 1870 AD or 1920 AD to modern	1989, **31**(1), 24
Small slag heap, Site 2, trench 2	charcoal	BM-2487	1930 ± 80	40 BC to 180 AD	120 BC to 250 AD	1989, **31**(1), 24
Small slag heap, Site 7, trench 2	charcoal	BM-2488	1370 ± 80	590 to 770 AD	530 to 880 AD	1989, **31**(1), 24

ZAWAR ZINC SMELTING RETORT DUMPS

Ash dump north of Ramanath Temple (adjacent to Site 5)	charcoal	PRL-935	840 ± 130	1040 to 1270 AD	950 to 1400 AD	
Ash dump, Site 5	charcoal, *Terminalia* sp	BM-2782	modern			in press
Furnace, Site 30	charcoal *Artocarpus* sp	BM-2223N	530 ± 50	1320 to 1350 AD or 1390 to 1440 AD	1290 to 1450 AD	1985, **27**(3), 519
Retort heap, Site 5	charcoal	BM-2578	500 ± 50	1330 to 1340 AD or 1390 to 1450 AD	1300 to 1360 AD or 1380 to 1480 AD	1991, **33**(1), 61
Large retort heaps, Site 1, trench 1	charcoal	BM-2222R	240 ± 110	1490 to 1690 AD or 1730 to 1820 AD or 1920 AD to modern	1460 AD to modern	1985, **27**(3), 519
Large retorts, lower layers of Site 34, cut by road	charcoal	BM-2243R	350 ± 130	1420 to 1670 AD	1300 AD to modern	1985, **27**(3), 519
Mouth of furnace block, beneath coin hoard in furnace near Site 1	charcoal	BM-2638	Modern			1994, **36**(1), 108
Contents of retort from wall	charcoal	BM-2017R	110 ± 260	1530 to 1555 AD or 1635 AD to modern	1395 AD to modern	1984, **26**(1), 67
Contents of retort	charcoal	BM-2065R	modern			1984, **26**(1), 67

AGUCHA MINES

Old mine shaft	wood	PRL-930	2860 ± 100	760 to 680 BC or 660 to 630 BC or 600 to 580 BC or 560 to 390 BC	850 to 250 BC

Mine prop in gallery 30mm below surface	small timber *Terminalia* sp	BM-2356	2240 ± 60	390 to 350 BC or 320 to 210 BC	410 to 160 BC	1987, **29**(2), 189
RA/LW/87/13 south wall exposed by modern opencast	charcoal, *Anogeissus* sp	BM-2630	2320 ± 50	510 to 360 BC or 290 to 250 BC	800 to 700 BC or 550 to 200 BC	1994, **36**(1), 107
RA/LW/87/11 from basket found in old mine, site 11	wood (small branches)	BM-2631	2380 ± 130	770 to 380 BC	850 to 150 BC	1994, **36**(1), 107
RA/LW/87/10, from gallery	outer rings of timber post	BM-2632	2240 ± 50	390 to 350 BC or 310 to 210 BC	400 to 190 BC	1994, **36**(1), 107

AGUCHA SILVER/LEAD SMELTING SITES

Well site layers 3 and 4	charcoal	BM-2489	2380 ± 40	510 to 380 BC	760 to 690 BC or 540 to 370 BC	1989, **31**(1), 25
Below slag heap, Site 1, layer 3,	charcoal	BM-2633	2140 ± 50	360 to 310 BC or 240 to 100 BC	370 to 50 BC	1994, **36**(1), 107

DARIBA MINES

Depth 64 mm layer 436	timber	TF-1117	2245 ± 100	410 to 170 BC	800 BC to 1 AD
East lode 4 to 5 mm depth, top of huge open cast mine	timber	NPL-208a	2140 ± 100	370 to 280 BC or 260 to 90 BC	400 BC to 60 AD
South Lode 100mm depth	*Aogeissus* sp	NPL-210	3040 ± 150	1450 to 1060 BC	1650 to 900 BC
South Lode 100mm depth	rope	teledyne	2100 ± 280	500 BC to 250 AD	900 BC to 600 AD
East Lode 263mm depth	bamboo	NPL-209	1790 ± 120	90 to 380 AD	50 BC to 550 AD

Depth 64 mm layer 436	timber	TF-1117	2245± 100	410 to 170 BC	800 BC to 1 AD	
RD/LW/87/10 from massive timber revetment in South Lode area	wood (less than 10yrs growth)	BM-2635	2220 ± 50	380 to 350 BC or 320 to 200 BC	400 to 170 BC	1994, **36**(1), 108
DM/85/LW/3 part of support timber in mine gallery	wood (cellulose)	BM-2636	2160 ± 50	360 to 290 BC or 250 to 160 BC or 140 to 120 BC	380 to 100 BC	1994, **36**(1), 108
RD/LW/87/7 from small chamber off drainage shaft	charcoal	BM-2637	2040 ± 50	120 BC to 20 AD	180 BC to 60 AD	1994, **36**(1), 108

DARIBA SILVER/LEAD SMELTING SLAG HEAP

Area of extensive silver production, Site 9, layer 4	charcoal	BM-2490	2340± 60	750 to 730 BC or 530 to 370 BC or 280 to 260 BC	800 to 200 BC	1989, **31**(1), 25
Lower layers in massive buildup of debris, Site 10, layer 23	charcoal	BM-2491	2170 ± 45	360 to 280 BC or 260 to 170 BC	370 to 110 BC	1989, **31**(1), 25
One of number of slag heaps, Site 7, layer 4	charcoal	BM-2492	1940 ± 70	40 BC to 130 AD	110 BC to 230 AD	1989, **31**(1), 25
Site 15, west of North Lode opencast	charcoal	BM-2640	160 ± 50	1660 to 1700 AD or 1720 to 1820 AD or 1850 to 1880 AD or 1920 AD to modern	1650 to modern	1994, **36**(1), 106

Plate 1 Small retort with condenser (site 30)

Plate 2 Large gallery in Zawar Mala Magra, mined over 2,000 years ago by firesetting for zinc ore

Plate 3 Iron tools from Mochia mine, including pestles, and gads (chisels)

Plate 4 Launders (drainage channels) of hollowed tree trunks collected and channelled water in the mines

Plate 5 One of the many small mortars for crushing ore, formed in rock surfaces adjacent to mines on Baroi Magra

Plate 6 Large used retort with the condenser removed

Plate 7 Two condenser heads. In both cases the necks have been broken off to recover the zinc inside. That on the left is hand made, while that on the right was formed in a polygonal mould.

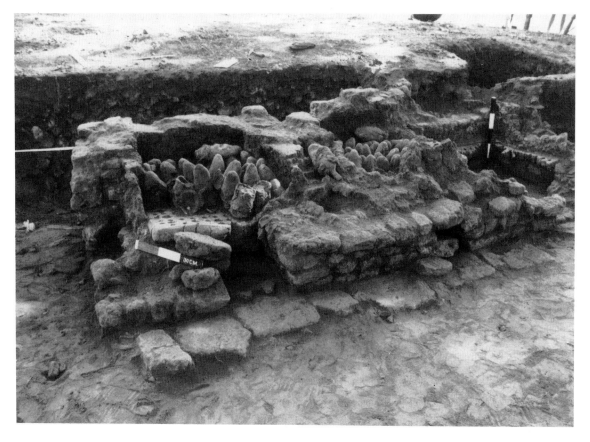

Plate 8 Four of a bank of seven small retort furnaces or *koshthi*, (site 30)

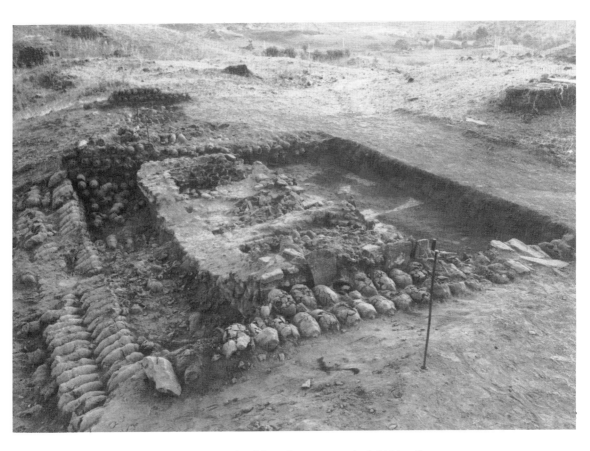

Plate 9 Bank of three large retorts *koshthi* (site 1)

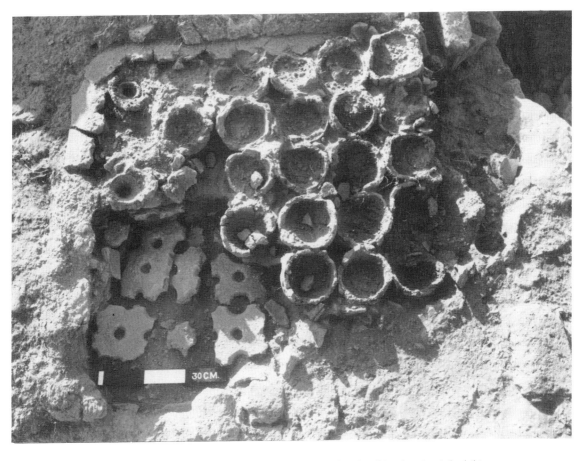

Plate 10 Remains of large retorts *in situ* at plate level in the site 1 *koshthi*

Plate 11 Bank of a bank of three *koshthi* for intermediate retorts (site 32)

Plate 12 Detail of the *koshthi* in Plate 11

66

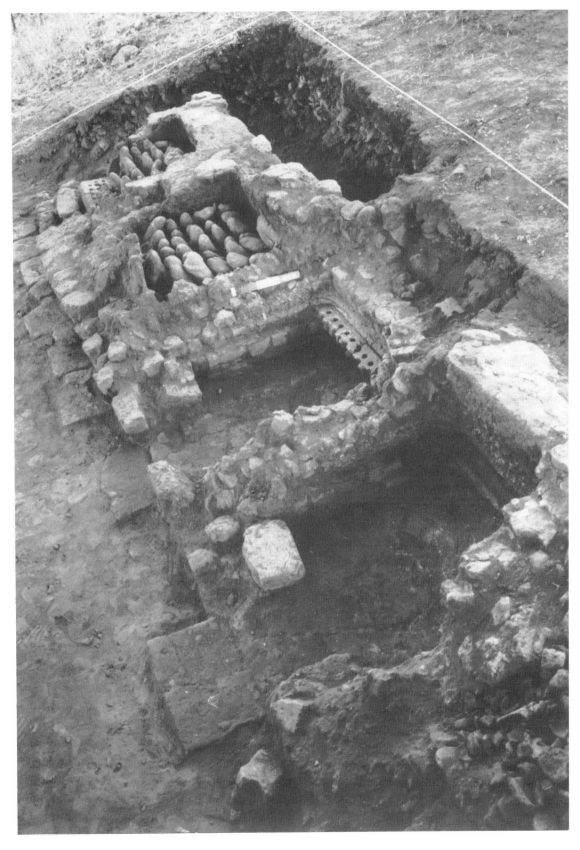

Plate 13 Four of the seven *koshthi* furnaces for small retorts at site 30

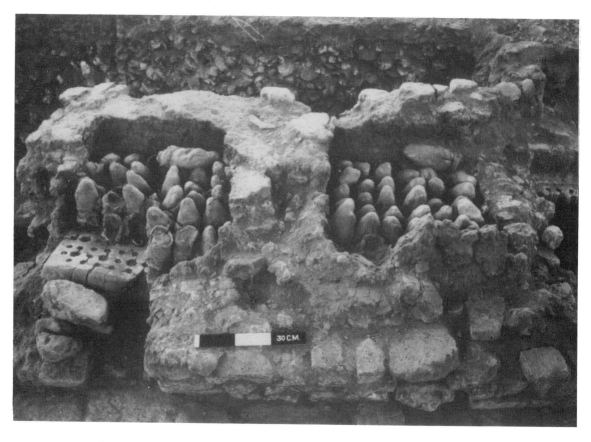

Plate 14 Two of the seven *koshthi* at site 30 retained almost all of their retorts.

Plate 15 Profile of a *koshthi* interior, in the form of a truncated pyramid, site 30

Plate 16 Lower, cool collecting chamber with remains of the perforated plates and a freestanding central clay pillar

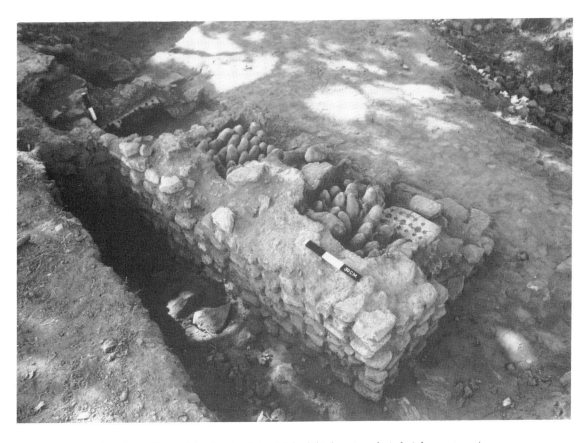

Plate 17 View of the bank of site 30 *koshthi* showing their brick construction

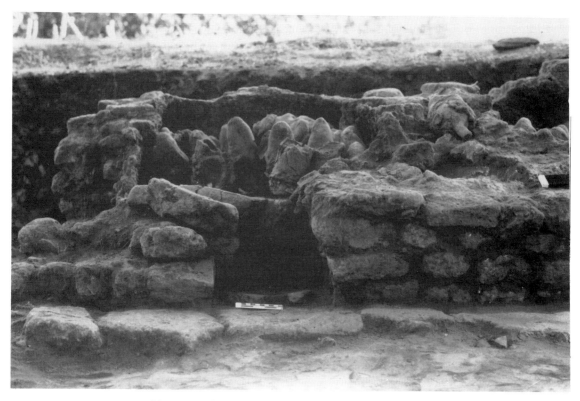

Plate 18 Close up of the entrance to *koshthi* 1 (site 30)

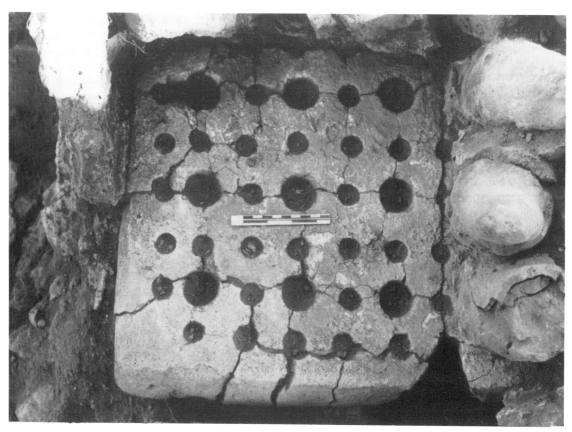

Plate 19 One of the four perforated plates dividing the combustion chamber of the *koshthi* from the cool chamber beneath. The large holes held the condenser necks and the smaller ones were for the air and ash (site 30).

70

Plate 20 Clay pillar still *in situ* for supporting the perforated plates (site 1, large retort *koshthi*)

Plate 21 Plaque of the goddess Tara with donor, style
of the tenth century AD, from Kashmir. Made from a
zinc amalgam pressed into a mould (private collection).

Plate 22 Bidri vessel, mid-seventeenth century AD. Cast from an alloy of zinc with a small addition of copper, inlaid and patinated (Victoria and Albert Museum reg. 1479-1904, Stronge 1985, Cat. 2, pp.39-40)

BRASS IN THE MEDIEVAL ISLAMIC WORLD

P.T. Craddock, S.C. La Niece and D.R. Hook

Department of Scientific Research, The British Museum, London WC1B 3DG

INTRODUCTION

The use of brass steadily increased through the first millennium BC (Craddock and Hook 1996) such that by the end of the Roman Empire brass was in common, but by no means universal usage. This change must have been accelerated by the increasing difficulty experienced in obtaining supplies of the relatively rare tin. After the loss of the tin producing provinces of *Britannia* and *Hispania*, and also of easy access to any production in the Bohemian tin fields with the loss of *Pannonia* in the late fourth-early fifth centuries, tin became difficult to obtain throughout the Mediterranean world and the Middle East. Despite periodic claims for the production of tin in Greece (Davies 1929), Egypt (Muhly 1978), Afghanistan (Muhly 1985) and Serbia (McGeehan-Liritzis and Taylor 1987), there really do seem to be no substantial deposits in or close to the Middle East that were worked in the last three thousand years. Production at the tin mine at Kestel in southern Anatolia seems to have been confined to the Bronze Age (Yener and Özbal 1987, Yener and Vandiver 1993). There is abundant evidence of Byzantine occupation in the abandoned workings but no evidence at all for further mining (Willies 1992).

Contemporary written sources also state that tin was coming to the Middle East from far away. Thus in the seventh century AD, Coptic writers still spoke of tin coming from Cornwall (Penhallurick 1986, 10, 237). In medieval times, most tin seems to have come to the Islamic world from southeast Asia *via* the port of Kalah, which probably lay somewhere in the Bay of Bengal, although some still came from Europe and some apparently from central Asia (Allan 1979, 27-8, Dayton 1971). There was little early Arab interest in the extensive tin fields of southern Nigeria even though they do seem to have been exploited locally at least from the tenth century AD, and probably much earlier (Craddock and Picton 1986), and Arab traders were active in West Africa from at least the eleventh century AD (Herbert 1984, 113-6). However, there are apparently no records before the early nineteenth century of Arab traders purchasing Nigerian tin (at Kano in the north) to transport across the Sahara (Fawns 1921, 139-41).

Thus, the tin supplies which did reach the Middle East would have travelled very long distances from lands well beyond the control of the Caliph or any other ruler in the region. The metal was therefore likely to be expensive and its supply not always assured. By contrast, sources of zinc are abundant throughout Anatolia (de Jesus 1980, Anon 1972), Iran (Allan 1979) and Afghanistan (Muhly 1985). These are predominantly of sphalerite (zinc sulphide, ZnS) with only relatively minor amounts of smithsonite (zinc carbonate, $ZnCO_3$) compared to western Europe and to China where the latter was the prevalent ore. This had important repercussions for Islamic brass production technology which are discussed below. Other ores such as hemimorphite (hydrated zinc silicate, $2ZnO.SiO_2.H_2O$), willemite (zinc silicate, $2ZnO.SiO_2$) or zincite (zinc oxide, ZnO) are of even more limited occurrence, although some of the early Islamic descriptions (see below) possibly refer to them.

This situation is reflected in the composition of the metalwork. In the preceding Roman period, Bayley (Chapter 2, p.17) estimates that probably no more than 20% of copper alloys could be classified as being of brass, but by the sixth-seventh centuries AD, however, this figure had risen very considerably, at least for Coptic Egypt (Fig. 1 and Table 1, Oddy and Craddock 1983, Dannheimer 1979). This high incidence of brass usage was inherited and continued throughout the succeeding Islamic world (Fig. 2).

BRASS PRODUCTION IN THE ISLAMIC WORLD

Brass was produced exclusively by the cementation process in the Islamic world, a technology inherited from the preceding Roman and Byzantine civilisations, and probably used with little or no modification through the centuries. The best summary in English of the various surviving contemporary Islamic descriptions of metal production is given in Allan (1979). There are few contemporary details of the actual cementation stage in the crucible, but rather more on the preparation of ore to produce zinc oxide ready to be mixed with the charcoal and copper in the crucible.

PRODUCTION OF ZINC OXIDE

Recent work on the remains at the ancient zinc mines at Zawar in North West India (Eckstein *et al.* 1996 and Chapter 5) has confirmed that in the early phases of the mine's history, about two thousand years ago, zinc oxide was being produced. The recent scientific study has shown that two separate processes were involved. First, the sulphidic ore was roasted to convert the sulphides to oxides and then this was separated and refined by smelting and condensation. The first reaction is exothermic, that is, heat is evolved and thus it proceeds readily. However, it is difficult to eliminate all the sulphur, and the sulphur content must be very low if the cementation process of brass making is to be successful, and thus a second stage was necessary. Zinc oxide is non-volatile and so it had first to be converted to the metal which is volatile. Consequently, the calcined ore was smelted under locally reducing conditions to produce a zinc vapour which promptly oxidised above the furnace to form fumes of zinc oxide. This was condensed as described below to give pure zinc oxide that was almost free of sulphur and involatiles such as iron, and containing only lead as a significant impurity. Many of the Islamic accounts described a sublimation process where the fumes of zinc oxide, or *tūtīyā* (literally 'smoke' in Persian), condensed on a framework of iron or clay pegs. This recalls the much earlier account given by Dioscorides in the *Materia Medica* Book V, Chapter 84 (Gunther 1934, p.623-5, [84]; Riddle 1985; and see Chapter 2, p.73). It is clear that, as with the descriptions of Dioscorides where brass was itself the raw material, and also of Galen (Walsh 1929), the zinc oxide so produced was sometimes intended for medicinal purposes rather than brass making. This is echoed by Persian writers of the ninth and tenth centuries AD who describe varieties of *tūtīyā*; for example the Iranian Abu Dulaf wrote in the *al-risālat al-thāniya*, compiled in the tenth century AD, that the Indian variety was to be preferred as it was made from the vapour of 'tin' (Allan 1979, 44). Almost certainly metallic zinc is to be understood here, and this was intended for medicinal purposes as it is unlikely that zinc oxide was being produced from zinc to make brass. The reason why zinc oxide made from zinc, rather than from the ore, was preferred for medicinal purposes was the lead content of the zinc ore. Lead is always associated with zinc ore, often in substantial proportions and it is fairly volatile. In the sublimation processes described above, some lead oxide would inevitably carry over with the zinc oxide. For

example, analysis of the deposits still adhering to the ancient clay bars found at Kushk in Central Iran showed them to contain 11.4% of zinc and 0.18% of lead, that is the zinc oxide would have contained approximately 2% of lead (Barnes 1973, and see below p.75). This would have presented a problem in medicinal use, and using lead-free zinc or brass as the source material instead of the ore would have overcome this problem. However it does seem that the bulk of *tūtīyā* production was for use in brass making.

Numerous variations of the process appear in the Iranian literature. Al Birūnī, writing in the eleventh century, stated that:

> The *tūtīyā* used in this business is the vapour (*dukhān*) of (a type of) earth (*tīn*). Its ore is put in a furnace (*atūn*) in which are things like baked pottery pegs. The fire is lit under the furnace floor. The *tūtīyā* rises and attaches itself to the pegs and covers them like a wrapping, so that the pegs cool looking as though they have scales on them. (Allan 1979, 40)

He then goes on to relate how this is used to make *shabah*: '*Shabah* is copper made yellow by mixing into it *tūtīyā* with sweetened things (*Halāwāt*) etc. as additives until it becomes like gold'. (Allan 1979, 39)

Later in the thirteenth century, both the Italian traveller Marco Polo (Latham 1972) and the Iranian, al-Kāshānī described the process as carried out at Kirman in central Iran. Al-Kāshānī wrote:

> They obtain Kirmānī *tūtīyā* as follows. They make a furnace and fix earthenware pegs in its walls, pour the *tūtīyā* ore on to a shelf there and make a strong fire. Fumes from the burning of this ore rise and attach themselves to the earthenware pegs. When they remove the fire and it is cooled they separate the sublimated *tūtīyā* from those pegs. (Allan 1979, 40)

Marco Polo described the bars as being of iron. This may have been a mistake, as al-Muqaddasī (see below) stated that the coated clay bars looked like iron, but it should be remembered that centuries earlier, Dioscorides had specified iron.

Al-Muqaddasī's description of the Kirmān process written in the tenth century AD is as follows:

> Among their specialties is *al-tūtīyā al-marāzibī*. It is called *marāzibī* because they use things like fingers made of baked clay as important elements. They pour the *tūtīyā* onto them, and it clings to them so that there remains the equivalent of iron bars (*marāzib* rather than text's *marāz īb*). I saw them gathering it from the mountains, and having built amazing long furnaces (*akwār*), they purify it as iron is purified. I did not see it except in the villages. (Allan 1979, 40)

The process as described does not seem to involve sublimation, and it is possible that it is describing the calcination of zinc carbonate ore. In the thirteenth century AD, al-Jawbarī also described a process whereby the zinc ore was attached to clay pegs but not sublimated:

> To produce tutty one builds a square oven (*tunūr*), and puts a shelf in the middle. One then makes a fitted lid to go over it, and makes clay sticks and fires them. When these are completely fired like earthenware, one takes yellow earth and kneads it carefully with *hindabā* water, and covers the sticks with it. Then one takes a large white earthenware vessel pulverises it like millet and rolls (*marragha*, not *faragha*) the sticks in it. One lays the sticks in the oven on the shelf, leaving space between them through which the vapour can go. Then one puts the lid over the oven again and kindles under it wood from the green tamarisk: no other is so satisfactory. When the sticks are red hot one takes them and quenches them in *hindabā*. This one does thrice and after the third time one rolls the stick in the earthenware vessel. Then one lays it in the oven in the above described way. One heats it further till it is smelted. Then one stops the heating and leaves it to cool. Then the stick is taken out and hit lightly with a hammer; plates of *tūṭīyā* fall off it of the highest excellence. I know seven methods for this operation and know them well. (Allan 1979, 41)

Finally al-Mustawfī, early in the fourteenth century AD, claimed the bars were made of ore throughout:

> *Tūṭīyā* is got from the mine as an ore, which being moistened is made up into the form of bars, each an ell in length. When dry these are put in a furnace, and the action of the fire extracts the *tūṭīyā* which remains in the shape of bars, and like sword sheaths, which are then taken out. (Allan 1979, 40)

It is difficult to be sure whether at least two very different processes, one involving sublimation, the other without, were in use in Iran, possibly reflecting the use of both sulphidic and oxidised ores, or whether the process was sometimes incompletely understood by those describing it. Thus in the latter references it is possible that the operation described the calcination of the carbonate or oxide ore, and this is supported by the description of the ore as being a yellow earth, which is the case for the oxidised ores due to iron staining. It also seems unlikely that rods of sphalerite could have preserved their shape after roasting as they would almost certainly have disintegrated during their combustion, whereas the oxidised ores, which would not actually burn, would be much more likely to preserve their shape.

Heaps of used clay bars are still to be found at the smelting sites near lead/zinc mines all over Iran, and some were studied by Barnes (1973) from Kushk in Central Iran. These were cigar-shaped, about 30cm long by 2-4cm in diameter. They clearly had a concentration of zinc in their surfaces, and Barnes considered they were most likely to have been used to condense vapour of zinc oxide which had then been scraped off and used.

THE CEMENTATION PROCESS

The zinc oxide so produced was then used to make brass by the cementation process, which apparently is not described in detail in any of the published sources, and no material remains have yet been recognised in the form of furnaces or crucibles.

Al-Hamdānī writing in the Yemen in the mid-10th century AD stated:

> The best of *al-iqlīmīyā* is the pure clustered type. If it is pulverised and spread over molten copper, one may produce from it *tūṭīyā* which is sublimated from its vapour onto the surface of the molten metal. (Allan 1979, 42)

Allan considers that al-Hamdānī used the term *al-iqlīmīyā* to indicate a metal oxide. It is possible that calcined zinc carbonate or oxide ores are meant here.

A much more detailed description is given by al-Kāshānī:

> If they bray half pounded *tūṭīyā* with raisins without seeds until it becomes soft, and it is roasted without burning over a low fire, and if copper is melted and they throw onto it a certain amount of that prepared *tūṭīyā* and cover the top of the crucible for a moment until the *tūṭīyā* has had its effect, and it then cools down, copper results the colour of red gold. (Allan 1979, 42)

It is interesting that both of these accounts speak of the copper as molten during the process, as does the near-contemporary European description given by Theophilus (Hawthorne and Smith 1963, 143), and thus strictly speaking the Medieval processes were not real cementation but rather co-smelting.

The later European process used finely divided copper to ensure a large surface area was exposed to the zinc vapour, and the resulting brass was not molten until the very end of the process. This could account for the increased zinc content of the later European cementation brasses (Mortimer 1989, Hook and Craddock 1988).

The technology of Persian and Turkish brass making in the seventeenth-nineteenth centuries is at

present little known. Persian merchants were very active in India and could have brought back zinc for brass making, or the cementation process may have continued as in Europe.

ZINC

Although Iranians were aware of the 'Indian tin' or *rasa* which gave off zinc oxide when burned (p.30), there is no evidence that metallic zinc was used to make brass in the medieval Islamic world. Although there was extensive contact at every level between much of India and the Middle East, the hilly regions of Rajasthan where the zinc was made, were more isolated, even during the Mughal period, from the Islamic presence.

However, in the sixteenth century vessels of metallic zinc enjoyed a short-lived vogue in Iran and Turkey, the zinc metal concerned was probably from India, although the style of the vessels would indicate Afghanistan as their place of manufacture. The vessels, known as *tutya*, are similar in shape to vessels of gold or jade and are heavily encrusted with jewels and inlays and were thus high status items intended for court use (see above Chapter 3, p.48 and Pls 1,2). The results, however, were frankly unattractive and impracticable to keep polished, but zinc as a hitherto unknown material had novelty value. One is reminded of the aluminium spoons briefly used by Napoleon III in the 1850s to impress visitors to the French court, but as soon as aluminium became common the silver quickly resumed its accustomed place.

From the beginning of the sixteenth century, Indian zinc was brought to Europe in Portuguese vessels (see Chapter 3, p.48), and by the early seventeenth century, cargoes of over 100 tons were regularly flooding onto the European market from both India and China, and must also have become available in the Islamic world. Zinc could thus no longer be classed as a rarity and production of the *tutya* vessels ceased. Fortunately some are preserved in the Topkapi Saray Museum in Istanbul (Atil *et al.* 1985, 29–30; Rogers and Ward 1987, 132-3). One of these vessels (TKS 2/2873) was examined when it came to London for exhibition. Non-destructive surface analysis of the lid of the vessel by energy dispersive X-Ray fluorescence showed it to be of zinc with about 1.0% of lead and traces of silver, showing the zinc had not been alloyed with copper to produce a metal such as bidri (see Chapter 3, p.47).

RESULTS AND DISCUSSION

A total of well over three hundred items of Islamic metalwork from the collections of the British Museum; the Ashmolean Museum, Oxford; the Courtauld Institute, London; and the Archaeological Museum, Granada, have been analysed, initially using atomic absorption spectrophotometry (AAS), and latterly by inductively coupled plasma atomic emission spectrometry (ICP-AES). Details of these methods are published in Hughes *et al.* (1976) and Hook (forthcoming). The analyses shown in the Tables 1 to 7 have approximate precisions of \pm 2% for copper and of *c.* \pm 5-10% for zinc, tin and lead when present in major amounts. The remaining minor and trace elements have precisions of *c.* \pm 30%, deteriorating to *c.* \pm 50% at their respective detection limits.

The approximate detection limits for the AAS data are: cadmium (Cd) and manganese (Mn) - 0.001%; silver (Ag), gold (Au), cobalt (Co), nickel (Ni) - 0.005%; bismuth (Bi), iron (Fe), lead (Pb), antimony (Sb) and zinc (Zn) -0.01%; Arsenic (As) - 0.04% and tin (Sn) - 0.2%. The detection limits for the ICP-AES analyses are essentially similar to those for AAS with the exception of tin, for which ICP-AES has a detection limit of *c.* 0.02%. ICP-AES has the added advantage of being able to analyse for sulphur which cannot be easily undertaken using AAS.

The AAS analyses were carried out over a number of years, with changes of equipment and materials, resulting in differing levels of precision and detection limits for some elements. The original procedure of rounding the final decimal place to the nearest zero or five, to indicate that little stress should be placed on the actual value of this figure, has been replaced for the most recent analyses by the more usual method of expressing decimal numbers. Some of the earlier results have been previously discussed, in Craddock (1979) and published in the microfiche accompanying Craddock (1983).

Few copper alloy artefacts from the immediate successors to the classical world have yet been analysed. Exceptions include some Byzantine material of the fifth and sixth century AD, now in Geneva which is mainly of brass (Bujard and Schweizer 1994a), and groups of material from Umm er-Rasas (Kastron Mefaa) and from Umm el-Walid, in Jordan which included a wide range of metals, copper, high tin martensitic bronzes, heavily leaded bronze as well as brass from both Byzantine and the succeeding Omeyyad periods (Bujard and Schweizer 1994b). Some Coptic vessels of the sixth and seventh

centuries AD have also been analysed (Dannheimer 1979, and Table 1, Fig. 1, taken from Oddy and Craddock 1983). Most of these are of brass or at least contain zinc as a significant alloying metal (Fig. 1). Indeed it is probable that by the time Islam began its lightning spread through the Middle East, brass was already the prevalent alloy. Unfortunately, very few small everyday items have been analysed and the comments which follow are restricted to the major prestige pieces, commissioned by the rich and powerful, which now adorn public collections.

The analytical results of the Islamic material are presented in Tables 2-7 and Figures 2-5 below. The majority of the alloys fall into two basic types: firstly, relatively pure brass with an average zinc content of about 17%, with little or no tin or lead (Figs 2-5), used for sheet or raised metalwork and some castings, and secondly, a metal of much wider composition, but with less zinc, (average 12%), up to 25% of lead, and a few percent of tin (Figs 2-5). This latter alloy was used exclusively for castings. The purer brass alloy would seem to be the direct product of the cementation process with little or no additions of other metals. The leaded casting alloy is more complex, and the reduction in the zinc figure, typically by 30%, cannot always be explained just by the dilution of cementation brass with lead and by the evaporation of zinc upon each melting. It would seem that as well as lead some copper, possibly including scrap bronze or brass, was also added. The persistent occurrence of tin in the leaded brasses is significant. The use of scrap bronze could account in part for the tin, although most scrap should have been of brass, with the tin coming in the main from residual tinning or from solders. Unfortunately, there are no extant medieval Islamic recipes for alloys, but if there was a conscious alloy then it could be based on one of the alloys for statues described by Pliny in the *Natural History* (34.97), (Rackham 1952, p.198; Craddock 1988). This contained two parts fresh bronze and one part of scrap metal with the addition of about10% of lead, the Islamic equivalent would be made of two parts fresh brass, two parts scrap brass /bronze and one part lead or possibly even a lead/tin alloy. Recipes such as this could account for many of the compositions in Table 3 or Figures 4-6.

There were a few exceptional classes of object for which bronze was still preferred and they include mirrors, (Table 5), which are all bronze castings. Also, the highly specialised *haft jush* vessels of high tin bronze (Allan 1979, 51) (Table 4), forged at red heat and then quenched to preserve the martensitic structure which gives the metal its special properties.

Forged high tin bronzes have not been encountered in the Roman world, although it was used in the south of India from the end of the second millennium BC (Srinivasan 1994, Srinivasan and Glover 1995) and examples were found at the Omeyyad fortress of Umm er-Rasas in Jordan, in deposits dating to the eighth and ninth centuries AD (Bujard and Schweizer 1994b). There are a number of such vessels which are believed to originate from Khurasan (the region around Herat), dating to the seventh to ninth centuries AD (Melikan-Chirvani 1974), including two boat-shaped vessels in the British Museum (OA 1991, 7-27, 1 & 2: unpublished). The mortars (Table 6) are of a more mixed alloy but do have a much higher tin content than the other castings, in this they are similar to the contemporary European mortars and heavy cast vessels (Brownsword and Pitt 1981 and 1996).

Decorated copper vessels, copying brass types, (Table 7) were more in evidence from the fifteenth century AD (but note the two copper flasks found at Umm er-Rasas, dating to the eighth or ninth centuries AD (Bujard and Schweizer 1994b). The later examples were engraved with the same designs as found on the brasses but were always tinned rather than inlaid.

Broadly, the composition of the Islamic brasses is comparable to contemporary European brass. Hammered sheet or wrought metal was usually of brass straight from the cementation crucible and containing only such lead as had come with the zinc ore (Brownsword and Pitt 1983, Caple 1995), and cast metalwork was usually of leaded brass with some tin but less zinc than the wrought metalwork (Werner 1977, 1981 & 1982). It does seem that tin was rather more prevalent in European brass than in Islamic brass, although it has to be borne in mind that much of the European material analysed by Brownsword and Pitt came from Britain where it appears that the brasses regularly had more tin than their continental counterparts. True bronze remained in regular use only for the heavily leaded alloys used for heavy castings such as mortars. The relations between European and Islamic brass are discussed in more detail in Ward *et al.* (1995).

At the western edge of the Islamic world, southern Spain might be expected to have a different metallurgical background than the rest of the Islamic world especially as tin sources were relatively close in the northwest of Spain. It is here if anywhere that the European technologies might have been expected to exercise an influence on the Islamic traditions. The analyses of Spanish Islamic material (included in

Tables 2 and 3), however, do not appear to be greatly different from the bulk of the other Islamic material, although one should note that relatively few Spanish items have been included in the programme.

There is evidence of a difference between the iron content of the Islamic and European brasses (Fig. 6), the European brass is generally higher in iron and some brasses have several percent of the metal. The two data sets, however, are not strictly comparable as the Islamic metal includes far more wrought metal which could be expected to be purer than the cast metal, but the difference seems to be maintained when comparing just the cast metalwork of the two groups. Like the Islamic brass, European brass was also made by the cementation process, as described by Theophilus (Chapter 6 and Hawthorne and Smith 1963, 143). Copper picks up some iron during smelting, but during the cementation process any additional iron in the zinc ore could be reduced to metal and may have dissolved into the copper. In Europe there were large deposits of zinc carbonate ore which were the only sources used until well into the post-medieval period (Chapter 6, pp.133-4). These could be used directly after calcining, which would not remove the iron, whereas in the Middle East, zinc sulphide ores predominated and these ores were oxidised and sublimated to remove the sulphur which also served to completely separate the involatile iron from the zinc before it entered the cementation crucible. This may explain why the majority of the Islamic brasses contain no more iron than would be expected to have come from the copper alone, typically about 0.2%.

Generally, the trace elements in the Islamic metalwork appear to show only relatively minor changes with time. The main exception to this is the nickel, which shows a marked increase in concentration in the fifteenth and sixteenth centuries AD compared to the preceding centuries (Fig. 7). A general increase in the nickel content of European copper alloys over the period of the eleventh to the sixteenth centuries AD has been reported previously (Werner 1977, 1981 and 1982, Pollard 1996, 218), and this suggests that by the late medieval period the Islamic and European worlds were sharing some of the more important sources of copper. Indeed, there is documentary evidence from both European and Muslim sources that Europe was the main supplier of copper to the Eastern Mediterranean at least in the fifteenth and sixteenth centuries AD (Braunstein 1977).

Further study of the trace element content of the Islamic metalwork appears to indicate that any patterning within the data set is not related to the place of manufacture of the objects.

CONCLUSIONS

The sublimation process originated at least 2,000 years ago, most probably somewhere between Greece and Northern India, possibly as a pharmaceutical process (See Chapter 3, p.53) which was adapted so that the more prevalent deposits of zinc sulphides could be utilised in brass making. Europe by contrast had abundant supplies of zinc carbonate, and this additional process was not required.

Thus the usual copper alloy of the Islamic work was brass produced using a technology little if any changed from that developed in the Middle East more than half a millennium before.

ACKNOWLEDGEMENTS

We wish to thank Rachel Ward of the Department of Oriental Antiquities, British Museum, for extensive checking of the tables, and to thank Madame A. Mendoza Eguaras of the Granada Museum for permission to sample the material in her care and for checking the tables.

REFERENCES

Anon, 1972. *Lead, Copper and Zinc Deposits in Turkey.* Mineral Research and Exploration Institute of Turkey. Ankara.

Allan, J.W. 1979. *Persian Metal Technology 700-1300 AD.* Ithaca Press, London.

Atil, E., Chase, W.T. and Jett, P. 1985. *Islamic Metalwork.* Freer Gallery of Art, Washington DC.

Barnes, J.W. 1973. Ancient Clay Furnace Bars from Iran. *Bulletin of the Historical Metallurgy Group*, 7 (2), 8-17.

Braunstein, P. 1977. Le marché du cuivre à Venise à la fin du moyen-age, in *Schwerpunkte der Kupferproduktion und des Kupferhandels in Europa 1500-1650*, Böhlau, Cologne. 78-94.

Brownsword, R. and Pitt, E.E.H. 1981. Medieval 'bell-metal' mortars-a misnomer, *The Metallurgist and Materials Technologist* 13 4, 184-5.

Brownsword, R. and Pitt, E.E.H. 1983. Alloy composition of some cast Latten objects of the 15/16th centuries. *Journal of the Historical Metallurgy Society* 17 (1), 44-9.

Brownsword, R. and Pitt, E.E.H. 1996. British Late-Medieval Inscribed Bronze Jugs, *Antique Metalware Society* 4, 11-25.

Bujard, J. and Schweizer, F. 1994a. Etudes techniques de laitons byzantins *L'Oeuvre d'art sous le regard des sciences*, Slatkine, Genève. 175-86.

Bujard, J. and Schweizer, F. 1994b. Aspect métallurgie de quelques objets byzantins et omeyyades découverts récemment en Jordanie, *L'Oeuvre d'art sous le regard des sciences*, Slatkine. Genève. 191-207.

Caple, C., 1995. Factors in the production of Medieval and Post-Medieval brass pins, in D.R. Hook and D.R.M Gaimster (eds.) *Trade and Discovery: The Scientific Study of Artefacts from Post-Medieval Europe and Beyond*. British Museum Occasional Paper **109**, London. 221-34.

Craddock, P.T. 1979. The Copper Alloys of the Medieval Islamic World. *World Archaeology* **11** (1), 68-79.

Craddock, P.T. 1988. Copper Alloys of the Hellenistic and Roman World. in J. Ellis Jones ed. *Aspects of Ancient Mining and Metallurgy*. University College of North Wales, Bangor. 55-65.

Craddock, P.T. and Picton, J. 1986. Medieval copper alloy production and West African bronze analyses - II. *Archaeometry* **28** (11), 3-32.

Dannheimer, H. 1979. Zur Herkunst der 'koptischen' Bronze gefasse der Merowingerzeit, *Bayerische vorgeschicts-Blatter* **44**, 123-47.

Davies, O. 1929. Two North Greek mining towns. *Journal of Hellenic Studies* **49**, 89-99.

Dayton, J.E. 1971. The problem of tin in the ancient world. *World Archaeology* **3**, 49-71.

Eckstein, K., Craddock, P.T. and Freestone, I.C. 1996, Frühe Bergbau- und Verhüttungsaktivutäten in Zawar, Dariba und Agucha (Nordwestindien) *Metalla* **3** 1, 11-26.

Fawns, S. 1921. *Tin Deposits of the World*, The Mining Magazine, London.

Gunther, R.T., (ed.) 1934. *The Greek Herbal of Dioscorides*, John Goodyear's 1688 translation. OUP. Oxford.

Hawthorne, J.G. and Smith, C.S. 1963. *On Divers Arts: The Treatise of Theophilus*. University of Chicago Press, Chicago.

Hook, D.R. forthcoming. Inductively-coupled plasma atomic emission spectrometry in numismatics, in W.A. Oddy and M.R. Cowell (eds.) *Metallurgy in Numismatics IV*, Royal Numismatic Society, London.

Herbert, E.W. 1984. *Red Gold of Africa*. University of Wisconsin Press. Madison, Wisconsin.

Hook, D.R. and Craddock, P.T. 1988. The Composition of Bristol Brass, appendix to J. Day's Bristol Brass Furnaces, *Journal of the Historical Metallurgy Society* **22** 1, 38-40.

Hook, D.R. and Craddock, P.T. 1996. The Scientific Analysis of the Copper Alloy Lamps, appendix in D.M. Bayley *A Catalogue of Lamps in the British Museum* **IV**. BMP, London. 144-64.

Hughes, M.J., Cowell, M.R. and Craddock, P.T. 1976. Atomic Absorption techniques. in Archaeology. *Archaeometry*, **18**, 19-36.

de Jesus, P.S. 1980. *The Development of Prehistoric Mining and Metallurgy in Anatolia*. B.A.R. International Series **74**, Oxford.

Latham, R.E. 1972. *The Travels of Marco Polo*. Penguin Books, London.

McGeehan-Liritzis and Taylor, J.W. 1987. Yugoslavian Tin Deposits and the Early Bronze Age Industries of the Aegean Region. *Oxford Journal of Archaeology* **6** (3), 287-300.

Melikian-Chirvani, A.S. 1974. The White Bronzes of Early Islamic Iran, *Metropolitan Museum Journal* **9**, 123-51. (appendix with analyses by Arrhenius, Hodges, van Zelst and Meyers)

Mortimer, C. 1989. An Investigation of the Brass used in Medieval and Later European Scientific Instruments. in Maniatis, Y. (ed.), *Archaeometry: Proceedings of the 25th Archaeometry Conference, Athens, 1985*. Elsevier. Amsterdam. 311-7.

Muhly, J.D. 1978. New Evidence for Sources of and Trade in Tin. in Franklin, A.D., Olin, J.S. and Wertime, T.A. (eds.), *The Search of Ancient Tin*. Smithsonian Institution, Washington DC.

Muhly, J.D. 1985. Sources of Tin and the Beginnings of Bronze Metallurgy, *American Journal of Archaeology* **89**, 275-291.

Oddy, W.A. and Craddock, P.T. 1983. Scientific Examination of the Coptic Bowl and related Coptic Material, in *The Sutton Hoo Burial* **3** II, R. Bruce Mitford, ed. A. Care Evans. BMP. London. 753-7.

Penhallurick, R.D. 1986. *Tin in Antiquity*. Institute of Metals, London.

Pollard, A.M. 1996. *Archaeological Chemistry*, Royal Society of Chemistry. London.

Rackham, H. 1952. *Pliny: the Natural History IX*. (Loeb Classical Library). London, Heinemann.

Riddle, J.M. 1985. *Dioscorides on Pharmacy and Medicine*. University of Texas Press, Austin.

Rogers, J.M. and Ward, R.M. 1988. *Süleyman the Magnificent* BMP, London.

Srinivasan, S. 1994. High-tin bronze bowl-making in Kerala, South India, and its archaeological implications, in *South Asian Archaeology 1993* Proceedings of the twelfth International Conference of the European Association of South Asian Archaeologists, Helsinki, 5-9th July 1993. Suomalainen Tiededeakatemia, Helsinki. Vol. 2, 695-706.

Srinivasan, S. and Glover, I. 1995. The contemporary manufacture of wrought and quenched and cast high tin bronzes in Kerala State, India, *Journal of the Historical Metallurgy Society* **29** 2.

Walsh, R. 1929. Galen visits the Dead Sea and copper mines of Cyprus (166 AD), *Bulletin of the Geographical Society of Philadelphia* **25**, 92-110.

Ward, R., La Niece, S.C., Hook, D.R. and White, R. 1995. Veneto-Saracenic Metalwork: An analysis of the bowls and incense burners in the British Museum, in D.R. Hook and D.R.M. Gaimster (eds.) *Trade and Discovery: The Scientific Study of Artefacts from Post-*

Medieval Europe and Beyond. British Museum Occasional Paper **109**, London. 235-58.

Werner, O. 1977. Analysen mittelalterlicher Bronzen und Messinge I, *Archäologie und Naturwissenschaft* **1**, 44-120.

Werner, O. 1981. Analysen mittelalterlicher Bronzen und Messinge II & III, *Archäologie und Naturwissenschaft* **2**, 106-20.

Werner, O. 1982. Analysen mittelalterlicher Bronzen und Messing IV, *Berliner Beitrage zur Archäometrie* **7**, 35-174.

Willies, L. 1992. Report on the 1991 archaeological survey of Kestel tin mine, Turkey, *Bulletin of the Peak District Mines Historical Society Ltd.* **11** 5, 241-7.

Yener, K.A. and Özbal, H. 1987. Tin in the Turkish Taurus Mountains: The Bolkardag mining district. *Antiquity* **61** (2), 220-6.

Yener, K.A. and Vandiver, P.B. 1993. Tin processing at Göltepe, an Early Bronze Age site in Anatolia, *American Journal of Archaeology* **97**, 207-38.

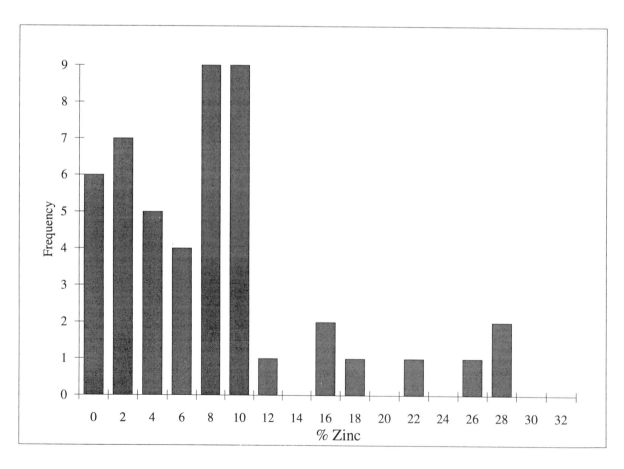

Fig. 1 Histogram of zinc content of Coptic metalwork (see Table 1).

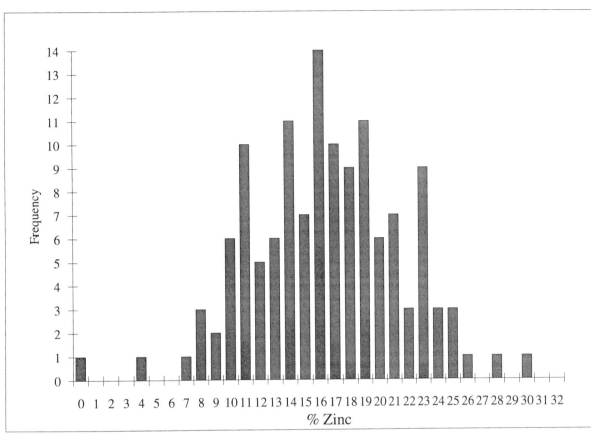

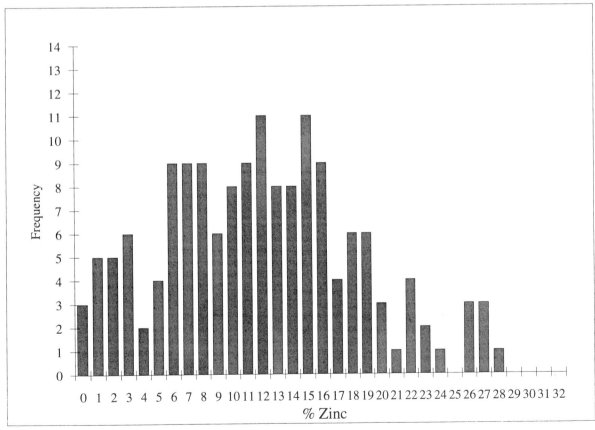

Fig. 2 Histograms of the zinc contents of Islamic sheet and raised metalwork (top) and Islamic cast metalwork (bottom) (see Tables 2 and 3).

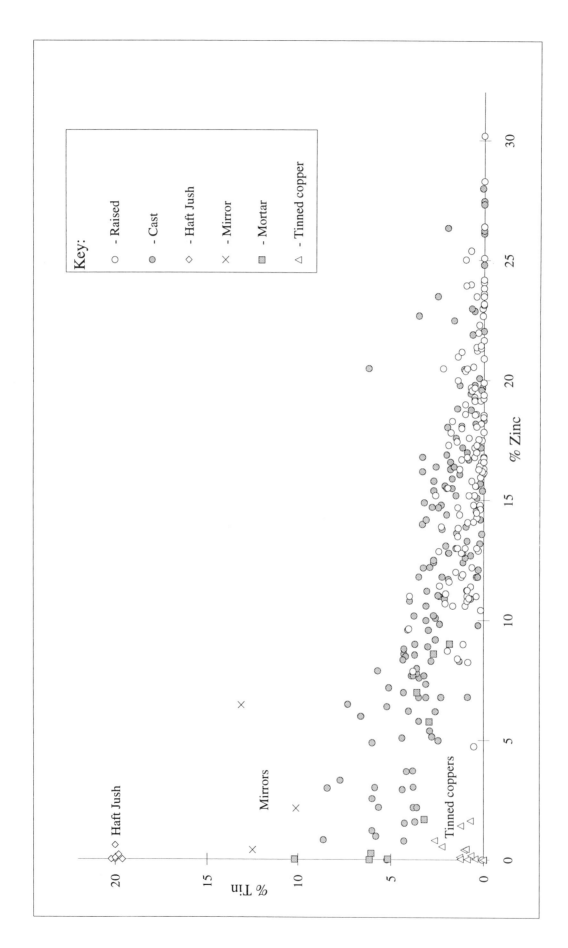

Fig. 3 Tin against zinc scatter plot of Islamic metalwork

82

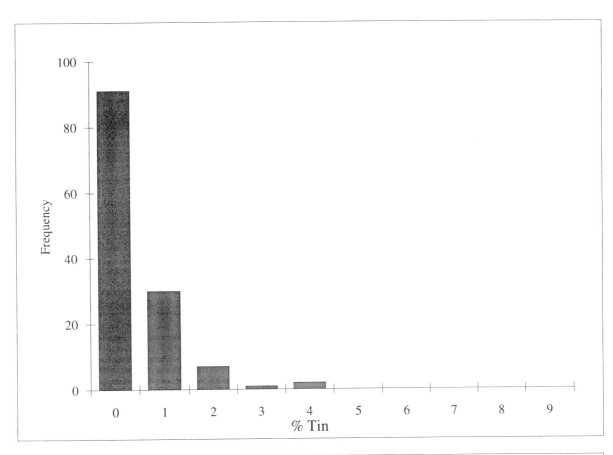

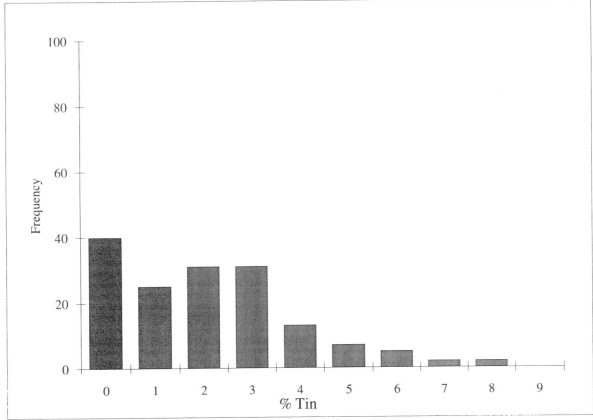

Fig. 4 Histograms of tin contents of Islamic sheet and raised metalwork (top) and Islamic cast metalwork (bottom)

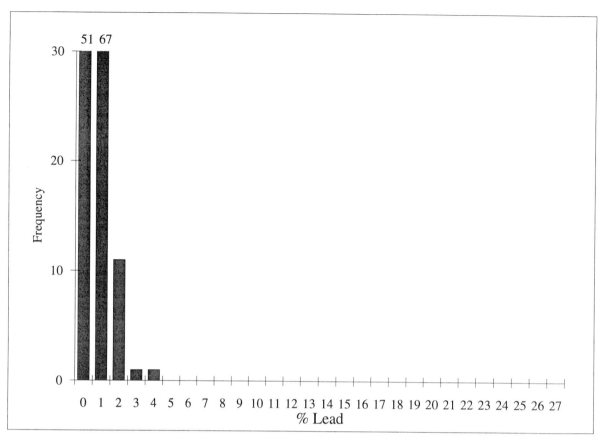

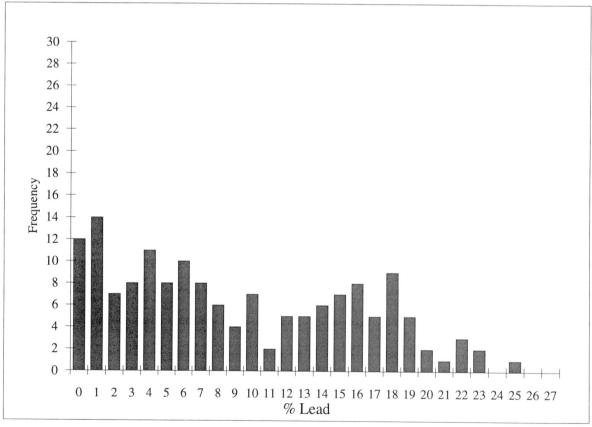

Fig. 5 Histograms of lead contents of Islamic sheet and raised metalwork (top) and Islamic cast metalwork (bottom)

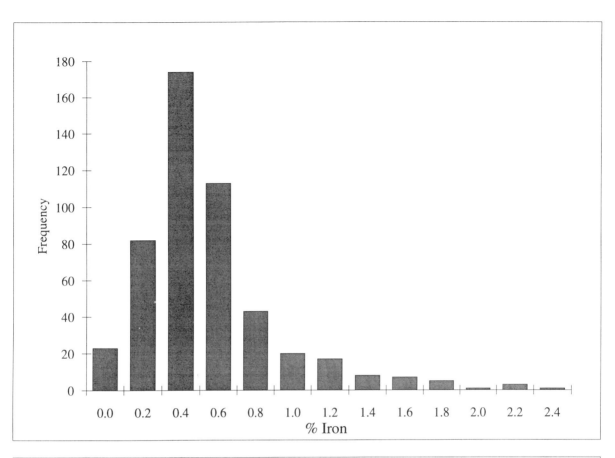

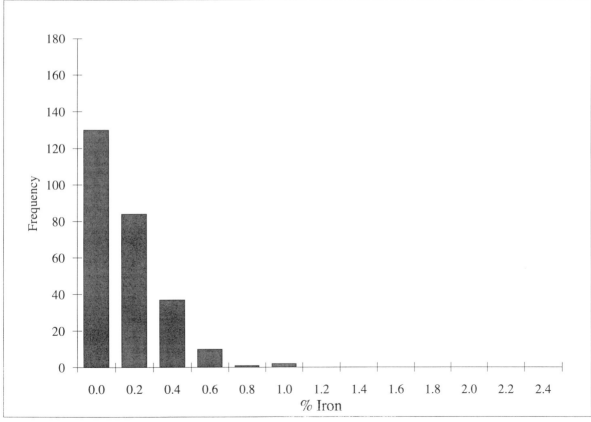

Fig. 6 Histograms of iron contents of contemporary European brasses (top) and Islamic brasses (Zinc contents greater than 5%). The analyses of the European brasses were carried out using wavelength X-ray fluorescence on drilled or filed samples. Some of the data has been published, e.g. Brownsword and Pitt (1983).

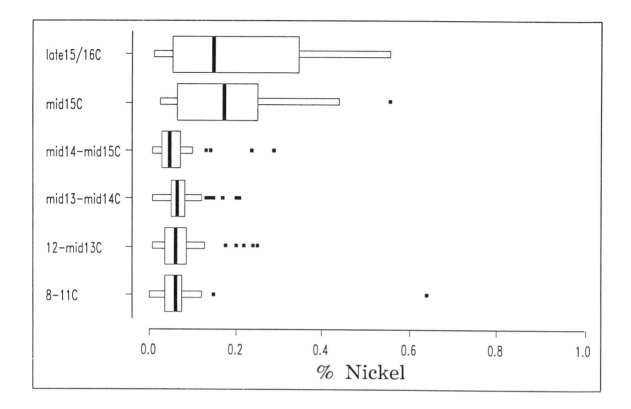

Fig. 7 'Box and whisker' plot of nickel content of Islamic metalwork by approximate date range, showing an increase in nickel content from the fifteenth century AD onwards. The 'box' represents the inter-quartile range; the thick vertical line in each 'box' represents the median value; the 'whiskers' extend from the quartiles to the observation not further than 1.5 times the inter-quartile range (any points beyond this range are plotted as individual squares).

Table 1 Analyses of Coptic metalwork

Reg No.	Description (part)	Provenance	Date	Cu	Zn	Pb	Sn	Ag	Fe	Sb	Ni	Au	Co	As	Bi	Mn	Cd
Ash.1923.776	Bowl (handle lug)	Egypt	6-7C	66.5	6.50	22.1	4.10	.11	.27	.10	.06		.005	.10	.01		
MLA 129070	Bowl (body)	Egypt	6-7C	68.0	4.50	23.5	2.90	.08	.30	.08	.06				.03		
	Bowl (handle)			68.5	.18	25.6	5.50	.04	.15	.15	.09			.10	<.01		
1879-5-24.53	Bowl (body)	Egypt	6-7C	73.0	4.30	20.1	2.10	.07	.10	.08	.04				<.01		
	Bowl (base)			69.0	4.40	25.0	1.90	.22	.11		.06				<.01		
	Bowl (handle lug)			74.5	3.00	20.8	1.90	.08	.10		.05				<.01		
	Bowl (handle)			66.5	1.90	27.0	4.60	.08	.16		.05				<.01		
MLA 1293'70	Bowl (rim)	Egypt	6-7C	68.0	3.60	25.0	2.90	.08	.13	.12	.06				<.01		
	Bowl (handle)			70.5	3.20	21.6	4.50	.08	.13		.08				<.01		
Ash.1927.6685	Bowl (body)	Egypt	6-7C	70.0	9.50	18.4	2.00	.08	.17	.03	.10			.05	.01		
	Bowl (handle)			70.0	11.0	15.5	2.30	.09	.42	.10	.18		.003	.15	.01		
	Bowl (handle)			67.5	6.80	21.5	2.20	.09	.23	.10	.08			.10	.01		
1860-10-24,3	Bowl (handle)	Egypt	6-7C	72.0	3.20	24.0	.27	.08	.18	.08	.05				.02		
Ash.1942.257	Bowl (body)	Egypt	6-7C	72.5	2.80	20.5	3.90	.10	.10	.10	.08			.10	.01		
	Bowl (handle A)			69.5	1.15	24.5	3.60	.09	.07	.15	.08		.002	.10	<.01		
	Bowl (handle B)			69.5	3.60	27.0	4.50	.12	.11	.05	.07			.07	.01		

Table 1 Analyses of Coptic metalwork

Reg No.	Description (part)	Provenance	Date	Cu	Zn	Pb	Sn	Ag	Fe	Sb	Ni	Au	Co	As	Bi	Mn	Cd
1883-7-2,38	Bowl (body)	Egypt	6-7C	67.5	13.0	17.4	2.50	.09	.25	.10	.09				<.01		
	Bowl (base)			69.0	10.0	17.0	2.40	.09	.25	.10	.09				<.01		
	Bowl (handle lug)			70.0	9.80	16.5	2.40	.09	.26	.10	.13				<.01		
	Bowl (handle)			71.0	7.20	20.2	1.50	.07	.25	.10	.12				<.01		
1905-4-18,8	Bowl (body)	Egypt	6-7C	71.5	9.50	16.5	2.30	.10	.27	.10	.08				<.01		
	Bowl (base)			74.0	9.40	13.1	2.30	.11	.03	.10	.08				.02		
	Bowl (handle)			68.0	9.00	19.0	2.00	.06	.21	.08	.03			.20	<.01		
MLA 128970	Bowl (body)	Egypt	6-7C	72.0	10.6	15.1	2.20	.11	.30	.12	.04			.10	<.01		
	Bowl (handle)			72.0	9.40	17.3	2.30	.18	.07	.12	.04			.10	.02		
1939-10-10,109	Bowl (body)	Egypt	6-7C	79.5	11.0	6.30	2.60	.06	.30	.08	.05		.020		.01		
	Bowl (lug)			79.0	11.6	7.05	2.35	.11	.33	.09	.09		.020		.02		
	Bowl (handle)			70.5	5.00	19.5	4.50	.23	.28	.08	.05	.003	.070	.15	.01		
1925-1-9,1	Bowl (body)	Egypt	6-7C	80.0	7.60	10.0	2.20	.15	.32	.08	.02				<.01		
	Bowl (base)			78.0	10.0	10.4	2.20	.14	.29	.10	.10				<.01		
	Bowl (handle lug)			72.0	11.0	13.6	2.70	.18	.25		.06				<.01		
	Bowl (handle)			73.0	3.60	18.1	5.10	.09	.25		.06				<.01		

Table 1 Analyses of Coptic metalwork

Reg No.	Description (part)	Provenance	Date	Cu	Zn	Pb	Sn	Ag	Fe	Sb	Ni	Au	Co	As	Bi	Mn	Cd
1883-12-14.8	Bowl (body)	Egypt	6-7C	84.0	9.60	2.80	2.85	.04	.10	.10	.05		.045	.20	.01		
	Bowl (stem)			73.0	8.40	12.9	3.60	.08	.25	.08	.06		.010	.50	.01		
	Bowl (base)			82.0	9.00	5.90	3.30	.08	.27	.10	.05		.005	.10	.01		
	Bowl (handle)			75.0	10.5	11.5	2.50	.20	.52	.10	.07		.005	.10	.01		
	Bowl (handle)			74.5	10.6	11.0	2.35	.20	.57	.12	.07		.005	.20	.01		
1867-7-29,136	Bowl (handle lug)	Egypt	6-7C	76.0	22.8	.03	.20	.02	.15		.15				<.01		
	Bowl (handle)			82.0	17.0	.35	.10	.10	.27		.40				<.01		
1869-10-11,10	Bowl (handle)	Egypt	6-7C	82.0	16.8	.08	.45	.12	.32	.09	.15				<.01		
Ash.1975.308	Bucket (body)	Egypt	6-7C	79.5	18.0			.01	1.45	.02	.14			.02	<.01		
	Bucket (handle)			68.0	26.9	5.10		.07	.05	.01	.13			.05	.01		
1929-7-13,9	Ewer (foot)	Egypt	6-7C	72.0	28.0	.57	.05	.07	.16	.05	.03				<.01		
	Ewer (body)			71.0	28.0	.57	.15	.07	.17		.03				<.01		
1900-7-19,4	Ewer (foot)	Egypt	6-7C	76.5	1.60	15.8	5.50	.07	.14	.10	.04				<.01		
	Ewer (body)			73.0	1.50	19.0	5.50	.07	.13	.15	.04				<.01		
	Ewer (handle)			73.5	1.50	20.3	5.50	.07	.12	.15	.04				<.01		
	Ewer (lid)			78.5	4.50	12.6	3.80	.06	.15	.15	.08				<.01		

Table 2 Analyses of Islamic raised metalwork

Reg No.	Description (part)	Provenance	Date	Cu	Zn	Pb	Sn	Ag	Fe	Sb	Ni	Au	Co	As	Bi	Mn	Cd	S
OA+1880	Bucket (rim)	Egypt	11C	78.9	16.1	1.43	.05	.09	.08	.06	.04	<.003	.008	.34	.02	<.0005	<.0013	.07
	Bucket (handle)			80.1	14.6	1.83	.28	.06	.14	.10	.12	<.003	.025	.61	.02	<.0005	<.0014	.11
1968-12-24,1	Tray	Iran	12C	78.7	19.7	.45	.70	.16	.13	.06	.04		.012					
1848-8-5,1	Ewer (foot)	Khurasan	c.1200	78.9	25.1	1.44	<.05	.03	.13	.03	.24	<.011	<.011	.07	<.05	.0054	<.0108	<.05
	Ewer (body)			77.0	22.3	.09	.25	.04	.60	<.02	.01	<.004	<.004	.01	.03	.0050	<.0040	.04
	Ewer (neck)			79.0	21.3	.09	.37	.05	.05	<.02	.01	<.005	<.005	.03	.03	.0023	<.0046	.04
1848-8-5,2	Ewer (handle)	Iran	c.1200	79.5	19.3	1.15	.50	.06	.31		.03				<.01			
	Ewer (spout cover)			80.0	19.2	.16	.50	.08	.07		.02				<.01			
	Ewer (neck)			78.0	20.4	.20	1.00	.09	.09		.03							
	Ewer (body)			80.0	19.0	.20	1.00	.09	.22		.03				.01			
	Ewer (base)			79.5	18.6	.86	1.00	.10	.12		.02			.05				
1959-7-23,1	Bucket (rim)	Iran	12-13C	87.7	8.26	2.50	.84	.08	.21	.11	.18	<.005	.020	.39	<.02	.0017	<.0010	
	Bucket (handle)			92.3	4.76	1.97	.52	.09	.36	.11	.13	<.005	.016	.37	<.01	.0016	<.0010	
1866-12-29,61	Ewer (base)	Mosul	1232	81.0	14.8	1.60	.55	.07	.25	.45	.04		.015	1.00	.01			
	Ewer (body)			81.0	16.3	1.50	1.30	.06	.25	.22	.05		.050	.30	.01			
	Ewer (neck)			85.0	14.8	.48	.20	.08	.14	.17	.02		.065	.50	.01			

Table 2 Analyses of Islamic raised metalwork

Reg No.	Description (part)	Provenance	Date	Cu	Zn	Pb	Sn	Ag	Fe	Sb	Ni	Au	Co	As	Bi	Mn	Cd	S
1888-5-26.1	Astronomical table (suspension ring)	Iraq	1241-2	78.5	16.8	3.70	.90	.07	.35	.15	.06		.035	.40	.01			
	Astronomical table (top)			80.0	17.6	1.50	.80	.08	.17	.10	.06		.030	.35	.01			
	Astronomical table (quadrant frame)			80.5	17.2	1.30	.50	.10	.15	.15	.04		.010	.30	.02			
	Astronomical table (back plate)			82.5	15.2	.90	.50	.06	.13	.15	.05		.080	.55	<.01			
1969-9-22.1	Candlestick (base)	Iraq	13C	77.9	19.1	.88	.49	.06	.12	.12	.06	<.005	.023	.43	<.01	<.0013	<.0013	
1954-2-15.1	Candlestick (base)	Iraq	13C	82.0	15.2	.95	.80	1.50	.15	.10	.05			.40	<.01			
1878-12-30,674	Box (base)	Iraq	13C	85.0	10.6	2.20	1.00	.10	.40	.20	.05		.035	1.02	.01			
	Box (ring)			84.5	11.0	2.40	.90	.07	.30	.13	.04		.025	1.60	<.01			
	Box (lid)			82.0	9.00	2.05	1.10	.07	.40	.12	.05		.020	.60	<.01			
1855-7-9,1	Astrolabe (pin)	Egypt	1236	80.0	18.6	.75	.40	.04	.05	.10	.04			.55	<.01			
	Astrolabe (disc)			78.0	20.2	.30	.50	.03	.12		.28			.20	.02			
	Astrolabe (dial peg)			76.0	23.5	.21	.40	.04	.11		.25			.05	.01			
	Astrolabe (dial)			76.5	21.4	.55	.40	.05	.09	.10	.05		.060	.03	<.01			
1878-12-30,682	Spherical incense burner	Syria	1264-79	80.3	16.6	1.67	.13	.04	.23	.11	.04	<.002	.054	.68	<.02	.0012	<.0013	.03
1890-3-15,3	Astrolabe (disc)	Syria	1270-1	83.0	12.8	1.90	1.20	.05	.30	.10	.06		.040	.06	<.01			

Table 2 Analyses of Islamic raised metalwork

Reg No.	Description (part)	Provenance	Date	Cu	Zn	Pb	Sn	Ag	Fe	Sb	Ni	Au	Co	As	Bi	Mn	Cd	S
1880-3-8,1	Astrolabe (locating pin)	Syria	1270-1	84.0	15.6	.75	.45	.11	.15	.02	.03			.06	<.01			
	Astrolabe (pin)			83.0	12.0	2.90	1.50	.14	.35	.20	.20			.30	<.01			
	Astrolabe (disc)			79.0	18.2	.55	.15	.04	.20	.15	.04		.040	.80	.01			
	Astrolabe (arm)			83.0	13.5	.65	1.40	.08	.25	.14	.03		.007	.25	<.01			
	Astrolabe (split pin)			75.5	24.0	.50	.70	.12	.12	.14	.04			.05	<.01			
1878-12-30,706	Tray	Iran	13C	83.5	13.0	1.18	1.41	.08	.25	.08	.04	<.002	.018	.31	.02	<.001	<.0020	.04
1885-7-11,1	Vase	Iran	13C	78.5	20.5	.20	.90	.02	.35	.05	.03			.15	.03			
1866-12-29,62	Candlestick (base)	Syria	13C	85.5	10.8	1.10	.90	1.10	.18	.30	.02			.70	<.01			
1878-12-30,691	Bowl	Egypt/Syria	13C	83.0	13.0	2.70	1.00	.02	1.00	.15	.02			.50	.01			
1948-5-8,3	Vase (handle)	Iraq	13-14C	73.2	25.0	.81	.99	.05	.19	<.02	.01	<.008	<.005	<.09	<.02	<.0023	<.0023	
1888-12-1,276	Quadrant (body)	Syria	1333-4	83.5	14.7	.60	1.40	.15	.02	.05	.05		.030	.25	<.01			
	Quadrant (upright)			83.5	14.4	.50	2.10	.16	.13	.06	.04		.020	.10	<.01			
1866-12-29,63	Bowl	Egypt/Syria	13-14C	81.8	15.5	.78	1.94	.14	.27	.10	.05	<.008	.036	<.10	<.02	<.0024	<.0024	
1878-12-30,687	Bowl	Egypt/Syria	14C	82.7	12.9	1.00	2.42	.07	.12	.34	.03	<.004	.028	.11	<.01	<.0011	<.0011	
1878-12-30,688	Bowl	Egypt/Syria	14C	84.7	11.4	1.02	2.38	.12	.15	.36	.06	<.008	.024	<.10	<.02	<.0024	<.0024	
1953-10-21,1	Bowl	Egypt/Syria	14C	78.4	17.8	1.26	1.78	.13	.50	.06	.06	<.009	.082	.15	<.02	<.0025	<.0025	
1851-1-4,1	Basin: for Sultan M. Ibn Qala'un	Egypt/Syria	14C	80.0	15.2	1.10	2.60	.16	.35	.05	.02		.070	.30	<.01			
1881-8-2,19	Pencase (body)	Egypt/Syria	14C	82.0	11.0	2.30	4.00	.08	.25	.30	.05			.20	<.01			
	Pencase (lid)			87.0	11.0	.95	.40	.70	.20	.20	.04	.080		.25	<.01			

Table 2 Analyses of Islamic raised metalwork

Reg No.	Description (part)	Provenance	Date	Cu	Zn	Pb	Sn	Ag	Fe	Sb	Ni	Au	Co	As	Bi	Mn	Cd	S
1866-12-29,68	Large dish	Egypt/Syria	14C	84.5	11.8	.70	1.20	.15	.10	.31	.03			.60	.01			
1897-5-10,1	Stand : for Nasiri ibn Kalaun (base)	Egypt/Syria	14C	85.0	11.1	1.30	2.05	.18	.12	.35	.05		.007	.20	.01			
	Stand (rim)			84.5	11.6	1.10	2.10	.18	.16	.31	.03		.020	.16	.01			
1866-12-29,74	Box (base)	Egypt/Syria	14C	79.5	16.8	1.30	.50	.08	.25	.20	.10			.50	.01			
	Box (attached rim)			81.5	17.5	.60	.10	.03	.16	.06	.04		.040	.60	<.01			
1878-12-30,686	Bowl	Egypt/Syria	14C	80.5	16.7	.25	1.20	.15	.16	.08	.03		.030	.70	<.01			
1966-10-19,1	Drum	Egypt/Syria	14C	88.5	8.40	1.40	1.40	.22	.17	.04	.03			.35	<.01			
1960-7-31,1	Basin	Egypt/Syria	14C	81.7	13.9	.40	2.29	.17	.11	.04	.03	<.002	.030	.23	.02	<.0005	<.0013	.11
1866-12-29,60	Tray	Egypt/Syria	14C	83.8	11.9	.77	1.13	.12	.08	.24	.03	<.002	.001	.66	.02	.0011	<.0013	.06
1878-12-30,690	Bowl	Egypt/Syria	14C	83.0	10.7	1.71	2.08	.11	.27	.31	.06	<.003	.022	.32	.02	<.0005	<.0013	.05
1878-11-1,101	Basin	Syria	14-15C	76.5	23.0	1.47	.07	.05	.20	.03	.24	<.003	<.003	.08	.02	.0008	<.0014	.01
1901-6-6,3	Bowl (body)	Iran	14C	77.5	18.0	2.40	1.20	.05	.06	.09	.01			.04	<.01			
.1948-5-8.1	Candlestick (base)	Iran	14C	76.0	20.0	1.90	1.40	.07	.43	.06	.01			.04	<.01			
	Candlestick (top)			76.0	21.0	1.50	1.40	.05	.07	.15	.02			.03	<.01			
1969-6-20,1	Vase	Iran	1484	72.3	25.4	1.28	.70	.02	.12	.07	.03		.007					
1948-5-8,2	Bowl	Iran/Syria	14-15C	81.1	15.8	.60	.65	.07	.09	.09	.06	<.003	.028	.47	.02	<.0005	<.0015	.02
1878-12-30,732	Lidded jug (lid)	Iran	15C	81.5	16.6	.80		.17	.10		.20			.10				
1865-12-9,1	Bucket (rim)	Iran	15C	81.8	11.4	2.01	.70	.08	.45	.69	.35	<.002	.009	.41	.02	.0008	<.0012	.05
	Bucket (handle)			83.0	10.6	2.11	1.66	.08	.44	.75	.35	<.002	.008	.44	.02	.0008	<.0013	.04

Table 2 Analyses of Islamic raised metalwork

Reg No.	Description (part)	Provenance	Date	Cu	Zn	Pb	Sn	Ag	Fe	Sb	Ni	Au	Co	As	Bi	Mn	Cd	S
1866-12-29,65	Bowl	Egypt/Syria	15C	71.7	26.4	.16	<.01	.18	.07	.01	.44	<.002	.032	.33	<.02	.0012	<.0012	.03
1889-5-7,13	Bowl	Egypt/Syria	15C	71.0	30.2	.25	.01	.19	.16	.01	.32	<.002	.016	.22	<.02	.0032	<.0012	.02
1866-12-29,66	Bowl (rim)	Egypt/Syria	15C	69.5	28.3	1.48	<.01	.04	.07	.01	.13	<.002	<.003	.04	<.02	.0013	<.0013	<.01
1866-12-29,67	Bowl (rim)	Egypt/Syria	15C	74.8	24.2	.83	<.01	.10	.05	.02	.23	<.002	.004	.19	<.02	.0014	<.0012	.01
1960-7-31,2	Basin	Egypt/Syria	15C	87.8	8.73	.63	1.95	.11	.18	.49	.05	<.002	<.003	.27	.04	.0009	<.0012	.03
OA+373	Box (lower)	Egypt	15C	77.0	22.0	.50		.04	.09		.05		.015	.13	<.01			
	Box (top compartment)			77.0	22.0	.37		.05	.07		.06		.015	.13				
	Box (mid compartment)			77.0	22.0	.33	.30	.04	.07		.05		.015	.09	.01			
	Box (lid)			78.0	22.0	.33	.20	.05	.12		.05			.02	.01			
	Box (rivet)			99.5	.02	.95	.07	.02	.08		.06		.006	.04				
1882-3-21,17	Bottle (neck)	Veneto-Saracenic	15C	76.0	23.6	1.40	<.36	.03	.16	<.04	.24	.138	<.007	<.11	<.04	<.0036	<.0029	
1866-12-29,69	Round-bottomed bowl	Veneto-Saracenic	15C	79.3	17.5	.58	.27	.12	.20	.05	.28	<.003	.010	.32	<.01	.0008	<.0030	.02
1878-12-30,692	Round-bottomed bowl (lid)	Veneto-Saracenic	15C	74.6	21.7	1.13	<.01	.05	.11	.05	.25	<.003	<.005	.12	<.02	.0020	<.0030	.02
	Round-bottomed bowl (bowl)			73.6	21.8	1.30	<.01	.05	.12	.05	.25	<.004	<.006	.14	<.02	.0021	<.0040	.04
1878-12-30,693	Round-bottomed bowl (lid)	Veneto-Saracenic	15C	75.5	19.6	1.17	.64	.05	.11	.02	.28	<.003	<.005	.07	<.02	.0018	<.0030	.03
	Round-bottomed bowl (bowl)			76.7	20.9	1.17	<.01	.06	.10	.05	.21	<.004	<.005	.11	<.02	.0014	<.0040	.03
1874-12-30,694	Round-bottomed bowl (lid)	Veneto-Saracenic	15C	76.6	19.2	1.50	.17	.05	.07	.03	.24	<.005	<.007	.04	<.02	.0016	<.0050	.08
	Round-bottomed bowl (bowl)			75.7	18.6	1.51	.47	.04	.08	.02	.28	<.004	<.006	.05	<.02	.0016	<.0040	.04

Table 2 Analyses of Islamic raised metalwork

Reg No.	Description (part)	Provenance	Date	Cu	Zn	Pb	Sn	Ag	Fe	Sb	Ni	Au	Co	As	Bi	Mn	Cd	S
1878-12-30,695	Round-bottomed bowl (lid)	Veneto-Saracenic	15C	76.1	21.4	1.30	.15	.04	.25	.04	.23	<.003	<.005	.04	<.02	.0018	<.0030	.03
	Round-bottomed bowl (bowl)			75.8	21.5	1.33	.16	.05	.07	.03	.23	<.004	<.006	.04	<.02	.0016	<.0040	<.01
1878-12-30,696	Round-bottomed bowl	Veneto-Saracenic	15C	76.9	19.7	1.56	.49	.05	.09	.02	.28	<.004	<.007	.04	<.02	.0014	<.0040	.02
1878-12-30,697	Round-bottomed bowl (lid)	Veneto-Saracenic	15C	79.8	16.8	1.36	<.01	.04	.07	.02	.27	<.003	<.004	.04	<.01	.0013	<.0030	.03
	Round-bottomed bowl (bowl)			81.8	16.8	1.47	<.22	.04	.07	<.02	.25	<.007	<.004	.07	<.02	<.0022	<.0018	
	Round-bottomed bowl (bowl)			80.7	16.3	1.46	<.01	.04	.06	.02	.26	<.003	<.004	.04	<.01	.0009	<.0030	.02
1887-12-16,2	Small round-bottomed bowl	Veneto-Saracenic	15C	80.2	19.2	.18	.01	.01	.04	<.01	.03	<.004	.016	.22	<.02	<.0009	<.0040	<.01
1887-12-16,4	Round-bottomed bowl	Veneto-Saracenic	15C	79.6	18.1	.58	.39	.06	.13	.08	.09	<.003	.015	.23	<.02	.0008	<.0030	<.01
1891-6-23,6	Spherical incense burner (body)	Veneto-Saracenic	15C	72.7	24.0	1.58	.95	.06	.10	.06	.22	<.007	<.004	<.08	<.02	<.0020	<.0020	
1895-5-21,2	Round-bottomed bowl (bowl)	Veneto-Saracenic	15C	83.7	10.9	1.88	.80	.09	.13	.13	.12	<.003	.016	.21	<.02	<.0009	<.0030	.05
	Round-bottomed bowl (lid)			80.2	17.8	1.54	<.01	.02	.34	<.01	.06	<.004	.030	.02	<.02	.0035	<.0040	.02
1895-5-21,3	Round-bottomed bowl (bowl)	Veneto-Saracenic	15C	85.1	11.2	1.90	.88	.09	.26	.10	.11	<.004	.019	.20	<.02	<.0010	<.0040	.04
	Round-bottomed bowl (lid)			79.8	16.4	1.03	.22	.03	.11	.03	.05	<.005	.018	<.02	<.02	<.0012	<.0050	.04
1970,04-2,1	Round-bottomed bowl	Veneto-Saracenic	15C	81.7	14.6	.33	.18	.26	.16	.03	.56	<.004	.010	.90	<.02	<.0011	<.0040	.02
1985-11-20,1	Straight sided bowl (rim)	Veneto-Saracenic	15C	88.1	10.4	1.04	.15	.03	.22	.32	.11	<.006	.017	.33	<.02	<.0019	<.0015	
Courtauld 199	Round-bottomed bowl (lid)	Veneto-Saracenic	15C	77.2	19.4	1.35	<.01	.03	.07	.05	.27	<.004	<.005	.13	<.01	<.0008	<.0015	.05
Courtauld 200	Round bottomed bowl (lid)	Veneto-Saracenic	15C	71.7	23.1	2.93	<.01	.08	.02	.05	.17	<.002	<.003	.07	<.01	.0006	<.0008	.02
Courtauld 204	Round-bottomed bowl (lid)	Veneto-Saracenic	15C	79.4	16.2	1.36	.08	.07	.13	.12	.30	<.006	<.008	.06	<.02	<.0013	<.0025	.08
	Round-bottomed bowl (bowl)			77.3	19.9	.97	<.01	.04	.08	.07	.17	<.003	<.003	.12	<.01	<.0005	<.0011	.04

Table 2 Analyses of Islamic raised metalwork

Reg No.	Description (part)	Provenance	Date	Cu	Zn	Pb	Sn	Ag	Fe	Sb	Ni	Au	Co	As	Bi	Mn	Cd	S
Courtauld 205	Round-bottomed bowl (lid)	Veneto-Saracenic	15C	78.9	14.3	1.33	.37	.05	.22	.07	.06	<.004	.011	.08	<.01	.0008	<.0016	.05
	Round-bottomed bowl (bowl)			80.8	14.5	1.45	.38	.05	.21	.07	.06	<.004	.014	.07	<.01	.0008	<.0016	.04
Courtauld 211	Round-bottomed bowl	Veneto-Saracenic	15C	74.5	18.6	1.59	<.02	.03	.14	<.02	.26	<.005	<.007	.05	<.02	.0025	<.0021	.06
1878-12-30,701	Round-bottomed bowl (rim)	Veneto-Saracenic	15C	83.9	12.2	1.13	.63	.12	.19	.17	.15	<.004	.008	.31	<.01	<.0013	<.0010	
1891-6-23,6	Round-bottomed bowl (rim)	Veneto-Saracenic	15C	82.6	14.5	1.59	.41	.10	.16	.13	.22	<.008	.007	.18	<.03	<.0027	<.0022	
	Round-bottomed bowl (lid)			81.8	14.1	1.52	.87	.11	.14	.13	.22	<.003	.009	.25	<.01	<.0012	<.0009	
1972-9-22,1	Round bottomed bowl	Veneto-Saracenic	15C	79.4	16.3	1.80	.27	.08	.21	.04	.05	<.005	.009	<.06	<.01	<.0016	<.0016	
1882-3-21,19	Spherical incense burner	Veneto-Saracenic	15C	78.1	18.5	1.78	.01	.04	.25	.01	.30	<.002	<.002	.07	<.01	.0017	<.0008	.04
1882-3-21,20	Spherical incense burner	Veneto-Saracenic	15C	69.5	20.6	1.39	.56	.05	.18	.05	.24	<.01	<.015	.05	<.05	.0026	<.01	.08
1878-12-30,683	Spherical incense burner (bowl)	Veneto-Saracenic	15C	71.9	23.2	1.52	<.01	.05	.13	.01	.25	<.003	<.004	.07	<.01	.0015	<.0012	.05
	(fastening band)			73.8	24.1	1.40	<.02	.05	.16	.03	.24	<.007	<.009	.10	<.02	.0018	<.0027	.11
	(inner ring)			73.9	23.6	1.32	<.01	.04	.14	.03	.25	<.003	<.004	.09	<.01	.0017	<.0013	.05
	(outer ring)			73.6	23.8	1.51	<.01	.04	.11	.03	.25	<.003	<.003	.10	<.01	.0022	<.0011	.04
1878-12-30,684	Spherical incense burner	Veneto-Saracenic	15C	81.5	16.0	1.11	.17	.05	.09	.05	.21	<.003	<.005	.08	<.02	<.0008	<.0030	.02
1878-12-30,685	Spherical incense burner	Veneto-Saracenic	15C	82.7	16.2	1.35	<.01	.04	.13	.03	.05	<.004	.015	.03	<.02	<.001	<.0040	.02
1878-12-30,728	Bucket (handle)	Veneto-Saracenic	15C	75.2	22.7	1.38	.05	.03	.16	.01	.25	<.002	<.003	.05	<.01	.0017	<.0012	.04
1878-12-30,714	Tray	Veneto-Saracenic	15C	70.2	12.1	.67	.33	.03	16.5†	.01	.20	<.003	.013	.05	<.02	.0017	.0059	.01
1878-12-30,712	Tray	Veneto-Saracenic	15-16C	80.2	17.3	.20	.38	.04	2.66	.02	.19	<.003	.019	.12	<.01	.0013	<.0011	.08
1878-12-30,713	Tray	Veneto-Saracenic	15-16C	80.8	14.4	1.95	1.30	.10	.23	.15	.16	<.003	.016	.25	<.01	<.0006	<.0010	.06
1891-6-23,7	Tray	Veneto-Saracenic	15-16C	80.3	17.0	.06	.39	.09	.76	.01	.56	<.003	.020	.34	<.01	.0008	<.0009	.11

Table 2 Analyses of Islamic raised metalwork

Reg No.	Description (part)	Provenance	Date	Cu	Zn	Pb	Sn	Ag	Fe	Sb	Ni	Au	Co	As	Bi	Mn	Cd	S
1957-2,3	Tray	Veneto-Saracenic	15-16C	83.6	14.1	1.08	.55	.07	.19	.08	.21	<.003	.007	.14	<.01	<.0006	<.0011	.03
1957-2,4	Tray	Veneto-Saracenic	15-16C	76.2	14.2	.09	.43	.07	9.0†	.03	.25	<.004	.014	.18	<.01	.0014	.0013	.08
1881-8-2.22	Spouted bowl (rim)	Veneto-Saracenic	15-16C	81.9	11.6	1.93	1.86	.11	.24	.23	.06	<.004	.035	.34	.04	.0009	<.0013	.08
1878-12-30,705	Tray	Jazira/Iran	15-16C	85.3	12.9	.94	.29	.06	.17	.03	.07	<.005	.024	.08	<.03	<.0009	<.0024	.02
1887-12-16,3	Bowl	Egypt	16C	84.7	13.0	1.20	.37	.04	.18	.05	.10	<.003	.023	.05	<.02	<.0005	<.0014	.02
OA+371	Astrolabe (frame)	Iberia	10C	75.0	23.5	.65		.10	.15		.02			.05				
	Astrolabe (pin)			79.5	18.3	.90	1.70		.15	.20	.04			.05				
	Astrolabe (dial)			77.5	20.5		2.20	.08	.15		.05			.20	<.01			
	Astrolabe (main pin)			77.0	21.2		1.20		.04					.02				
	Astrolabe (bar)			81.0	17.3	.39	1.90	.02	.09		.01			.03	<.01			
	Astrolabe (bar vertical)			80.5	17.2	.40	2.00	.02	.10		.02			.04	<.01			

Note:

† denotes iron contamination from iron wire used in the construction of the rim of the tray.

Table 3 Analyses of Islamic cast metalwork

Reg No.	Description (part)	Provenance	Date	Cu	Zn	Pb	Sn	Ag	Fe	Sb	Ni	Au	Co	As	Bi	Mn	Cd	S
1959-10-23,1	Ewer (handle)	Iran	8C	72.0	14.8	10.2	2.30	.13	.20	.10	.06			.55	.01			
	Ewer (base)			71.5	14.4	9.80	2.20	.12	.18	.10	.05			.70	.01			
1980-7-1,1	Ewer	Iran/Iraq	9C	67.0	14.7	15.1	2.78	.03	.20	.03	.03	<.005	.018	<.05	<.01	.0023	<.0020	
Zoh 48	Bottle (neck)	Iran	9-10C	68.2	11.2	15.8	3.06	.02	.44	.05	.64	<.004	.189	<.04	<.01	.0011	<.0011	
1926-3-19,1	Bottle (base)	Iran	9-10C	73.5	6.40	12.7	5.20	.06	.27	.35	.08		.030	.20	.01			
1969-3-19,1	Bottle (base)	Iran	9-10C	73.5	20.5	3.19	1.06	.14	.24	.12	.05	<.005	.004	.25	<.01	.0010	<.0015	
EC539	Ewer	Egypt	9-10C	69.8	2.57	19.0	6.00	.10	.23	.24	.07	<.002	.017	.33	.03	.0005	<.0013	.22
1975-9-22,1	Eagle	Egypt	10C	78.5	12.4	6.40	1.12	.05	.11	.08	.03		.008	.25	.01			
1923-5-12,376	Incense burner (lid)	Egypt	10-11C	71.0	2.21	18.8	5.65	.10	.25	.20	.07	<.002	.016	.24	.02	<.0005	<.0013	.18
1975-3-12,19	Eagle finial	Egypt	11C	71.6	3.73	18.1	3.82	.09	.68	.18	.07	<.003	.017	.32	.03	.0010	<.0014	.15
1964-6-15,1	Flask	Iran	10-11C	62.9	8.56	21.7	3.72	.10	.32	.35	.12	<.005	.017	.60	.02	<.0015	<.0015	
1939-10-18,1	Mortar	Iran	10-11C	74.5	1.70	19.4	3.20	.10	.50	.20	.06		.020	.30	.01			
1949-2-17,2	Plate	Iran	10-11C	80.5	.80	13.6	4.30	.11	.13	.25	.06		.015	.60	.01			
Ash. 1974.22	Incense burner (handle)	Iraq	10-12C	74.0	6.50	10.4	7.30	.10	.10	.55	.03			1.20	.03			
	Incense burner (base)			60.0	6.00	25.0	6.60	.08	.20	.38	.03			2.50	.03			
Ash. 1969.8	Ewer (handle)	Iran	12C	67.5	6.60	18.4	3.60	.13	.35	.80	.11		.020	1.10	.02			
	Ewer (base)			67.5	7.70	19.2	3.90	.11	.43	.95	.08		.020	.40	.03			
	Ewer (base)			63.0	7.70	23.0	3.20	.10	.40	.80	.11		.020	1.20	.03			

Table 3 Analyses of Islamic cast metalwork

Reg No.	Description (part)	Provenance	Date	Cu	Zn	Pb	Sn	Ag	Fe	Sb	Ni	Au	Co	As	Bi	Mn	Cd	S
1905-11-10,10	Lampstand (base)	Iran	12C	67.0	5.40	23.1	2.90	.10	.14	.42	.08		.010	.75	.01			
	Lampstand (base ring)			66.5	4.80	24.2	2.90	.10	.20	.45	.08		.070	.80	.01			
	Lamp (column)			72.0	4.60	18.0	3.00	.10	.15	.35	.08			.80	.01			
1966-7-28,1	Incense burner	Iran	12C	69.0	5.10	19.0	4.40	.09	.19	.45	.07		.020	.60	.02			
1956-7-26,2	Ewer (base)	Iran	12C	70.0	7.10	17.1	3.20	.10	.29	.40	.11		.020	.60	.02			
	Ewer (lip)			71.5	6.80	18.0	3.10	.10	.28	.45	.08		.015	.65	.02			
	Ewer (bird)			71.5	4.80	19.3	2.50	.08	.30	.40	.10		.045	.70	.02			
1956-7-26,8	Incense burner	Iran	12C	65.0	8.30	22.8	2.83	.08	.40	.24	.07		.015	.45	.01			
1953-2-17,2	Incense burner	Iran	12C	67.0	7.80	20.3	3.60	.13	.63	.45	.09		.020	.60	.02			
1939-6-20,1	Inkwell (body)	Iran	12C	73.0	10.6	13.0	3.10	.09	.21	.38	.06		.015	.47	.02			
	Inkwell (lid)			75.0	8.30	13.8	1.30	.08	.45	.50	.06	.040	.040		.04			
	Inkwell (loop)			73.0	9.00	14.2	3.70	.11	.23	.50	.05		.008	.25	.03			
1969-1-13,1	Ewer (spout)	Iran	12C	71.0	11.8	13.1	2.25	.11	.25	.20	.07		.025	.32	.02			
	Ewer (base)			72.0	6.80	16.9	2.30	.06	.23	.20	.06		.025	.35	.02			
1956-7-26,10	2 spouted lamp (trunion)	Iran	12C	72.0	6.80	15.8	3.50	.11	.46	.80	.11		.020	.65	.04			
	2 spouted lamp (right spout)			71.5	6.90	14.9	3.60	.10	.50	.80	.10		.020	.57	.03			
	2 spouted lamp (left spout)			73.0	6.50	14.5	3.50	.10	.55	.78	.10		.017	.35	.04			

Table 3 Analyses of Islamic cast metalwork

Reg No.	Description (part)	Provenance	Date	Cu	Zn	Pb	Sn	Ag	Fe	Sb	Ni	Au	Co	As	Bi	Mn	Cd	S
1969-2-13,1	Lampstand (cylinder)	Iran	12C	65.5	13.1	16.7	2.05	.11	.52	1.04	.09		.010	.38	.04			
	Lampstand (bottom knop)			66.0	10.1	19.2	2.60	.13	.36	.90	.09		.007	.50	.04			
	Lampstand (base knop)			68.0	15.4	12.5	2.70	.11	.50	.84	.09	.002	.008	.75	.02			
1981-8-6,1	Horse trapping	Syria	12C	86.0	11.0	.65	2.40	.13	.25	.04	.20		.003	.22				
1969-2-13,1	Lampstand (column)	Iran	12-13C	70.0	6.20	17.6	2.60	.11	.20	1.15	.11		.008	.97	.06			
	Lampstand (base)			67.0	12.4	14.5	2.70	.14	.22	.95	.13		.010	.70	.12			
1959-7-23,1	Bucket (footring)	Iran	12-13C	68.7	6.81	22.0	.86	.07	.17	.07	.13	<.009	.017	.56	<.03	<.0029	<.0017	
Ash. 1968.35	Incense burner (foot)	Iran	12-13C	67.0	8.90	18.8	3.00	.10	.18	.60	.10		.015	.50	.02			
	Incense burner (body)			67.0	7.50	20.3	3.20	.11	.19	.65	.10		.020	1.30	.02			
1956-7-26,9	Lamp	Iran	12-13C	67.5	7.35	18.5	3.10	.10	.42	.52	.10		.011	.65	.02			
Private coll.	Bird vessel			65.0	5.80	22.5	3.50	.05	.20	.60	.15		.015	.55	.01			
	Ring base		12-13C	69.0	12.5	14.0	2.70	.30	.25	.65	.21		.020	.40	.01			
1958-10-13.1	Cauldron	Iran	13C	63.7	13.0	20.6	1.50	.08	.44	.48	.14		.025					
1891-6-23.5	Writing box (lid)	Iran	13C	78.0	15.8	4.20	2.70	.05	.20	.10	.07		.050	.05	.01			
	Writing box (sides)			72.5	14.9	8.80	3.20	.06	.20	.20	.07		.040	.35	.01			
1967-7-24.1	Covered box (box)	Iran	13C	67.5	10.2	17.0	2.70	.10	.37	.40	.08		.015	.50	.02			
	Covered box (lid)			68.0	9.00	18.6	2.90	.11	.39	.50	.11		.020	.60	.02			

Table 3 Analyses of Islamic cast metalwork

Reg No.	Description (part)	Provenance	Date	Cu	Zn	Pb	Sn	Ag	Fe	Sb	Ni	Au	Co	As	Bi	Mn	Cd	S
1954-2-16,1	Lampstand (base)	Iran	13C	69.5	7.90	15.5	5.70	.10	.55	.35	.07		.040	.30	.04			
	Lampstand (column)			69.5	6.10	18.4	5.40	.20	.46	.25	.08		.025	.15	.01			
1885-10-10,10	Bucket (base)	Iran	13C	68.5	16.3	12.3	1.80	.09	.25	.48	.07		.010	.40	.04			
	Bucket (handle)			69.0	14.8	11.7	2.05	.10	.20	.50	.07		.010	.50	.04			
	Bucket (body)			70.0	16.8	11.3	1.60	.09	.24	.45	.08		.013	.45	.02			
1883-10-19,7	Flask (body)	Iran	13C	69.0	11.7	15.1	1.90	.08	.54	.45	.06		.015	.45	.04			
	Flask (ibex)			70.0	12.2	14.6	1.20	.08	.40	.47	.15		.015	.50	.04			
1914-5-15,1	Lamp (base)	Egypt	12-13C	65.5	13.8	16.9	2.25	.07	.37	.20	.08		.010	.40	.01			
	Lamp (stem)			78.5	2.20	14.8	3.80	.10	.18	.30	.06		.015	.40	.01			
	Lamp (bowl)			76.5	3.05	16.0	3.80	.10	.25	.30	.07		.015	.60	.01			
	Lamp (bird)			78.5	1.60	14.2	3.70	.10	.23	.20	.06			.30	.01			
	Lamp (lid)			77.5	9.80	12.6	.30	.04	.18	.09	.04		.015	.30	.01			
	Lamp (top)			75.0	2.20	18.0	3.60	.09	.17	.30	.07		.012	.45	.01			
1855-7-9,1	Astrolabe (frame)	Egypt	1236	78.0	13.6	8.00	.10	.06	.64	.15	.04		.025	.05	.02			
	Astrolabe (attachment ring)			78.0	12.7	6.80	.70	.05	.22	.15	.09		.035	.25	.01			
	Astrolabe (suspension ring)			73.0	20.5	.77	6.20	.04	.16	.02	.22			.08	.02			
	Astrolabe (main pin)			79.0	11.8	5.60	3.50	.05	.20	.15	.09		.045	.15	.01			
	Astrolabe (bar)			79.0	16.9	1.80	2.00	.04	.11	.02	.03			.10	.01			
	Astrolabe (bar upright)			80.0	16.5	1.90	2.00	.05	.15	.05	.03				.01			

Table 3 Analyses of Islamic cast metalwork

Reg No.	Description (part)	Provenance	Date	Cu	Zn	Pb	Sn	Ag	Fe	Sb	Ni	Au	Co	As	Bi	Mn	Cd	S
1880-3-8,1	Astrolabe (frame)	Syria	1270-1	76.5	17.6	4.70	1.50	.06	.12	.06	.04		.020	.30	.02			
	Astrolabe (suspension ring)			75.0	20.1	3.90	.25	.06	.18	.16	.17			.07	.02			
	Astrolabe (attached ring)			82.0	15.6	.60	.40	.08	.06	.30	.14		.075	1.30	<.01			
	Astrolabe (dial)			73.0	18.2	7.10	.45	.05	.19	.15	.05		.050	.40	<.01			
	Astrolabe (main pin)			74.0	1.00	16.2	5.80	.34	.06	1.90	.14	.080	.008	.60	.03			
1878-12-30,679	Incense burner (foot)	Syria	13C	71.5	7.70	16.1	3.80	.10	.42	.25	.07		.025	.30	.01			
	Incense burner (rim)			71.5	7.60	16.5	3.90	.10	.40	.30	.07		.025	.25	<.01			
	Incense burner (lid)			75.0	7.60	12.8	3.20	.08	.35	.15	.07		.020	.40	<.01			
1848-8-5,1	Ewer (handle)	Khurasan	c.1200	79.5	18.8	1.26	.69	.03	.10	.04	.02	<.004	.009	.44	.03	<.0019	<.0037	.05
1888-5-26,1	Astronomical table (frame)	Iraq	1241-2	76.5	17.0	4.40	.90	.07	.29	.15	.05		.050	.30	<.01			
	Astronomical table (frame)			82.0	17.2	.65	.15	.04	.35	.06	.04		.060	.50	<.01			
1878-12-30,678	Incense burner	Iraq	1243-4	71.0	14.0	10.6	3.30	.51	.35	.12	.07		.030	.60	<.01			
1871-3-1,1	Globe (base ring)	Iraq	1275	74.0	15.6	7.80	2.10	.10	.26	.25	.06		.010	.08	<.01			
	Globe (base stem)			74.0	15.5	7.20	2.00	.90	.35	.15	.05		.015	.50	<.01			
	Globe (frame)			74.0	16.6	5.00	1.80	.60	.32	.08	.05		.025	.50	<.01			
1871-3-1,1	Globe (upper hemisphere)	Iraq	13C	76.0	15.2	6.30	1.50	.06	.28	.25	.06		.045	.25	.01			
	Globe (lower hemisphere)			76.5	14.0	6.40	1.20	.06	.23	.26	.06		.045	.40	.01			

Table 3 Analyses of Islamic cast metalwork

Reg No.	Description (part)	Provenance	Date	Cu	Zn	Pb	Sn	Ag	Fe	Sb	Ni	Au	Co	As	Bi	Mn	Cd	S
1878-12-30,674	Box (catch plate)	Iraq	13C	78.0	12.0	6.80	1.90	.07	.28	.13	.04		.040	.50	.01			
	Box (top catch plate)			78.5	12.4	6.60	1.90	.07	.28	.18	.04		.040	.55	.01			
	Box (bottom hinge)			76.5	13.5	6.60	1.80	.07	.33	.19	.06		.025	.75	.01			
	Box (top hinge)			77.5	12.8	6.60	1.90	.11	.31	.02	.05		.030	.60	.01			
1949-2-17,1	Candlestick	Iran/Jazira	13C	77.0	9.59	8.58	2.97	.17	.28	.19	.07	<.003	.034	.45	.02	<.0005	<.0014	.07
1954-10-16,1	Candlestick	Iran/Jazira	13C	72.0	1.23	18.4	6.01	.15	.32	.22	.06	<.003	.009	.33	.02	.0005	<.0013	.14
1955-2-14,1	Candlestick	Anatolia/Jazira	13C	73.0	3.33	13.1	7.71	.08	.37	.22	.08	<.002	.025	.54	.04	<.0005	<.0012	.11
	Candlestick			73.1	3.03	17.1	5.86	.09	.22	.32	.06	<.003	.015	.35	.03	<.0005	<.0014	.12
1881-1-27,1	Candlestick	Iran/Jazira	13C	74.8	12.8	7.73	1.88	.06	.29	.14	.07	<.003	.066	.44	.02	<.0005	<.0013	.15
1885-10-10,8	Candlestick	E. Turkey	13C	71.7	7.61	16.5	3.47	.09	.41	.31	.08	<.004	.043	.49	.04	<.0020	<.0040	.14
1948-5-8,3	Vase (rim)	Iraq	13-14C	74.6	18.8	2.75	1.43	.06	.37	.11	.07	<.005	.043	.40	<.01	<.0014	<.0014	
1955-4-23,1	Candlestick	Iraq	14C	73.3	11.0	11.3	2.47	.08	.60	.21	.07	<.007	.045	.59	<.02	<.0021	<.0021	
1862-12-27,1	Quadrant (body metal)	Egypt/Syria	1345-6	81.0	14.4	1.30	2.00	.06	.05	.25	.12		.015		<.01			
	Quadrant (stud)			81.5	14.3	1.30	2.05	.04	.13	.28	.12				<.01			
	Quadrant (ring)			81.0	16.4	.60	1.60	.06	.15	.03	.06		.015	.04				
1878-12-30,681	Incense burner (base)	Egypt/Syria	14C	75.5	10.8	8.50	4.00	.08	.60	.15	.05		.050	.50	<.01			
	Incense burner (lid)			76.5	7.20	8.80	5.10	.09	.40	.20	.05		.035	.50	.01			

Table 3 Analyses of Islamic cast metalwork

Reg No.	Description (part)	Provenance	Date	Cu	Zn	Pb	Sn	Ag	Fe	Sb	Ni	Au	Co	As	Bi	Mn	Cd	S
1866-12-29,74	Box (catch plate)	Egypt/Syria	14C	71.5	4.90	18.0	6.00	.12	.23	.43	.08		.010	.50	.01			
	Box (catch plate)			81.5	12.2	3.20	2.90	.16	.25	.09	.04		.020	.10	<.01			
	Box (hinge)			81.0	12.6	2.40	2.50	.19	.27	.12	.04		.030	.12	<.01			
1878-12-30,680	Incense burner (foot)	Egypt/Syria	14C	80.5	8.60	4.40	4.30	.14	.12	.85	.03		.010	.20	.01			
	Incense burner (lid)			80.0	8.80	5.90	4.30	.16	.15	1.10	.09		.007	.50	.01			
1887-6-12,1	Ewer (handle)	Egypt	14C	76.0	10.9	7.80	.70	.15	.19	2.40	.29		.007	.70	.02			
	Ewer (body)			83.0	11.8	4.00	.40	.15	.20	.25	.02			.15	.01			
	Ewer (ring)			74.5	10.8	10.1	.60	.13	.17	2.80	.26		.006	.65	.03			
1908-3-28.2	Box (lower stanchion)	Egypt	15C	71.5	10.0	9.60	3.10	.06	.80	.20	.09		.003	.06	.01			
	Box (handle)			70.0	22.5	5.60	1.60	.03	.18	.04	.05			.05	<.01			
1953-10-21,2	Candlestick (base)	Egypt/Syria	15C	81.8	9.64	1.57	4.04	.16	.04	1.00	.02	<.002	<.003	.04	.08	.0011	<.0013	<.01
	Candlestick (top)			84.4	7.88	1.00	3.81	.17	.05	1.05	.04	<.002	<.003	.08	.07	.0012	<.0012	.02
1956-7-26,17	Sauce boat (bird finial)	Syria	16C	71.4	28.0	.51	.07	.26	.10	<.01	.01	<.003	<.003	.02	.02	<.0005	.0152	.02
1878-12-30,676	Casket (foot)	Iran	14C	71.5	16.8	6.80	3.30	.21	.30	.10	.03		.010	.25	<.01			
	Casket (lid)			73.0	16.2	6.75	3.30	.08	.60	.09	.03		.006	.25	<.01			
	Casket (stud)			76.5	19.8	2.20	.50	.08	.12	.07	.02			.20	<.01			
1957-8-1,1	Casket (body)	Iran	14C	73.5	15.5	9.10	1.70	.05	.20	.13	.03		.050	.17	<.01			
	Casket (lid)			73.0	15.7	9.00	1.70	.05	.20	.17	.03		.008	.25	<.01			

Table 3 Analyses of Islamic cast metalwork

Reg No.	Description (part)	Provenance	Date	Cu	Zn	Pb	Sn	Ag	Fe	Sb	Ni	Au	Co	As	Bi	Mn	Cd	S
1878-12-30,675	Casket (foot)	Iran	14C	68.0	9.60	17.5	4.10	.11	.20	.40	.07		.020	.45	.01			
	Casket (lid)			67.5	9.50	17.5	4.30	.10	.20	.40	.07		.015	.55	.01			
	Casket (handle)			77.0	19.8	1.10	1.30	.31	.28	.18	.05			.65	.01			
1969-11-9,1	Cymbal	Iran	14C	66.0	8.00	17.8	3.60	.11	.37	.68	.07		.027	2.00	.04			
	Cymbal			66.5	6.70	18.6	3.85	.11	.40	.70	.08		.025	2.25	.04			
1896-3-23,1	Celestial globe (lower half)	Iran	1430-1	83.0	.84	6.40	8.60	.10	.15	.25	.06		.005	.30	.01			
	Celestial globe (frame)			72.0	3.00	14.8	8.40	.07	.41	.25	.06		.010	.50				
1962-7-18,1	Vase	Iran	1497	77.7	15.9	4.39	1.70	.03	.12	.04	.05		.008					
1956-7-26,14	Cup	Iran	15C	68.5	8.50	16.3	4.20	.07	.25	.34	.07		.024	.55	.04			
1878-12-30,730	Vase	Iran	15C	63.9	22.7	9.38	3.50	.04	.26	.06	.05		.019					
1878-12-30,731	Vase	Iran	15C	71.2	18.1	8.95	1.20	.05	.31	.11	.07		.021					
1878-12-30,732	Vase	Iran	1511	82.0	12.6	4.11	1.00	.02	.10	.04	.04		.005					
1847-3-20,1	Ewer (base)	Iran	16C	93.5	.01	.10	5.20	.06	.05		.07			.30	<.01			
1878-12-30,700	Bowl (rim)	Veneto-Saracenic	15C	76.1	22.1	.68	<.16	.09	.10	<.02	.33	<.005	.007	.33	<.02	.0008	<.0013	
1891-6-23,6	Incense burner (inner bowl)	Veneto-Saracenic	15C	72.5	1.55	19.0	4.27	.11	.14	.76	.09	<.005	.007	.43	<.01	<.0014	<.0014	
1970-6-3,1	Jug (rim)	Veneto-Saracenic	15C	81.0	15.7	1.90	.17	.06	.13	.08	.20	<.005	<.003	.12	<.02	.0017	<.0014	
	Jug (lid)			83.5	13.7	2.10	.11	.06	.11	.09	.21	<.003	<.002	.10	<.01	.0006	<.0009	
1855-12-1,6	Candlestick	Veneto-Saracenic	15C	78.8	10.2	6.70	3.75	.20	.12	.47	.07	<.004	.004	.46	.01	<.0011	<.0011	
OA+4555	Bowl with foot ring	Veneto-Saracenic	15C	81.6	13.6	2.30	1.47	.10	.20	.47	.19	<.003	<.004	.15	<.01	<.0007	<.0030	.07

Table 3 Analyses of Islamic cast metalwork

Reg No.	Description (part)	Provenance	Date	Cu	Zn	Pb	Sn	Ag	Fe	Sb	Ni	Au	Co	As	Bi	Mn	Cd	S
1878-12-30,728	Bucket (washer)	Veneto-Saracenic	15C	84.4	14.2	1.79	.18	.04	.19	.23	.08	<.002	<.003	.28	<.02	<.0005	<.0012	.02
	Bucket (rim)			81.6	15.4	3.50	.07	.03	.18	.20	.09	<.002	<.003	.26	<.02	<.0005	<.0013	.01
1957-2-2,6	Bucket (handle)	Veneto-Saracenic	15C	69.7	23.5	2.61	2.48	.04	.39	.09	.07	<.003	<.003	.16	.03	<.0005	.0042	.05
	Bucket (rim)			81.0	15.1	4.73	.36	.06	.23	.06	.04	<.003	.005	.04	<.02	.0008	<.0014	.02
1855-12-1,6	Candlestick	Veneto-Saracenic	15C	71.9	2.95	15.9	4.38	.14	.13	1.42	.09	<.002	.009	.32	.05	<.0005	<.0012	.14
	Candlestick			75.7	3.70	12.8	4.16	.14	.14	1.51	.08	<.002	.006	.30	.05	<.0005	<.0013	.08
1878-12-30,721	Candlestick (top)	Veneto-Saracenic	15C	79.2	4.00	9.55	2.55	.17	.08	2.24	.10	<.006	<.004	.36	.06	<.0019	<.0015	.09
	Candlestick (base)			79.8	5.00	7.84	2.44	.17	.08	2.05	.09	<.005	<.004	.55	.05	<.0018	<.0014	.09
Courtauld 202	Tray	Veneto-Saracenic	15C	77.8	11.2	4.51	.91	.04	.22	1.17	1.39	<.002	.005	.74	<.01	.0007	<.0009	.18
OA+2604	Spouted bowl (rim)	Veneto-Saracenic	15-16C	71.7	6.22	15.9	4.05	.10	.39	.31	.08	<.003	.027	.51	.02	<.0005	<.001	.34
1865-12-9,2	Bucket (handle)	Veneto-Saracenic	15-16C	72.8	19.7	6.10	.08	.04	.56	.02	.10	<.002	.008	.04	<.01	<.0005	.0009	.09
	Bucket (rim)			74.1	16.7	4.16	.81	.04	.50	.70	1.78	<.003	.006	.67	.01	.0009	<.0009	.09
1878-12-30,724	Candlestick (top)	Veneto-Saracenic	15-16C	77.9	10.9	7.00	2.11	.10	.45	.59	.34	<.003	.008	.41	.04	<.0005	<.0009	.08
	Candlestick (drip tray)			78.7	7.00	7.72	4.32	.09	.54	.61	.36	<.002	.009	.41	.03	<.0005	<.0008	.10
	Candlestick (base)			81.8	9.84	4.86	2.37	.08	.42	.60	.41	<.003	.008	.43	.03	<.0005	<.0009	.10
1878-12-30,725	Candlestick (top)	Veneto-Saracenic	15-16C	83.0	13.9	2.29	.96	.07	.48	.32	.38	<.003	.003	.28	<.01	<.0005	<.0009	.06
	Candlestick (drip tray)			78.7	5.15	10.3	2.78	.09	.41	.86	.44	<.003	.016	.38	.03	<.0005	<.0009	.11
	Candlestick (base)			80.4	9.19	5.63	2.60	.10	.44	.58	.36	<.003	.006	.39	.03	<.0005	<.0009	.09
1882-3-21,18	Vase (foot)	Veneto-Saracenic	15-16C	77.9	19.6	1.57	.12	.05	.11	.23	.29	<.003	<.003	.38	<.01	.0006	<.0009	.06
1896-10-9,2	Candlestick (base)	Veneto-Saracenic	15-16C	79.5	11.8	3.45	.31	.04	.40	3.15	1.31	<.002	.022	.62	.03	.0004	<.0008	.08

Table 3 Analyses of Islamic cast metalwork

Reg No.	Description (part)	Provenance	Date	Cu	Zn	Pb	Sn	Ag	Fe	Sb	Ni	Au	Co	As	Bi	Mn	Cd	S
1896-10-9.3	Candlestick (base)	Veneto-Saracenic	15-16C	78.8	12.1	3.44	.29	.04	.49	2.96	1.53	<.003	.028	.62	.03	.0006	<.0010	.08
1957-2-2.5	Bucket (handle)	Veneto-Saracenic	15-16C	79.5	13.3	5.41	.90	.05	.50	.10	.12	<.002	.004	.11	<.01	<.0004	<.0007	.08
	Bucket (rim)			80.7	12.8	6.02	1.13	.05	.58	.09	.14	<.002	.006	.11	.02	<.0005	<.0008	.08
OA+371	Astrolabe (suspension ring)	Iberia	10C	77.0	22.9	.12	.50	.01	.07		.01							
	Astrolabe (attachment ring)			75.5	23.0	.55	.65	.01	.11	.30	.15			.04	<.01			
Granada 143	Candlestick (base)	Spain	10C	68.2	27.8	3.43	<.21	.02	.12	<.02	.03	<.007	<.004	.19	<.02	.0021	<.0021	
	Candlestick (pillar)			68.1	26.8	3.39	<.19	.02	.03	<.02	.02	<.007	<.004	.15	<.02	.0019	<.0019	
	Candlestick (openwork)			69.1	28.0	3.49	<.19	.02	.02	<.02	.02	<.007	<.004	<.08	<.02	.0019	<.0019	
	Candlestick (bird)			69.4	27.3	3.12	<.12	.02	.03	<.01	.02	<.004	<.002	.09	<.01	.0024	<.0012	
	Candlestick (ring)			67.8	28.4	3.51	<.13	.02	.04	<.01	.02	<.005	<.003	.12	<.01	.0027	<.0013	
	Candlestick (pricket)			68.2	28.3	3.68	<.12	.02	.03	<.01	.02	<.004	<.002	.13	<.01	.0027	<.0012	
Granada 1	Lamp fragment	Spain	10C	67.1	16.4	11.8	2.58	.08	1.04	.64	.07	<.004	.008	.36	.01	.0010	<.0010	
Granada 2	Lamp fragment	Spain	10C	72.4	17.2	1.89	1.15	.03	.05	.23	.10	<.004	.002	2.20	<.01	.0015	<.0010	
Granada 552	Lamp (base)	Spain	10C	69.0	14.2	10.4	3.10	.11	.33	.73	.07	<.004	.008	.41	.02	<.0010	.0030	
	Lamp (chain)			79.8	17.4	.47	1.45	.04	.27	<.01	.11	<.004	.009	<.04	<.01	.0021	<.0010	
	Lamp (cap)			76.1	13.8	4.12	1.37	.05	.21	.35	.12	<.004	.004	2.02	<.01	.0010	<.0010	
	Lamp (ball)			71.1	16.1	9.69	1.30	.04	.16	.16	.05	<.004	.003	.39	.01	<.0010	<.0010	
Granada 406	Handle of vessel	Spain	10C	77.7	18.0	2.05	1.97	.03	.46	.07	.03	<.004	<.002	.28	.01	.0021	<.0011	
Granada 632	Disc	Spain	10C	69.2	12.2	10.2	3.25	.12	.50	.78	.07	<.004	.010	.51	.02	<.0010	<.0010	

Table 3 Analyses of Islamic cast metalwork

Reg No.	Description (part)	Provenance	Date	Cu	Zn	Pb	Sn	Ag	Fe	Sb	Ni	Au	Co	As	Bi	Mn	Cd	S
Granada 140	Astrolabe (base)	Spain	16C	73.5	8.35	10.0	4.35	.13	.79	.15	.04	.007	.010	1.73	<.01	<.0012	.0025	
	Astrolabe (finial)			66.6	26.3	3.60	1.94	.16	.73	.15	.07	.006	.002	.28	.02	<.0011	<.0011	
	Astrolabe (crossbar)			77.8	19.5	1.84	.71	.06	.16	.06	.22	<.004	.002	.23	<.01	<.0011	<.0011	
	Astrolabe (rim of disc)			76.8	19.8	1.84	.49	.07	.21	.10	.26	<.004	<.002	.52	<.01	.0012	<.0012	
	Astrolabe (large ring)			79.9	18.3	1.43	<.11	.11	.16	.06	.24	.006	<.002	.06	<.01	<.0011	<.0011	
	Astrolabe (rotating dial)			73.8	24.8	1.52	<.18	.04	.13	.04	.20	<.006	<.004	<.07	<.01	.0018	<.0018	
Granada 4421	Lamp (base)	Spain		74.5	14.7	5.50	2.44	.04	.64	.17	.04	<.004	<.003	.38	.02	.0016	<.0013	
Granada 3365/617	Fitting	Spain		70.8	27.5	1.36	<.11	.01	.05	<.01	.04	<.004	<.002	.23	<.01	.0016	.0011	
Granada 615	Candlestick (base)	Spain		72.0	27.3	1.02	<.18	.01	.10	<.02	.02	<.006	<.004	.15	<.02	.0018	<.0018	
Granada 65	Handle	Spain		73.3	26.1	.11	<.22	.00	.02	<.02	.03	<.008	<.004	.11	<.02	<.0022	.0022	
Granada 25	Handle	Spain		74.0	26.2	.35	<.20	.01	.07	<.02	.04	<.007	<.004	.10	<.02	<.0020	<.0020	
Granada 684	Candlestick fragment	Spain		73.9	21.9	2.90	.61	.02	.43	<.01	.02	<.004	<.002	.12	<.01	<.0012	<.0012	

Table 4 Analyses of 'Haft Jush' metalwork

Reg No.	Description (part)	Provenance	Date	Cu	Zn	Pb	Sn	Ag	Fe	Sb	Ni	Au	Co	As	Bi	Mn	Cd
1950-7-25,1	Covered bowl (lid)	Iran	12C	79.0		.04	19.6	.01	.05		.04		.020	.05			
	Covered bowl (base)	Iran	12C	78.5	.20	.03	19.8	.06	.07		.02			.15	.01		
Private coll.	Handle	East Iran	12C	79.5		.20	20.0	.06	.15	.05	.05	.060	.030	.30	<.01		
1969-9-24,1	Footed bowl	Iran	12C	78.4	.01	.03	20.2	.02	.91	.03	.08		.278				
Private coll.	Bowl	Iran	14C	78.0	.60	.05	20.0	.04	.08	.10	.08		.040	.80			
1891-6-23,4	Goblet (body)	Iran	14C	79.0	.06	.05	20.0	.06	.06	.10	.05		.035	.20	<.01		
1969-2-15,1	Lid (copy of Haft Jush)	Iran	11C	65.0	9.70	20.7	3.10	.07	.27	.12	.09		.015	.25	.01		

Table 5 Analyses of Islamic mirrors

Reg No.	Description (part)	Provenance	Date	Cu	Zn	Pb	Sn	Ag	Fe	Sb	Ni	Au	Co	As	Bi	Mn	Cd
1866-12-29,76	Mirror	Iran	11-12C	81.0	.40	5.50	12.5	.06	.90	.15	.06		.050	.50	.01		
1866-12-29,75	Mirror	Iran	12C	76.0	2.15	10.2	10.1	.06	.26	.45	.07		.035	.30	.01		
1963-7-18,1	Mirror	Iran	13C	76.9	6.46	2.10	13.1	.18	.10	1.26	.10	<.007	.016	.20	<.01	<.002	<.002

Table 6 Analyses of Islamic mortars

Reg No.	Description (part)	Provenance	Date	Cu	Zn	Pb	Sn	Ag	Fe	Sb	Ni	Au	Co	As	Bi	Mn	Cd
1939-10-18,1	Mortar	Iran	10-11C	74.5	1.70	19.4	3.20	.10	.50	.20	.06		.020	.30	.01		
A.Rigby loan 3	Mortar	Iraq	12C	67.0	7.00	20.1	3.60	.10	.32	.58	.12		.020	.06	.02		
1883-10-20,7	Mortar	Iran	13C	69.5	8.60	17.6	2.70	.13	.32	.75	.11		.020	.62	.05		
1907-11-9,1	Mortar	Syria?	12-16C	66.3	.04	26.8	5.17	.08	.02	.22	.02			.94	.12		
1907-11-9,4	Mortar	Syria?	12-16C	82.0	.01	10.4	6.16	.02	.01	.09	.14	.001	.011	.27	.01		
1907-11-9,5	Mortar	Syria?	12-16C	79.1	.02	7.63	10.2	.11	.04	.80	.13		.009	.40	.06		
1907-11-9,6	Mortar	Syria?	12-16C	83.7	9.02	5.24	1.84	.01	.49	.18	.02			.54			.0020
1907-11-9,7	Mortar	Syria?	12-16C	74.1	.27	19.4	6.07	.02	.02	.33	.05	.001		.22	.07		
1956-7-26,4	Mortar	Syria?	12-16C	68.2	5.78	21.2	2.93	.01	.16	.39	.09	.003	.010	.68	.02		

Table 7 Analyses of Islamic tinned-copper metalwork

Reg No.	Description (part)	Provenance	Date	Cu	Zn	Pb	Sn	Ag	Fe	Sb	Ni	Au	Co	As	Bi	Mn	Cd	S
Raised:																		
1956-7-26,5	Ewer (neck)	Iran	12C	97.5	<.01	.72	.02	.06	<.01	.06	.07	<.003	<.003	.24	.02	<.0017	<.0033	.02
	Ewer (base)			94.3	.05	3.65	.47	.12	.02	.17	.05	<.002	<.002	.37	.03	<.0012	<.0023	.04
	Ewer (handle)			99.2	.01	.68	<.01	.13	.01	.12	.05	<.003	<.003	.22	.03	<.0013	<.0027	.03
1957-2-2,8	Bowl	Veneto-Saracenic	15C	98.5	.12	.83	1.29	.06	.27	.16	.06	<.002	.009	.17	<.02	<.0005	<.0013	<.01
OA+2526	Bowl	Egypt/Syria	15C	94.5	1.64	.79	.72	.05	.29	.11	.07	<.003	.016	.29	<.02	<.0005	<.0014	.02
1866-12-29,68	Bowl	Egypt/Syria	15C	99.0	.03	.39	1.26	.05	.42	.12	.05	<.003	.013	.22	.02	<.0005	<.0014	.04
1957-2-2,7	Bowl	Egypt/Syria	15C	94.4	1.43	1.91	1.24	.11	.08	.20	.06	<.002	.017	.26	<.02	<.0005	<.0013	.03
1888-1-5,2	Bowl	Egypt/Syria	15C	93.9	.55	2.22	2.26	.10	.23	.28	.05	<.003	.007	.18	.02	<.0005	<.0013	.02
1957-8-2,1	Bowl	Egypt/Syria	15-16C	96.2	.02	.51	.88	.03	.24	.08	.05	<.003	.018	.21	<.02	<.0005	<.0014	<.01
1957-8-2,2	Basin	Egypt/Syria	15-16C	98.5	.45	.74	.95	.06	.34	.15	.05	<.002	.011	.19	.02	<.0005	<.0013	.02
1957-8-2,3	Basin	Egypt/Syria	15-16C	96.2	.42	.68	1.07	.05	.65	.14	.04	<.003	.008	.21	.02	<.0005	<.0014	<.01
1957-8-2,4	Spouted bowl	Egypt/Syria	15-16C	97.4	.18	.60	.69	.06	.22	.19	.05	<.003	.011	.18	.02	<.0005	<.0014	<.01
Cast:																		
1988-5-24,1	Tray	Veneto-Saracenic	15C	89.3	.81	4.47	2.65	.08	1.52	.31	.06	<.005	.009	.20	.04	<.0011	<.0029	.03

Notes to Tables 1 to 7:

The analyses were carried out over a number of years, initially using atomic absorption (AAS), but later using inductively coupled plasma atomic emission spectrometry (ICP-AES).

The final decimal place of the early AAS results were rounded to the nearest zero or five to indicate that little stress should be placed on the actual value of this figure. This procedure has been replaced by the more usual use of decimal numbers for the later AAS analyses and all the ICP-AES analyses.

Some of the earlier results have been previously discussed, but not published, in Craddock (1979).

The figures (expressed in weight per cent) have a precision of c. ±2% for copper and c. ±5-10% for zinc, tin and lead when present in major amounts.

The remaining minor and trace elements have a precision of c. ±10-30%, deteriorating to ±50% at the detection limit.

A blank (missing value) usually denotes an element not found using AAS. The following approximate detection limits apply:

Cadmium (Cd) and Manganese (Mn) 0.001; Silver (Ag), Gold (Au), Cobalt (Co) and Nickel (Ni) 0.005; Bismuth (Bi), Iron (Fe), Lead (Pb), Antimony (Sb) and Zinc (Zn) 0.01; Arsenic (As) 0.04 and Tin (Sn) 0.2. '<' denotes an element not present above the quoted detection limit.

Bismuth was analysed using AAS throughout. Sulphur cannot be analysed using AAS.

Phosphorus was looked for during the ICP-AES analyses, but was not present above the detection limit in any of the samples.

'Ash' denotes an object from the Ashmolean Museum, Oxford.

The term 'Veneto-Saracenic' has been used to describe a large group of metal vessels produced in the 14-16th centuries which display a mixture of Middle Eastern and European elements (see Ward et al. 1995).

Plate 1 *Tutiya* globular jug of cast zinc, heavily encrusted with jewels. Dated to the mid-sixteenth century AD. Topkapi Saray Museum, Istanbul (TKS 2/2856)

Plate 2 *Tutiya* globular jug of cast zinc, heavily encrusted with jewels. Dated to the mid-sixteenth century AD. Topkapi Saray Museum, Istanbul (TKS 2/2873)

Fig. 1 Location map of some of the principal places mentioned in the text 'Traditional zinc-smelting technology in the Guma district of Hezhang county of Guizhou province, China' by Xu li.

TRADITIONAL ZINC-SMELTING TECHNOLOGY IN THE GUMA DISTRICT OF HEZHANG COUNTY OF GUIZHOU PROVINCE, CHINA

Xu Li

Chinese University of Science and Technology

Translated by Jens O. Petersen, Copenhagen, Denmark[1]

Smelting zinc is relatively difficult, the thermal reduction of zinc oxide requiring an intense reducing atmosphere and high temperatures. Generally speaking the reducing reaction of zinc oxide will proceed smoothly only at temperatures above 1000°C, but as the boiling point of zinc is *c.* 907°C, the metallic zinc obtained by reduction in pyrogenic zinc-smelting with furnace temperatures above 1000°C is gaseous. The metallic zinc vapour contained in the furnace gas is very easily re-oxidized, and therefore in order to obtain usable zinc, one must provide for an effective way of condensing the zinc-bearing furnace gas. This means in terms of production processes that one must adopt a distillation method.

China was relatively early to adopt the pyrogenic method of zinc-smelting. In the 1920s Chinese scholars carried out systematic, text-critical research into the origins, development and technology of zinc-smelting in ancient China (Wang Jin and Zhang Hongzhao 1957). More than 60 years have passed since then, but research in this area has not shown great progress. The main reason for this is that the source material found to date is far too meagre - if one depends solely on the presently available written sources, one will not reach a deeper understanding of the zinc-smelting techniques of ancient China. In order to make headway within this field one must - if more source material is not excavated - study the traditional zinc-smelting technology that has been handed down from ancient times among the people.

The importance of the study of traditional techniques to research on the history of science and technology was noted many years ago. Wang Jin (1919) pointed out that

> since in ancient times China excelled in the study and use of metallic substances, there must have existed a wealth of experience and methods within the fields of mining and smelting. Alas, the written sources are so few and there is no way of knowing about these things other than conducting field studies.

The mountainous western part of Guizhou Province occupies an important place in Chinese history as a zinc-smelting area (Fig. 1, see opposite). Here the traditional zinc-smelting technology, passed down from former times, is still practised, thus making the area ideal for pursuing such studies. The present paper contains the partial results of studies made in the Guma district in Hezhang County.

A BRIEF DESCRIPTION OF THE GUMA DISTRICT

The Guma district is located in the western part of Hezhang County, Guizhou Province, on the eastern border of the Yunnan-Guizhou Plateau and to the south of Mount Wumeng. Its elevation is generally around 2000m. The area has a ragged terrain.

The subterranean resources of the Guma district are very rich. All the raw materials necessary for traditional zinc-smelting, such as oxidised zinc ores (mostly calamine (smithsonite) and hemimorphite), coal (both the kind used for fuel and that used as reducing agent), and the different kinds of fireclay all exist in abundance and do not have to be brought in from other areas. Moreover, the deposits do not lie deep in the ground and are ideal for unmechanized extraction. Because this area had such advantageous natural conditions, an economic zone based on mining and smelting with the town of Magu as its centre gradually developed. The prosperity and decline of these industries directly influenced the economic ups and downs of the area.

There are several ancient zinc-smelter sites in the Guma district. At these sites there are piles of slag and distillation residues so thick that one can dig several metres down without reaching the bottom. There are also numerous ancient retorts used for zinc-smelting and other remains. At the ore veins can be seen many old shafts, mostly completely worked out. From these remains one can not only observe the scale of mining and smelting in bygone times, but also infer that zinc-smelting has a fairly long history in this area.

There is at the present moment no way of determining when the smelting of metallic zinc began in the Magu district, but we are able to find some clues in local gazetteers.

According to the *Dading Prefectural Gazetteer* (Zou Hanxun and Fu Ruhuai n.d.) the *Weining Subprefectural Gazetteer* says:

At Yinchanggou [Silver Works Canal] in Tiangiao [Heavenly Bridge] black lead and white lead are produced; there are both long and high furnaces. [The works] are located on the border between Yunnan and Guizhou Provinces. A tradition passed down by the elders has it that the works have been in operation since the Tianfu reign period of Emperor Gaozu of the Han dynasty of the Five Dynasties period.[2]

Tiangiao Yinchanggou is in the present Shashi Township in Magu district, Hezhang County. White lead is metallic zinc; long furnaces are the local furnaces for smelting zinc to be described below (Pls 2-6). Black lead denotes metallic lead and high furnaces are furnaces for lead-smelting. The reign-name Tianfu was used only in the one year of AD 907.

The same local gazetteer also has the following entry:

Mt. Dabao is 105 *li* [c. 50 km] to the east of the city, by Yinchanggou. There is a silver and lead works called Tiangiaochang [Heavenly Bridge Works]; its original name was Lianhuachang [Lotus Blossom Works]. The extraction began in the Tianfu reign period of the Han dynasty of the Five Dynasties period; by the old mine shafts there is an inscription on the side of the cliff to record this fact. The mine shafts are the oldest in Yunnan and Guizhou Provinces.

The twentieth century *Weining County Gazetteer* (Miao Boran and Wang Zuyi 1924) is a more or less similar entry:

Mt. Dabao lies 105 *li* to the east of the city. The high-quality zinc (*lian*) and lead it produced at Tiangiao (formerly Yinchanggou) is much sought after. From the zinc ore silver of a most beautiful colour can be extracted. The works called Yangjiao, Lianhua, Fulai, Tianyuan, Zhazi, Woyan and Sibao are adjacent to it, those furthest away at a distance of 50 *li* [c. 25 km], those closest by at a distance of only 10-15 *li* [c. 5-7 km. The extraction began in the Tianfu reign period of the Han dynasty of the Five Dynasties period; above the old mine shafts there is an inscription on the side of the cliff recording this fact. It is the most ancient mine in the Southwest.[3]

From the description in the above sources one can see that in the Guma district the smelting of various metals, among them zinc, very possibly began as early as the tenth century AD. Above the old mine shafts on Mount Dabao in Tiangiao the stone inscription that records the fact still exists. These descriptions not only provide important source material for the study of the origin and development of zinc-smelting in the Guma district, but also furnish interesting clues for further research on several questions in the history of zinc-smelting in China. (But see below, p.124.)

TRADITIONAL DISTILLATION-SMELTING TECHNOLOGY

We have made detailed observations on each working operation connected with the extraction of zinc by distillation according to traditional methods, and have thus reached a preliminary understanding of the technology involved. The techniques of traditional zinc-smelting are based on experience and they are handed down from one generation to the next. Through the study of these techniques we will be able to understand some aspects of zinc-smelting in ancient times.

In the Guma district there are two kinds of furnaces used in the smelting of zinc according to traditional methods: the high tuyere trough furnace and the *yan* furnace[4]. The first was developed in 1954 by improving the *yan* furnace according to a rationalization proposal made by the worker Yang Kan of the Hezhang County Lead and Zinc Works. Because this kind of furnace makes it possible to simplify working procedures and diminish toil, it spread quickly along the Sichuan-Yunnan Highway. Going eastwards along the highway away from Magu Township, one finds that this type of furnace is used as far away as Baiguo Township near the county city of Hezhang (p.125, Fig. 11). The history of the *yan* furnace is longer and it is closer to the ancient zinc-smelting furnaces. This type of furnace is still in use in mountain areas far from the highway, and we have investigated it in Xiaoshuijing in Shashi Township, Guma district. The furnaces described in this paper are the *yan* furnaces of Xiaoshuijing (Pl. 1).

The flow chart given in Figure 2 shows the total production process involved in the distillation-smelting of zinc in Xiaoshuijing. In the following pages we will describe the more important of these operations.

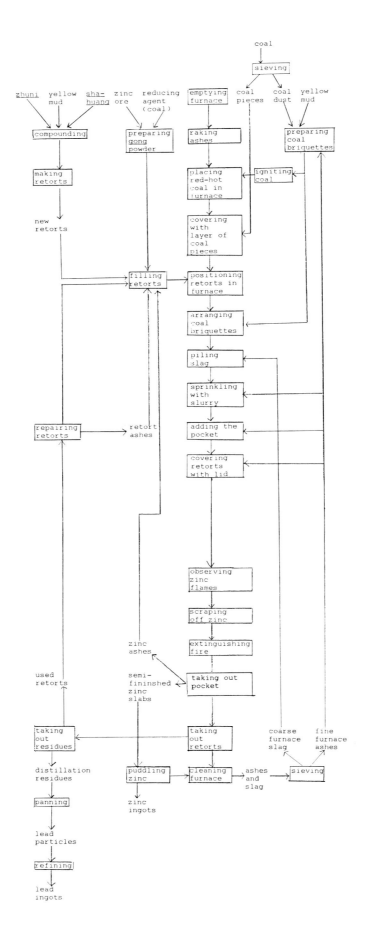

Fig. 2 Flow diagram of the total production process involved in the distillation and smelting of zinc in Xiaoshiujing

117

1. The *Yan* Furnaces and their Distillation Retorts

The structure and dimensions of the *yan* furnaces are shown in Figure 3, Plates 2, 3.

The *yan* furnaces are constructed according to experience and do not have a standard plan. There will always be small differences between different furnaces and thus the dimensions given in Figure 3 are not absolute. In Xiaoshuijing each furnace has 12 furnace-bars, on each of which 3 retorts are placed, giving a total of 36 retorts in one firing. One furnace is worked by 3 persons (one furnace master and two unskilled labourers). One firing takes 24 hours.

The shape and dimensions of the retort used in Xiaoshuijing are shown in Figure 4, Plate 4.

The main materials used for constructing retorts are three kinds of locally produced fireclay: *zhuni* (locally also called 'sticky', *huang*), yellow mud and *shahuang*. *Zhuni* is found in the lower layers of coal seams and is adhesive. *Shahuang* is found in the upper layers of coal seams and is not adhesive. Their chemical constitution is shown in Table 1.

When making retorts the three materials are used in the following proportion:

zhuni: 53%, yellow mud 26%, *shahuang* 21%.

When the retort has been formed, it must first be glazed (to prevent air leakage), then after firing it is ready to use. If not badly damaged, used retorts can be repaired and re-used. A retort is usually used ten or more times.

Fig. 3 A *yan* furnace

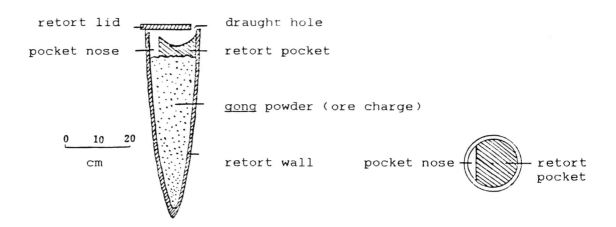

Fig. 4 Retort and retort pocket

Table 1 The chemical constitution of the three raw materials used for making retorts

Raw materials	Chemical constitution (%)							Loss of volume after firing
	SiO_2	Fe_2O_3	Al_2O_3	TiO_2	CaO	MgO	H_2O+	
zhuni	40.16	2.77	27.94	0.60	0.60	1.72	9.61	23.94
yellow mud	61.88	7.35	17.49	0.94	0.22	1.58	8.20	7.58
shahuang	42.64	3.29	21.83	1.00	0.81	1.92	7.16	26.46

Analysis by Anhui Province Geology and Mining Bureau Testing Centre

2. Preparing Coal Briquettes

In the traditional distillation-smelting of zinc, coal directly from the mine is not used. Instead briquettes of various sizes and shapes are formed by mixing powdered coal with yellow mud, furnace ashes, and water. These briquettes are used not only as fuel, but also for propping up the pointed retorts, making them stand stable and upright in the furnace. Therefore much importance is attached to where the briquettes of various shapes and sizes are placed in the furnace. The important thing in repairing the briquettes is obtaining the right proportions among the three substances used. There are two major reasons for this.

(i) In traditional zinc-smelting, fuel is placed in the furnace only once. After igniting the furnace the furnace master is only to a small extent able to regulate the combustion process and the furnace temperature. If the proportion used in mixing the briquettes is not correct the temperature will be too high or too low or the combustion time will be too long or too short. Should any of this happen the smelt will fail.

(ii) The briquettes must have a certain amount of sintering character. If the sintering character is deficient, the furnace will collapse. This occurs when the lower briquettes are not able to support the upper briquettes after having burnt out, making the upper briquettes fall into the bottom of the furnace. This will lead to too fierce a combustion in the lower part of the furnace and to too low a temperature in the upper part and make it impossible to preserve the same temperature in the different parts of the furnace. If the sintering character of the briquettes is too high, the adhesion of slag, furnace and retort will often damage the furnace and the retort.

The composition of the briquettes made at Xiaoshuijing is: coal powder 54%, yellow mud 32%, fine furnace ashes 14%. This is only an approximate proportion. Because combustion proceeds differently in different furnaces and because there are differences in the ways different furnace masters work their furnaces, the briquettes used in some of the furnaces examined showed variations of the above proportions.

One firing requires approximately 400kg coal powder.

3. Preparing Gong Powder

In the dialect of the Guma district ore is called *gong*. 'Preparing *gong* powder' means preparing the ore charge. In fact, gong is the ancient pronunciation of *kuang* (ore).

To prepare ore charge means to mix ore and reducing agent (coal) according to a set proportion. Because the grade of the ore and the quality of the reducing agent used varies, the proportions used in compounding ore are not always the same.

An analysis of part of a sample of the ore charge used at Xiaoshuijing reveals the composition shown in Table 2. One can see that in traditional zinc-smelting the content of zinc oxide in the zinc ore is above 8% and in some cases above 40%, i.e. relatively high-grade zinc oxide ore is used.

Table 2 Results of analysis of part of ore samples

	Zinc contents of ore (%)	
Sample number	Zn in ZnO	Zn in ZnS
1	46.50	2.41
2	43.60	5.16
3	24.82	5.85
4	8.82	2.48
5	8.62	0.24
6	18.76	2.67
7	47.90	6.88

Analysis by the Testing Centre of the Anhui Province Geological and Mineral Products Bureau

The method of extracting zinc by distillation also puts certain demands on the coal used as reducing agent: the lower the sulphur content and the lower the ash content, the better.

In Xiaoshuijing ore and reducing coal are generally used in the proportions (by volume) 60% ore and 40% reducing coal. In actual fact, this proportion varies because of the difference in the grade of the ore used. An insufficient amount of ore in the charge will lead to a diminution of the amount of zinc produced. If the amount is too high, it will result in, on the one hand, the incomplete reduction of the zinc oxide ore, and, on the other hand, the close-burning of the distillation residues, so that they solidify firmly in the retort. The residues thus being impossible to pour out, the retort must be discarded. (In local parlance this is called *chongzha*, to be stuffed with dregs).

Generally speaking, each firing requires 220kg of ore and 60kg of reducing coal.

4. Raking Ashes

'Raking ashes' is the first of the working operations connected with traditional zinc-smelting. The bottom of the furnace is covered with a 7-8 *cun* (23-27cm) thick layer of fine furnace ash. In order to regulate the draught of the furnace, the furnace master must make it into a definite shape, taking into account the shape and combustion characteristics of the furnace. This is called 'raking ashes'. The operation influences significantly the whole smelting and distillation process and it often affects the temperature and length of combustion. It is an operation to which the furnace master pays great attention.

If the cross-bar bricks in the furnace are inclined too steeply, the floor ash must be raked into a convex shape - among the local furnace masters this shape is called the back of a wooden comb (Fig. 5).

Fig. 5 The 'back of the wooden comb' furnace floor

From Figure 3 one can see that if the cross-bars are too steeply inclined, the furnace draught will be too strong, making combustion too fierce and too fast. When the furnace master rakes the floor ashes into the shape of the back of a wooden comb, what he does is to reduce the cross-section of the tuyere, thus reducing the draught capability of the furnace and normalizing combustion.

If the inclination of the cross-bars is normal the ash layer must be made level; this shape is locally called a quadrilateral board (Fig. 6).

Fig. 6 The 'quadrilateral board' furnace floor

If the inclination of the cross-bars is too small (a condition rarely encountered) the floor ashes must be made to assume a concave shape. This shape is locally called boat-shaped ashes (Fig. 7).

Fig. 7 The 'boat-shaped ashes' furnace floor

From the above it is clear that the purpose of raking ashes is to achieve an appropriate amount of draught, thus normalizing combustion. Because

furnaces have different characteristics, how exactly the floor ashes are to be formed in a given furnace can only be decided by the furnace master after many trial firings.

5. Tasks Prior to Distillation

The tasks to be performed after igniting the furnace and before the start of the distillation process are described below.

(i) **Piling up slag.** Distillation takes place in a zone *c.* 8cm thick in the uppermost part of the retort. Here the gaseous zinc condenses into liquid zinc. To control the temperature of this zone, keeping it around 800°C, is an important part of traditional zinc-smelting technology. The local furnace masters use slag for separation and cooling, a method both simple and effective. The slag used must be in lumps greater than 3cm in diameter. If they are too small, the gaps between them will be filled up too easily and this will impair the draught of the furnace, hindering combustion and at times even extinguishing the fire. The slag is therefore sieved to eliminate ashes and small lumps. The sieved slag is spread evenly *c.* 7cm high on top of the coal layer (the distance between the opening of the retort and the top of the slag being *c.* 1cm). This is called piling up slag, a work process performed by an unskilled labourer.

Slag has excellent properties for separation and cooling. The slag layer covers closely the briquette layer (Fig. 8). The temperature of the briquette layer (the combustion zone) is generally around 1200-1399°C, but in the slag layer (the distillation zone) the temperature drops quickly to around 800°C, thus making distillation proceed smoothly.

(ii) **Sprinkling with slurry.** As a further measure to control furnace temperature, a layer of slurry *c.* 1cm thick must be sprinkled on top of the slag layer. Special care must be taken to do this at the right time; sprinkling too late or too early causes great damage. This work process is performed by the furnace master himself.

Prior to sprinkling, the slurry must be mixed. The requirements for this are not strict, however, the slurry consisting of yellow mud mixed with a suitable amount of fine furnace ash which has been made into a thin gluey substance by adding water.

When sprinkling with slurry one must pay particular attention to the state of combustion in the furnace. If the combustion is found to be on the weak side one must sprinkle with slurry relatively early. Then the slurry will form a shell on top of the furnace, somewhat like a large lid. This improves the draught, making combustion gradually grow stronger. If the combustion tends to be too strong, one must postpone sprinkling with slurry. This means letting the furnace burn in an open state for a longer period of time, letting the fire cool down a little (Fig. 8).

If slurry is sprinkled on too early, the furnace temperature will become too high. The refractory capability of the retorts may be exceeded and they may be damaged. Moreover, under such conditions the temperature in the condensing zone will rise correspondingly, so that the gaseous zinc does not condense; this seriously affects the amount of zinc produced. Because of the excessive temperature the cooling-off period will also be prolonged, directly influencing the next work cycle.

If the slurry is sprinkled on too late, the furnace temperature will not be sufficiently high. This can lead to a shortening of the combustion time, not allowing the zinc oxide to be reduced in a regular fashion and greatly reducing the recovery rate.

(iii) **Adding the pocket.** What is obtained in the retort by the thermal reduction of zinc oxide is gaseous zinc. This must be condensed into liquid zinc in a condensing unit; only after this is done can metallic zinc be obtained. How the ancient zinc-smelting technology solved the problem of condensing the gaseous zinc is not described in the written sources known today. But the ancient Chinese traditional zinc-smelting technology preserved in the Guma district enables us to

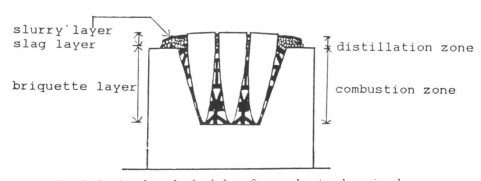

Fig. 8 Section through a loaded *yan* furnace showing the various layers

understand fairly clearly some of the details of the extraction of zinc by distillation in ancient times.

In Guma no separate condensing unit is used; condensation takes place inside the retort itself. 'Adding the pocket' consists in using a clay and ashes to form a pocket-shaped partition about 6cm from the top of the retort, partitioning off a condensation chamber in the upper part of the retort. Here the gaseous zinc condenses into liquid metallic zinc.

The pocket is used only once. After each firing one must throw it away when putting the retort in order. For this reason one must add the pocket in each zinc-smelting cycle.

The material used for making the pocket (locally called pocket ashes) is mixed thoroughly from fine furnace ashes and yellow mud to obtain a substance that can be kneaded into balls. There are no strict proportions for the ingredients of the pocket ash, but one must not use too much yellow mud. If substances not resistant to heat are mixed up with the pocket ash, small holes will be formed in the bottom of the pocket during smelting. Zinc will leak out through these and cause unnecessary losses.

Adding the pocket is done after sprinkling with slurry, at a time when the retort has already been heated unsealed in the furnace for about three hours. By this time the water and volatile substances in the ore will already have evaporated. An iron bar is used to compact the ore, creating an empty space in the upper *c.* 6cm of the retort. After this is done one can start adding the pocket.

6. Tasks connected with distillation

After the pocket is added, a lid is used to cover the retort opening (it must not be covered completely but left slightly open opposite the pocket nose), and one can start the distillation operations, the aim of which is mainly to regulate the combustion of the furnace to ensure that the distillation process can proceed smoothly.

(i) **Zinc flames.** When smelting has proceeded to a certain point, inflammable gases escape through the opening in the retort lid which, if ignited, will have a blue flame. This is carbon monoxide. After a certain period of time the flame will gradually turn green, a sign that the combustion of zinc vapour is taking place. Locally these are called zinc flames. These flames are very important, as the furnace master observes them in order to understand the state of the distillation process and regulates the combustion in the furnace accordingly.

From the time of the appearance of the flames one can infer the general condition of the combustion in the furnace. If they appear relatively early the combustion is too weak; the time in which the furnace has been above 1000°C has not been long enough, so that the ore in the retort has not been heated sufficiently and the zinc oxide has not been completely reduced. This influences the recovery rate. If the flames appear relatively late this signifies that the combustion is too fierce. Should this happen, the retort will often be severely damaged, thus affecting the amount of zinc produced.

From the size of the zinc flames one can infer the state of distillation. If there is too much flame, this indicates that the distillation temperature is on the high side. If this is the case one must adopt measures to make the temperature drop by making the draught holes in the slurry layer smaller or by covering the side of the furnace with slurry. If the zinc flames are too small, this indicates that the distillation temperature is too low and one must take measures to bring it up.

(ii) **Furnace temperature**. In pyrogenic zinc-smelting, for a fairly quick reduction of the zinc oxide to take place, the temperature of the reaction zone must be held between 1000°C and 1200°C (this is somewhat higher than the theoretical value, as one must take into account the loss of heat through the furnace walls and other forms of heat dissipation) (Dongbei Gongxueyuan *et al.* 1978).

Table 3 Temperature measurements (using a platinum-rhodium thermocouple) in zinc furnaces in Xiaoshuijing

Furnace zone	Combustion zone					Distillation zone	
Depth (cm)	30	27	25	20	15	5 slag layer	2 slurry layer
Measurement no.	Furnace temperatures (°C)						
1	1180	1000	1000	990	970	810	350
2	1210	1110	-	1050	1030	830	480
3	1195	-	1055	1045	1030	855	445

Gaseous zinc condenses at temperatures in the range 456°C-850°C. If the temperature is above 850°C it will not condense; if below 419.5°C (the melting point of zinc) it will condense to form zinc dust. If the condensation is to proceed smoothly the temperature of the distillation zone must be held between 450°C and 850°C (Yeijin Gongye Chubanshe 1958).

We have used a platinum-rhodium thermocouple to measure temperatures (under normal smelting conditions) in the zinc-smelting furnaces in Xiaoshuijing; the results are shown in Table 3. From the above measurements it can be seen that even though traditional zinc-smelting technology regulates furnace temperature on the basis of experience only, its control of furnace temperature is fairly precise.

7. Work Operations in Later Stages

(i) **Scraping off zinc.** After the furnace has been ignited for 16-17 hours, the fire has gradually subsided and the zinc flames issuing from the retort opening have also grown weaker or have vanished. This is a sign that the reaction in the retort is nearing its completion, that the distillation process has almost finished. Then one can start on the next procedure - scraping off zinc.

Scraping off zinc is relatively easy. The retort lid is removed and the zinc adhering to the inner surface of the lid is scraped off into the pocket. The furnace temperature must be neither too low nor too high. If it is too low the zinc on the lid will have condensed and cannot be scraped off; if it is too high the zinc will combust - this is locally called burning the pocket. If this should happen the fire can be doused with water. After this task is completed the slurry layer is knocked off, so that the furnace cools off.

(ii) **Taking out the retort.** After the zinc in the pocket has condensed it can be taken out. The zinc will at this time contain many impurities and is locally called semi-finished *yan* slabs.

After these slabs have been taken out the clay pockets are broken and the slag layer is removed. Then the retort is taken out (Pl. 4) and the distillation residues are tipped. After mending the retort it can be used again, one retort lasting about 10 firings.

(iii) **Puddling zinc.** The relatively high amount of impurities in the slabs necessitates that they undergo another refining process before they can be cast as finished ingots. An ordinary iron wok (braising pan) is used for this. After the slabs have been melted, the impurities will float to the surface of the liquified zinc and among these impurities are many particles covered by a coating of ZnO. In order to increase the recovery rate the zinc in these particles must be separated from the ZnO coating. The method used by the local furnace masters is very simple: inflammable substances (discarded plastic and rubber are often used) are thrown into the wok and thus ignited; at the same time the liquid zinc is kept in continual motion using an iron ladle, thereby effecting the separation of the zinc from the ZnO coating on the particles. Locally this working process is called stir-frying zinc.

After stir-frying zinc one can start casting zinc ingots. In one firing one can generally obtain 20-25kg of fifth grade zinc. Some of the tools used are shown in Plate 7.

(iv) **Panning lead.** The distillation residues can be considered as waste products from the smelting process, but in the residues there are often lead particles that have been reduced during the smelting process. In Xiaoshuijing lead is recovered from the residues by panning in water. The relative weight of the lead particles is relatively high and after washing away the residues the lead particles remain in the pan. Generally speaking, 2.5-3kg of lead particles result from the distillation residues of one furnace.

AUTHOR'S POSTSCRIPT

Traditional zinc-smelting technology has been preserved in many different localities in Southwestern China, but the technology employed in different places is not completely identical. When carrying out investigations in Huize in Yunnan Province the author observed furnaces and retorts different from those used in the Magu area.

At Huize in Yunnan Province a rather different technology has evolved. The process is basically similar but a separate external condenser is employed instead of the internal collecting saucer or 'pocket' (Figs 9,10, Pls 8-10).

The furnaces used in Huize are also rectangular in shape, but only two rows of retorts are placed in each of them (see Fig. 9, Pl. 8), each row containing 27 retorts. In the upper part of each retort a still is installed (see Fig. 10, Pl. 9).

In a forthcoming article the author will describe the zinc-smelting technology employed in Huize in detail.

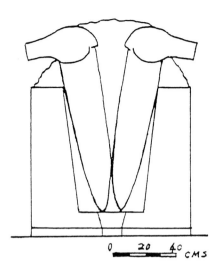

Fig. 9 Section through a furnace of the type used at Huize, Yunnan. Note the separate condensers on top of the retorts.

Fig 10 Section through a retort of the type used at Huize, Yunnan. Note the separate condenser on top of the retort

TRANSLATOR'S NOTES

1. This paper was translated from *Ziran kexue shi yanjiu* (Studies in the history of the natural sciences), vol. 5, no. 4 (1986, pp.361-9).

2. The preface to this gazetteer is dated 1850. The city of Dading corresponds to the present city of Dafang. Weining Subprefecture and Weining County both correspond to the present Weining Yi- Hui- Miao Autonomous Xian. The Han dynasty mentioned in this quote was a short-lived dynasty (AD 947-50) in the interregnum between the Tang and the Song dynasties,

not the one usually associated with this name, which has the dates 206 BC-AD 220.

3. The *lian* mentioned in the text is a dialect word for zinc; zinc ore is popularly called *lian* ore is Guizhou. Zhang Hongzhao also mentions that 'at the present time zinc is called lian in Yunnan.'

4. In the Guma district the same character is used to signify both zinc and lead, butit is read *yan* when used to denote zinc and *gian* when used to denote lead.

Acknowledgements

The translator wishes to thank Donald B. Wagner (University of Copenhagen) for his assistance in carrying out the translation.

REVISIONS AND UPDATE TO THE FIRST EDITION (P.T. Craddock)

Since the first edition of this paper there has been further work on the traditional process in China by the editor of this volume and others, notably Zhou Weirong. We were fortunate on our travels through China to meet up with Xu Li and to discuss his paper. In particular we got him to explain the function of the various tools shown in Plate 7.

Zhu Shouhang (1986) gives details of the firing sequence for the retorts. The freshly made retorts are first slowly dried in the shade, then baked at around 400°C before being slowly raised to about 1200°C and finally 1300°C.

The references to very early mining and smelting given above in the *Dading Prefectural Gazetteer* (Zhou Hanxun and Fu Ruhuai nd) were compiled in the nineteenth century, and probably refer in the main to other metals, notably silver and lead. There is no certain evidence for zinc production in China before the mid-sixteenth century AD (Zhou Weirong 1993, 1996, and Zhou Weirong and Fan Xiangxi 1993, but see Bowman *et al.* (1989) and Cowell *et al.* (1993) who argue for a late fifteenth century date). Brass, made by the cementation process, was used in China on a limited from early in the first millennium AD. It may have been brought initially to China by Buddhist monks from India.

Recent Fieldwork

Visits by the editor and Zhou Weirong as part of a joint British Museum-China Numismatic Museum project were made to both Yunnan and Guizhou in 1994 and again in 1995 to record the process (Zhou Weirong 1996, Craddock and Zhou Weirong forthcoming). The older *yan* furnace, described by

Xu Li in this paper seems no longer to be in use, and the retorts with separate condensers (Figs 9,10) reported from Huize are not in use, at least in the Huize area itself. In the more modern design of furnace the fire is kept separate from the retorts (Fig. 11). The retorts are heated in a separate chamber with the firebox on one side and the chimney on the other, thus the flames are drawn through the retort chamber and up the chimney. The gaps between the retorts at the top of the chamber have to be sealed to prevent escape of flames and to ensure that the tops of the retorts and their lids remain relatively cool.

This is done with pieces of broken refractory and clinker, sealed with clay. The retorts themselves are somewhat larger than those used in the *yan* furnaces, being about 90cm tall and 20cm wide at the rim, and each chamber holds between 60 and 90 retorts, thus the amount of zinc produced in each operation is significantly increased, and separating the retorts from the fire makes it much easier to control the process. The furnaces are usually in pairs sharing a common chimney and it is the usual practice to load one of the furnaces whilst the other is being fired, thus ensuring an almost continuous operation.

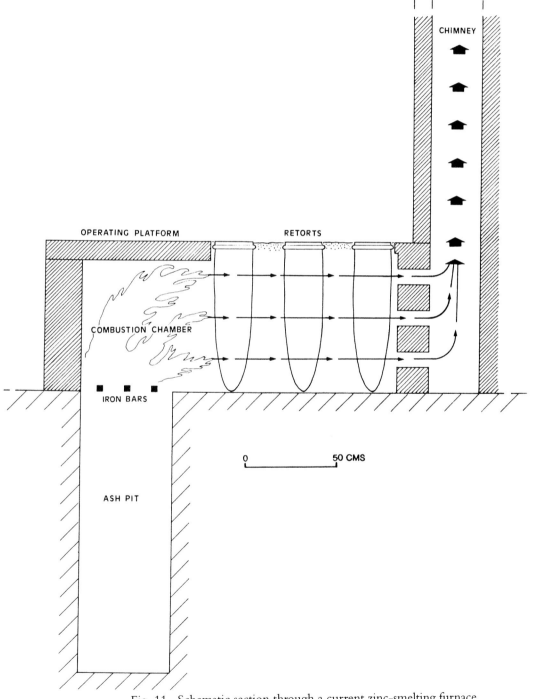

CHIMNEY

OPERATING PLATFORM RETORTS

COMBUSTION CHAMBER

IRON BARS

0 _____ 50 CMS

ASH PIT

Fig. 11 Schematic section through a current zinc-smelting furnace

This development of the traditional zinc smelting process is taking place at Zhehai, near Huize, side by side with a large modern electrolytic-process plant. This juxta-position of old and new technologies is highly unusual, normally advanced local traditional processes are very susceptible to new technology from elsewhere. The traditional Indian zinc smelting process, for example failed to adapt and ceased altogether (see p.46), and geographically closer, much of the Chinese traditional steelmaking industry contracted in the face of Western imports and became technologically simpler where it survived at all (Wagner 1995).

There are also problems as the various localities run short of their own ore or coal supplies and these have to be brought in by truck over very difficult terrain. An additional problem is that all of these traditional producers in Yunnan, Guizhou and Sechuan are remote from their main markets, although the road system has improved very markedly over the last few years. However, due in part no doubt to the peculiar economic and political circumstances of China through much of the twentieth century, the traditional privately owned process has evolved and is currently (1995) thriving.

Identification of tools shown in Plate 7

Top left: The tongs are for lifting the hot ingots from the pockets in the top of the retorts. The spear-shaped tool is for removing the lids of the retorts at the end of the process, and it is also sometimes placed in the top of the retort whilst the pocket is being made, to preserve the gap through which the zinc vapour must pass.

Top right: The cleaver is to cut up the coal briquettes. The two points are used to clear out the retorts after use. The fork is to rake up and prepare the furnace floor prior to smelting.

Bottom right: The tool on the top left hand side is used to form the pocket gap. The top right is a form of hammer used to crush the zinc ore. The two shovels beneath are to empty the retorts after use.

Bottom left: The ladle is for ladling molten zinc in the 'stir fry' refining process. The hooked tool in the centre is used to rake out the coal ash from the process during the process and also to free the zinc ingots from the pocket. The angled tool is to clean out the retorts whilst still hot.

REFERENCES

Bowman, S.G.E., Cowell, M.R. and Cribb, J. 1989. Two thousand years of coinage in China: an analytical survey, *Journal of the Historical Metallurgy Society* **23** 1, 25-30.

Cowell, M.R., Cribb, J., Bowman, S.G.E. and Shashoua, Y. 1993. The Chinese Cash: Composition and Production, in *Metallurgy in Numismatics* **3** ed. M.M. Archibald and M.R. Cowell. Royal Numismatic Society, London, 185-98.

Craddock, P.T. and Zhou Weirong, forthcoming. Traditional Zinc Production in the west of China, *The Prehistory of Mining and Extractive Metallurgy*, in ed. P.T. Craddock and J. Lang. BMP. London.

Dongbei Gongxueyuan, Youse Zhong, Jinshu Yelian, Jiaoyanshi and Yejin Gongye Chubanshe, 1978. *Xin yejin* (The metallurgy of zinc), 123-4.

Miao Boran and Wang Zuyi, 1924. *Weining xian zhi* (The Weining County Gazetteer), chapter 1. (The *Weining Subprefectural Gazetteer* quoted in the *Dading Subprefectural Gazetteer* was a predecessor of the *Weining County Gazetteer*. - Translator's note.)

Wagner, D.B. 1995. The Traditional Chinese Iron Industry, *Chinese Science* **12**, 139-52.

Wang Jin, 1919. *Zhongguo gudai jinshu yuanzhi zhi huaxue* (The chemistry of metallurgical operations in ancient China). *Kexue* (Science), 5 (6), 555 ff. (This article was republished in *Zhongguo gudai jinshu huaxue ji jindanshu*, Wang Jin & Zhang Hongzhao, 7ff).

Wang Jin and Zhang Hongzhao, 1957. *Zhongguo gudai jinshu huaxue ji jindanshu* (Alchemy and the development of metallurgical chemistry in ancient China). Kexue Jishu Chubanshe. (Originally published in 1955 in Shanghai by Zhongguo Kexue Tushu Yigi Gongsi. - Translator's note.)

Yeijin Gongye Chubanshe, 1958. *Macaolu lianxin* (The smelting of zinc in trough furnaces), 5.

Zhou Weirong, 1993. A New Study on the History of the Use of Zinc in China, *Bulletin of the Metals Museum of the Japan Institute of Metals*, **19** 49-53.

Zhou Weirong, 1996. Chinese Traditional Zinc Smelting Technology and the History of Zinc Production in China, *Bulletin of the Metals Museum of the Japan Institute of Metals* **25**, 36-47.

Zhou Weirong and Fan Xiangxi, 1993. A Study of the Development of Brass for Coinage in China, *Bulletin of the Metals Museum of the Japan Institute of Metals* **20**, 35-45.

Zhu Shoukang, 1986. Ancient metallurgy of non-ferrous metals in China, *Bulletin of the Metals Museum of the Japan Institute of Metals* **11**, 1-13.

Zou Hanxun and Fu Ruhuai, n.d. *Daoguang Dading fu zhi* (The Dading Prefectural Gazetteer compiled in the Daoguang period), chapter 42.

Plate 1 A traditional smelting workshop in the Magu district of Guizhou province

Plate 2 Interior of empty *yan* furnace, relined and ready for use

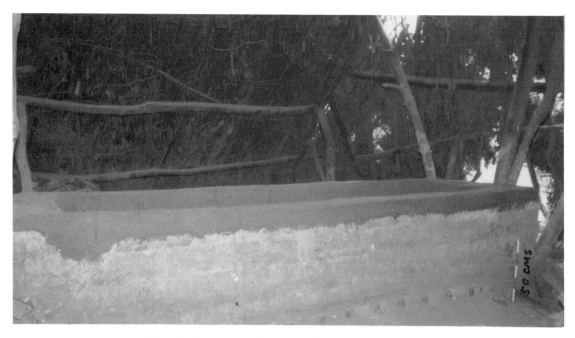

Plate 3 Exterior of relined *yan* furnace prior to loading

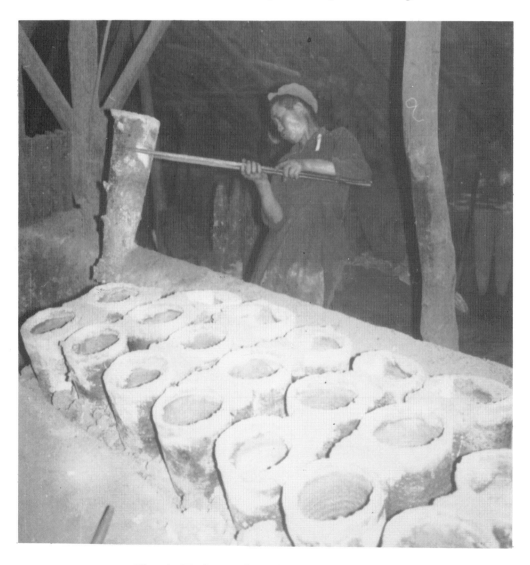

Plate 4 Used retorts being lifted from the furnace

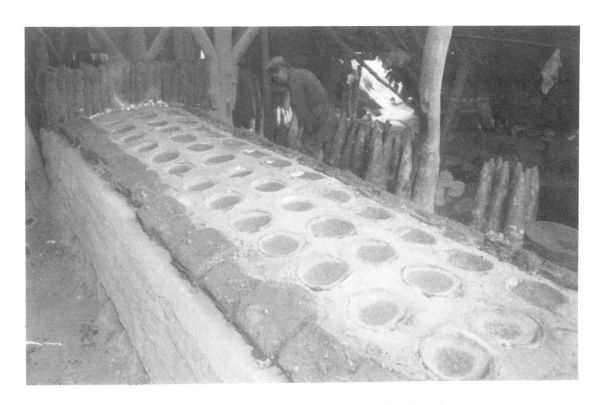

Plate 5 A *yan* furnace loaded with retorts and ready to fire

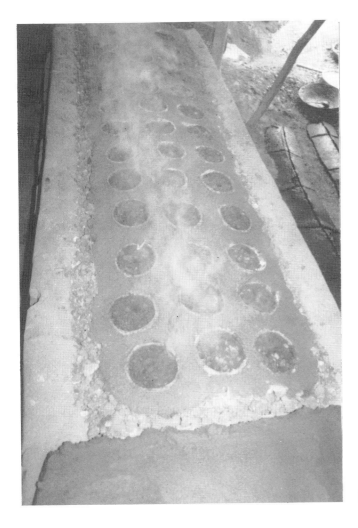

Plate 6 A *yan* furnace in operation

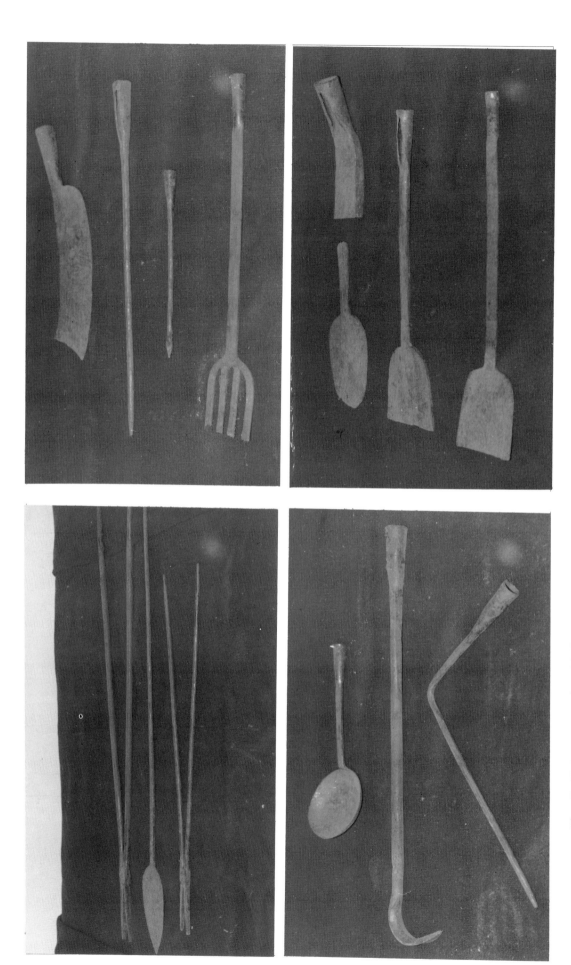

Plate 7 Various iron tools and ladles used in the traditional zinc smelting industry. For the function of each tool see p.126.

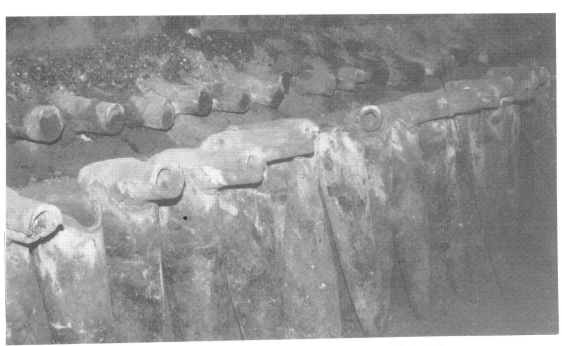

Plate 8 Zinc smelting retorts with external condensers at Huize, Yunnan

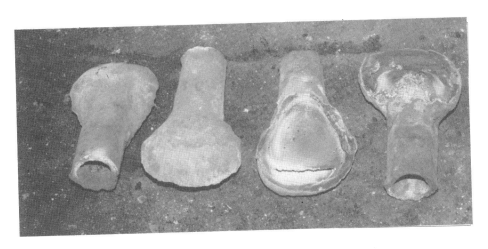

Plate 9 A detail of separate internal condenser vessels from Huize, Yunnan

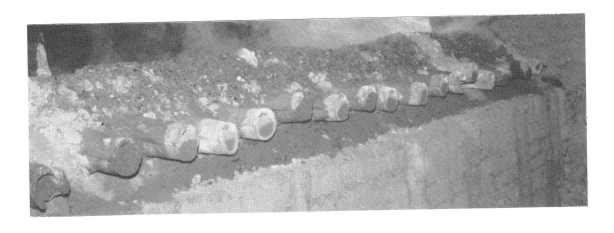

Plate 10 Zinc smelting at Huize, Yunnan. Only the ends of the external condensers are visible.

Fig. 1 Sketch map showing traditional brass and calamine-working areas between the Meuse and the Rhine

BRASS AND ZINC IN EUROPE
FROM THE MIDDLE AGES UNTIL THE MID-NINETEENTH CENTURY

Joan Day

Hunter's Hill, 3 Oakfield Road, Keynsham, Bristol BS18 1JQ

THE EARLY CENTURIES

European interest in the production of copper-based alloys in the Middle Ages can claim its origins from the time of Charlemagne's rule over the Holy Roman Empire. His desire to enhance the ceremony and buildings of the Christian religion produced many liturgical items and fine furnishings for his churches, including the great bronze doors of the Palatine Chapel at Aachen. These notable survivors, like the treasured products of centuries which followed, provide a large part of the existing evidence for the industry (Haedeke 1970, 40-3). The quiescent period which followed Charlemagne's death was re-awakened by a resurgence of work on ecclesiastical metalwork just prior to the start of the new millennium.

The increasing use of various techniques of analysis confirm that, as in earlier times, many of the 'bronzes' from this period are of a more complex nature than the simple copper-tin alloys implied by the strict present-day use of this term (Werner 1977). Apart from a lead content, which could have been expected to be included to improve the fluidity in the casting of any item, zinc also is often found, sometimes in quite significant proportions. Similarly too the 'brasswares' are frequently shown to contain lead and tin in addition to the copper-zinc content denoted by modern terminology (Cameron 1974). This situation gives rise to a certain amount of confusion in the current nomenclature for these quaternary alloys which, in turn, reflects similar difficulties in interpreting the mixed terminology for all of these non-ferrous materials which have been used in the past (Oddy *et al.* 1986, 5-6). It poses questions which have yet to be adequately resolved.

Similar 'bronze' doors to those of Aachen can be seen at Mainz Cathedral made in 988 under the direction of Archbishop Willigis (Tavenor-Perry 1910, 60), who also presented a large crucifix of 600 lb which no longer survives there. By 1015 Bishop Bernward was involved in the production of cathedral doors which incorporated highly decorative scenes from the bible for his cathedral at Hildesheim (Savage 1968, 86-7). The location, just south of Hannover near the Harz mountains (a major source of copper and other ores), was a factor which encouraged the school of craftsmen founded by Bernward to flourish in the area. Bernward and those that came after him were responsible for many fine features, alter crosses, candlesticks candelabra, the famous Christusäule column and baptismal font, some of which still survive in Hildesheim, but his influence spread over a wide area (Tavenor-Perry 1910, 60-2). Similar doors were made later for cathedrals at Gnesen and Augsburg.

In Italy 'bronze' doors cast in Byzantium were presented to the monastery of Monte Cassino by the Pantaleone family of Amalfi in 1087 who, later, went on to make similar gifts to other nearby churches (Savage 1986, 82-5). Some examples of wares produced in countries bordering the Mediterranean show influences from their Byzantine and Saracenic neighbours to the East (Haedeke 1970, 41, 45, 49, 65).

In small communities on the banks of the Meuse such as Huy and Dinant, in an area now located in Belgium, lay workers had been involved in the production of brassware from at least the tenth century. Evidence can be shown in the workshop tariffs from the customs house at Visé, situated on the Meuse north of Liège (Haedeke 1970, 30). Monasteries in both Belgium and France have inventories that show they once possessed collections of bronze and brass items which have long since disappeared. A bookrest fashioned from a model of an eagle, the emblem of St John, was made for Abbot Folcuin in the time of his rule over the monastery at Lobbes between 965 and 990 (Oman 1930, 120). Free-standing eagle lecterns are known to have been produced at Dinant from an early date.

There was good reason for a concentration of these crafts in the Meuse area where an important raw material for making brass was readily available. Little copper was to be had from nearby resources but, by both bulk and weight, calamine,[1] the carbonate ore of zinc, $(ZnCO_3)$, was required in greater quantity. Its sources were to be found in pockets along the north banks of the river itself between Dinant and Liège at the northern fringes of the Ardennes (Day 1984, Peltzer 1909). Those same uplands extending into German territory but there

known as the Eifel, also had similar calamine deposits at its northern extremities in the vicinity of Aachen or Aix-la-Chapelle. There, the quality was particularly high having less contamination from lead than most supplies found elsewhere (Schleicher 1974, 36-8). At Gressenich, a few miles East of Aachen there is evidence that the calamine deposits had been exploited in the Roman era as well as the deposits at Stolberg (Willers 1907; Davies 1935, 178) and more recently Gechter (1993).

The craftsmen of the Meuse region were able to produce fine cast wares such as their eagle lecterns but they also developed their skills in making a wide range of hand-beaten wares, known as *battery*, which exploited the lead-free properties of the calamine ores available to them. These hollow-ware vessels were hammered from sheets of metal to dishes, pans, kettles or basins, some being finely decorated by repoussé or cut-out work to create treasured works of art (Douxchamps-Lefevre 1977, 41) . Others were destined to meet an increasing demand for domestic utensils. 'Batterie de cuivre' is specifically mentioned among Cologne importations from Dinant in 1104 (Tavenor-Perry 1910, 16). The descriptive 'cuivre', or copper, was applied generally to goods of both brass and copper wares until well into the eighteenth century, under the misapprehension that brass was merely a type of yellow copper. Some confusion between brass and copper still survives in historic material influenced by French nomenclature.

England in the medieval period had no such resources of calamine that had, at the time, been discovered. The production of brassware was restricted by the necessity of using imported materials or recovering and remelting scrap metal. In consequence, those pieces that can be identified as of English make with certainty are few in this period of Romanesque art (Oddy et al. 1986, 5).

Documentary evidence for the use of copper-based alloys in England points to the existence of bellfounding by 1091, when Fergus of Boston described as 'brazarius' must have been a bronze founder (Cameron 1974, 215). Names of bell founders can be identified on twelfth century bells at Bury St Edmunds and by the early thirteenth century great foundries in such cities as London, Bristol and Gloucester had become established. References to bell founding in 1283 at Bridgwater in Somerset illustrate the confusion which could exist between bronze and brass, in the use of materials as well as their nomenclature and the difficulty of accurate translation from such early documents. Of the 1861 lb of metal acquired by gift and purchase to produce a new bell, 1781 lb was used subsequently from:

> 180 pounds of brass, received as gifts, as in pots, platters, basons, lavers, kettles, brass mortars, and mill-pots. Also 425 pounds received from one old bell. Also, 40 pounds of brass received by purchase. Also 896 pounds of copper, received by purchase. Also 320 pounds of tin received by purchase.

Quite clearly it had been thought to be necessary to purchase the 40 lb of brass for such a purpose (Riley 1875, 77). The donations of 'brassware' appear to include possible bronze items in the lavers and mortars and those more likely to have been of brass in the kettles, pots, platters and basons. The inclusion of copper-zinc alloys in the founding of such a bell may have been thought, mistakenly, to be technically desirable or, possibly, it was found to be financially expedient to incorporate cheaper materials.

EVOLVING SKILLS

The lack of precision in nomenclature, varying as it did with time, geographical location and individual writers and craftsmen, is symptomatic of an overall lack of understanding of the true nature of these materials. The craftsman was guided by the working properties of his alloys rather than their precise composition which he had no means of knowing, and his expectations were derived from collective knowledge built upon past generations of experience.

Ores from varying locations differed in their constituents. It has been estimated, for instance, that a zinc content of perhaps up to 7% in a finished article could result from an accidental and unknown inclusion from high-zinc copper deposits, such as those found in Cyprus, Persia and other Middle-East locations (Forbes 1950, 1966; Werner 1982). Similarly, lead may have been introduced as an impurity from either copper or zinc ores, but can be regarded as a deliberate inclusion when amounting to more than 3% (Craddock 1978, Oddy et al. 1986, 9). The working properties of metals and their alloys produced from these variable sources undoubtedly became known to the skilled practitioners at different times and places but not all would have become so aware. The increasing use of scrap metal would have added to the resulting complexity of some alloys which have been found, by analysis, to exist in some items. So too would the practice of replacing tin with a less expensive and more easily acquired commodity such as lead or zinc. The widespread and general use of the copper-based alloys containing tin,

lead and zinc indicates that their preparation on the continent must have been quite deliberate. Whether this quaternary alloy, with its expensive tin content, was always used to its best advantage is another question still to be answered.

There is evidence, nevertheless, that some craftsmen were capable of quite precise selection of the correct materials for specific purposes (Oddy *et al.* 1986, 9). This is illustrated by the analysis at the British Museum Research Laboratory of the twelfth century Plaques of the Apostles, associated with the Shrine of St Walbourg, which are now at the Gronigen Museum in Holland. The thin cast metal of the plaques was found to be of a copper-based alloy with just small inclusions of tin and zinc, but they were mounted with enamelled settings. The settings were in the form of trays of *unalloyed* copper, shown by its impurities to be of the same stock as the main body of the plaques, and suggesting that just this small amount had been excluded from the alloying process for fear of detriment to the enamelling.

THEOPHILUS

It is this kind of technical detail which Theophilus described for the first time in any European writing about the year 1100. He is believed to have been Roger of Helmarhausen, a German monk but a practical man who made two portable altars which can still be seen at Paderborn (Hawthorne and Smith 1963, xv). It is his descriptions which provide the first comprehensible information on the method of making brass, together with the materials, crucibles and the type of furnace used for the purpose. Writing in Latin, he used the terms *aes* and *auricalcum* for brass, (from the Greek orichalkos and Roman aurichalcum) used by writers of the Roman era, but with some differences in their application. Whereas they had used *aes* to denote both copper and its alloys, and *aurichalcum* for a refined alloy particularly employed for coinage, Theophilus used *cuprum* for copper and *aes* for an impure copper-based alloy (Dodwell 1961, 125). *Auricalcum* was the word he reserved for a refined alloy, of either brass or bronze after the elimination of the lead had rendered it suitable for taking the gilding process. This was a technique which was of particular importance to him in his instructions for preparing fine liturgical items (Hawthorne and Smith 1963, 143).

The details given by Theophilus for his brass-making furnace refer to a cylinder of clay greater in height than width and bound with iron bands. It was mounted on a clay base with a pattern of holes pierced through to the apertures of a grid of iron bars on which it stood. The grid was supported by four stones set one foot apart and raised one foot above ground level. A number of crucibles containing the raw materials were placed inside, together with blazing and dead coals. Immediately the flames were drawn up by the draught entering through the base without any need for a bellows (Fig. 2).

Fig. 2 The brass-making furnace as described by Theophilus, *c.* 1110, as reconstructed by Theobald (1933) and modified by Hawthorne and Smith (1963, 142)

This furnace and the process which he later described are both quite recognisable when compared with the larger-scaled version which was still being used until the mid-nineteenth century. The method evolved in some minor details but its basic principles were still those of the 'cementation' process as it became known. It involved the heating of copper to a temperature of about 1000°C, just below melting, at which point it absorbed the zinc vapour being released from the calamine at above 900°C. The use of an 'air' furnace with an induced draught remained normal practice just as Theophilus described. Although a few references indicate the use of bellows at some locations they appear never to have been widely adopted.[2]

The comprehensive nature of the descriptions given by Theophilus, highlights the omissions in the collective knowledge and techniques of his time. Calamine, the carbonate ore of zinc, is mentioned only as material to be crushed for the preparation of *aes* and *auricalcum*. Such references as those made by the Greek writer Strabo to *pseudargyrum*, the 'droplets of false silver' believed to have been metallic zinc, do not occur in this context. Neither do the description by Dioscorides and the Roman Pliny to the production of *pompholyx*, the zinc oxide converted from calamine to facilitate brass production (Hoover and Hoover 1912, n404, n112, n409). Writing after Theophilus in the following century Albertus Magnus, another German monk, gives less practical information on the processes of brassmaking, being influenced by the alchemist literature (Wyckoff 1967 249-50). He does, however, refer to *tuchia*, or tutty which appears to be similar to the pompholyx of earlier centuries. He also makes reference to the addition of small amounts of tin to give a more golden appearance to brass (Wyckoff 1967, 224 and de Ruette 1986), but which, he says, significantly, affects the ductility of the resulting product. There is a considerable lapse after Theophilus and Albertus Magnus before further technical writing of comparable quality becomes available during the sixteenth century.

In the centuries which intervened the actual production of copper-based alloys, particularly those of brasswares, continued to expand and flourish. Most of the items surviving from those years have a religious significance, being amongst the most treasured and finest examples of the art. Undoubtedly many of the more every-day articles, which are mentioned increasingly in documents of the time, have been lost having succumbed to the melting pot. Only the best, mostly housed in museum displays, remain as examples of their type - the ewers, basins, aquamaniles and candlesticks produced for the houses of the wealthy (Haedeke 1970, 34). Other objects, usually smaller and often fragmented pieces of ornamentation, are being recovered gradually from excavation to add to the store of material illustrating these periods.

THE EARLY CRAFTSMEN

Some craftsmen possessing a mastery of the highest levels of expertise were engaged in the production of the finest ecclesiastical art of their time. Not surprisingly, it is their names which have been recorded rather than those from the more mundane sectors of production. The very fine baptismal font surviving at the church of St Barthelemy at Liège is believed by some to have been made in 1112 by Renier of Huy, who is also referred to in an inscription on a censer now in the museum of Lille (Haedeke 1970, 47-8; Boussard 1958). Nicolas of Verdun is another such craftsman of the Meuse region who was working from *c.* 1180-1230 and was responsible for fine brass, 'bronze' and enamelled items such as the Klosterneuburg altarpiece near Vienna, the shrines to the Virgin Mary at Tournai, and to the Three Wise Men at Cologne Cathedral. He is also thought to have made the seven-branched candlestick at Milan Cathedral (Haedeke 1970, 51). In the production regions of the North, Apengater of Sassenlant is known for his brassware produced *c.* 1327-44. Examples of his work may be seen in areas widely distributed from Hildesheim and Gottingen near the Harz, to Keil on the northern coast and further East to Wisman and Rostock, and Kolobrzeg and Szczecin in Poland (Haedeke 1970, 57). In the latter years of his working life Apengater was based in Lübeck, a developing centre of brass production.

THE ENGLISH TRADE

As trade in copper and brassware expanded during the thirteenth century it came under the control of the merchants of the Hanseatic League which was developing at a similar period. The men of Dinant took the initiative in securing an alliance with the Hansa and putting themselves in direct communication with merchants of Cologne and Bruges (Pirenne 1903, 523-46). In so doing, they achieved supremacy over the remaining communities of the Meuse who were engaged in the same trade. The brass products of the whole area became known as 'dinanderie' (Tavenor-Perry 1910). Dinant itself was recognised as the market place for the sale of raw materials such as copper from the Harz mountains and supplies of tin from England. The Cologne Hansa too was well placed to trade goods from the areas between the Meuse and the Rhine, which gave rise to references to 'Cullen' brassware. This name in documents should not be taken to denote Cologne production specifically but, rather, that from the wide area over which the trade was organised (Tavenor-Perry 1910). By 1282 the Hansa League had established trading concessions with England, with their representatives, the 'mercatores de Dynant and Allemania', directing their operations from their

own base at Dinant Hall, near the Steelyard in London (Pirenne 1903).

It is from this latter part of the thirteenth century that early references to the existence of commemorative church brasses in England start to accumulate, although some surviving examples, thought previously to date from these years, have now been shown to be somewhat later. For instance the brass which commemorates Sir John D'Aubernon, to be seen in the church of Stoke D'Abernon, near Guildford, is now thought to be from about the year 1300, while others at Acton in Suffolk, Trumpington in Cambridgeshire, and Chartham in Kent have been dated some 20-30 years later (Norris 1987, 6). The practice of laying such brasses had first appeared on the continent in the early part of the thirteenth century, with several examples *c.* 1230 being recorded either in or adjacent to the Meuse country, although the earliest surviving figure brass is in the Andreaskirke at Verden, Lower Saxony. Only a few have survived on the continent, perhaps 5% of the English total of some 4,000 examples which can still be seen in this country.

It is not known if the earliest brass plates imported for memorial brasses were already engraved but it is usually accepted that most of those which followed in the late fourteenth and fifteenth centuries must have been the work of English engravers (Cameron 1974). The imported material they were working on is often described as latten, latton or latyn, believed to have been derived from *latta* in the Latin version, through the German *Latte*, meaning lath, denoting brass plate or sheet (Cameron 1974). The French *laiton* became synonymous with their *cuivre jaune*, or yellow copper, so-called because brass still was regarded as merely copper of a yellow or golden colour until well into the eighteenth century (Day 1984, Douxchamps-Lefèvre 1977). In both French and German references to *copper* masters, workers, battery or the industry generally, there is need for careful interpretation as the word 'brass' is often the word intended in modern usage. Equal care is needed with the word 'latten', adopted in some quarters to imply the quaternary alloy of a brass containing both tin and lead (Cameron 1974). Whilst the present-day use of this term is convenient to imply the difference between a true brass and the more complex alloy, its historic basis is questionable. Although the imported plates of many monumental brasses have been shown to consist of quaternary alloys and are referred to as latten, the same term was also being used for plate and sheet of true brass and also the goods made from sheet brass such as wire and battery.[3]

Latten was also the material particularly specified for the grander three-dimensional monuments produced for the Plantagenet tombs which still survive in Westminster Abbey together with the evidence elsewhere for the craftsmanship used in their creation. The London goldsmith Torel, perhaps Torelli of Italian origin, is known to have cast the effigies for the tomb of Henry III and Queen, Eleanor, in 1291 (Savage 1968, 98; Macklin 1907). From 1395-7, a few years prior to his death, the tomb for Richard II was being prepared with the assistance of London coppersmiths, Nicholas Broker and Godfrey Prest (Macklin 1907, 60-1). In Canterbury Cathedral the tomb of the Black Prince who died in 1376 may have been the work of John Orchard, although it is sometimes attributed to the craftsmen of Limoges (Savage 1968, 98). The instructions for preparing the monument, made in 1453 after the death of Richard Beauchamp, Earl of Warwick, give considerable details of the materials to be used and how they were to be worked, the craftsmen to be employed and their payments (Dugdale 1730, 445-7). Above a high tomb of marble, William Austen, founder, and Thomas Stevyns, coppersmith, were to place a large 'Cullen' plate of thickest, finest, latten which they were to make, forge and work. Austen was also to make the castings, from patterns by John Massingham (Newton-Friend and Thorneycroft 1927), of numerous other parts including figures and the effigy of the Earl, all to be finished, honed, gilded and engraved by Bartholomew Lambespring, Dutchman and Goldsmith of London. The results, still to be seen in the Beauchamp Chapel of St Mary's Church, Warwick, have been described as 'perhaps the most perfect monumental effigy in existence' (Macklin 1907, 65) (Fig. 3).

The development of such standards of craftsmanship in England did not halt the importation of further fine items from continental sources. Only a few of the magnificent candelabra still remain hanging in the churches of this country such as those at Bristol Cathedral of *c.* 1450 and at Norwich of 1500 (Oman 1936, 265-6), but they illustrate workmanship and style which is typical of the Meuse country.

Similarly, the store of early brass lecterns surviving in churches of this country can be compared with their counterparts remaining on the continent. An intensive study of their individual styles, common parts, measurements and the patterns from which they would have been made has revealed evidence to suggest a Continental influence where previously the

Fig. 3 The commemorative tomb of Richard Beauchamp, Earl of Warwick, erected 1453 in St Mary's Church, Warwick

methods had been thought to have been English (de Ruette 1986, Oman 1930). Details of the techniques used, such as the identification of chaplets, (the supports used for the inner core of a lost-wax casting) have indicated the Continental method of production rather than the English process of sand casting which had previously been presumed (de Ruette 1986). Different types of chaplet used in some of the English lecterns can be connected with individual schools of continental workmanship,[4] such as those at Tournai and Malines. These communities had taken on some of the production formerly carried out at Dinant after it had lost its domination over the industry.

THE FALL OF DINANT

From the thirteenth century, there had been rivalry and jealousy between Dinant and Bouvignes, the community on the opposite bank of the river where craftsmen produced batteryware of the more utilitarian kind compared with that of Dinant (Douxchamps-Lefèvre 1977). Squabbles and more serious skirmishes continued, exacerbated by the

influence of Bouvignes over sources of 'derle', the plastic clay needed for crucibles and models made by both communities. The Duke of Burgundy took control of the territory in which Bouvignes lay during the 1400s, as the hostility between the two increased. In 1466 the duke took measures to quell a further attack from Dinant by sending an army to sack the town. He brought Dinant to such complete ruin that those craftsmen who survived had to flee to other areas to continue their business.

It was the end of the century before the industry was able to re-assert itself at Dinant but by then its former ascendancy had been dissipated throughout a wide area of the Low Countries. Its fugitives had joined craftsmen at towns of previous minor importance in the industry and, in addition, had established completely new centres where they were practising their skills. Apart from Malines (van Door-slaer 1929) and Tournai, mentioned above, and similar centres which developed their techniques in brass foundry, Namur, down river on the Meuse some 24 km to the north, encouraged the battery workers to settle and later became known for such products (Douxchamps-Lefèvre 1977, 49). Later troubles at Bouvignes resulted in their skilled battery

workers fleeing to Aachen to join men of Dinant already there. They were drawn by the sources of high quality calamine, so necessary for their best work, which were available in the area, particularly from Altenberg, the Vieille Montagne, or 'old mountain' near Kelmis a few miles to the south-west of the city.[5]

THE RISE OF AACHEN

At Aachen, where brass production had long been practised on a small scale, the importance of the industry grew with the influx of skilled men from the banks of the Meuse. As the small local sources of copper, such as those from Nideggen, proved inadequate, distant supplies mainly from Mansfeld in Saxony, became more important. It was also brought from Eisleben in the Harz, which was considered the best source, and from Slovakia and Sweden, the latter country being anxious to increase its production throughout most of the century. (Pohl 1977, 229).

These increased outputs of copper, mainly used for alloy production, had been facilitated by technical innovation in both mining and ore preparation. Reversible waterwheels drained flooded mines in Hungary (probably located in present day Slovakia) by the 1470s (Bornhardt 1931, 113). Drainage adits, first mentioned in 1471 enabled the Sneeberg silver-mines in Saxony to increase their depth from 200m to double that depth after 1480. Water was extracted from a depth of 70m by water-powered Paternoster pumps consisting of iron buckets on a continuous iron cable, while rag and chain pumps, said to have originated in Slovakia, were effective to depths from 160m to 170m (Kellenbenz 1977 294-5). Cranked piston pumps powered by waterwheels as introduced in Slovakia by the mid-century were installed in the Harz mines in 1564 (Bornhardt, 1931, 161). Waterpower was considered for raising ore in some Bohemian mines but was abandoned owing to the expense, but in the Tyrol a reversible waterwheel of 10m diameter was constructed in 1554 to raise ore in buckets and water in large leather pouches each holding 1400 litres. Somewhat earlier, the *hund* or wagon (Lewis 1970, 10-12), pushed individually by manpower but guided by a vertical pin running in the groove between plank rails, did much to improve the transport of ore.

Methods of ore preparation had been improved in the fifteenth century by adoption of troughs and sieves for water separation, and by introduction of single water-powered stamps to mechanise the crush-ing process. Initially they were used dry but wet stamping was found to reduce losses of pulverised ore. By the early 1500s, waterwheel-powered multiple plant could, with three stamps, crush 450 to 750 tons of ore, with four stamps, 650 to 1,000 tons. Undoubtedly these developments in efficiency were spreading throughout the main centres of copper production. In mainland Europe such centres were found in Slovakia, the Harz and Thuringia, the Tyrol and Carinthia. Outside Central Europe only the Swedish Falun mine was of any considerable importance.

In the early 1500s there were works capable of smelting 7,000 cwt of copper per year. One such complex at Eisfeld (Thuringia) comprised eight smelting furnaces, ten liquation furnaces for extracting silver, three refining hearths, and three cupelling hearths as well as two drying ovens. In Slovakia, small copperworks at Stare Hory and Harmanec became unprofitable because of an increasing shortage of wood and were replaced by much larger installations further South at Neusohl, (now Banska Bystrica) in the 1550s. The shortage of timber for fuel became an increasing problem of many of these works. (Kellenbenz 1974, 296; Cipolla 1974, 208).

At Neusohl, smelted copper was cast and hammered into standard, 'half-finished' wares such as square and circular discs, to be transported for finishing elsewhere. Granular copper was also produced for use in the mints. Finished hollow-ware including pots, pans and basins, were made also by use of fast tail-tripped water-powered hammers with long-nosed heads, termed 'tief' hammers (Kellenbenz 1974, 298). The introduction of this water-powered innovation brought vast improvements in efficiency compared with the old hand-powered battery methods. Possibly brass manufacture was included here with the copper but in available records there is no such differentiation, as with many other sources of the times.

On the Meuse at Bouvignes and Dinant, the use of waterpower for production of brassware was heavily restricted by overlords, favouring its use for more lucrative iron goods, especially arms manufacture.[6] By contrast, on moving to Aachen the brass batterymen of Dinant and Bouvignes were able to adapt their hand-working methods by using the slow, heavy nose-lift water-powered hammers, the 'mühlenhammers', introduced in the early sixteenth century for 'flattening' brass sheet. (Kellenbenz 1974, 298; Pohl 1974, 235; Peltzer 1908, 365).

Use of waterpower here was limited, however, by the guilds, which rigidly controlled methods of production, ostensibly, to protect their high standards of workmanship in the city, but also with an eye to guarding the existing state of employment. They permitted use of water-powered hammers only to flatten thin sheet from plate or ingot. (Schleicher 1974; Pohl 1977, 235). These ingots were in the form of thick plates of brass, which the melters produced by pouring molten alloy between heavy stone slab moulds. After flattening by the mühlenhammers, any further processing had to be carried out by hand, including the production of wire and of hollow-ware vessels, the pans, bowls and basins which were a high proportion of the output.

This ban on further use of waterpower was first mentioned in 1510, (Kellenbenz 1974, 298) in a decree declaring that such mechanisation produced goods inferior to hand beaten wares. Significantly, the output per man could be greatly increased by waterpower, as several sheets of metal could be hollowed out simultaneously under one mechanised hammer. It was said that the water-powered tief hammers could produce more in one day than ten handworkers in ten days. The threat to the employment of the city's skilled craftsmen was more than the guilds could permit. This restriction of technical progress eventually diminished the importance of the city's crafts and trade which the guilds administered, as craftsmen moved outside the city to Stolberg, where they could work without restraint. (Peltzer 1908, 365; Schleicher 1974, 236; Pohl 1977, 236). Religious persecution of protestant workers within the city gave further impetus to the settlement in which Stolberg eventually replaced Aachen as the main production centre of water-powered battery wares.[7] At Stolberg they had freedom to follow their religious beliefs and also to use the fast water-powered tief hammers (Pohl 1977, 235-6). This process continued to be denied to the Meuse craftsmen well into the following century (Douxchamps-Lefèvre 1977, 47-8).

THE TECHNICAL RECORD

The widespread distribution of skills from the Meuse which led to important adaptations of waterpower elsewhere in the brass-working processes had come to fruition during the sixteenth century (Fig. 4). At the same time a new level of technical writing was appearing, which described production and working of copper-based alloys and their constituents. These records are the first of any considerable importance which had been produced since the time of Theophilus, apart from minor references.

The anonymous *Nutzlich Bergbüchlin* on mining and *Probierbüchlein* on assaying methods were both much revised and reprinted from the early years of the century (Sisco and Smith 1949, Hoover and Hoover 1912, 609-14). Of far greater significance to the methods of production and working brass was Biringuccio's *Pirotechnia*, published in Italian in 1540. He had visited Germany and other European centres of production to study metallurgical methods and described them as a practical man (Smith and Gnudi 1942, 70-6). He observed brass-making furnaces in several locations which were on a much larger scale than those described by Theophilus. They were partially below the working surface and, according to his illustration, built in multiples of three. A large part of his section of brass was taken up with descriptions of multiple-mould-making for the casting of decorative objects which he had witnessed in Milan, where he thought the methods more advanced than those of Germany. Calamine he considered a 'semi-mineral' which coloured copper and increased its weight and could be used in every place where it could easily be procured. He also noted that 'tutty', referred to earlier by Albertus Magnus (Wykoff 1967, 250, and see also Craddock 1995, 317), could be used for the same purpose. This was the impure zinc oxide which condensed in the upper parts of furnaces smelting lead ores of high zinc content. Its use in brassmaking was later said to have been introduced at Rammelsburg by Erasmus Ebener about 1550, although several sources refer to it, under different names, well before that time.

De re Metallica (Hoover and Hoover 1912), another important technical publication by Georgius Agricola (Georg Bauer), published a few years later in 1556, concentrated on mining and smelting, omitting references to brass production. He did, however, refer to *contrefei*, his term for the furnace accretions of metallic zinc which occurred in lead furnaces in similar circumstances to *tutty*, the zinc oxide noted by Biringuccio. Agricola also made obscure mentions to *zincum* in two separate publications but did not link this material with *contrefei*. These references appear to have predated the publication of those by Paracelsus to *zinken*, usually credited as the first mention of metallic zinc (Hoover and Hoover 1912, 409-10). Such knowledge of its existence did not, however, contribute towards an explanation of the properties of this newly discovered material.

Fig. 4 Water-powered hammers for the manufacture of
brass battery in Germany, as illustrated by Christoff Weigel
in his *Abbiludung der gemmeinnützlichen Haupstände bis auf
alle Künstler und Handwerker...*(1698)

Fig. 5 Ercker's illustration of a brass-making furnace,
published in 1574 (Sisco and Smith 1951, fig. 35, p.258).
This needs a tolerant interpretation to discern features
described in the text, such as the underground furnace and
the flat stone slabs of the moulds used for casting brass
plate

Fig. 6 The coppersmith as illustrated by Jost Ammann in
1568. Using a bellows-blown hearth to anneal his hand-
beaten wares individually, these are just as likely to have
been made of brass as of copper.

Fig. 7 The bowlmaker, hand-beating brass hollow-ware
to a smaller scale compared with Fig. 6 by Jost Ammann

Lazarus Ercker in his *Treatise on Ores and Assaying* published in 1574 refers in the opening words of his section on brass production to 'furnace calamine', his term for the accretions mentioned above, being available in the Harz area and there used for making brass. He later warns that the brass produced from this material needed greater care in annealing when being worked to prevent cracking with a greyish fracture. He was noting an indication of the contamination from lead in this material gained as a byproduct of lead smelting (Sisco and Smith 1951, 254-7). He remarks that other works use mineral calamine which is 'added to copper to give it a yellow colour and convert it to brass'. The furnaces he describes are underground like those seen by Biringuccio but containing eight crucibles. If the brass produced is required for battery work it is poured between two large stone slabs to cast a flat plate of metal, the method which continued in use until well into the eighteenth century but Ercker's account is the earliest known of this particular technique. His whole description of brassmaking can be recognised as the method employed until the end of the era of calamine brass production and, undoubtedly, came from a man who was familiar with the processes.

The woodcut used to illustrate these processes in his publication fails by lack of artistic techniques to convey the underground situation of the furnace or the scale of the stone slabs used as moulds to cast the brass plate (Fig. 5). All the elements are there but they need careful interpretation. In contrast, a book of woodcuts by Jost Amman, published in Frankfurt a few years prior to Ercker's work, shows the standard of artistic competence required (Amman 1568). Although not covering the detailed processes of brass production, the illustrations depicting craftsmen making battery by hand, or producing candlesticks and candelabra, convey these activities well (Figs 6,7). Its publication date of 1568 was at a time of importance for the establishment of a native industry of brass production in England.

THE INTRODUCTION OF BRASS PRODUCTION TO ENGLAND

There is some slight evidence for suggesting that, possibly, the production of brass may have been attempted in England in the previous centuries (Blair *et al.* 1986), but, undoubtedly, it would have been on a small scale and of an intermittent nature.[8]

During the reign of Henry VIII earlier in the sixteenth century, unsuccessful attempts had been made to induce German entrepreneurs to set up the production of brass in England. The aim was to free the country from its reliance on continental sources. Further efforts by the later Elizabethan administration eventually achieved co-operation from Augsburg merchants who controlled mining interests in the Tyrol (Hamilton 1926, 1-16). Their first task was to find suitable resources of the necessary raw materials. Copper ore was soon discovered in Cumberland and experienced workers brought from the continent to start mining and smelting operations under the auspices of the Mines Royal Company. This was the first of the two powerful monopolies set up to establish the industry.

The Society of Mineral and Battery Works was later established to take responsibility for mining calamine and the production of brass and brass wire. Its search for calamine proved more difficult than that for copper as, previously, this zinc ore had not been known in this country. In consequence, it was recognized by Sir William Cecil, Elizabeth's minister, in 1565 that supplies might have to brought from the mining area near Aachen (Day 1984, 95). Just as the search was about to be abandoned a source was discovered on a Mendip outlier at Worle Hill in Somerset. Plans to use Bristol, just twelve miles distant, as the site of brass manufacture were frustrated by the inability of the company to find a suitable watermill as, from the outset, it had been intended to employ water-powered methods. The works were established subsequently, during 1566, on a small tributary of the River Wye at Tintern, across the Severn from Worle Hill. In the following year the first efforts at making brass in England were taking place at Tintern. It was soon found that the brass produced appeared to be of the right colour and good weight but lacked the malleable qualities needed to make it workable into sheet and wire, the main products required (Donald 1961, 91-3). Those responsible appeared to be unable to find the cause which probably had resulted from some impurity in the copper or calamine, which may have arisen from the introduction of mineral coal to fuel the processes.[9]

The attempts to make brass ceased at Tintern and the works adapted its processes to manufacture iron wire in the absence of home production in brass. The Society of Mineral and Battery Works still retained its monopoly for brass production but continued its operations by leasing this right to a series of entrepreneurs through most of the following

century. The majority of these efforts either failed to establish themselves, or, after a few years of unprofitable working, were undercut by cheaper imported goods from the continent (Day 1973, 20-4). Additional problems were caused when the Mines Royal Company, having failed to extend its smelting activities to Aberdulais in South Wales, ceased completely by the 1640s to produce supplies of copper because of financial constraints (Hammersley 1973, 14-15).

It was apparent that 'Dutch and German merchants, using Swedish copper for the making of brass, were importing great quantities of brass-ware, pans and kettles into England, thereby reducing costs and breaking the English out of this trade' (Rees 1968, 588). This was the plea put forward by the industry in an unsuccessful petition to the government to raise the duties on such imported wares. In fact supplies were coming through Holland from Swedish sources (Hamilton 1926, 57). Significantly, the most successful and long-lasting of the seventeenth century brass manufacturers in England was Jacob Momma, one of several continental immigrants engaged in the trade but he was from a well-established brass-making family at Stolberg, near Aachen (Day 1984, 47-54). He set up his brass plate and wire mill at Esher in Surrey where a previous enterprise had failed. A few years later he was appealing to Parliament for a reduction in duties on the Swedish copper required for his brass-making furnaces, supported by his countrymen Daniel Demetrius and Peter Hoet whom he joined in partnership. Sweden had become the predominant exporter of copper during the seventeenth century and was also sending large quantities of brass goods to the English market, against which Momma later protested when petitioning unsuccessfully for import duties to be raised. He extended his interests to copper mining at Ecton Hill in Staffordshire, smelting his ore at nearby Ellaston Mill for a brief period (Robey 1981, 149-51). He is believed also to have had connections with the trading of calamine from Mendip, which he used for his own brassworks and exported to his continental associates (Morton and Robey 1985).

Further sources of zinc ore had been discovered on several Mendip sites since the initial investigation (Gough 1967, 215). Large amounts were being exported to continental markets where it was valued as being of excellent quality. In 1662 John Tripp of Mendip was called to explain to the Society of Mineral and Battery Works why he had been engaged in this trade without their permission (Day 1973, 24). In stating his ignorance of the need, he also offered to supply them between 400-500 tons per annum, already calcined, suggesting that he was trading on a considerable scale. It seems possible that he was associated with the Trip family of the Netherlands who were leading merchants in metal trading during the seventeenth century (Klein 1965). Sir John Pettus of the Society in his *Fleta Minor* of 1783 remarked of English calamine, 'We have mountains of it [yet] we let the Calaminaris for Ballast into foreign parts in every Quantities, before it be wrought, so as the best Brass beyond the Seas is made of our stone rather then their own'. Clearly, the main cause of difficulty in the production of brass in England lay with the supply of copper rather than that of calamine.

As the situation deteriorated in both the supply of copper and production of brass, important steps were taken in the last two decades of the century which eventually produced a remedy to these difficulties of brass manufacture. Amongst increasing opposition to the monopoly organisations the Mines Royal Act was passed in 1689 which limited the powers of the two companies which had governed the industry. Its effect was endorsed and strengthened by an additional Act in 1693 to prevent any further dispute (Hamilton 1926, 64).

INNOVATION IN ENGLISH COPPER PRODUCTION

As these parliamentary measures were being taken in freeing industrial enterprise, important technical progress was being made towards cheaper supplies of copper for the production of brass. Earlier experiments in Bristol with the smelting of lead gave rise to the use of coal fuel in reverberatory furnaces which were now being adapted to copper smelting. By the late 1680s small amounts of copper had been produced successfully which showed signs of alleviating previous difficulties brought about by the rising costs of wood fuels (Jenkins 1934, 1943, 1943-4)(Fig. 8).

The technical problems of using coal as the fuel were overcome partly by creating a greater draught through the furnace to a chimney built at the opposite end from the firebox. Contamination from coal fumes was avoided by the crosswall which separated the grate from the main chamber, and directed flames to follow the curved line of the vaulted roof to 'reverberate' or radiate heat to the ore hearth below. The vaulted construction gave rise to

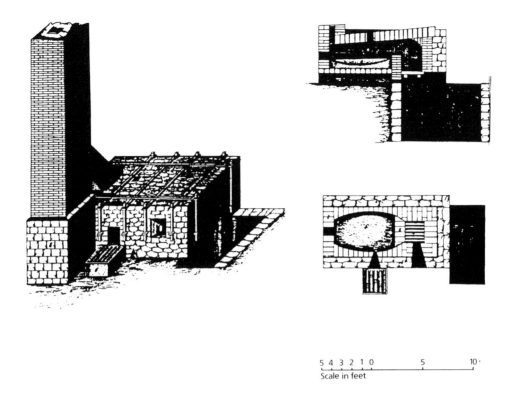

5 4 3 2 1 0 5 10·
Scale in feet

Fig. 8 The reverberatory furnace as used for copper smelting in Bristol by 1711, from Schlüter, *Grundlicher Unterrichte von Hütte-werken*, 1738

the local name of 'cupilo' for these constructions. The practical work for their development was undertaken by John Coster and Gabriel Wayne who were both to prove influential in the future course of the industry. Their early financial masters, however, were unable to make a commercial success of these early experiments and both Coster and Wayne left Bristol in the early 1690s to establish separate new smelting works at Redbrook on the River Wye on the other side of the Severn. At the time other companies were being formed elsewhere in the country to exploit these new techniques but their achievements were not comparable with those that were associated with the pioneering efforts of Coster and Wayne.

Coster's works at Upper Redbrook was run by a joint-stock company whose leading proprietors included William Dockwra, owner of Esher brass works and the only one known still to be working in England during the last decade of the century (Day 1974-6, 47)). His mill was probably a successor to that of Jacob Momma whose main premises are said to have been destroyed after his death in 1680 but who by then had acquired further properties in the area. Apart from his production of wire and pins at Esher, Dockwra is credited with having introduced a rolling mill to supersede the old method of hammering sheet and plate metal (Houghton 1697,

192-4). His works were later to be amalgamated with the Bristol industry, in which Coster's family was to play a large part after the turn of the century. In the mean time, the main stocks of brass metal and wares continued to be imported from the Low Countries, Sweden and Germany only to be halted by developments at Bristol which proved to be the start of a new era of brass manufacture in England.

By 1696 Gabriel Wayne had returned to Bristol to set up a new smelting works partnership with Abraham Elton, a prominent merchant of the city. Two years later, Elton was seeking a market for his mounting stocks of copper (Day 1973, 29-32; Jenkins 1943-4).

BRASS PRODUCTION IN BRISTOL

With the prospect of copper being produced just outside the city's boundaries and calamine available from Mendip just 12-15 miles away it is hardly surprising that by 1700 initiatives were being taken to establish a brass industry in Bristol. In July Edward Lloyd was one of five Quaker partners who petitioned the Privy Council for a Charter of Incorporation in order to establish a company (Day 1973, 35). Nothing emerged from this petition but two years later a works had been set up at Baptist

Mills on the River Frome by Lloyd and a group of different Quakers, which included Abraham Darby as the 'active man' or manager. These works were to survive and flourish, eventually to be described as the largest of their kind in Europe but, at the outset, it was deemed prudent to acquire skilled men from the continent. According to Hannah Rose, writing in old age of her early years, Abraham Darby 'went over to Holland and hired some Dutch workmen'. The relevant dates she quotes are not in accordance with other sources and it is also believed that her references to Holland and the Dutch might well be interpreted more generally to the area between the Meuse and the Rhine where the skills being used at Bristol were particularly concentrated. It can be inferred from early company documents that skilled melters to produce brass metal would have been required and also batterymen to operate the fast water-powered hammers capable of producing batteryware. This was to be the main product of the early company, featured in its new deed of partnership in 1706 establishing a business of eight proprietors (Day 1973, 35-7).

By then additional new premises[10] had already been taken at Keynsham in the valley of the River Avon some five miles away and a new copper-smelting site was being established at Crews Hole near the Conham works of Elton and Wayne. Abraham Darby was soon to leave Bristol for Coalbrookdale in pursuit of his main interest in developing new techniques in the iron industry but his departure appears not to have affected progress at Bristol. The company continued to expand to new sites along the Avon Valley between Bath and Bristol where records can still be traced of immigrant brassworkers from the continent (Day 1984).

The products being made were of a practical nature which included a range of hollow-ware for domestic and industrial purposes in addition to stocks of brass plate and hammered sheet to provide craftsmen working elsewhere with their raw materials. By 1709 the company had amalgamated with the successors to William Dockwra owning the brass-wire works at Esher, increasing the range of products which were eventually to be incorporated with the Bristol production (Day 1973, 40). Thus, it evolved to become very similar to the industry which had developed throughout the previous century at Stolberg, near Aachen (Schleicher 1974, 34-5). There, they lacked sources of local copper and production was organised under a number of wealthy *kupfermeisters* (translated literally as copper masters but

which, again, should be interpreted as masters of brass production).

The Stolberg trade was in goods described as 'half-finished', such as brass plate, sheet and wire and unfinished bottoms of large hollow-ware vessels. Their finished goods included all kinds of hollow-ware such as pots, pans, kettles and vats, and wire goods such as pins and needles, all of which had been among the wares exported to England in quantity during the previous century. The finer items such as clocks, scientific instruments and highly decorated objects were, in the mean time, being made in such centres as Cologne and Nurenberg, but often from brass produced in Stolberg (Schleicher 1974, 35). The Meuse communities continued to produce the decorative wares in which they had formerly specialized but with less dominance than formerly.

The 'half-finished' brassware being produced at Bristol found a wide market in the Midlands where small workshops made a wide variety of metal goods such as buttons, buckles, and furnishing fittings. Local Bristol craftsmen took the opportunity presented by this new source of material to make domestic items such as candlesticks, sconces and candelabra (Oman 1936; Sherlock 1958, 1962). Several examples of candelabra still hanging in West Country churches can be identified as being of local origin. They were also made elsewhere in the country, primarily by fine London craftsmen who, possibly, still used imported brass in the early years of the eighteenth century (Oman 1936; Sherlock 1958, 1962). They would have had other nearby sources at Esher brass mills and separate concerns that were being established. Temple Mills works on the River Thames near Marlow was one of the more important establishments but hardly on a comparable scale with the industry being created at Bristol.

A further concentration of the Bristol industry occurred when John Coster, the Redbrook copper smelter, with his three sons, acquired mill sites in the surrounding areas of the city where they rolled copper sheet and produced batteryware and a range of half-finished copper goods (Day 1974-6, 51). Their Upper Redbrook smelting works was formally amalgamated with the Bristol brass company by 1721. During the 1720s an important improvement was being introduced in the traditional brass-making process by Nehemiah Champion who had succeeded Abraham Darby in managing the Bristol works. In 1723 he registered his new method of making brass in Patent No 454 in which the copper was granulated before being placed in the crucibles of the cementation furnace. The greater surface area of the

granules, compared with the broken pieces used previously, was more easily permeated by zinc vapour from the calamine during the brass-making process. Because less zinc vapour was wasted a greater yield of brass was created from the same raw materials and in less time than formerly required. Using broken copper, it was said that 56 lb of brass resulted from every 40 lb copper after adding 56 to 60 lb calamine (Day 1973, 58-61). This increased weight represented the basis of the brassmakers' art, as much zinc in the calamine was inevitably lost in the process, owing to the difficulty of handling a substance which volatilised at such low temperatures. In present-day terms the old Baptist Mill methods appears to have produced a brass of 72% copper to 28% zinc inclusive of any impurities present.

After the introduction of granulation to the process the works were said to have produced a 50% increase on the weight of copper used, representing a brass of 66.7% copper to 33.3% zinc, approaching the most economical grade capable of being used in the company's products. Gradually, the granulation of copper was adopted as general practice throughout the industry for the production of cementation brass but it was still being described as a new process by

Gabriel Jars, the French metallurgist when he visited Bristol in the 1760s (Jars 1774, 152-4). However, this may not have been quite the innovation Champion claimed as brasses with over 30% zinc are known from the sixteenth century[11] (Cameron 1974).

Nehemiah Champion also used the same patent to register a new method for annealing brassware, in bulk, inside a coal-fired furnace (Day 1973, 61). Previously goods which had been work-hardened by the severe mechanical treatment of batterywork, rolling or wiredrawing, the usual production methods of the Bristol company, had been annealed individually. What evidence there is suggests that an open waist-high charcoal-fired hearth had been used for the purpose. Limited use of coal had been employed for the purpose at Stolberg but, there, the best goods were said to have been annealed with charcoal, suggesting that coalfiring may have been less than satisfactory (Schleicher 1974, 38-41). The possible harmful contamination from coal fumes was avoided in Nehemiah Champion's method by sealing the brassware in an iron container before its insertion into the furnace chamber. The method lent itself to a more intensive production flow and saved expensive charcoal by using locally available coal in its place.

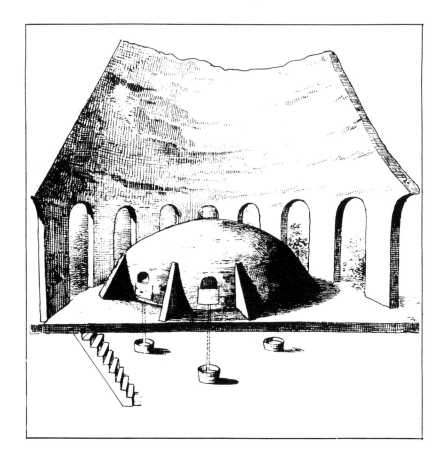

Fig. 9 The sketch of William Champion's zinc-smelting furnace recorded by Swedish observer Reinhold Angerstein in 1752. The lack of detail suggests that no intensive study had been possible.

WILLIAM CHAMPION AND THE PRODUCTION OF ZINC

Champion's innovative approach was shared by his two sons John and William who were both actively engaged in the industry and responsible for introducing new processes. The younger son William became interested in the problems of zinc production at an early age and visited several European countries to improve his knowledge on the subject. Glauber in the previous century had related metallic zinc to the ore, calamine, but confusion remained about its true nature because of the difficulty experienced when attempts were made to produce the metal from its ore by experimental methods. The German writer Henckel stated in 1721 that he had succeeded in making zinc but no developments resulted from his discoveries. William Champion was only 20 years old when he returned to Bristol in 1730 to start a series of experiments (Day 1973, 73-4). He aimed to replace imported supplies of the metal brought at high costs from the East to England, the impure 'tutty' recovered from the furnace accretions of German lead-smelting furnaces not being available in this country.

By 1738 William Champion appears to have solved the problem, having then applied for Patent No 564 for 'A method of Invention for the Reducing of Sulpurous British Mineralls into a body of Metallick Sulphur' (Jenkins 1945-7). This obscure title covered his new large-scale technique for the production of metallic zinc (Fig. 9). Calamine and charcoal was sealed in a number of large crucibles by luting the covers with clay. A large hole in the base of each crucible allowed a three-inch diameter iron tube to be similarly luted and protrude below through the bed of the furnace for several feet to a vessel of water at the base of the condensation chamber. The aperture to the crucible was temporarily blocked by a wooden plug which charred away during the process. Coal fuel occupied a grated trough placed through the centre of the combustion chamber with the crucibles formed in a ring around it. Above the domed roof of this chamber the chimney was built into a cone in a similar manner to those of the coalfired glasshouses of the city which had been working from the early years of eighteenth century. The condensation chamber below the bed of the furnace was called the cave, from glass-working parlance, suggesting a further connection (Fig. 10).

By providing a large-scale distillation plant, William Champion had overcome the main problem

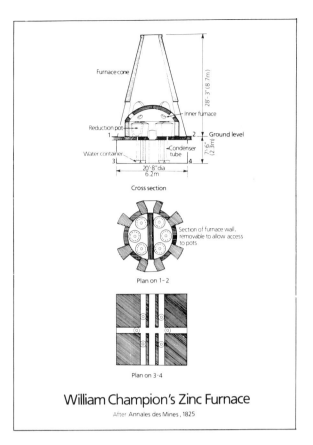

William Champion's Zinc Furnace
After *Annales des Mines* , 1825

Fig. 10 A more detailed arrangement of Champion's zinc-smelting furnace was eventually published by Mosselman of the newly emerging Belgian zinc-smelting company, in *Annales des Mines*

experienced by others trying to produce a metal which vaporizes at such low temperatures. At approaching the 1000°C which is required for its reduction, zinc is being released as a vapour which rapidly re-oxidises in the presence of air. This had been prevented by Champion's process of *distillation per descencum*, as it became known (Watson 1786, 38-40). Recent investigations have shown the arrangement of his furnace was a scaled-up version of the method used in India centuries before (Craddock *et al.* 1985 and this volume). A comparison strongly suggests a connection between the two, although this has yet to be discovered.

After securing patent protection for his zinc production, Champion set out to form his own business and, in so doing, established a rival organisation to the old Bristol Company. On one large site he smelted copper, produced brass by the traditional cementation method and manufactured half-finished and finished goods (Day 1973, 73-94). Eventually, he also included pin-making at his new works at Warmley just outside Bristol. By 1748, he had built his new zinc-smelting furnaces there and

copper-smelting reverberatories, together with his brass furnaces and waterpowered plant for rolling, wiredrawing and battery-work. Steam power was introduced with a large Newcomen engine which recycled water used by his waterwheels, as he was short of water on his site. These supplies were also conserved by a windmill and a horsemill used for crushing his ores. Warmley was thus planned as the first integrated production plant of its kind for nonferrous metal goods where all the processes were completed, from the smelting of ores to the manufacture of finished wares for sale.

Despite his qualities as a capable metallurgist, inventor and adapter of new ideas, William Champion lacked some of the attributes required in managing such an enterprise. His constant plans for expanding his business outran his own financial resources and those of his fellow proprietors. By 1769 he was bankrupt and afterwards, most of his sites were taken over by the old original brass company (Day 1973, 84-94). On one of his last schemes for expansion being built in 1764,

Champion had erected annealing furnaces of a design which greatly improved the type introduced by his father some forty years before (Fig. 11). This new annealing technique was carried out in a large coal-fired muffle furnace. Its fireboxes were placed on either side of the structure, separated from an inner chamber by an arched wall, inside which the brassware to be annealed was positioned without need for further protection. These furnaces were built later on all the manufacturing sites of the old Bristol company and they were still being used until the 1920s in the last years of the Bristol industry (Day 1988) (Pls 1-3). They appear only to have been built in the environs of the city, with one possible exception at the Holywell brassmill in Flintshire, built by William's elder brother John in the 1760s. John had been responsible for several patented improvements in brass production, including the introduction of zinc blende, or sphalerite, a zinc sulphide common in North and Mid-Wales to English brass-making methods which provided a replacement for carbonate ore of calamine.

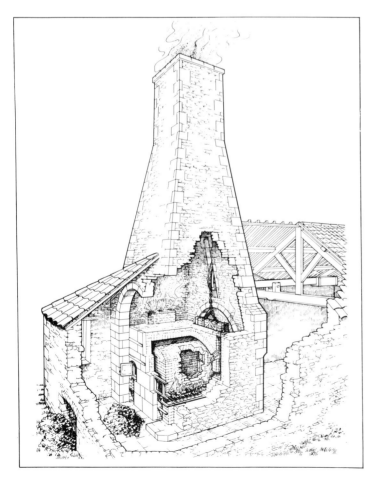

Fig. 11 A conjectural drawing of the surviving annealing furnace as used until the 1920s at Saltford Brass Mill, near Bristol

OPPOSITION TO BRISTOL DOMINATION

With the demise of the Warmley company and withdrawal of expertise by members of the Champion family, the industrial initiative rested with the proprietors of the old Bristol company. Although the concern had grown to become a powerful organization it appears at this stage to have been settling towards complacency in technical matters. Its commercial methods of lowering its prices to cut out competitors and then raising them indiscriminately were soon to evoke strong opposition among manufacturers in Birmingham who relied mainly on Bristol for its stocks of brass. Production of the alloy in Birmingham had been only on a very small scale and comparatively short-lived. The Cheadle company in Cheshire which had been making brass from the 1730s was the only other early source of supply and this business worked in collaboration with Bristol's commercial policies (Morton 1983 and 1985, Harris 1964). In 1781 the situation provoked a co-ordinated effort by Birmingham manufacturers to establish a viable industry in the local production of brass. They were aided in their plans by Matthew Boulton and also by Thomas Williams, the entrepreneur of new copper deposits which had been discovered in Anglesey (Harris 1964). These became important as the copper mining in Cornwall, on which Bristol depended, became more difficult at greater depths of working. Williams forced a re-organisation of copper supplies in England to which Bristol became subservient during the 1780s (Harris 1964, 37 *et seq*). By the close of the century, copper smelting at Bristol had ceased. Although its brass industry was described as 'perhaps the largest of its kind in Europe' in a Parliamentary Committee Report of 1799, its position was already threatened by developments in Birmingham.

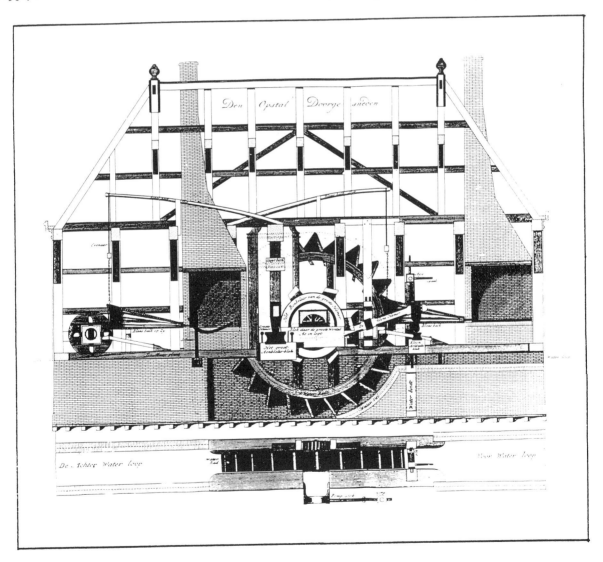

Fig. 12 Annealing furnaces blown by bellows are shown in several continental illustrations of eighteenth-century brass mills. This Dutch example is from *Groot Volkomen Moolenbook*, by van Natrus, Pouy and van Vuuren, in 1734.

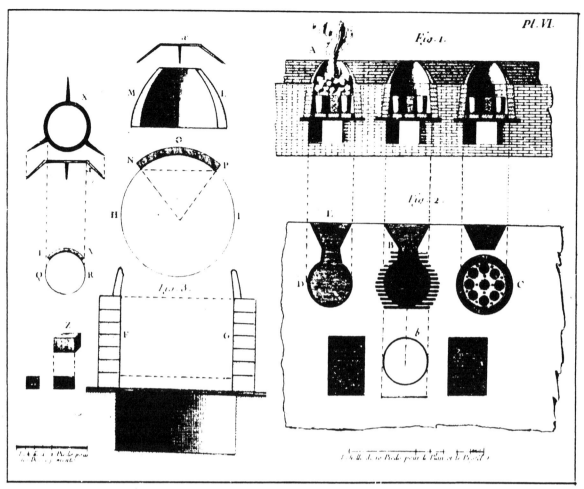

Fig. 13 The brass-making furnaces illustrating M. Galon's account of the industry at Namur are the best portrayal of the calamine brass furnace.

THE DECLINING IMPORTANCE OF THE CONTINENTAL BRASS INDUSTRY

The production of brass in other European countries had not kept pace with the technical innovation occurring in eighteenth-century England. The fine continental workmanship of its artistic products remained a powerful attraction but there is little evidence of progress equalling measures being adopted in this country for making goods of a more mundane nature (Schleicher 1974, 34–57). Although the English manufacturers had made unsuccessful petitions to Parliament in the early part of the century for higher duties on imported wares to protect their own markets, these were regarded as being unnecessary by 1740. It was said that, by then, the stage of technical competence reached in England 'not only raised the Trade but was principally Instrumental in Establishing it so Effectually that the Importation of Foreign Wrought Brass and Copper Manufactures was greatly diminished' (Day 1973, 47).

When M. Galon described the brass works he saw at Namur in 1748, he wrote of methods which had already been outdated in England. Namur brass was being produced by using broken copper rather than the more efficient granulation technique. Water-powered hammers were still used for making plate and sheet, a method outdated by the rolling mill (Galon 1764, 32). Annealing processes were hardly mentioned but illustrations suggest that they involved individual handling over a charcoal hearth, the use of coal being only minimal (Fig. 12). The advanced innovations of William Champion at Warmley were outside the scope of current continental enterprise, but it can be presumed that Namur represented the most advanced works available to the French writer.[12] The account he produced was well illustrated and a technically accurate account of processes for that time on the continent (Fig. 13). Descriptions of sites located in his own country, which were added to those of Namur when Galon's work was published in 1764, suggest that they were less advanced (Galon 1764). The main site at the ancient centre of

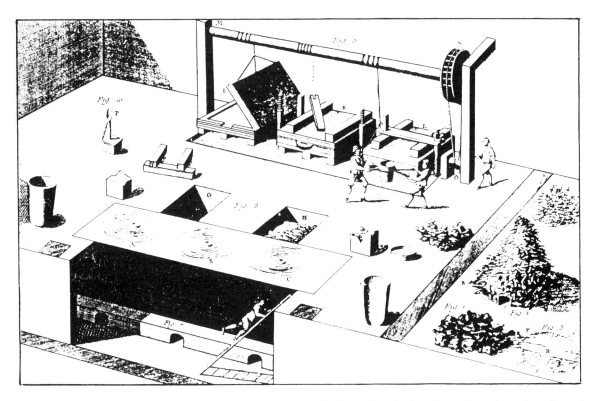

Fig. 14 This illustration of brass making from Diderot's *Encyclopédie* of 1763, thought to have been based on those produced for Galon, shows clearly the housing for brass-making furnaces beneath A, B and C, with the stone slab moulds on the working floor. The scene is comparable to, and assists the interpretation of, the Ercker illustration (Fig. 5)

bellfounding at Villedieu-les-Poèles in Normandy, depended entirely on remelted scrap as its only source of brass. The melting was carried out in furnaces below working-floor level which were blown by water-powered bellows, rather than the efficient use of natural draught which left water power available to operate other processes (Fig. 14).

In the large industry centred at Stolberg to the south-east of Aachen, 38 individual businesses were said to be working at the close of the eighteenth century but, already, they had lost initiative in their market of half-finished and battery wares to England (Schleicher 1974, 84). Rolling mills had not been installed, possibly because surplus water power was lacking on the small River Vicht in their tightly-packed court-yard sites. They were only adopted when steam-power was introduced after the mid-nineteenth century. Coal-fired annealing had been used to a limited extent as previously noted, although the method is not recorded. In other areas of Germany, as at Hegermühle near Potsdam, large-scale annealing furnaces were in use prior to 1830 when they were recorded in an English publication (Ure 1839, 168).

CONTINENTAL PRODUCTION OF ZINC

It was in the area of Altenberg, the source of the finest European calamine supplies, that technical innovation of outstanding importance was eventually developed. The area of mining had become more important as alternative deposits were worked out, or found to be more contaminated with impurities as lower levels were reached. With the emergence of the French Republic towards the close of the century Altenberg, or Vieille Montagne in its French version, had been appropriated by the State. At Liège, on the Meuse to the West of the area Jean-Jacques Daniel Dony was trying to make improvements on the English technique of producing metallic zinc (Day 1984, 39-41).

It seems likely that he learned details of Champion's process from Henri Delloye of Liège who had visited Bristol in 1804 on a clandestine tour of Britain. According to his own account published in 1810, he posed as a travelling musician while carefully recording his observations on zinc smelting. Dony was trying to evolve a continuously-heated furnace with large numbers of cylindrical retorts which could be inserted horizontally, and withdrawn without substantial cooling of the main structure.

Furnaces with horizontal retorts had previously been employed in the production of mercury in some continental centres. The high-quality refractory materials (locally known as *derle*) available in the Meuse Valley enabled the use of long clay retorts supported only at either end, which could be heated on all sides, using fuel most efficiently (Centenaire Société 1937). Napoleon awarded a concession of the Vieille Montagne mineral rights to Dony in 1806 in support of his new process, but after financial difficulties the work was taken over by Mosselman leaving Dony to die in poverty. His smelting method had far-reaching results, however, both from its fuel economy and the ease of handling of its small retorts compared with other processes (Morgan, 1977), which were under development at a similar time.

In 1798, Bergrath Dillinger had established zinc works at Dollach in Carinthia on the borders of Austria and Italy, based on his earlier efforts to develop Champion's method (Ingalls, 1906, 1-2). His wood-fuelled furnaces incorporated more than a hundred small vertical retorts, terminating in tubes at the lower ends which passed zinc vapour to a common condensation chamber. Dillinger built other sites and was appointed director of Austrian zinc production, but management of his Carinthian furnace proved difficult and costly, leading to its eventual abandonment.

Johann Ruhberg of Pless (now the Polish Pszczyna) in Silesia, having learned of the English method, adapted a circular wood-fired glass furnace to distil calamine in pots at Wessola in 1799. Later, he replaced the pots by devising a system of large-capacity muffles, up to 4ft (1.22m) in length, placed either side of a coal-fired grate through the length of a rectangular furnace. The muffles were attached to horizontal tubes which protruded through arches to the furnace exterior. There they were bent downwards enabling the collection of zinc droplets as vapour condensed in the lower temperatures. This Silesian furnace with its element of continuous working proved capable of further development, forming the basis of an extensive zinc industry. Fuel consumption of 20 parts of coal to 1 part of zinc produced, was reduced to 17:1 and again much later to 11.5:1 at Swansea, a considerable improvement on the English furnace (Ingalls 1906, 396-401). The process was widely adopted, often working alongside, but, eventually, being superseded or partly incorporated into the more efficient process developed by Dony.

In England, metallic zinc as produced by the original Champion method had proved too expensive for industrial and work-a-day brass goods. It had been employed for the more costly items of decorative art metal, jewellery, and for special purposes, where prices had been of little consequence, but not for regular industrial output. Following William Champion's bankruptcy one of his managers, James Emerson, had set up his own business at Hanham with his own zinc-smelting furnaces on the pattern of those at Warmley (Watson 1786, 50). By 1781 he had patented a method of brass production using copper and metallic zinc. Under Patent No 1297, he described the process involving the granulation of both copper and zinc but it also included a small proportion of calcined calamine in what must have been a partial cementation process (Day 1973, 123-5). The resulting brass was said to be of very high quality, free of blemishes and iron impurities, and so particularly suitable for making the bowls of compasses. His business, however, failed commercially and by 1803 he was bankrupt. Bankruptcy also followed his successors, Philip George and Christopher Pope who were later associated with his site in their Bristol businesses.

THE INTRODUCTION OF ZINC SHEET

By 1809, Pope was also advertising the manufacture of 'patent Malleable Zinc', probably produced at Emerson's old site at Hanham (Day 1973, 133-4). Delloye from Liège commented on this early use of zinc sheet a roofing material which he had seen as in Bristol in 1804 (Delloye 1810, 57). His observations may well have inspired the later development of zinc sheet for this purpose by Dony and his successors. Malleable zinc was patented originally in April 1805, by Charles Sylvester and Charles Hobson of Sheffield, where zinc had been produced from about the turn of the century from calamine on Alston Moor. The Patent No. 2842 referred to methods of hot-working zinc sheet, heating it to between 210°F to 300°F (99°C to 149°C) to undergo treatment under the hammer or drawing into wire. In 1823 in Bristol, Pope patented alloys of zinc and tin, and zinc, lead and tin as rolled sheet for roofing material and ships' sheathing. These alloys were never adopted, contrasting with the comparative success of the unalloyed zinc sheet and tiled roofing as widely developed for use on the continent. Zinc sheet became increasingly popular as roofing material from the 1850s. Thus the *Building Practical Director*, published about 1860 (Tarbuck and Payne n.d.),

notes (Supplement vol., p.99) that

> the plumber and coppersmith have received a considerable shock from the introduction of sheet zinc into this country by the Vieille Montagne Company, and this material has, to a certain extent, from its exceeding cheapness and lightness, superceded both lead and copper.

Vieille Montagne Zinc sheet was clearly the market leader, elsewhere (main volume, p.130), the specification for the roof of an Italian villa, notes that: 'main roof of Italian-formed Zinc (i.e. the sheet formed into pan tiles) ... Vieille Montagne Zinc to be used, no other is to be depended on'. And elsewhere again (p.100): 'Zinc sheet for roofs 'The Vieille Montagne Zinc is by far the best; and it may be procured, of excellent quality, from Mr Frederick Braby's works in the New Road, London.' Bristol was no longer involved in this later production of zinc sheet. By 1832, Pope had also succumbed to bankruptcy like his earlier Bristol predecessors in the zinc industry (Day, 1973, 134). His collapse came just prior to new impetus in the use of zinc roofing material with the introduction of 'galvanised' iron.

'GALVANISED' IRON

In Paris in the previous century, as early as 1742, Paul-Jacques Malouin had produced memoirs on zinc and tin in which he suggested that zinc might be used to replace tin as a coating for iron. At the time no practical results were recorded but in 1786, Watson referred to recent use in Rouen, later abandoned, of zinc as a coating on hammered iron saucepans (Watson, 1786, 177). Nothing further appears to have developed until 1836 when a French chemist, Sorel, who had been working in collaboration with Ledru, introduced and patented a process in which he used the misleading term 'galvanising', later so widely adopted. Sorel's process appears to have been the direct basis for English Patent No. 7355, of 1837, granted to H.V. Craufurd. (Dickinson 1943-4). Although described as Commander of the Royal Navy, other personal details of Craufurd appear to be little known. In his patent he directed that iron objects were dipped in a bath of molten zinc protected from volatilization by a layer of sal ammoniac, (ammonium chloride, NH_4Cl) which also served as a flux. Craufurd's patent was infringed in England soon after granting, and was followed by several improvements, particularly by Edmund Morewood, collaborating with George Rogers in Patent Nos. 9055, 10859,

11476, 13971 and 14040, the four latter referring to methods of corrugation. The protection which the zinc conferred was much later discovered to depend for its effectiveness on a layer of zinc-iron alloy being formed which resisted corrosion. By the 1840s, the more general introduction of 'galvanised' sheet established the basis for a new industry in the manufacture of domestic, agricultural and industrial goods, and for building in its corrugated form. It also brought additional demands for zinc. By mid-century wrought-iron sheet hot-dipped with zinc, such a common feature of the home and landscape in later years was being produced in London, Bristol and the Midlands and early examples still survive on the covered boatyards at Chatham Naval Dockyard, dating from the early 1840s (P.T. Craddock pers. comm). Imported continental zinc was being increasingly utilised, particularly that made by the Vieille Montagne company, successor to the Dony enterprise, taking its name from the ancient calamine mine near Aachen at the Belgian-German border country.

THE GROWTH OF BIRMINGHAM PRODUCTION

In England the new century had brought hard times generally in the industry but particularly in the declining centres of Bristol and Cheadle. In Birmingham, steam power was adopted to introduce improved methods of production. The manufacture of an ever-widening range of industrial components and domestic fittings, such as those needed for the new gas lighting, were being undertaken. Many of the new goods could be made as multiple castings in their numerous foundries where scrap metals could be utilised, together with raw materials of lower cost, as impurities had a less damaging effect on this work compared with batteryware.

During the 1830s a reduction in English import tariffs allowed continental supplies of zinc into the country at substantially lower costs, making its use far more economic than in previous years (Hunt 1887, 905). This was the stage at which zinc from the continent began to be universally employed to make brass in a simple melting operation. Small individual foundries could produce their own brass, and to the different grades, with percentages of copper to zinc adjusted to their own requirements. In 1832, George Frederick Muntz of Birmingham patented his highly successful method of producing yellow metal, which could be hot-rolled, could accommodate minor

impurities, was resistant to corrosion and useful for a variety of purposes. It consisted of 60 per cent copper, and 40 per cent zinc, together with a small adventitious presence of iron, although the proportions could be varied from 63:37 to 50:50 (Alexander 1955, 419-20). Aitken, Birmingham's brass historian protested that Muntz had been able to patent an alloy when several of his predecessors had previously lodged similar patents (Aitken 1866, 313). But he was referring to the years before the availability of cheaper, imported zinc and those previous alloys had been forgotten (Alexander 1955, 402-3). Muntz metal was to achieve widespread production, estimated to be about 11,000 tons per annum by the mid-century in Birmingham, in addition to large-scale production at Swansea. Although the old cementation method for brass lingered in a few places until after the mid-century (Percy 1861, 612), it was the end of the era for calamine brass.

END NOTES

1 Calamine, the carbonate ore of zinc, $ZnCO_3$, known as smithsonite in the USA terminology. As the historic term was calamine there is good reason for retaining it here.

2 References to bellows in the small handworked battery sites of the Meuse, for instance, appear to relate to annealing rather than brass production, but both Diderot and Ure describe instances of brass furnaces which are blown by waterpower. They can be seen as the exception rather than the rule.

3 The word 'latten' is frequently used to describe wire and brass battery imports to England during the seventeenth and eighteenth centuries, and a quaternary alloy would have been far from suitable in these products. The word was still being used specifically to denote sheet brass until the last mills closed in the Bristol area in 1927. It was verified by the writer with one of the last remaining brass workers. It also has a history of being adopted to other types of sheet metal such as black plate (wrought-iron plate) and tinplate.

4 Dr de Ruette has made an extensive study of the production and construction of medieval artefacts and also medieval brass-making techniques. The present writer acknowledges her guidance in studying the medieval industry.

5 The French 'Vieille Montagne' or German 'Altenberg' of La Calamine, or Kelmis near Aix-la-Chappelle, or Aachen on the borders between Belgium, Holland and Germany, can be compared with the English term 'Old Man' for an ancient mine working.

6 The use of waterpower had been developing in mining practice and ore preparation from the late 1400s and was extended to operate water-powered hammers at Aachen by 1510. Such methods were being used at Neusohl in Hungary (now Slovakia) in the first half of the sixteenth century (Kellenbenz 1977).

7 Other countries also benefitted by the spread of craftsmen at this time, Sweden and England amongst them.

8 In a document of a brasiers' legal dispute, the puzzling word 'stelebake' has been interpreted as Stolberg (from the similarities in pronunciation) to define calamine, used with 'graycober' (gray copper) and 'old bras' [sic], as the raw materials of brass production at Oxford in the 1390s.

9 Calamine ore revealed by construction of a reservoir on the flanks of Worle Hill in recent years shows a high lead content in contrast to samples from other Mendip areas. This possibly may account for the initial difficulties in producing brass with malleable qualities. The 'rough' copper produced in the Lake District was an even more likely source of troublesome impurities.

10 The former evidence for 1708 as the earliest occupation of a brass mill at Keynsham has recently been surpassed by the discovery of a lease dating from 1705.

11 There is no evidence from present sources of the method of production for this brass. It may possibly have involved the incorporation of metallic zinc from Goslar.

12 No mention is made of copper granulation in the use production of brass. Most surprising is the omission of rolling here in the eighteenth century, as was also the case in the brass works of Stolberg, see below.

REFERENCES

Aitken, W.J. 1866. 'Brass and Brass Manufactures', in *Birmingham and the Midland Hardware District*, Timmins (Ed.), London.

Alexander, W.O. 1955. 'A Brief Review of the Development of Copper, Zinc and Brass Industries of Great Britain 1500 to 1900', *Murex Review*, 1, 389-423

Amman, J. 1568. *Eigentliche Beschreibung aller Stände auf Erden...*, Frankfurt

Biringuccio, V. 1540. *Pirotechnia*, Venice, translated by Smith and Gnudi, Chicago, 1942

Blair, J. and C. and Brownsword, R. 1986. An Oxford brasiers' dispute of the 1390s: evidence for brassmaking in medieval England. *Antiquaries Journal*, **LXVI**, 82-90

Bornhardt, W. 1988. *The History of the Rammelsberg Mine*, 1931; trans to English, T.A. Morrison. London.

Boussard, F. 1958. Les fonts Baptismaux de l'église Saint-Barthélemy à Liège. *La fonderie Belge*, 9-10.

Cameron, H.K. 1974. Technical aspects of medieval monumental brasses. *Archaeological Journal*, **131**, 215-37.

Centenaire de la Société des Mines et Fonderies de Zinc de la Vieille Montagne 1837-1937. 1937. Liège.

Cipolla, C.M. 1974. *The Fontana Economic History of Europe, sixteenth and seventeenth centuries*. London.

Craddock, P.T. 1978. Origins and early use of brass. *Journal of Archaeological Science*, **5**, 1-16.

Craddock, P.T. 1995. *Early Metal Mining and Production.* Edinburgh.

Craddock, P. Gurjar, L.K., Hegde, K.T.M. and Sonawane 1985. Early zinc production in India. *The Mining Magazine* (Jan.), 45-51.

Davies, O. 1935. *Roman Mines in Europe.* Oxford.

Day, J. 1973. *Bristol brass: a history of the industry.* Newton Abbot.

Day, J. 1974-6. The Costers: copper smelters and manufacturers. *Trans. Newcomen Society,* **47**, 47-50.

Day, J. 1984. The continental origins of Bristol brass. *Industrial Archaeology Review,* **8**, no. 1, 32-55.

Day, J. 1988. The Bristol brass industry: furnace structures and their associated remains. *Historical Metallurgy,* **22**, pt 1, 24-41.

de Ruette, M. 1986. *Etude technologique de la fonderie de laiton au Moyen Age et à la Renaissance,* PhD thesis, Louvain-La-Neuve.

Delloye, H. 1810. *Récherches sur la Calamine, le Zinc et leurs divers Emplois,* Liège.

Dickinson, H.W. 1943-4. A Study of Galvanised and Corrugated Sheet Metal, *Trans Newcomen Soc.* **24**, 27-36.

Dodwell, C.R. 1961. *Theophilus: De Diversus Artibus,* London, translation to English.

Donald, M.B. 1961. *Elizabethan monopolies,* London.

Douxchamps Lefèvre , *c.* 1977. Note sur la Métallurgie du cuivre en Pays Mosan de 1500-1650. In *Schwerpunkte der Kupferproduction und des Kupferhandels in Europa - 1500-1650,* ed. Herman Kellenbenz. Cologne, Vienna, 41-55.

Dugdale, Sir W. 1730. The Antiquities of Warwickshire. London.

Forbes, R.J. 1966. *Studies in Ancient Technology,* VIII. Leiden.

Forbes, R.J. 1950. *Metallurgy in antiquity.* Leiden.

Galon, J. 1764. *L'Art de convertir le Cuivre Rouge et le Cuivre Rosette en Laiton ou Cuivre Jaune.*

Gechter, M. 1993. Römischer Bergbau in der Germania Inferior, Eine Bestandsaufnahme, in *Montanarchäologie in Europe* ed. H. Steuer and U. Zimmermann. Jan Thorbecke. Sigmaringen, Germany 161-6.

Gough, J.W. 1967. *Mines of Mendip,* rev.edn. Newton Abbot.

Haedeke, H.U. 1970. *Metalwork.* London.

Hamilton, H. 1926. *History of the English brass and copper industries to 1800.* London.

Hammersley, G. 1973. Technique or economy: The rise and decline of the early English copper industry, ca 1550-1660. *Business History,* **XV**, January.

Harris, J. 1964. *The Copper King.* Liverpool.

Hawthorne, J.G. and Smith, C.S. *On Divers Arts.* 1963. (A translation of Theophilus, *Schedula diversarium artium*) Chicago.

Hoover, H.C. and L.H. 1912. *Georgius Agricola: De re Metallica.* London.

Houghton, J. 1697. *Husbandry and Trade Improv'd,* London.

Hunt, R. 1887. *British Mining* London.

Jars, G. 1774. *Voyages Métallurgiques.* Lyons, 222-3.

Jenkins, R. 1934. The Reverberatory furnace with coal fuel. *Trans. Newcomen Society,* **14**, 67-81.

Jenkins, R. 1943. Copper Works at Redbrook and Bristol. *Trans. Bristol and Glos. Arch. Society,* **63**, 145-54.

Jenkins, R. 1943-4. Copper smelting in England: Revival at the end of the seventeenth century. *Trans. Newcomen Society,* 24, 73-80.

Jenkins, R. 1945-7. The zinc industry in England. *Trans. Newcomen Society,* **25**, 41-52

Kellenbenz, H., (ed.) 1977 Schwerpunkte der Kupferproduction und des Kuperhandels in Europa, 1500-1650 Cologne, Vienna.

Klein, P.W. 1965. The Trip family in the 17th century: a study of the behaviour of the entrepreneur on the Dutch staple market, *Acta Historica Neerlandica.* Leiden, Brill, 187-211.

Lewis, M.J.T. 1970. *Early Wooden Railways,* London, 11-41.

Macklin, H.W. 1907. *The brasses of England,* London.

Morgan, S.W.K. *Zinc and its Alloys,* Plymouth, Macdonald & Evans, 1977, and personal communications.

Morton, J. 1983. *Thomas Bolton & Sons Ltd.* Ashbourne, Derbyshire.

Morton, J. 1985. The rise of the modern copper and brass industry in Britain, 1690-1750, PhD Thesis.

Morton, J. and Robey, J. 1985. Jacob Momma and the Ecton copper mines, *Bulletin of the Peak District Mines Historical Society,* **9**, No. 3.

Mott, R.A. Shropshire iron industry. *Trans. Shropshire Arch. Soc.,* **56**, pt 1.

Newton-Friend, J., and Thorneycroft, W.E. 1927. Examinations of a fifteenth-century brass. *Journal of Institute of Metals,* 37, 71-2.

Norris, M. 1965. *Brass rubbing.* London.

Norris, M.W. 1987. Views on the early knights. *The earliest English brasses,* ed. J. Coales. Monumental Brass Society. London.

Oddy, W.A., La Niece, S. and Stratford, N. 1986. *Romanesque metalwork.* British Museum Publications. London.

Oman, C. 1930. Medieval brass lecterns in England. *Archaeological Journal,* 87, 117-49.

Oman, C. 1936. English brass chandeliers. *Archaeological Journal,* 93, 263-86.

Peltzer, A. 1909. Geschichte der Messingindustrie und der künstlerischen Arbeiten in Messing (Dinanderien) in Aachen und den Ländern zwischen Maas und Rhein von der Römerzeit bis zur Gegenwort. In *Zeitschrift des Aachener Geschichtsvereins.* Aachen, 235-463.

Percy, J. 1861. *Metallurgy: fuels, fireclays, copper, zinc and brass.* London.

Pirenne, H. 1903. Dinant dans la Hanse Teutonique. *Annales de la Fédération* Archéologique et Historique de Belgique, 12, 523-46.

Pohl, H. 1977. Kupfergewinnung, kupferarbeitung und kupferhandel in Aachen-Stolberger Raum von 1500-

1650. In *Schwerpunkte der Kupferproduction und des Kupferhandels in Europa*, ed. H. Kellenbenz. Cologne, Vienna, 225-40.

Rees, W. 1961. *Industry before the Industrial Revolution*, II. Cardiff.

Riley, H.T. 1875. Double Christian names; bellmaking, *Notes & Queries* 5th Ser. 3, 77.

Robey, J.A. 1981. Ecton Copper Mines in the seventeenth century. *Bulletin of Peak District Mines Historical Society*, 4, Pt 2, 149-51.

Savage, G. 1968. *A Concise History of Bronzes*. London.

Schleicher, Karl. 1974. *Geschichte der Stolberger Messingindustrie*. Julich.

Sherlock, R. 1958. Churches and candlelight. *The Connoisseur*, 44-51; and also numerous articles in following editions of *The Connoisseur* and *The Connoisseur* Year Book, up to 1973.

Sherlock, R. 1962. Chandeliers in Gloucestershire churches. *Trans. Bristol & Glos. Arch. Society*, 81, 119-37; and further articles in transactions of other county societies.

Sisco, A.G. and Smith, C.S. 1949. *Bergwerk und Proberbüchlein*. New York.

Sisco, A.G., and Smith, C.S. 1951. *Lazarus Ercker's treatise on ores and assaying*, trans. from the German edn of 1580, Chicago.

Smith, E.A. 1918. *The Zinc Industry*, London.

Smith, C.S. and Gnudi, M. 1942. *Pirotechnia*. A translation of Biringuccio's 1540 book. Chicago.

Société de la Vieille-Montagne, 1905. *L'Industrie du Zinc, 1837- 1905*. Liège.

Tarbuck, E.L. and Payne, A.H. nd. *The Builder's Practical Director*. Leipzig and London.

Tavenor-Perry, J. 1910. *Dinanderie: A history and description of medieval art work in copper, brass and bronze*. London.

Ure, A. 1839. *A dictionary of arts, manufactures and mines*. London, 165-9

van Doorslaer, G. 1929. *L'Ancienne industrie de Cuivre à Malines*. Mechelin.

Watson, R. 1786. *Chemical Essays*, vol. 4. London.

Werner, O. 1982. Analysen Mittelalterlicher Bronzen und Messinge, Pt IV. *Berliner Beiträge zur Archäometrie*. 7 35-174.

Willers, H.W. 1907. *Neue Untersuchungen über die Römische Bronze Industrie von Capua und von Niedergermnien*. Leipzig.

Wykoff, D. 1967. *Albertus Magnus: Book of Minerals*, Translation to English.

Plate 1 These water-powered battery hammers, of the same design as those used in the Bristol area, were still being used at Stolberg, as they were at Bristol, until the early years of the twentieth century.

Plate 2 A selection of battery-ware produced by one worker for use by his family, on the water-powered rolling mills and hammers at Saltford

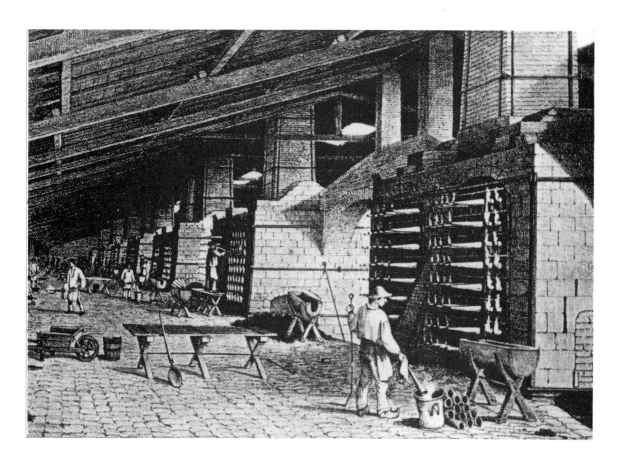

Plate 3 Early horizontal retort zinc-smelting furnaces in use in Liège

Plate 4 Water-powered rolling mills were still used at Keynsham until the 1920s

ZINC PRODUCTION TECHNOLOGY 1801–1950: A REVIEW

J.K. Almond

61, High Street, Eston, Teesside TS6 9EH

ABSTRACT

The conditions necessary to yield zinc from its minerals are stated. Close to 1801 these conditions were met in four districts of Europe: in Britain, and in Carinthia, Silesia and Belgium. In the years between 1801 and 1950 world production of metallic zinc grew from less than 1 x 10³ tonnes to more than 2,000 x 10³ tonnes annually. For each of the several steps involved in progressing from ore to refined metal the technology that emerged in the 150-year period to 1950 is reviewed and, where possible, the sources of the technology are indicated. In dressing, because of the unfavourable specific gravities of the minerals, separations by gravity were supplemented by those based on magnetic and electrostatic behaviour, prior to the introduction and development of flotation. The preliminary high-temperature treatments of calcination, roasting and sintering are considered, tracing the evolution of roasting technology for the zinc industry. The high-temperature reduction-and-distillation step is examined under the headings: choice of reductant; generation of the necessary high temperatures; charge treatment without access to air; and condensation. Within these subdivisions the features of horizontal batch retorting, vertical continuous retorting, and electrothermic distillation are discussed. Metal refining by various means is outlined, as is zinc-oxide production, both for its own sake and to recover zinc values from fluid slags and granular solids. Finally, the historical development of techniques adopted for zinc production by hydrometallurgy and electrolysis is summarised, and practice around 1950 is exemplified by notes on the method used by the Rhodesia Broken Hill Development Company. Estimated figures are given for metal production by various processes. One hundred sources are listed.

INTRODUCTION

The Ingredients of Successful Production

This survey considers European and American zinc-production technology during the 150-year period in which activity was transformed. Under the stimulus of market demand zinc production changed from a 'cottage' occupation involving a handful of people at only two or three sites into a large-scale industrial activity occupying thousands of employees and practised at several dozen places. Throughout the period the methods used depended heavily upon manual labour, both raw and experienced. Besides the use of appropriate technology, successful zinc production resulted from the skilled use of equipment and the management of resources and labour. Without these other ingredients the technology would have been worthless.

Growth of Production

In 1801 world zinc production was negligible in tonnage terms; by 1950 it had reached 2×10^6 tonnes. Although compared with zinc the longer-established metals lead, copper and iron were produced in 1801 in quantities that were already substantial, during the subsequent 150 years all showed similar growth patterns (Fig. 1). World output of non-ferrous metals taken together multiplied some thirtyfold between 1851 and 1950. Throughout that hundred-year period zinc ranked fourth in terms of quantities produced after iron (and steel), copper and lead.

Taking a world view, from a level of about 10,000 tonnes in 1830, zinc production increased at a rapid rate, especially during the following forty years when output doubled every ten years. After 1870 the rate of increase slowed down so that it was around 1890 that production reached twice the 1870 figure, and 1907 before this was in turn doubled. The optimistic upward curve with time was upset in the aftermath of the Great War of 1914-18, in the economic depression of around 1930, and following World War II. Even so, by shortly after 1950 world output was 40 times what it had been in 1870, over the eighty-year period on average doubling every 20 years. When the second half of the twentieth century was entered the buoyant mood did not cease: by 1970 world zinc-production capacity was to double again, to exceed 4×10^6 yearly tonnes.

Looking at some individual countries, around 1830 Silesia (then part of Germany) was the chief zinc producer; Belgian output began to grow strongly from 1840 and British zinc production, though on a smaller scale, followed from 1860. From 1865 France (not shown on Fig. 1) and the USA became significant

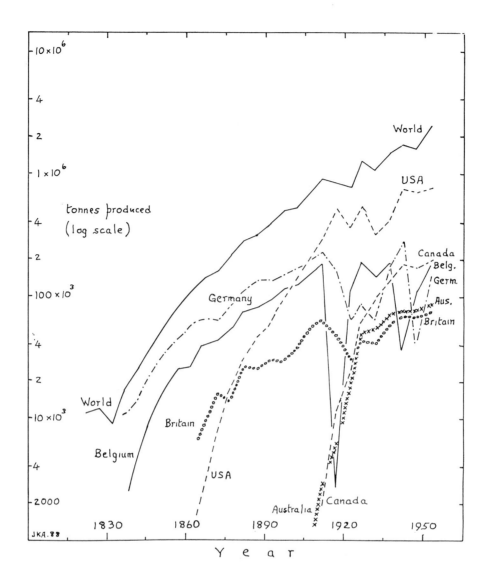

Fig. 1 Zinc production 1821-1950, world wide and by selected countries. (Based on five-year averages, using figures of Schmitz 1979)

From then onwards, French production levels were generally similar to those in Britain, while by contrast the US output expanded unabated until after 1918. From 1910, the USA was the world's leading zinc producer, in some years accounting for one half of the total output. In the first quarter of the twentieth century several notable new producers made increasing contributions, particularly Australia and Canada. As a complication to the statistics, in the 1920s the Silesian smelting district passed from Germany to Poland (not shown here). The USSR and Mexico were among the countries which, in the second quarter of the twentieth century, joined the important makers. Around 1950 the major zinc-producing countries were: the USA, Canada, Belgium, Poland, Australia, the USSR, Britain, France, Mexico and Japan.

Chief Uses

The markets for zinc were several. Besides the element's key place as a substantial constituent of all brasses, some new uses for the metal developed: from the beginning of the nineteenth century zinc formed a component of primary electrical cells; it then came into use as a surface coating for iron-and-steel articles to protect them from rusting ('galvanised' ware); rolled zinc sheet provided an alternative to lead for weatherproofing purposes in buildings. During the 1930s precision diecastings of zinc came to be widely adopted for motor-vehicle components such as carburettor housings and door handles. In addition to these uses for metallic zinc, there grew a market for zinc oxide, first as a substitute for 'white lead' in paints and then as an additive in motor tyres and papers.

Technical Problems in Making Zinc

To European merchants and metallurgical workers at the end of the eighteenth century the element zinc must have presented a frustrating challenge. Zinc *minerals* were well known, and commonly occurred abundantly in association with those of lead, but whereas the lead sulphide (galena) could be changed into liquid metallic lead by heating in a fire, the corresponding zinc sulphide (blende, blackjack, sphalerite) and also the carbonate (calamine, smithsonite) yielded only a white smoke, forming a powdery non-metallic deposit in the cooler parts of the flues. Moreover during lead smelting the presence of zinc minerals resulted in an unsatisfactory brittle product. The techniques for producing lead were used, with relatively minor modifications, to yield copper and iron.

With hindsight, it is possible to state the conditions which have to be fulfilled in order to succeed in making metallic zinc from its minerals, but these were not clear in 1801. Compared with the 'classical' metals copper, iron, silver, etc., zinc possesses a more stable oxide ZnO. In this respect it occupies a position midway between copper, lead and iron on the one hand and the 'newer' metals aluminium, magnesium and titanium on the other. To obtain metallic zinc from its oxide required more-strongly-reducing conditions then were needed to yield copper and lead. Moreover, a temperature of at least 1000°C was needed. The practical difficulties were compounded by the fact that, at one atmosphere pressure, zinc boils at 907°C so that the product of the reduction reaction was gaseous. Unless the strongly-reducing conditions were maintained as the gaseous zinc cooled, the element reverted to its oxide, so yielding white powder rather than grey metal.

Successful Processing Paths

It appears that within a few years of 1801 the techniques necessary to obtain metallic zinc were established in several districts of Europe: Britain, Carinthia, Silesia and Belgium. As succeeding years went by, many improvements of details were introduced to give greater working efficiencies, but the basic principles of high-temperature extraction remained unaltered. The essential steps were:

1. high-temperature treatment of the mineral with air to yield zinc oxide;
2. high-temperature treatment of the zinc oxide in reducing conditions to give gaseous zinc;

3. condensation of the gaseous zinc to yield liquid metal.

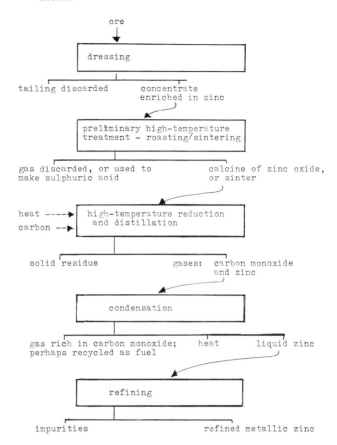

Fig. 2 Steps in processing ore to marketable metal by high-temperature methods.

The first step, oxidation, was not hard to accomplish, but, by contrast, the simple statement of the other two steps gives no indication of the considerable difficulties that were associated with their practical realization. Once suitable equipment and techniques had become established for them, they tended to remain in use, unchanged, despite their shortcomings. Alternative high-temperature treatments and conditions to effect steps (2) and (3) were proposed, but, in general, none was successful until after 1950 when the 'ISP zinc-lead blastfurnace' was brought into commercial working and attracted world-wide attention. This survey specifically excludes the ISP (the Imperial Smelting Process) for continuously treating mixed materials in a shaft furnace to yield both lead and zinc as metals (see chapter 8, p.229).

However, another extraction path which came into successful production around 1915 marked a more-radical departure from established high-temperature practice. This was the hydrometallurgical route involving large-scale wet chemistry to dissolve

the zinc from its oxide compound by leaching with acid, followed by electrolysis to deposit solid metal from the solution.

Zinc production involving high-temperature chemical reactions (pyrometallurgy) was characterized by heavy fuel consumption, hot heavy manual work exposed to unpleasant gases, and relatively-low extraction efficiencies. It is an indication of the abundance of the raw resources and of their ready availability as by-products of lead production that, despite the technological difficulties in extracting the metal, the market price of zinc since 1801 has never strayed far from that of lead. Generally, but not always, zinc has commanded somewhat higher prices than lead.

The ingenuity applied to zinc extraction well exemplifies some of the general trends that occurred in the technology of metal production during the 150-year period. Around 1801, high-temperature reactions carried out in solidly-built furnaces fired by coal or wood were predominant. During the second half of the nineteenth century a degree of mechanization began to the introduced, in the case of zinc giving rise particularly to mechanically-rabbled roasting furnaces. In the last quarter of the nineteenth century ideas of processing based on aqueous solutions (hydrometallurgy) began to be developed practically. At the same time, the potential of electrolysis came to be applied.

A leading innovator of high-temperature zinc treatment in the first quarter of the twentieth century, Gilbert Rigg, commenting in 1925 on the recent establishment of sizeable leach-electrolysis plants and the apparent stagnation of new high-temperature techniques, gave as his view that the conditions were then ripe for further developments. In the event, not only was his own application of sintering a notable advance in the 1930s, but in the USA two new continuous reduction-distillation processes appeared commercially, vertical retorting and electrothermic treatment. In addition in the 1930s a new refining process, fractional distillation, came into use. Also in the second quarter of the twentieth century significant developments took place with 'fuming' processes which gave zinc as oxide, so the years 1925-50 were indeed fruitful. Nonetheless, as S.W.K. Morgan noted in 1959, in 1953 over 50% of the world's zinc was still being made by the 150-year-old process using horizontal retorts. Soon afterwards, however, high-temperature horizontal retorting was to be supplanted as the predominant extraction method by leaching and electrolysis.

The relative proportions of world zinc produced by the various techniques in selected years in the third quarter of the twentieth century were stated by A.R. Gordon In 1977 and are shown in Table 1.

Table 1 Proportions of world zinc produced by different methods in selected years

Process		Percentage of Zinc capacity		
		1960	1970	1975
high-temperature methods (1000–1200°C)	horizontal retort	34.5	15	3
	vertical retort	11	10	7
	electrothermic	7.5	6.5	6
	ISP blast furnace	2	12.5	10
	total of above	55	44	26
aqueous leaching and electrolysis		45	56	74
total capacity, tonnes		3,070,000	4,917,600	6,000,000

Some further features of the various processes were set out by D.A. Temple in 1986 (Table 2).

Table 2 Comparative demands for energy and working space by different production methods

Process	Nett total energy consumed, GJ tonne⁻¹ zinc	Specific capacity, or operating intensity, tonnes zinc day⁻¹m⁻³
horizontal retort	more than 70	0.3-0.5
continuous vertical retort	66	1.25
continuous electrothermic distillation	73	1.5
blast furnace	46-55	3.4
	(0.5 tonne of lead bullion is also produced for this energy consumption)	(based on both lead and zinc produced)
leaching and electrolysis	52-63	0.08-0.12

The Steps in Processing

The treatment steps generally needed to yield saleable zinc from ore by high-temperature means are summarised in Figure 2.

In the remainder of this chapter the relevant technology is reviewed under the following headings, which include sections on the leach–electrolysis method of zinc production and the extraction of zinc in the form of oxide fume.

Throughout the text the word 'calamine' is used in the European sense to denote zinc carbonate (smithsonite), not silicate.

ORE DRESSING

General Comments

As with the ores of other metals, the first to be exploited for zinc came from easily-worked deposits yielding coarsely-crystalline clean materials. However, as demand for zinc increased so there came incentive to work less-amenable deposits, and the ores taken from these required more-extensive dressing to yield the best economic product. Two treatment methods, magnetic separation and flotation, which respectively became important after about 1880 and 1905, were closely associated with zinc ores. Early in the twentieth century, before the development of flotation, another novel technique applied to zinc ores was electrostatic separation.

For almost the whole of the nineteenth century the dressing of zinc ores had to rely upon the techniques of (1) hand sorting and (2) gravity sorting, that is separations based on specific-gravity (s.g.) differences between the several mineral constituents present in the crushed ore. The use of hand sorting, even with cheap labour in Europe, probably would have been limited to individual fragments larger than peas (approximately 8mm plus); in favourable circumstances it could be effective. With gravity sorting, the problem was that several common zinc minerals possessed specific gravities which were rather close to those of associated, but unwanted, gangue minerals. Nonetheless, skilled working with jigs (for gravel-sized fragments) and tables and vanners (for finer particle sizes) could generally effect a worthwhile separation between the wanted zinc mineral and unwanted gangue. Thus in the Joplin district of Missouri, stated by J.W. Richards (1908) to be the largest zinc field in America, the mined ore averaged 4.3% of zinc and was concentrated by jigging to 60%, with 70% of the zinc reporting in the concentrate, which weighed only one twentieth of the ore weight.

Outside the USA, the aim in dressing was generally to obtain a concentrate containing 45% of zinc. Naturally, a higher-grade concentrate assaying 55% of zinc might be attractive, but the losses of zinc mineral incurred in achieving it could be prohibitive. The concentrate also needed to be free from harmful impurities such as fluorite (calcium fluoride) and

barite (barium sulphate). Barite was indistinguishable from blende by gravity methods. One solution adopted if it was present was to heat the granular gravity concentrate containing both blende and barite: the barite decrepitated while the blende fragments remained intact, so that subsequent sizing by screening achieved a useful separation. S.J. Truscott (1923) noted the use of this technique at the Tahoma mine in the Missouri zinc district of the USA. W.R. Ingalls (1902) recorded several other instances of selective decrepitation.

Use of Low-intensity Magnetic Separation

By about 1880 the technology of electrical machines had advanced to the stage where it became practicable to separate particles of strongly-magnetic magnetite (iron oxide) from a mineral assemblage. This was done using a weak, cheap, magnetic field. Although magnetite itself did not occur in blende concentrates, two other iron minerals, siderite (iron carbonate) and pyrite (the sulphide), were common and troublesome. However, by heating to some 500°C in an atmosphere made chemically reducing by adding carbon to the charge, the iron minerals could be partially transformed into the highly-susceptible magnetite. Consequently when the product of this 'magnetic roasting' was passed through the magnetic separator the blende would be separated from its contaminating companions. Ingalls (1902) stated that separation of siderite from blende was done in the decade 1871-80 at Prizibram in Bohemia, with a similar separation of siderite from oxidised zinc minerals made in Spain at much the same date, and equipment installed at Friedrichssegen, near Ems in Nassau, soon after 1880. At Friedrichssegen the feed material assayed 11-15% of zinc and 18-23% of iron, while the product contained 38-42% of zinc with 6-8% of iron. In the 1890s iron minerals present with zinc carbonate at Monteponi in Sicily were removed by the same kind of treatment, the zinc content being improved from 21 to 45%. Again, in the case of a treatment plant in Wisconsin USA, Truscott (1923) reported that the concentrate from gravity dressing assayed 35% of zinc and 25% of iron and consisted of zinc and iron sulphides. By means of magnetic roasting followed by magnetic separation a final concentrate was obtained containing 55% of zinc with only 3% of iron.

Use of High-intensity Magnetic Separation

A second mode of making a separation based upon differences in magnetic susceptibility entailed the use of a strong, but costly, field. In these circumstances the zinc minerals themselves might respond. The zinc-sulphide mineral, blende, commonly contained significant proportions of iron within its lattice, then being known as 'marmatite'. While posing a problem for subsequent high-temperature processing, the presence of such iron would give the mineral magnetic susceptibility. With a strong separating field the expense of prior roasting was avoided. It was in the last decade of the nineteenth century that magnetic separators capable of developing suitably-intense fields were introduced. One pioneering construction was made in the mid-1890s in order to concentrate the components of the uncommon manganiferous zinc deposit found at Franklin Furnace in New Jersey. John Price Wetherill, general manager of the Lehigh Zinc Company of South Bethlehem, Pennsylvania, invented the separator that was used on the Franklin Furnace material and which was to bear his name in many parts of the world. The same type of high-intensity machine was applied in Europe to remove siderite (iron carbonate) from blende, and was extended to make other mineral separations.

In the opening years of the twentieth century the Wetherill and several other designs of magnetic separator were used in Australia in endeavours to maximise the financial gain to be obtained from the great Broken Hill lead-silver-zinc deposits, and in particular to extract treatable zinc concentrates from the large piles of accumulated lead-silver tailings. However, even the differentiation of sand-sized particles made possible by the combination of strong magnetic fields and moving belts was only of marginal benefit for treating the Broken Hill mineral assemblage. During the previous exploitation of lead- and silver-rich materials from the deposits in the 1890s about 5×10^6 tonnes of gravity-mill tailings had been dumped on the surface by the half-dozen operating companies. These sand dumps were estimated to contain 18.6% of zinc and 5.5% of lead and awaited a suitable method of treatment.

Flotation at Australian Broken Hill

Desperate and ingenious engineers connected with several rival companies which had claims to parts of the Broken Hill dumps or deposits turned to the novel technique of 'flotation'. This new procedure entailed the selective alteration of the surface characteristics of mineral grains by chemical treatment. In 1901, in Australia, Charles Vincent Potter obtained a patent for the use of hot acid solution, and between 1903 and 1905 one of the

Broken Hill companies worked a small plant based on this patent and sulphuric acid. Read and others (1961) recalled how the plant upgraded feed containing 14.8% of zinc and 5.0% of lead to a concentrate carrying 45.8% of zinc and 5.2% of lead, with almost three quarters of the zinc reporting in the concentrate. Although bubbles were not specifically mentioned in Potter's patent, it is generally agreed that this marked the beginning of flotation processes using gas bubbles (generated by action of the acid upon carbonates present in the pulp) to lift mineral grains. In 1904 a rival company started a plant which, after overcoming initial problems, ran until all the zinc-rich dump tailings had been consumed in 1923. This employed the Potter-Delprat system of treatment with hot acid: acid consumption was 12kg per tonne of feed and the pulp was heated to 93°C. According to Read and others (1961), from feed containing 14% of zinc and 3% of lead the method produced a zinc concentrate assaying 47.0% of zinc and 6% of lead.

Further innovations were to come. In 1905 another Broken Hill proprietor, directed by its London-based promoter, started to produce a zinc concentrate using oleic acid as a conditioning agent and subjecting the mixture of mineral particles, water and reagents to mechanical agitation. The particles of zinc sulphide in the pulp were preferentially coated with the oil and consequently attached themselves to the many air bubbles present as the result of the agitation. In this way the selectively 'oiled' mineral grains were carried to the top surface of the pulp. In this particular variant conditions were right for a froth to be created at the top of the pulp column, and into this froth layer the oiled particles transferred, so facilitating their separation from the remaining bulk of 'wetted' mineral particles. This 'froth-flotation process' was probably the greatest development in mineral-dressing techniques to appear in the first half of the twentieth century.

Between 1910 and 1914 Broken Hill engineers extended their use of chemical reagents as modifiers of flotation behaviour to enable them to produce from the mixed feed separate lead-rich and zinc-rich concentrate fractions. This was an early application of what became known as 'differential flotation'. One particular metallurgical engineer, Leslie Bradford, introduced the use of copper sulphate as an activating agent for sulphides, particularly blende, while two other workers found that dichromates could drastically modify the flotation behaviour of sulphides (Read *et al.* 1961).

Use of Froth Flotation Generally

Truscott (1923) noted how in the USA the recovery of fine-sized blende was remarkably improved by the introduction of flotation at the Butte and Superior mine in Montana in 1912. At Anaconda a zinc-concentrating plant was built in 1916 to treat sulphide ore from Butte; this used 'collective' bulk flotation until 1924 when, according to Morrow (1929), a change was made by which the bulk concentrate was re-treated to give lead-rich and zinc-rich products. At almost the same time the Tooele plant (Utah) of the International Smelting Company started to treat by selective flotation lead-zinc ores bought on a custom basis (Young and McKenna, 1929).

Gaudin, in 1932, estimated that 15×10^6 tonnes a year of lead-zinc ores were being treated by flotation, half of that tonnage being in the USA. For the year 1929 Gaudin reported that in the USA 2.5×10^6 tonnes of zinc ores without significant lead contents were treated in 109 plants, with a further 3.5×10^6 tonnes of lead-zinc ores being processed in 43 plants. Flotation had become the primary method for dressing zinc ores, and its use made possible the economic treatment of deposits that would otherwise have lain untouched.

Electrostatic Separation

Among the mineral characteristics exploited in order to separate zinc minerals from others was their behaviour in a high-tension electric field. This method enjoyed limited application in the USA in the early years of the twentieth century. At Platteville, Wisconsin, a 20-tonnes-a-day electrostatic separating plant was installed in 1908 by the Huff Electrostatic Separator Company. It was rapidly expanded, but had only a brief life, being burnt down around 1912 when it had a daily capacity of 75 tonnes. There was a second similar plant. Their purpose was to treat middlings fractions consisting largely of blende and marcasite (iron sulphide), which originated in nearby gravity-concentrating mills. A feed containing 24% of zinc and 25% of iron could be turned into a concentrate assaying more than 50% of zinc with 3.5% of iron, and weighing 0.4 of the original. The necessary electric field was created by applying 24 kV after rectification. According to Ralston (1961), at least three other plants were operated for some time in the USA, treating otherwise-intractable middling products.

In some instances the technique used involved considerable ingenuity. Thus, at Cananea in Mexico

the Calumet and Sonora Mining Company installed an electrostatic plant to treat blende-chalcopyrite-pyrite middling containing 30% of zinc. Here, because some of the blende had become coated with conductive copper sulphide, chemical treatment was needed in order to make a useful separation. Before exposure to the high-tension field, the surface films were removed by washing with dilute cyanide solution. Then, after drying, electrostatic separation gave a poorly-conducting fraction consisting mainly of blende and gangue, and a highly-conducting fraction of pyrite and chalcopyrite. The zinc-rich fraction was then wetted with a dilute copper-sulphate solution which, on drying, selectively made the zinc minerals conductive while the gangue components remained non-conducting. Further electrostatic treatment yielded a concentrate containing 55% of zinc and 5% of iron (Ralston 1961). Similar conditioning of a gravity concentrate with copper-sulphate solution was used at Ouray, Colorado, prior to electrostatic separation to raise the zinc content from 40 to 50%. As Truscott remarked in 1923, even at its best, electrostatic separation made large proportions of middling fraction which had to be recirculated. In the 1920s the treatment method was superseded by differential flotation.

PRELIMINARY HIGH-TEMPERATURE TREATMENTS IN PREPARATION FOR METAL PRODUCTION

General Comments

It was early recognised that the zinc compound fed to the metal-production stage should be the oxide, ZnO. Indeed, oxide was similarly needed for the 'indirect' production of brass. For this purpose the calcination of zinc carbonate (calamine) was practised before 1800. An important processing step was therefore high-temperature oxidation of the ore mineral: 'calcination' if carbonate and 'roasting' if sulphide.

Among the reasons for technological developments made in the calcination or roasting of zinc-bearing materials are the following:
1. desire for fuel economy;
2. desire for labour economy;
3. desire for a uniform product;
4. change from gravel-sized mineral fragments (5-15mm in size) to fine-sand sizes (0.1-2mm);
5. change from zinc-carbonate minerals to sulphide minerals;
6. desire to contain the sulphur-laden gases generated;
7. increased scale of quantities treated.

In response to one or more of these reasons, as the nineteenth century progressed, so the equipment used for the preliminary heat treatment changed. In the closing decades of the century considerable developments took place with the object of economising on the requirements for both fuel and manpower, and also containing the sulphur-dioxide gas evolved.

The kind of equipment used was influenced by the heat generated by the roasting reaction, by the nature of the gas evolved, and by the availability of labour. One feature of converting blende (zinc sulphide) to oxide was that, unlike calamine, the reaction was highly exothermic, generating considerable heat. Thus, in favourable circumstances the oxidation reaction, once initiated, could be made self-supporting. With care such an autogenous roasting process required only minor quantities of carbonaceous fuel; at the same time, the roasting of blende demanded a higher temperature than the calcination of calamine. If some of the sulphur formed zinc sulphate, this was decomposed only with difficulty, by raising the temperature. Where appreciable iron was present the high temperature would encourage the formation of unwelcome zinc-ferrite compound, e.g. $ZnO.Fe_2O_3$.

In practice, while it was easy to lower the sulphur content of the product to only a few percent, it became increasingly difficult to remove the last 1 or 2 percentage units; generally an economic limit was reached at 1-1.5% of sulphur. Moreover, while in the earlier phases of desulphurisation the heat supply from the exothermic oxidation reaction was ample to maintain a working temperature of at least 700°C, there was inadequate self-generation of heat in the later phases. For this reason external heat had to be applied to the finishing stages of roasting.

The second important feature of converting blende to oxide was the co-production of sulphur-dioxide gas, SO_2. Released into the atmosphere the sulphur dioxide acted like dilute sulphuric acid, having a pronounced adverse effect upon surrounding vegetation, and hence upon grazing animals.

It was not only zinc which was largely obtained by treatment of sulphide minerals: the economic minerals of copper and lead were also sulphides. During the nineteenth century producers of all three metals released enormous amounts of sulphur dioxide

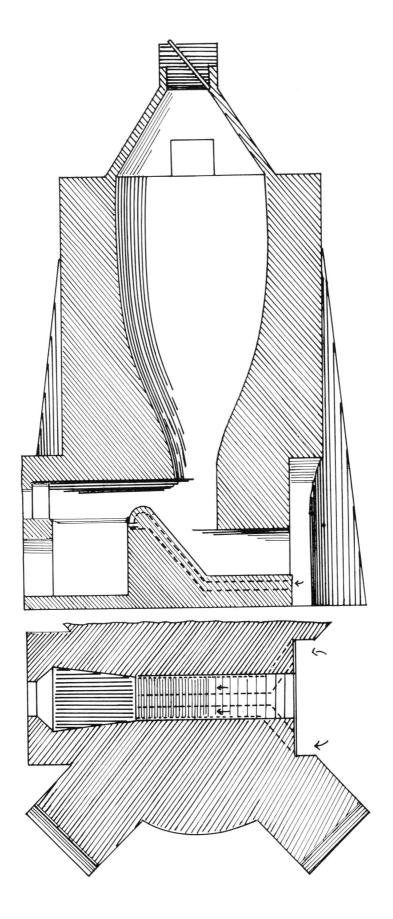

Fig. 3 Vertical-shaft calcining kiln for calamine (Redrawn by B.R. Craddock from Scoffern, Truran *et al.* 1861, 595)

and, generally by 1900, faced increasing hostility to their activities. Indeed, in some European localities constraints on the discharge of sulphurous gases were in force long before the end of the century. In many instances, in order to remain in business, and certainly to obtain sanction to erect new plants, it became expedient to curb the emission of sulphur dioxide. One solution adopted was to make the gas into sulphuric acid; not only did this curtail the quantities emitted to the atmosphere but it could provide another marketable product. Moreover, with the growth of zinc production by hydro-metallurgy from about 1915, the acid was needed for the extraction process itself.

A third factor which influenced roasting technology was the relative availability of manpower. Like the subsequent zinc-retorting step, roasting by manual methods was demanding in manpower and called for arduous work in unpleasant conditions. In western Europe labour was plentiful at least until the middle of the twentieth century; by contrast, in North America and Australia manpower was scarce. Labour scarcity encouraged the mechanisation of roasting equipment. Even in Belgium and Germany some efforts were made to replace hand labour by machinery well before 1900.

Calcining Calamine in Vertical Kilns

Zinc-carbonate mineral (calamine) could be charged directly to the metal-production stage, but it was soon recognised that the efficiency of that step was improved if the calamine was first heated strongly in air to convert it to zinc oxide. By this heating carbon-dioxide gas was evolved, thereby eliminating some 30% of useless mass, while at the same time any moisture present was expelled and the porosity of the material improved.

Where the calamine occurred in sizeable lumps, the conversion of carbonate to oxide could be effected in vertical-shaft kilns, similar to those widely used for burning limestone to lime, and in some areas for burning bracken to yield 'potashes'. The necessary heat would be generated from coal or coke fuel in one of two ways. Firstly, by burning the fuel in a firebox situated close to, but outside, the bottom of the kiln, so that the hot combustion gases could be led through the kiln. In northern Spain such a kiln installation was stated by Phillips and Bauerman in 1887 to produce 5-8 tonnes of calcine in 24 hours with a coal consumption of 7-9% of the ore weight. Secondly, the necessary heat could be obtained by mixing a proportion of fuel with the zinc mineral as it was charged to the kiln, or by charging alternate

layers of mineral and coal, so that slow combustion would take place within the shaft itself, aided by the blowing of a moderate draught. Figure 3 shows a mid-nineteenth-century impression of a vertical calamine-calcining kiln equipped with a grate for firing.

Heat treatment of calamine and blende in reverberatory furnaces

The successful working of such a vertical kiln depended upon having a permeable charge which would permit a uniform gas flow to take place. Where the fragments of zinc mineral were of fine size, say less than about 3mm (roughly 1/8 inch), the vertical-shaft kiln was impracticable, and in this case during the first three quarters of the nineteenth century the established reverberatory furnace was commonly used. Such furnaces were already employed for the preliminary treatment of ores of copper and tin. The furnace would be fired by coal, with the flames and hot combustion gases from the fireplace passing over the charge laid on the 'laboratory' hearth. For roasting, the hearth was lengthened to 12m or more, with a width of some 2.5m. A measure of helpful counter-current working was obtained by positioning the new feed on the hearth close to the flue-gas exit, and gradually raking it at intervals towards the hotter fire-bridge end. An extension of this practice was to fit the reverberatory furnace with a second hearth, or roasting chamber, situated on top of the first. The hot gases from the lower hearth would then be led through the upper chamber before they reached the flue to the chimney, while the new feed would be charged in to the upper chamber and gradually moved along both hearths in turn (Fig. 4).

Increasingly, as demand for zinc grew during the second half of the nineteenth century, it became necessary to process the zinc sulphide (blende) instead of the scarcer carbonate. While the heat treatment of calamine prior to reduction was desirable, the treatment of blende was essential, for zinc sulphide charged directly to retorts containing carbon would not yield metallic zinc. Thus the preliminary heat treatment came to assume great importance. As early as the middle of the eighteenth century, in 1758, John Champion of Bristol (the brother of William Champion) had obtained British patent no. 726 for the conversion of blende to oxide by roasting in a coal-fired furnace. According to Greenwood (1875) flat-bed reverberatory roasting furnaces stirred at frequent intervals could each treat about 0.8 tonne of blende in 24 hours for a coal consumption of 2

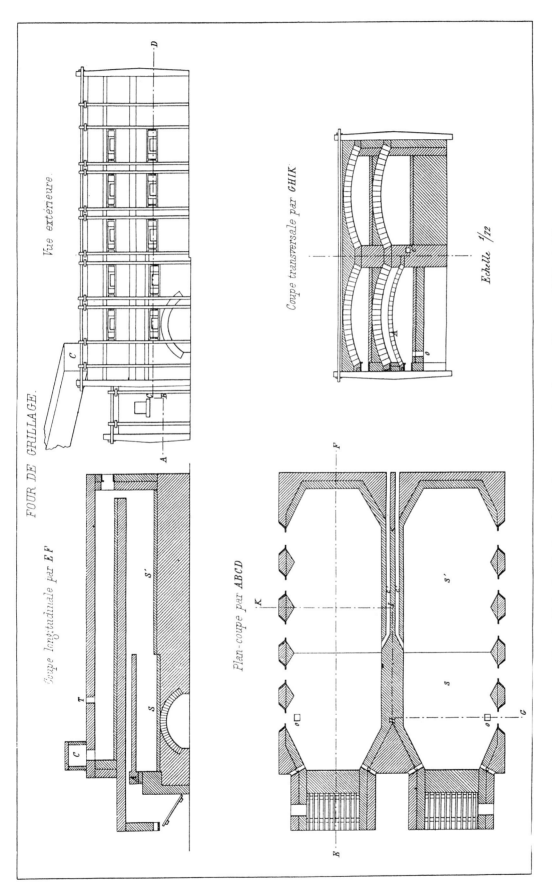

FOUR DE GRILLAGE.

Vue extérieure.

Coupe longitudinale par EF

Plan-coupe par ABCD

Coupe transversale par GHIK

Echelle 1/72

Fig. 4 Twin double-hearth reverberatory roasting furnace (Borgnet 1877, pl. 29)

169

tonnes, typical hearth areas being 3.3m x 2.3m. At Swansea, an innovation before 1861 was the double-bedded furnace which used waste heat from the reduction furnaces for roasting, although its critics considered the robbing of heat impaired the reduction process, and the practice was not extended widely. John Percy (1861) recorded that two hearths, each measuring 3.3m x 1.7m in area, processed 0.5 tonne in 24 hours.

The Containment of Sulphurous Gases: Muffle Furnaces

In muffle furnaces the hot fire gases arising from the combustion of carbonaceous fuel were kept isolated from the charge, being carried through labyrinthine ducts in the brickwork which formed the floors and roofs of the roasting chambers. For heat economy, the multiple-hearth muffle roasters were built in pairs or in larger blocks, so that the area of outside walls for radiation was restricted.

As early as about 1855, at the Rhenania works near Stolberg attempts were made to use the muffle principle to limit the proportion of sulphur-laden gas passing directly to atmosphere, by means of the Hasenclever design. H.M. Ridge in 1917 recalled how, in 1865, an improved furnace had been built at the same works and, twenty years later, further improvements were made to the Rhenania furnace. Besides the desire to restrict the quantities of sulphur

reaching the atmosphere in the flue gases, the introducers of such equipment were motivated by the wish to make sulphuric acid. Conversion to sulphuric acid could not be applied to the gases evolved from reverberatory furnaces for, not only was the sulphur-dioxide content, at less than 2% by volume, too dilute to be successfully converted, but the accompanying products of combustion contained components which were harmful to the acid-making process.

The Hasenclever roaster was one of several designs of hand-worked muffle furnace that were used towards the end of the nineteenth century. The three or four superimposed flat-hearthed muffles were in the form of long, horizontal, ovens constructed of firebricks with spaces for the fire gases to pass under and over each muffle chamber to provide thorough heating. Each furnace could process 4.0-4.5 tonnes of blende in 24 hours to yield a product containing about 1% of sulphur.

Another pattern of hand-worked roasting furnace, which supplanted those of the Hasenclever type and which persisted into the 1920s in Belgium, Germany, France and Britain, was the Delplace (Fig. 5). Like other roasting equipment for which the concentration of sulphur dioxide in the effluent gases needed to be as high as possible, the chambers through which the zinc mineral was passed were heated by hot gases travelling over their outer walls. The heat of the fire gases was concentrated onto the

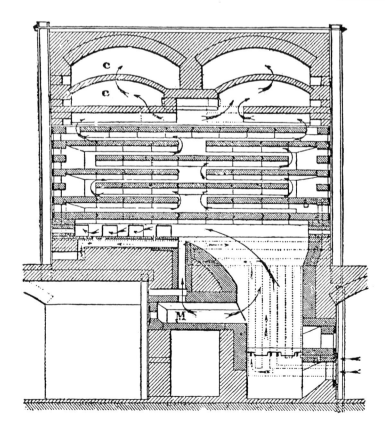

Fig. 5 Delplace hand-rabbled blende-roasting furnace. The fire gases were isolated from the roasting chambers in order to yield a gas rich in sulphur dioxide. (Gowland and Bannister 1930, 476)

lowest muffle hearths where the last remnants of sulphur were to be removed; in the upper chambers the exothermic oxidation of the blende contributed heat.

The Delplace furnace was reported by Gowland and Bannister (1930) to be the most efficient of all the hand-raked furnaces, yielding a gas rich in sulphur dioxide and having a small fuel consumption. However, to offset these advantages it required much skilled labour. It had seven hearths, arranged one above the other, and the blende was rabbled on each in turn, falling from one to the next below through openings, with only thin beds of mineral maintained on each hearth. The height of the roasting space of each hearth was only 160mm, so that both the heat and the sulphur-dioxide content of the gas were well concentrated. It was claimed that the roasting gases contained an average of 6.5 or 7% of sulphur dioxide, while the zinc-oxide product contained little remnant sulphur. The consumption of fuel amounted to 10% of the blende weight treated, and 1-1.75 tonnes would be handled in 24 hours in each furnace. A block of six furnaces would measure 11.25m long by 7m broad.

Furnaces Stirred Mechanically in Straight Paths

By the early years of the twentieth century there had been a proliferation of roasting equipment. The mechanisation of rabbling, or stirring, took many forms. One line of development took the flat-bed reverberatory furnace, lengthened the working chamber, and caused the material being treated to progress from one end to the other by periodically passing a mechanised plough from end to end. In the zinc industry such furnaces were in use at some North American plants at the turn of the century, e.g. in Kansas and Oklahoma. The gases containing sulphur dioxide were discharged directly to the atmosphere, and fuel consumption was relatively high. Ingalls (1902) reported how, at the Cherokee Lanyon works, such a furnace (of Zellweger design), 41m long by 4.5m wide, roasted 18 tons of ore containing 30% of sulphur down to 1% in 24 hours. This furnace was heated by natural gas, a feature of that particular district of the USA.

By contrast with the directly-heated Zellweger, and similar roasters, other furnaces were muffled to contain the sulphurous gases. In the Hegeler furnace, which was introduced in the USA in 1881 or 1882 expressly for roasting blende with recovery of the sulphur dioxide, the hoeing blades, or tines, were mounted on a bar across the width of the furnace hearth. The bar was carried, in turn, on a two-wheeled carriage that ran longitudinally through the muffle chambers on rails fixed at the outer edges. The carriage was propelled by a long iron rod for which room had to be provided at the ends of the furnace, outside it. The Hegeler furnace was a tall rectangular block constructed of firebrick. It possessed seven horizontal superimposed roasting chambers, and the ore being treated progressed from the top hearth to the bottom in a period of some 12 hours. To conserve heat, commonly two, or even four, sets of chambers were built side by side, sharing a middle dividing wall. The pattern was used for some 35-40 years, virtually unchanged. In the USA, where the Hegeler furnaces proved popular, the *Engineering and Mining Journal* in 1915 listed 35 of this pattern out of a total of 99 zinc roasters. Some persisted into the 1920s, though few could survive the economic downturn close to 1930. At Port Pirie in South Australia Hegeler furnaces were installed soon after 1911 for the treatment of zinc minerals from Broken Hill.

It was claimed that the Hegeler furnace was unsuitable for processing those sulphide concentrates which contained high proportions of lead as the intermittent rabbling allowed local bed temperatures to be high enough to cause fritting, or partial fusion of the charge, with its consequent sticking to the brickwork of the muffle hearths. The efficiency was also comparatively low, with fuel consumptions of up to 20-25% of ore weight and effluent gases containing only 4-5% of sulphur dioxide. In one installation made in 1915 at Donora in the Pittsburgh district of eastern USA the sulphur-dioxide content of the gases, before passing to the sulphuric-acid plant, was raised from 4.5% to 8% by burning brimstone. At Donora the six Hegeler furnaces were fired with producer gas, each furnace handling 40 tonnes of Australian concentrate in 24 hours, to give a roasted product containing 1.5-2% of sulphur.

Furnaces Stirred by Rabbles Moving in Circular Paths

To obtain a stirring action in the charge and to move the mineral particles along the furnace hearth, an alternative to the ploughs that travelled intermittently in straight paths was to mount small iron hoes on a horizontal arm carried by a mechanically-rotated vertical shaft. The area swept by such a mechanism was circular, but some furnace designs continued to use chambers that were rectangular in plan by arranging for several circular swept areas to overlap. This was the method adopted by the Merton and Ridge furnaces (Fig. 6).

171

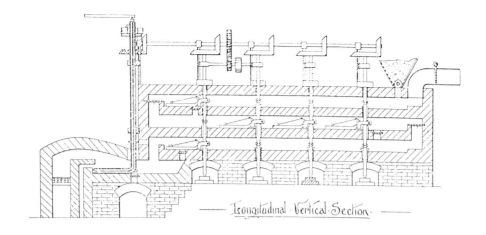

— Longitudinal · Vertical · Section. —

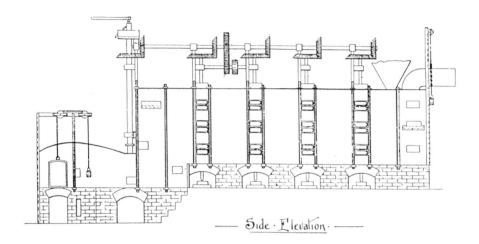

— Side · Elevation. —

Fig. 6 Merton roasting furnace, a mechanically-rabbled design in which the hot fire gases were directly in contact with the granular material being treated. (Power 1903, 775)

T.D. Merton of Melbourne, Australia, introduced his roasting furnace about 1890, evidently primarily for treating gold ores. Shortly before 1910 Merton furnaces were installed at two Swansea zinc works, where they replaced simple hand furnaces, and a few years later they were incorporated in a new zinc smelter in Siberia. Danvers Power in 1903 reported that when working zinc ore containing 33% of zinc with 20% of sulphur and 19% of lead the product would assay only 1.5% of sulphur. Capacity was stated to be 8-10 tons in 24 hours. Ridge in 1917 stated that a Merton furnace installed in Tasmania had given unsatisfactory performance due to mechanical weaknesses. Ridge's own modified version of this furnace, with muffled hearths to contain the sulphurous gases, was publicised in 1917 when it was stated that Ridge furnaces had been supplied to five companies with satisfactory results. The cost of such a furnace, prior to 1914, was quoted as £3000.

Another pattern of mechanized roasting furnace was the Spirlet, patented by Xavier de Spirlet of

Belgium as a source of gas for acid-making. This furnace resembled a series of millstones set one on top of another (Fig. 7). The Spirlet furnace attempted to achieve intimate and thorough mixing in the reaction chambers with a series of four or six superimposed hearths in the form of discs, the chief novelty lying in the use of each hearth as the anchor plate for the rabble teeth projecting over the hearth below (Fig. 7, Pl. 1). By arranging for alternate discs to revolve and remain stationary, all hearths were rabbled. The hearths were some 4m in diameter so that one furnace had a relatively-small (twentieth-century) capacity of between 5 and 20 tonnes in 24 hours. Although the complex construction led to awkward and sometimes costly maintenance, the advantages of thorough desulphurisation, a gas rich in sulphur dioxide, and a fuel consumption as low as 10%, led to the Spirlet furnaces being used at several works. Outside Belgium they were constructed in Germany and the USA, as recorded by Harlow in 1918. W.R. Ingalls in 1945 noted both the mechanical Spirlet and the hand-raked Delplace as

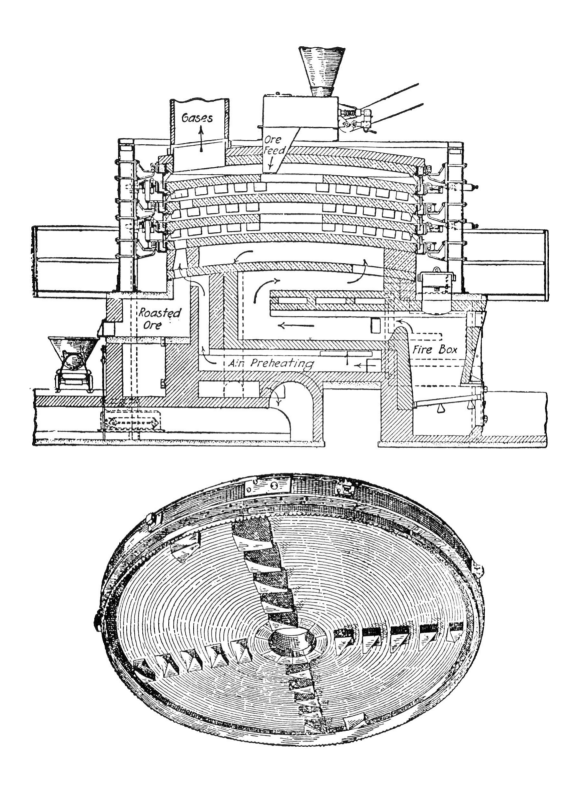

Fig. 7 Spirlet mechanically-rabbled muffle furnace with fire gases kept away from the material being roasted, to avoid dilution of sulphur dioxide. The view of one hearth shows the rabble teeth set in the masonry. (See Plate 1.) (Gowland and Bannister 1930, 475)

small-capacity, high-efficiency roasters which had served well in Europe but which proved unsatisfactory in US conditions. In the 1920s a total of 12 furnaces of Australian-modified design ('Barrier' roasters) was built for the National Smelting Company at Swansea and Avonmouth (Pl. 1). McBean in 1959 recorded that at mid-century in the Congo 18 of the roasters were at work, without auxiliary fuel.

Cylindrical Multi-hearth Furnaces

Another way of dealing with the circular path of the hoe or rabble carried on a vertical revolving shaft was to build a structure in the form of an upright cylinder. Alexander Parkes' furnace, tried in Britain in 1850 according to Chadwick (1958), was a pioneer of this style, intended for 'burning' iron sulphide (pyrite) for acid-making. In 1873 the idea was resurrected by MacDougall, again in Britain. Using the same principle the Belgian Vieille Montagne Company met with partial success sometime before 1880 and around that year, according to Schnabel and Louis (1907), an experimental furnace was worked at Oberhausen. It was another twenty years before the cylindrical, mechanically-rabbled, multiple-hearth furnace began to be taken up by industry, notably in the USA. Schnabel and Louis commented in 1907 that 'as the movable portions are continually in need of repair and occasion ... (considerable) expense, such furnaces can only be employed with advantage in districts where wages are high ... particularly in the United States'. Nonetheless, during the first half of the twentieth century the multi-hearth cylinder became the stock pattern of mechanised roaster in the metallurgical industry (Fig. 8).

One example from the USA was the Wedge roaster which, in the case of a large furnace, might have a steel cylindrical shell 6m in diameter and up to 9m high. The inside of the shell was lined with 400mm of firebrick and would house up to seven horizontal hearths superimposed on each other 400mm apart. A central hollow vertical steel column, 1.5m in diameter and clad with refractory tiles, rose through the full height of the furnace structure. The column was turned by appropriate motors and gearing, and it served to support numerous horizontal arms which carried the metal hoes over each hearth, continuously stirring and working the material thereon.

In operation, the damp feed material was continuously placed on the topmost hearth where it was stirred and dried as it gradually moved towards the centre; there a drophole allowed it to fall onto the hearth below. On this second hearth the rabbles would sweep the granular, sandy, material towards the periphery, where again a drophole enabled it to fall onto the third hearth. In this way, in the course of several hours, the zinc-bearing material would travel from the top to the bottom of the structure, over six or seven hearths. Meanwhile, heated gases would travel countercurrently over the five upper hearths, where auto-roasting of the blende took place. On the lower two hearths provision was made for direct firing, using the hot gases from burning oil, coal, or gas. The temperature of the top hearth on which the new feed was placed might be no more than 100-200°C, enough to drive off moisture, but as the solid material progressed across the lower hearths it would encounter higher temperatures, the maximum being 900-1000°C.

A feature of the Wedge roaster was that atmospheric air could be blown through the central column and along cavities inside the horizontal rabble arms to provide cooling and thereby help to prolong the lives of the arms. In some installations the rabble arms were water-cooled. Circulated air could also provide suitably oxidising conditions in all parts of the roasting system.

With careful control and the avoidance of gas leaks, it was possible to produce a gas leaving the roaster with a consistent sulphur-dioxide content of 4.5-6% by volume; this was an acceptable feed for making sulphuric acid in an adjoining plant. In the 1930s a large Wedge roaster could treat 40-50 tonnes in 24 hours to deliver a product containing less than 3% of sulphur.

Flash or Suspension Roasting: a post-1925 Development (Fig. 8)

In the second quarter of the twentieth century there came two further developments in roasting technology, both of which were important for the zinc industry treating blende. One development sprang directly from the MacDougall-type of multiple-hearth roasting furnace. It consisted of the removal of the middle two-to-four hearths of the cylindrical multi-hearth roaster leaving a large chamber some 6m in height through which the hot sulphide particles could travel, encountering oxidising gas at high temperature as they did so (Fig. 8). Provided conditions were right, the sulphide particles would react rapidly to form zinc oxide, at the same time giving out sufficient heat to sustain the temperature required for autogenous reaction (800-900°C). For the oxidation of iron sulphide (pyrite)

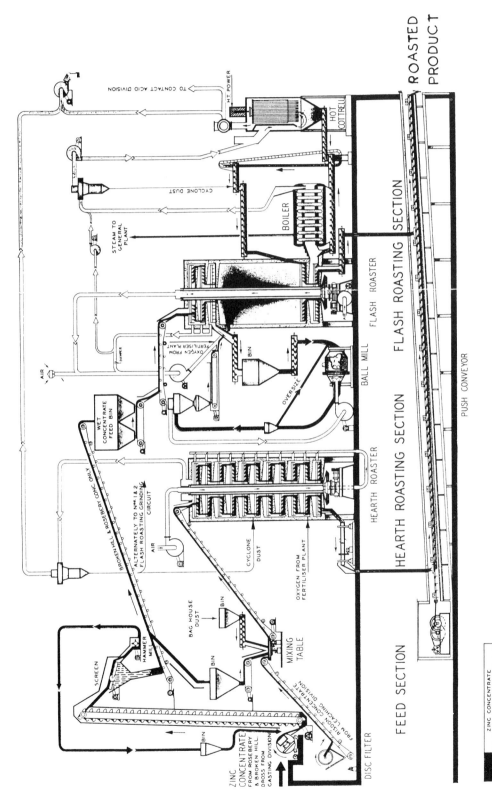

Fig. 8 Diagram of 11-hearth Skinner (MacDougall-type) cylindrical roaster and a flash roaster with ancillary equipment, as used at the Electrolytic Zinc Company of Australasia Ltd, Risdon, Tasmania, c. 1960 (Electrolytic Zinc Co. ...description of activities)

175

this method of 'flash roasting' or 'suspension roasting' was introduced in the USA by Robbins-Freeman around 1930. In its application to zinc, engineers at the Trail plant (British Columbia) of the Consolidated Mining and Smelting Company of Canada Ltd are generally credited with being the pioneers. The zinc-extraction plant at Trail used leaching and electrolysis rather than pyrometallurgical reduction, and it was works employing such hydrometallurgical methods which had the greatest interest in this kind of roasting. The product needed to be fine-sized, and the roasting temperature closely controlled to avoid the formation of intractable zinc ferrite. The system lent itself to the use of oxygen-enriched reaction air.

In practice the hot, dry particles issuing from the upper hearths required grinding, e.g. in a ballmill, before injection into the 'flash' chamber under pressure and intimately mixed with hot oxidising gas. A concentrate containing 30% of sulphur would flash roast down to 7% - or even 5% - of sulphur. Below the flash chamber the lowest one or two hearths ensured that the level of sulphide sulphur in the product was uniformly removed to less than 1.5-2%. These lower hearths also gave opportunity for heat exchange between the in-drawn air and the hot calcine.

By the early 1940s four or five North American zinc producers were using flash roasters. Dwight in 1945 compared the flash roaster with the ordinary multi-hearth furnace. Capacity of the flash roaster was 2-2.5 times as much, that is up to 100 tonnes of concentrate in 24 hours for one unit; but the dust-catching problems associated with the furnace gases were considerably increased. McBean indicated in 1959 how, by an ingenious rationalization of the functions of the various components, the two preliminary-drying hearths were transposed to the bottom of the cylindrical vessel, with finishing hearths above them, and the flash chamber itself placed on top. This rearrangement led to the advantageous shortening of the central revolving column, which was not needed to extend much above the floor level of the flash chamber.

Fluidised-bed Roasting

Since 1951 a further innovation applied to the roasting of zinc sulphide has been fluidised-bed processing. As with several other of the roasting methods used in zinc extraction, fluidised-bed roasting was first used for treating other metal sulphides, notably iron pyrite, for sulphuric-acid production. The product is suitable for leaching rather than for high-temperature reduction.

Sintering: the Second Post-1920 Development
(Fig. 9, Pl. 2)

All the roasting methods outlined so far brought about important, marked, chemical changes in the materials treated, but the only accompanying physical changes were the decrepitation of individual fragments and an increase in porosity. The second great development to occur in zinc desulphurisation between 1920 and 1950 was the application of sintering. In this treatment, not only were the individual particles changed chemically by the roasting reactions but, in addition, they were joined together into larger, porous yet strong, masses, this agglomeration taking place by the incipient fusion of a portion of the charge. Besides favourable chemistry and reactivity, the resultant agglomerates possessed good permeability combined with high mechanical strength; there was an absence of powdery material. The agglomerate therefore made ideal feed for gas-solid reactions done in retorts and in shaft furnaces.

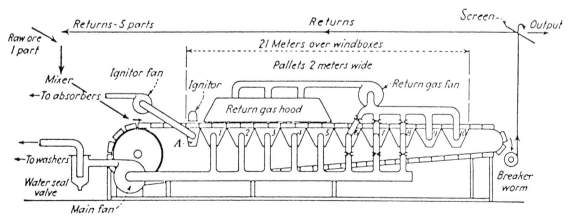

Fig. 9 Diagram of Dwight-Lloyd sintering equipment of the kind used in Britain by the National Smelting Company. (Gyles 1936, 421)

The sintering process emerged early in the twentieth century, when in the USA it was applied to the treatment of fine-sized lead-sulphide concentrates. At Broken Hill in Australia in 1907 a crude method of sintering slimes was in use but this, too, was for lead. In zinc sintering a pioneer was Gilbert Rigg in Australia who, with associates, experimented in connection with Broken Hill materials around 1917. Two years later, Rigg came to Britain and performed sintering tests at the Sulphide Corporation's zinc works at Seaton Snook, near Hartlepool on the Durham coast, where a stationary grate measuring 7.3m x 1.07m was used. However, because of the depressed economic conditions, that company did not adopt the new treatment. Rigg subsequently met with a better response from the National Smelting Company, in south-west Britain.

The basic method of making sinter was to prepare a bed of the mineral mixture containing a fuel, dampened with water and porous, and 110-500mm deep. One surface, generally the top, was then raised to a temperature of 800-1000°C, while a forced draught of air was drawn down through the bed from the heated surface. The air current would raise the temperature of the layers inside the bed so that combustion of the fuel occurred, with consequent increase of temperature locally to 1300-1450°C. At these temperatures not only would fresh compounds form but some of them would fuse to liquid. Once the fuel present in the particular layer had reacted, the in-drawn air would rapidly lower the temperature. In 15-20 minutes the whole thickness of the bed would have been converted to hard clinker, free from sulphur and largely bonded by the components which had fused.

In sintering zinc-sulphide flotation concentrates three of the chief problems that had to be overcome were: the excessive sulphur, which on oxidation generated too much heat; the dilution of the sulphur dioxide in the effluent gas with air drawn in through gaps in the equipment; and the perverse behaviour of lead minerals present, which both slagged too readily and delivered lead in gaseous form into the air stream.

Rigg's patented scheme for dealing with the excessive sulphur was first to roast the feed material from, say, 30% of sulphur down to 8-10% in a conventional roasting furnace, and then to complete the desulphurisation in the sintering process, in which the oxidisation of the remaining sulphur provided the requisite heat. An alternative scheme was proposed about 1924 by the Vieille Montagne Company at Baelen in Belgium. In this, complete desulphurisation of the feed was first done by conventional roasting (delivering a gas suitable for acid-making), with the solid product moistened and mixed with 5-10% of coal or coke prior to sintering. Here the coke supplied the necessary heat.

According to Weaton (1959) in the USA many zinc smelters installed sintering machines during the late 1920s in order to raise both the yield and the recovery obtained in the subsequent retorting. Robson in 1929 claimed that, by substituting sinter for roasted material in the retort-distillation stage, the extraction of zinc could be improved by about 5%, the load in each retort could be increased by about 10%, and at the same time the maximum working temperature could be 120°C lower, so leading to longer life for the equipment.

In Britain the National Smelting Company conducted sintering trials from about 1925 and, as a result, ordered large Dwight-Lloyd sintering machines in 1929, two for each of its new works at Avonmouth and Swansea (Fig. 9, Pl. 2). Commercial working started with the Rigg method, using Spirlet ('Barrier') and Delplace furnaces for the preliminary roasting to 8-9.5% of sulphur. However, after only four or five years another variation was applied: the separate preliminary-roasting step was dispensed with, the necessary sulphur level of 5-6% in the sinter feed being obtained by mixing with the new feed a large proportion of recycled sinter, i.e. about 5 parts of crushed product with one part of raw concentrate. This notable forward step in the technology of zinc production was associated with Stanley Robson, the acid-plant manager for the company. As Cocks and Walters related in 1968, it was covered by Robson's patent application of October 1927. Another advance made around 1928 by Robson's team was the sealing of the joints in the mechanical sintering hearths so that the concentration of sulphur dioxide in the plant exit gases was raised to levels for economic sulphuric acid production. The composition of the sintered product was about 62.5% of zinc, with 9.5% of iron and 0.5-0.75% of sulphur. The machines then used each had an endless chain of hearths about 1.8m wide. On the hearths was placed the feed mix to a depth of 127mm; after the exothermic oxidation reaction had been initiated by an oil burner situated over the bed, the oxidation and partial fusion took place while the material was carried a distance of 27m to the discharge end.

Morgan in 1977 noted how down-draught blende sintering produced a roasted granular material which was highly satisfactory as feed for the horizontal- and

vertical-retort processes. He went on to describe how, after 1950, the rather different requirements of feed for the zinc-lead blastfurnace were successfully met by reversing the air flow through the sinter bed, blowing upwards instead of drawing downwards. Early work on up-draught sintering had been done in Australia at Port Pirie and in Germany at Stolberg.

Summary of Preliminary Heat Treatments

In summary the heat treatment of zinc minerals prior to the reduction process has been, and remains, a vital step. During the century 1851-1950 a great many changes took place in the way the heat treatment was done. To a considerable extent zinc producers were able to draw on developments in equipment and technique which were made initially for processing other metals but, even so, large amounts of thought and experimental work were devoted by those within the industry to overcoming the problems peculiar to zinc. It was an impressive volume of endeavour.

HIGH-TEMPERATURE REDUCTION

The Conditions that had to be Fulfilled to Obtain Metallic Zinc

In order that metallic zinc could be obtained from its oxide, ZnO, by heating, several conditions had to be met. However, once all the conditions were met, it proved possible to vary the details of equipment within limits and still obtain metal. The four conditions found necessary for success were:

a. solid carbonaceous reductant had to be present with the zinc oxide;
b. air supply and fire gases had to be excluded from the charge being treated;
c. temperature of the charge had to exceed 1000°C. This was a 'bright orange heat' and it required strong firing to achieve and maintain;
d. a cooler part of the equipment, also out of contact with air, had to be provided to collect the metallic zinc as a liquid.

These requirements are reviewed in the sections which follow, pp.178-202.

(a) The Need for Solid Carbonaceous Reductant

This was the simplest of the conditions to meet, and it would be familiar to producers of other metals such as lead and iron. With experience gained during the early nineteenth century it was established that the best solid reductants were anthracite coal and partially-coked coal, or cinder, both materials possessing high proportions of carbon and relatively small contents of volatile hydrocarbons. A further requirement was a low content of mineral matter to minimise the quantity of ash produced and, more importantly, to avoid the formation of sticky clinker or slag which would damage the containing vessel and lead to difficulties in clearing out the residues after treatment of a charge. By itself, fully-formed coke was not effective, better results being obtained from a mixture with coal. In practice some zinc producers used reactant carbon whose properties fell far short of the ideal.

The proportion of solid carbon to be mixed with the zinc oxide varied between 30 and 60 % by weight, a charge containing roasted blende requiring a higher proportion than one of calcined calamine. The optimum size of the coal or cinder fragments incorporated with the reduction-distillation charge lay between 3 and 6mm, the preferred size depending upon the particular carbon used. In general, anything larger than 6mm might not react sufficiently quickly for a charge to be treated efficiently in 10-21 hours, while particles smaller than about 3mm tended to lower the permeability of the charge, thereby both hindering the evolution of gaseous zinc and impeding the flow of heat from the containing walls.

The significant zinc-producing techniques since 1750 which have used solid carbon as reductant are listed in Table 3. The term 'Belgo-Silesian process' is used here to include the variants of horizontal-retort distillation which are sometimes referred to as 'Rhenish'.

Table 3 Significant methods of zinc production using carbon as reductant, from 1750

Method	Remarks
English process	introduced before 1800; out of use on economic grounds by *c*.1860
Carinthian process	introduced about 1798; out of use on economic grounds by *c*.1840
Silesian process	introduced 1798-1805; continued in use, with modifications
Belgian process	introduced 1805-10; continued in use, with modifications
Belgo-Silesian process	used favourable features of both the Silesian and Belgian process; widely adopted in Europe in the third quarter of the nineteenth century, and in the USA somewhat later; the last USA plant closed 1976
vertical-retort process	developed in the USA *c*. 1930; adopted world-wide, and remains in use; unlike all the foregoing batch processes this is a continuous method
electrothermic process	following unsuccessful European attempts in the opening decades of the twentieth century, introduced successfully in the USA, with first metallic zinc made 1936; adopted elsewhere, and remains in use
blast-furnace process	developed in Britain *c*. 1950, and extended to some 10 installations world-wide (1990 estimate); remains in use

(b) Methods of Excluding Air and Fire Gases from the Charge being Treated

Introduction

The requirement to heat the charge to above 1000°C while at the same time isolating it from direct contact with the heating gases posed one of the major problems to zinc extractors. This requirement marked the chief difference between the techniques successfully used to produce the metals copper, lead and iron and that necessary to yield zinc. Before 1750 experiments would have clearly shown that when zinc minerals were heated strongly in contact with carbon, using the established metal-producing methods, the result was simply a tantalising white smoke of zinc oxide. It has been reported that sometimes during the intended production of lead chance droplets of metallic zinc would be observed lying in parts of the furnace flues (pp.4-5). Champion had developed his vertical distillation process by the mid-eighteenth century and after his bankruptcy in 1766 the process was taken up by other Bristol industrialists (p.152). It seems that by the opening of the nineteenth century individual workers in several different regions of Europe had begun to put together the combination of conditions needed to yield metallic zinc.

In all successful cases, fireclay was the material used to make the closed fire-proof box or container required for the reaction chamber. Fireclay was already used widely for parts of metallurgical furnaces and known as a material which could withstand the high temperatures generated in such furnaces and therefore employed to fashion glasspots and foundry crucibles. Moreover, fireclay was used to make the receiving vessels needed for the production of mercury - in Europe at Almaden in Spain and at Idrija in Slovenia.

Batch Treatment in Muffles and Retorts

The shape adopted for the fireclay vessels varied considerably between the four regions that made active progress around 1801. As explained on p.147 the fireclay vessels adopted in Bristol during the eighteenth century were crucibles, shaped like buckets. At the other end of Europe in the opening years of the nineteenth century, in Carinthia (close to what is now the Austro-Slovenian border), the vessels were pipes, each about 1m long by 80-115mm in diameter, made of clay to give walls 10mm thick. As quoted by Percy in 1861, as many as 84 of these pipes - each charged with 2.5-3kg of ore and carbon and closed at its upper end by a clay plug - were set vertically within an arched chamber for heating (Fig. 10).

Fig. 9.

Fig. 8.

Fig. 10.

Fig. 7.

Fig. 10 Furnace setting, retorts and condensers envisaged for the Carinthian process of distillation. The hot gases from the fireboxes 'a' would sweep through the chamber containing the vertical retorts into flues 'd' which lead to the chimney. Each conical retort 'p' stands on top of a ceramic tube which delivers the condensed zinc into the cooler space below the furnace chamber; the tubes are held in place by iron grids 'l'. Iron sheets, hung at the entrance to the collecting space, restrict the flow of air in order to prevent the metal from oxidising. (From Dumas 1847, pl. 40, pp. 16,17)

Five hundred kilometres north-east of Carinthia in Silesia (part of German territory during the nineteenth century but ceded to Poland shortly after 1920) relatively large rectangular boxes were favoured, giving rise to the 'Silesian' pattern of zinc-producing equipment. Did the inspiration for this shape of vessel owe anything to bread-baking ovens or to chemical-laboratory apparatus? What is clear is the practical nature of the resultant refractory box which could be stood upon a flat surface inside a furnace. Containers of this sort were known as 'muffles' (Fig. 11).

In eastern Belgium, cylindrical or elliptical tubes, supported more-or-less horizontally within a furnace, formed the basis of the 'Belgian' zinc industry. Again, the precursor is obscure, although these Belgian tubes bore marked resemblance to the vessels required and developed early in the nineteenth century for making coal gas by heating coal out of contact with air. The Belgian style of vessels came to be called 'retorts', although a widespread alternative name was 'pots'.

So, by use of a refractory container it became practicable to keep the zinc-bearing charge out of contact with air and furnace gases. By placing the muffle or retort inside a furnace chamber, its contents would be heated by a combination of conduction through the walls of the vessel, and by radiation inside it. This method of indirect heating, however, was extremely inefficient so that fuel consumption was large. In addition, the size of charge which could be treated was strictly limited by the need for sufficient heat to penetrate to its centre to raise the temperature to 1100-1200°C. In practice, this set an upper limit of about 200mm to the inside width of the vessel.

The *length* of one vessel would be constrained by several factors: the mechanical strength of the available fireclay, the kind of heating furnace used, and the nature and behaviour of the charge constituents; gases generated at the far, closed, end of the pot would have to be able to travel to the nearer, open end; solid charge would have to be placed along the whole length of the pot, and spent residues would have to be removable through the open end. As a result of these considerations the pots were made with lengths ranging from 1m up to 1.7m (for Silesian muffles) and to 2m (for the largest tubular retorts) (Fig. 12). The empty muffle weighed 200-260kg compared with the cylindrical retort's 40-65kg; a large elliptical retort weighed 70kg. Because of the severe limits to vessel size, the quantity of charge which could be treated in each pot was restricted to 120-150kg for the large Silesian muffles

Fig. 11 Early impression of the Silesian method of zinc production showing the characteristic muffle (a), condensers (b,c), discharge hole (d), and the furnace setting (Hebert 1836, 927)

and to 20-40kg for Belgian retorts. The Rhenish elliptical retort could accommodate 50kg. The large muffles were only satisfactory when enjoying a favourable combination of charge constitution and furnace fuel (Fig. 13).

For some 150 years the use of fireclay pots remained central to the predominant method of world zinc production, throughout a period when that production expanded enormously. The method of working was called 'horizontal distillation'. The time needed to treat an individual charge inside the heated pot varied from about 10 to 21 hours. In addition, time was needed for carrying out the 'manoeuvre' of discharging the residues from the pot, and re-charging it with fresh material. Generally it became convenient to operate the working cycle over 24-hour periods. In the USA in the 1940s, because of high labour costs, some plants moved to 48-hour cycles, claiming that the smaller number of batches treated was partially offset by the ability to charge larger quantities at each batch and to obtain a higher proportion of zinc from the longer treatment.

In order to obtain a daily output of tonnes rather than kilograms dozens of individual pots were required, and arrangements were made to heat many inside one furnace, i.e. the 'retort setting' (Pls 3,4).

In use, a distillation pot had a life of from 20 to (rarely, for Silesian muffles) 75 days, an upper limit of 45 days being general. At the end of this time it would have become so badly damaged by the

Fig. 12 Silesian muffle(A), fitted with condenser tubes (p, r, s) and equipped with a discharge hole (n), normally covered with a tile. The opening (q), also normally covered, provided access for an iron rod to clear accretions in (p). These details were published in Percy 1861. (Phillips and Bauermann 1887, 523)

Fig. 188.—Belgian Retorts. Sections. Belgo-Silesian Retorts. Sections.

Fig. 13 Typical retort and muffle sections with dimensions in feet and inches. (one foot = 12 inches; one inch = 25.4mm) (Gowland and Bannister 1930, 481)

combination of chemical attack by components in the heated charge (notably lead), mechanical abrasion by the tools used for removing the residues, and the vicious thermal environment with its fluctuations, that it would have to be scrapped.

Making a reliable supply of pots was thus an essential part of the whole operation. Clays, perhaps blended from several sources and mixed with crushed spent pots and/or crushed coke, and containing exactly the right proportion of added water, were shaped and then carefully dried. The large Silesian muffles were chiefly built up by hand from strips and slabs of clay. The cylindrical Belgian retorts lent themselves more readily to moulding. Hand moulding, including pugging and hammering to expel as much entrained air as possible, in the first part of the nineteenth century gave way to machine pressing. In 1861 John Percy described a boring-out machine that was in use at Angleur in Belgium to remove the central portion from a hammered clay block held within an iron mould, so leaving a cylindrical tube, closed at one end. Shortly afterwards, extrusion machines began to be applied to retort making, such equipment being widely used for forming unfired claywares which included bricks and drainage pipes. In augur machines, extrusion of the prepared clay through an annular orifice took place as the result of force exerted by a revolving screw. The resultant open tube had to be closed at one end with a clay disc, to form the butt. Extrusion using hydraulic rams was introduced at the Asturienne works at Auby in France in 1877, and by the end of the nineteenth century had been largely adopted at distilleries in Continental Europe. Despite being costly, hydraulically-pressed retorts possessed high density and strength and could provide good service, even with thinner walls.

After shaping, the vessels were placed in a series of rooms in which the moisture was controlled so that drying took place over a period of some ten weeks. After this the dried vessels were set in heated chambers where they were 'annealed' for several days and kept at high temperature until transferred, orange-hot, to take the place of old pots in the distillation furnace.

In more than 100 years of making zinc in batch muffles and retorts, the technological advances involving the vessels were small. However, besides the application of machinery to the fabrication of the large quantities of replacement pots required, mechanical devices were tried at some plants for assisting, or even carrying out, the two tasks of charging the pots and subsequently discharging them.

Such mechanical aids became commonly available during the early decades of the twentieth century.

For charging, several patterns of device were evolved. In one, a high-speed 'slinger', the mixed granular charge material, flowing at a regulated rate from a hopper, fell onto a whirling disk which projected the material into the open mouth of the waiting retort as a stream or jet. That at least was the idea. In another arrangement multiple screw conveyors, supplied with charge from a hopper, were carried on a trolley so that they were able to move forward inside several retorts at once. The conveyor than fed material into the retorts while its framework was gradually withdrawn. It was claimed this method took only one third the time of charging by hand, and Ingalls (1936b) quoted a charger at Rothem which could put 5,900kg of ore into 210 retorts in 20 minutes.

Although the potential advantages were greater, the application of mechanization to the discharging of residues from the hot retorts was even more difficult to achieve satisfactorily. One mechanical discharger consisted of a chain conveyor fitted with scraping hoes and mounted on a moveable near-horizontal arm which could penetrate inside the retort. Among the obstacles to success was the fact that, with use, the pots which were supported only at their two ends tended to sag in the middle. At some distilleries in the USA during the twentieth century it became the practice to thrust pipes carrying water into the retorts so that the explosive generation of steam blew out the solid contents. While this was certainly quick, it was dangerous and extremely dusty; it was acknowledged that the technique was only suited to certain restrictive charge compositions, and that the presence of lead rendered it unacceptable.

Fireclay remained the predominant material of construction for pots right up to the phasing out of the horizontal-distillation method after 1950. However, a new refractory material began to be applied to zinc production in the second quarter of the twentieth century; this was silicon carbide (carborundum) which combined good high-temperature strength and abrasion resistance with high heat conductivity. One USA zinc distiller in the 1930s made retorts from a mixture of 65 parts of silicon carbide with 35 parts of plastic clay. Bray (1941) reported that although the silicon carbide was costly, its use was claimed to be justified because retorts made with it lasted three times as long as the standard fireclay ones while their higher conductivity appreciably cut down the time of distillation and led

to a 2% increase in zinc recovery. However, by 1950 there had been some reversion to fireclay alone on the grounds of overall economy.

Continuous Treatment (in Vertical Retorts)

The desirability of continuous treatment with its steady working conditions and resultant fuel saving was appreciated before 1900, but a feasible method was realised only around 1930. Then, two successful variations emerged, the 'vertical-retort' and 'electrothermic' processes, both employing reaction vessels 9-12m high in the shape of a vertical shaft through which the solid charge progressed from top to bottom by gravity (Figs 14,15). Zinc was continuously distilled from the charge while solid residues were drawn off from the bottom of the vessel. The introduction of zinc distillation in vertical retorts in 1929 by the New Jersey Zinc Company of the USA marked a major technological advance. In this method, using conventional heating from a chemically-fired furnace surrounding the vessel, the shaft was given a rectangular cross section and the availability of silicon carbide as a constructional material contributed substantially to success. The walls were made of silicon-carbide slabs, possessing a thermal conductivity nine times that of fireclay (Pl. 5). On the other hand the containing walls of the internally-heated electrothermic process were satisfactorily constructed from fireclay held inside a steel-plate shell. It is only the New Jersey Company's process which is discussed further in this section (The electrothermic process for continuous treatment is considered under 'Electric Heating' on p.196).

The externally-heated vertical retorts were built up from silicon-carbide slabs and bricks to produce columnar vessels having a rectangular internal cross section of 0.3m by almost 2 m, and standing 9m high. For some 7.6m of their height, the outsides of the vessels' two longer walls were incorporated into combustion chambers in which fuel gas was burnt with controlled proportions of pre-heated air. The combustion-chamber temperature was maintained at 1300°C in the vertical retorts of the 1930s and 1940s. In the following decade at least one user tried a temperature of 1350°C, made possible by a modification to the refractory material in which the clay bonding component in the silicon-carbide blocks was replaced by silicon nitride. The thickness of the heated sides was then 100mm. This change was said to lead to a 10% increase in output (Morgan 1959).

Throughout its heated length the retort was kept full. It was found necessary to feed the zinc-bearing charge as briquettes, agglomerated lumps like soap tablets ('eggettes'), already coked at 700-800°C (Pl. 6). Such briquettes provided permeability for the evolved gases, they assisted the gravity flow of the solid material through the reaction column, and they aided heat transfer from the column walls to the centre of the charge. Typically, they were made from 55 parts of zinc sinter, 35 parts of coke breeze and coal, and 10 parts of recycled materials. The composition had to be such that there was no slagging or fusion, the charge remaining 'dry' throughout its 20-hour gravitational passage down the column. Halfacre and Peirce in 1959 described the spent residue briquettes emerging from the foot of the column as skeletons of coke, containing 30-40% of carbon and 2-4% of zinc. Gaseous zinc and carbon monoxide were drawn off at the top of the column.

The first commercial output in 1929 yielded 2.5 tonnes of zinc a day from a single column, but in the 1930s a bank of 16 vertical retorts could made 60 tonnes a day of zinc, or nearly 4 tonnes each; thirty years later the figure had risen to 6-7 tonnes each. After initial problems had been overcome the retorts had working lives of 2-3 years. Zinc-extraction efficiency exceeded 90%, sometimes reaching 94%. The process could yield metal containing 99.7% of zinc.

In 1945 vertical-retort plants were in place at three sites in the USA and also at Avonmouth in England and Oker in Germany. Later installations included those made in France and Japan.

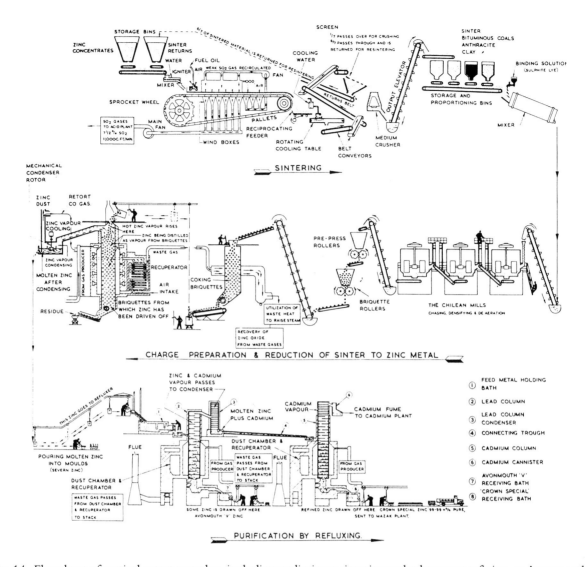

Fig. 14 Flowsheet of vertical-retort complex, including preliminary sintering and subsequent refining, at Avonmouth in Britain in the 1950s. (Morgan and Woods 1971, 163)

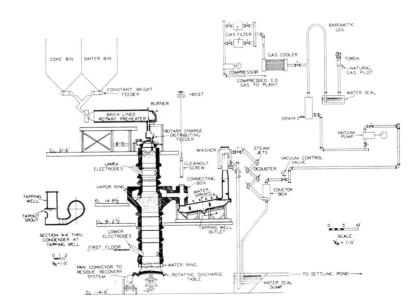

Fig. 15 Continuous electrothermic zinc furnace and condenser of St. Joseph Lead Company, USA. (Najarian 1944, 169)

185

(c) Ways of Attaining the High Temperatures Needed for Reaction and Distillation

Introduction

The thermal demands of the crucial reduction-distillation step are high. Not only has the charge of reactants to be raised to temperatures exceeding 1000°C (and preferably higher than 1150°C) but additional heat has to be supplied to satisfy the endothermic nature of the reduction reaction and to gasify the resultant zinc. The fact that the charge being treated must be isolated from contamination by furnace gases leads to unavoidable inefficiency in transferring heat. Altogether, the step has a large appetite for fuel.

Wood was apparently the fuel used to heat the Carinthian furnace around 1800, but the more important zinc-production methods established soon afterwards in both Silesia and Belgium relied upon coal. Coals varied a good deal in their characteristics. Upper Silesia possessed only coals containing relatively small proportions of volatile constituents, consequently yielding short flames. Preferable were coals which contained higher proportions of volatiles and hence burned with longer flames; they could be made to develop heat over a gas path several metres in length. Some Belgian coals had this property, while in Britain highly bituminous coals were available, able to give long flames. Similarly, in the western USA bituminous coal was obtainable, but in the eastern States anthracite coal, low in volatiles, was pressed into service.

As the nineteenth century progressed attempts were made to achieve greater zinc production from a given weight of coal consumed. By the turn of the century most zinc-distillation furnaces were fired by gas derived from coals, although in parts of the USA natural gas was used. At Palmerton in New Jersey around 1900 a rich fuel similar to 'coal gas' was available from the adjacent spiegeleisen (manganese-iron) blastfurnace (Ingalls 1936a); this was the exception. During the first half of the twentieth century heating by electrical energy came into use to a limited extent, associated with the reaction vessels intended to provide 'continuous' working. At cost-conscious plants there were also attempts made to channel the carbon monoxide issuing with the zinc from the reaction vessels into the fuel supply. A few works used oil as fuel, and in parts of the USA natural gas continued to be used after 1950.

Constructional materials used for distillation furnaces changed comparatively little in the 150 years from 1801. The parts exposed to high temperatures were constructed of bricks made from fireclay of one quality or another. For the outer, cooler, portions of the structure perhaps some common red bricks would be used. The brickwork might be tied together by iron, and later by steel, rods and sections. Cast-iron bars and frames were commonly incorporated in the furnace fronts to provide the supports for the retorts. In the earlier years of the period it is probable that a furnace life of 1-2 years would be regarded as good, whereas during the twentieth century a well-constructed furnace was expected to survive a 'campaign' of 3-4 years before it needed to be rebuilt. Minor patching and renewal would be done throughout the campaign. Writing of Hegeler distillation furnaces in the USA in 1959, K.A. Phillips stated that while first-quality fire-clay brick was required for the pillars and arches, silica brick was ordinarily used for the centre wall and shelves. At the same time fine silica sand was spread over the lower surfaces of the structure to form 'bottoms' to catch slag and retort fragments that fell to the floor and would weld together into a refractory mass.

Heating by Direct Combustion of Coal

Zinc makers in the early nineteenth century adopted technology for heating metallurgical furnaces, glass pots and, at lower temperatures, bakers' ovens. Coal fragments were placed on a grate of iron bars supported in a solid refractory structure (Fig. 11). Once the bed of fuel was hot, and air was drawn upwards through the grate, the coal would decompose and then react exothermically – i.e. 'burn' – to produce a stream of hot gases which would be made to envelop the objects to be heated, in this case clayware muffles or retorts. The grate in its firebox of stone blocks or fire-clay bricks was either surmounted by, or built at one end of, the chamber to be heated. Throughout the first half of the nineteenth century this was the only way to achieve the necessary high temperatures, but after 1860 firing by direct combustion increasingly met competition from gas firing. On a world basis by 1901 gas firing was predominant although direct coal firing survived in some places for another 30 years as the result of local conditions.

In the early Silesian zinc furnaces the closed muffles stood on slightly-inclined solid hearths placed at each side of the fireplace. The muffles were heated by the hot flames and combustion gases passing upwards and round them to escape from the chamber through a series of small vents placed at the corners of the roof (Fig. 11). From around 1840 the 20-muffle furnace was widely used in Upper Silesia. The

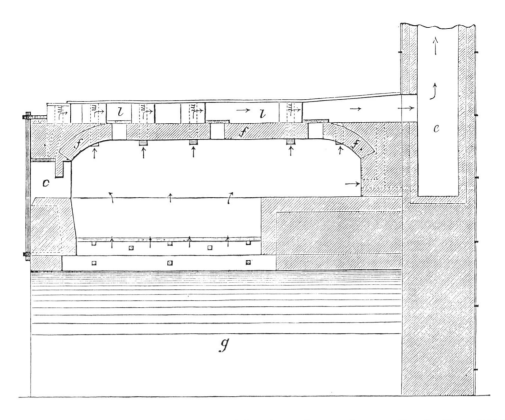

Fig. 16 Longitudinal section of 'Silesian' furnace recorded at Llansamlet, near Swansea. (See also Figure 17.) (Phillips and Baurermann 1887, 521; published earlier in Percy 1861)

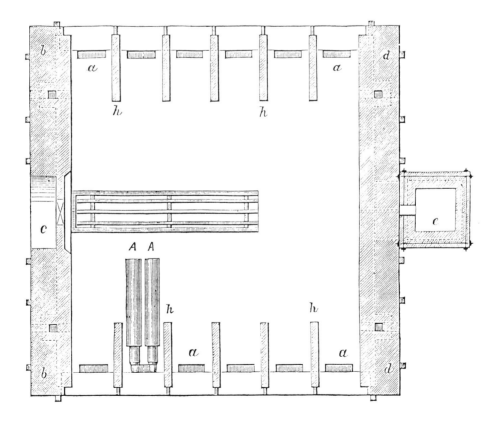

Fig. 17 Horizontal section through 'Silesian' furnace at Llansamlet, showing space for 12 pairs of muffles (A). (Phillips and Bauermann 1887, 522)

atmosphere round such a furnace was made extremely unpleasant by the smoke. Typically, the arched roof of the distillation chamber might be 0.9m above the hearth, while the fireplace measured 1.66m by 0.45 m. When working calamine it was usual for at least 15kg of coal to be consumed as fuel to yield 1kg of zinc (Ingalls 1903). The arch of the chamber might be made from a mixture of fireclay and sand, 'carefully beat down' to a thickness of about 0.22m on a temporary former, and it was expected to last for 2-3 years, according to Scoffern and Truran (1861).

Where long-flaming coals were available, as in Belgium and Britain, it became feasible to attach a chimney to the Silesian furnace pattern (Figs 16,17). Around 1860 a Swansea furnace reducing roasted blende consumed 11.5kg of coal for 1kg of zinc produced. At Valentin-Cocq in Belgium the Vieille Montagne Company showed what could be done if the furnace was fed with long-flaming coal. Coupled with the attachment of a chimney went a radical re-arrangement of the gas flow.

In the revised form of Silesian zinc furnace the flames and hot combustion gases rose directly from the fireplace to the furnace roof where they were reflected to travel downwards past the muffles at each side and so reach outlet ports situated at intervals along the hearth. These ports were connected to chimney suction by a system of ducts below hearth level. In Upper Silesia itself modifications made to the method of firing extended the flame length and enabled chimney draught to be used. A significant modification was the use of a deep bed of fuel (described more fully, p.189). By 1867 at least one Silesian plant was using an under-grate draught forced by a fan in order to burn coal successfully. According to Ingalls (1936a), the first chimney on a zinc furnace in Silesia was erected at Lipine in 1861.

By this change in the style of the Silesian furnace the efficiency of heat transfer was improved. Besides having lower coal consumption the revised furnace design enabled more even temperatures to be maintained. Eventually fuel consumption dropped to less than 8kg for 1kg of zinc. A subsequent modification made possible by the lengthened hot-gas path was the installation of a second row of small-sized muffles in the 1880s. The Belgo-Silesian or Rhenish pattern of hot-gas flow in the combustion chamber proved highly popular in European zinc distilleries both in the closing decades of the nineteenth century and the opening ones of the twentieth. (Besides the method of heating, the terms Belgo-Silesian and Rhenish related to other features

such as the use of two to four rows of retorts which were smaller than early Silesian muffles but larger than Belgian cylinders.)

In contrast with the relatively low, squat, heating chambers of Silesian practice, in Belgium the heating chambers were tall, with a predominantly upward flow of gases, from the firebox at the base to the exit flue at the top (Fig. 18, Pl. 7). This arrangement suited the readily-available coal, which tended to burn with a longer flame than that in Silesia.

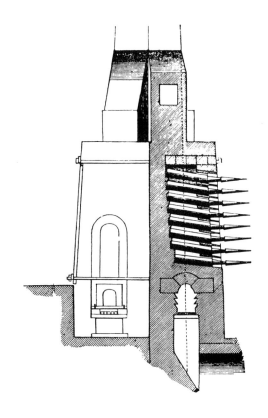

Fig. 18 Nineteenth-century Belgian zinc-distillation furnace. (See also Pl. 7.)

The shape of the Belgian furnace chamber was also compatible with the cylindrical tubes used as retorts. By being situated in the rising hot gases the retorts could be heated on all parts of their curved surfaces, although their lengths were restricted by the fact that they were supported by the furnace walls only at their two ends.

Around 1850 a Liège furnace might contain 61 retorts arranged in nine rows vertically above one another inside a chamber measuring 3.2m in height by 2.45m long and 1.5m wide. The firebox would be 0.4m wide. Immediately over the firebox and below the working retorts was sometimes inserted a row of empty fireclay tubes or 'cannons'. Their purpose was to protect the overlying retorts from variations in fire

intensity and to supply heated secondary air to the combustion chamber. After 1850 the benefits of eight or nine rows of retorts were increasingly questioned. The upper rows were not adequately heated so their output was poor; moreover they were difficult to reach from the working floor. Thus the trend was to limit the number of rows to five or even four.

To improve the structural stability of these furnace chambers with their retort settings it became usual to build them in pairs, back-to-back, sharing a common blank rear wall. This also gave the benefit of some heat economy and, to increase this advantage, some furnaces were built adjoining one another, so resulting in a block of four chambers, generally served by two grates, one situated at each end. (The same philosophy of heat economy and structural advantage deriving from shared furnace walls was expressed in some roasting furnaces, such as those of Hegeler pattern in the USA.)

The fire would be regulated both by the stoking and by dampers, commonly fitted to the chimney.

Belgian-style furnaces were erected in the USA. In Kansas and Missouri in the 1870s and 1880s they were of small size and directly fired. Ingalls (1936a) pithily recalled how their chimneys 'were torches to be seen from afar', indicating poor combustion efficiency. In the USA some coal-fired plants continued to be put up after 1900. Generally, however, by the end of the nineteenth century the direct coal-fired zinc furnace had declined to a minority position, being supplanted by gas-fired forms; e.g. between 1891 and 1901 in Upper Silesia the number of coal furnaces dwindled by nearly 30%, from 104 to 74 (Ingalls 1903).

One further European development of the direct-fired furnace deserving mention is that of Hauzeur, patented in 1877, and used in Belgium and Spain. The Hauzeur furnace incorporated two fruitful ideas, one of them a modification of the hot-gas flow through the structure, and the other the use of heat recuperation. By the 1870s neither of these ideas was novel, for they were already being applied to certain patterns of firing by gas (pp.189-95). The Hauzeur design consisted of two combustion chambers built back-to-back, with a common dividing wall which stopped some way below the roof arch to allow free communication between them. Only one chamber was fitted with a fireplace; in this chamber the hot gases rose up between the retorts. The gases then swept over into the second chamber, there to descend among its retorts before leaving by a flue. On their way from the second chamber to the chimney the hot gases passed along a labyrinthine

duct from which heat was transferred to neighbouring air passages. Thus the air entering the second combustion chamber was already hot when its oxygen reacted with unburnt portions of the combustion gases, thereby contributing to efficient working.

Improvements made in coal combustion

During the nineteenth century it became the practice at some works to use in the fireplace a relatively thick bed of fuel, 0.75-0.95m deep, and also sometimes to encourage a layer of clinkers of perhaps 0.25m over the grate bars. With such a deep bed the air drawn in through the grate was well heated by the time it reached the fresh coal in the upper layers. The coal itself was only partly burned in the bed, the remaining volatile constituents and carbon monoxide leaving the fireplace with the heated air and so continuing the combustion in the space above. Thus the overall effect was to lengthen the flame in the gases rising from the fuel bed. By this means, with skilled firing, it was possible to achieve more even temperature levels throughout the combustion chamber. Where the coal used contained a comparatively small proportion of 'volatile constituents', normally yielding a short flame, the adoption of the thick bed could be of substantial benefit: the furnaces could be enlarged, the output of zinc would be greater, and the muffles or retorts would last longer.

A second way by which firing came to be modified after 1850 was in the use of forced draught, the primary combustion air being blown into the firebox under pressure from a fan. Coupled with deep-bed firing, this practice was adopted in the 1860s at one works in Upper Silesia to take advantage of the Belgian-modified pattern of Silesian combustion chamber. In the eastern USA in the 1870s zinc furnaces were equipped with Wetherill grates in which the fuel rested on iron plates punched with conical holes, and sealed ashpits were combined with airblasts to burn anthracite fines.

Distillation Furnaces Heated by Gas. Generating Gas from Coal

During the first half of the nineteenth century in many European towns commercial enterprises were set up to supply 'coal gas' or 'town gas' made from coal by strongly heating it out of contact with air. The gas possessed good heating ability and was convenient for domestic purposes. Compared with coal itself it was clean and efficient in use, leaving minimal solid residues and being burnt to produce

heat exactly where it was required. Moreover the hot atmosphere could be arranged to be non-oxidising. For large-scale industrial purposes, however, use of such coal gas was generally prohibitively expensive. From the 1840s an alternative gas derived from coal was obtained, although at first only experimentally. This 'producer gas' was not as rich as coal gas, for its combustible constituents were diluted with nitrogen from added air, but it was considerably cheaper and it was therefore of particular interest industrially.

In the gas producer a deep bed of solid fuel was maintained in an incandescent state by passing through it just sufficient air for the purpose, but not enough to allow complete combustion. Thus perhaps one third of the potential heat energy in the initial fuel would be consumed in yielding a hot gas rich in combustible carbon monoxide and containing also some hydrogen. In a modification of the original working credited to A. Wilson, from the 1860s it came to be recognised that the injection of some steam with the air gave improved results. Rigg (1916) stated that a good gas for zinc furnaces contained 25-30% carbon monoxide and 7-8% hydrogen together with whatever methane and other hydrocarbons the coal yielded. Excessive proportions of hydrogen would cause trouble owing to the shortness of the resultant flame.

As W. R. Ingalls pointed out in 1903, in a furnace equipped with a firebox containing a deep bed of coal the dividing line between 'direct firing' and 'gas firing' was indistinct. He used the phrase 'semi-gas firing' for such circumstances. Broadly, in gas firing the coal was converted into gaseous fuel a significant distance away from the place where its heating potential was realised by combustion with air. Compared with direct coal firing, gas could offer several advantages: more-uniform temperature; greater heated volumes and hence larger furnaces; fuel economy; and positive pressure within the combustion chamber, thereby discouraging loss of zinc by migration through the fire-clay retorts. However, at least until the closing years of the nineteenth century, the kinds of coal suitable for gas generation were limited by the equipment available. France, Westphalia, and Rhenish Prussia were said to have access to coals rich in volatiles which favoured gas firing, while by contrast Belgian coals were lower in volatile constituents. For this reason those Belgian works which adopted gas firing used imported German coal. In the USA the cost of coal in many zinc-smelting districts was so low that there was little incentive to economise.

Development of Distillation Furnaces Fired by Producer Gas

As far as gas firing was concerned, the period 1865-75 was one of experimentation. By itself, the use of gas was only part of the story, for closely coupled with it went the development of heat exchange, a topic considered in the next section (pp.191-5).

In Upper Silesia gas-fired furnaces were introduced in the period 1865-70. In the simplest case the normal fireplace was discarded; instead a pair of gas-producing chambers was built at one side of the furnace structure, and below the working-floor level. Primary air for the producers was blown under their grates, a wide duct in the brickwork leading the resultant gas into the middle of the combustion chamber where secondary air was well mixed with it to enable burning to take place. By 1891 in Upper Silesia 78% of the zinc furnaces were fired by gas; by 1901 the proportion had risen to 85% (Ingalls 1903).

One of the most popular early forms of gas producer, or 'gazogene', was that attributable to Boetius, whose furnace was the subject of a British patent in 1865. The Boetius gas producer consisted of a firebrick chamber containing an inclined grate of iron bars upon which the coal fuel rested and through which air was passed. Below the grate was the ashpit, open to atmosphere. Coal was charged periodically through a hole at the top of the chamber, a close-fitting cover otherwise preventing the ingress of air above the fuel bed. For best results the generator was kept constantly full of coal. The generating chamber was built into the furnace structure, commonly at the end. The hot gases generated were led from the upper part of the chamber into the adjoining combustion section. Air for mixing and reaction with the fuel gas in the combustion chamber was preheated by passage through ducts in the brickwork surrounding the generator.

In Belgium, before 1877, such Boetius producers were installed at Moresnet. At Ougree and Bleyberg a furnace design attributed to Oscar Loiseau, and patented in 1878, was introduced. Angleur and Corphalie were two other Belgian works which used gas firing fairly early.

In the USA the first large gas-fired furnace was erected in 1872. It was designed by Edward C. Hegeler of the Matthiessen and Hegeler Zinc Company of La Salle, Illinois. (Among other innovations, Hegeler was also responsible for a pattern of mechanically-rabbled blende-roasting furnace, p.171.) In contrast with the up-and-down

flow of hot gases in the Belgo-Silesian furnace and the upward flow in the Belgian system, the Hegeler distillation furnace showed a departure in that inside the combustion chamber the hot gases were led from each end towards the middle along a largely-horizontal path 5-6m in length. By subsequent modifications the heat supply from the gas was maintained by the injection of air under pressure of 0.373 kPa (1.5 inches of water) through numerous ports along the front wall of the furnace. By the opening years of the twentieth century the size of this kind of furnace had been enlarged from 448 retorts to 864 and the pattern remained in use until after 1950.

Among the early gas producers was a unit developed by the Siemens brothers, patented in Britain in 1861-2. Broadly similar to the Boetius and several other designs, the Siemens' device relied upon natural draught to induce the air into the fuel bed. Moreover it involved a restrictive system of ducting to convey the resultant gas forward into the combustion chamber; this was considered necessary to avoid the possibility of air leaking into the gas duct, resulting in premature combustion. The Siemens' heating system is considered more fully below.

The addition of a steam injector improved the flow of air into the fuel bed of a producer. By the beginning of the twentieth century forced draught was common: generally the primary air was blown into the fuel bed under positive pressure from a fan, but an alternative was to include a mechanical blower, e.g. of Root's pattern, in the gas line leading from the producer to the furnace. Such an arrangement was made c. 1901 in Illinois by Hegeler in order to overcome some of the fluctuations in firing that resulted from intermittent charging of coal to his producers.

By 1901, too, gas producers generally took the form of upright cylinders of firebrick contained in a steel shell and situated outside the furnace house as distinct entities. Automatic charging of fuel and mechanical periodic pokering of the bed became available. A producer shaft 3.3m in diameter could gasify 25 tonnes of soft coal in 24 hours.

The gas might be conveyed from the producer to the furnace through iron pipes, but better efficiency would be obtained by lining the pipes with brickwork, or lagging them externally. In this way the gas would be at high temperature when it arrived at the combustion chamber inside the furnace.

For heating zinc-distillation furnaces, firing by producer gas remained the most important method throughout the first half of the twentieth century. In the USA natural gas was first used on zinc furnaces in Indiana. It was discovered at Iola in Kansas in 1895 (Pl. 8). Very quickly zinc smelting was started at the sites of boreholes but, when the gas was treated in the same way as producer gas, results were poor, with dissociation of the hydrocarbon leading to carbon deposition and clogging. By 1899 success was achieved at Cherryvale in Kansas by burning the gas in short sections of furnace. However, the gas resources in that district were soon depleted, though they continued to be available in Oklahoma for many years. In West Virginia two distillation plants used natural gas between 1900 and 1915. To a limited extent natural gas continued to be used in the USA until after 1950.

Increasing Thermal Efficiency by Heat Exchange
Around 1860 the brothers Wilhelm and Friedrich Siemens were developing their regenerative gas-fired furnace. Shortly afterwards one of their furnaces employing the two interlinked features of producer-gas firing and heat exchange between the combustion products and the incoming air was successfully used at a glassworks near Birmingham in Britain. Other, and better, gas-producer designs were developed subsequently (Harbord and Hall 1904, Juptner and Nagel 1908, Rambush 1923). A major aim of the Siemens brothers' work was to generate furnace temperatures of 1550°C which would be high enough to melt low-carbon steel, and in due course 'open-hearth steelmaking' resulted. For this application the preliminary conversion of coal to gaseous fuel was one of two essential steps, the other being the preheating of both gas and secondary combustion air to high temperature before their injection and reaction to produce heat.

For zinc-distillation furnaces somewhat lower temperatures of 1300-1450°C were generally adequate so that the heating of gas by passage through heat exchangers before combustion was not widely practised at least before 1901, for, though beneficial for fuel economy, it increased operating complexity. By contrast, by the 1890s the combustion air generally was preheated to provide concomitant benefits of increased fuel efficiency and larger furnace capacity. Two different methods were in use: either the air would be led through ducts in the hot furnace brickwork which formed continuous heat exchangers ('recuperators'), or it would be directed intermittently through Siemens-type chambers containing heated chequerbrick ('regenerators').

The use of recuperative heat exchange to raise the temperature of the air fed to the combustion chamber, and sometimes also that supplied to the gas generators, began *c.*1870 and went hand in hand with the application of gas firing. The Hauzeur furnace of the 1870s is one of the few instances of such preheating of combustion air applied to direct coal firing. Even in the Boetius producer of *c.*1870 ducts were provided to permit the heating of air passed through its firebrick walls. About 1880 both the gas-fired Hegeler distillation furnace in the USA and the Loiseau pattern in Belgium used recuperation to raise the temperature of the secondary air fed into the combustion chambers, the heated air then being introduced at intervals along the length of the furnaces to sustain combustion and so provide heat over a long gas path. In Belgo-Silesian furnaces in Europe in the 1890s heat recuperation was widely used to preheat the air.

The techniques used to achieve recuperative heating of the incoming air ranged from passing it through ducts or channels built into the brickwork of the furnace hearth to feeding it through tubes over the outside of which flowed the hot combustion gases. Where chambers were used they were generally situated beneath the furnace hearth. The tubes or ducts were formed of fireclay so that there was inevitably a compromise between the requirements of good heat conductivity through the partition and of adequate strength involving a wall thickness of at least about 25mm. In the early part of the twentieth century the American Convers and De Saulles furnace offered such a counter-current system. The combustion air was subjected to heating from contact with the waste gases in large under-hearth exchange chambers, while the fuel gas obtained some increase in heat content by passage through ducts in the hearth brickwork, which might be at a temperature of more than 500°C during hard firing. To achieve the smooth performance they wanted, the designers of this furnace reversed the established Belgo-Silesian flow path. Here, on both sides of the furnace, the flaming hot gases travelled upwards round five rows of retorts to be deflected at the top of the combustion chamber and so pass back down through a middle flue which led to the heat-exchange chambers (Ingalls 1903).

At Port Pirie in South Australia in 1913 there were 8 distillation furnaces of Rhenish (Belgo-Silesian) pattern, each consisting of two tiers of 72 retorts mounted back-to-back. The combustion air was forced by means of a fan through an intricate system of flues before it reached the burners. As described by Reid in 1913, each furnace had four burners, built in the form of large Bunsen burners 455mm in diameter and set in the hearth between the two retort tiers, or sides. The burners had 228mm gas inlets at the bottom and air ports at the side.

In at least one instance the heat exchange took place through the iron walls of tubes mounted in a brick chamber and comprising a 'pipe-stove unit'. Such units were built at one end of the Hegeler furnaces at La Salle, Illinois, *c.*1890, but may not have survived for long. At the same works further heat was recovered from the gases leaving the stoves by passing them through steam boilers, and this method of heat recovery was used for many years. Earlier Hunt and Rudler (1878) quoted a record of the use of an iron-pipe stove at Tarnowitz in Silesia.

The proportions of the overall heat which could be exchanged by continuous recuperation were limited but were nonetheless fairly widely accepted as being well worthwhile. The system had the merits of comparative simplicity and continuous working, with minimal manpower requirement.

By contrast, regenerative heat exchange involved periodic flow reversals of combustion gases and incoming air, and of fuel gas too if it was to be preheated. It was the Siemens brothers' scheme of the early 1860s which offered regenerative exchange. With this, the hot waste gases leaving the furnace combustion chamber were directed through either one or two large chambers packed with a chequerwork of firebricks; the gases transferred part of their heat content to the chequers during their passage towards the exit flues. After a suitable time period, ranging in practice from 20 to 60 minutes and commonly 30 minutes for zinc furnaces, the flow of hot gases was switched away from the regenerator chambers, and in their place was drawn or blown through them the incoming air and, if a second chamber was available, fuel gas. After a further period of around 30 minutes the gas flows would be switched once more so that the generator chequerwork began to be heated again. Duplicate sets of chequerwork were required so that while one was being heated the other set was giving out its heat to the air and gas. As with continuous recuperative exchange where chambers were used, the heat exchangers were commonly situated beneath the hearth of the furnace.

Flap valves in the various flues were used to switch the gas flows as required. However, the Siemens' system overcame the need to throttle and switch the hot gases leaving the combustion chamber, and at the

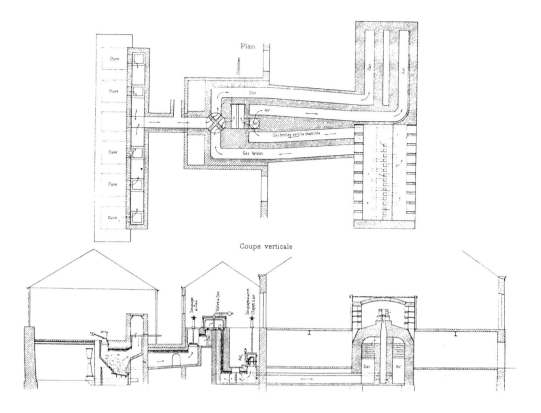

Fig. 19 The Siemens type of regenerative furnace, set in the retort house (right), was supplied with fuel gas from a battery of 'producers' fed with coal. Valves regulated the combustion (left) and also periodically switched the gas flow through the heat-exchange chambers. (Prost 1912, pl. IV)

same time eased the problem of supplying heat where it was needed in the regenerative circuit, by arranging for the direction of furnace firing to alternate from one end or side to the other. In steel furnaces the alternation was between the two ends of the combustion chamber. Thus, for one half-hour period the fuel gas and air would be introduced through burners at the left-hand end with the hot combusted gases leaving at the right-hand end and passing through the regenerators built under the hearth at that end; meanwhile the air and gas would be preheated by passage through the hot regenerators situated at the left-hand end. During the succeeding half hour the direction of the gas flow would be reversed, with firing taking place through burners at the right-hand end. Figure 19 shows details of a Siemens' installation operating in this manner.

The pioneering installations of Siemens' furnaces in the zinc industry were largely failures. The system was complicated to handle, the chequerworks became clogged with debris and with zinc oxide derived from leaky retorts, local furnace temperatures were excessively high, and the associated gas producers proved inadequate. This was certainly the case with the furnace constructed at Auby in France *c.* 1866 (the same works in which afterwards the

Hauzeur furnace was built). Ten years later Siemens' furnaces were present at the Birkengang works in Stolberg, alongside a recuperative type, and in the USA at Peru in Illinois.

By the 1890s the situation had changed. At least in Europe, zinc makers had come to realise the value of heat economy, and had acquired sufficient experience to make a success of the Siemens' system. Moreover, the Siemens' patents had expired and other forms of gas producer were fitted.

As already stated, with the Siemens' regenerative system it was necessary to have a symmetrical combustion chamber so that firing could be done alternately in opposite directions. Copying the practice in the steel industry, some zinc furnaces were fired along their lengths from the two ends, but a more common arrangement was to use a double furnace, with two tiers of retorts mounted back-to-back, and to fire them from one side to the other, the gas flows within the combustion chamber resembling those in direct-fired Belgo-Silesian, or Rhenish, furnaces. Figure 20 illustrates this firing mode, and the position of the chequerwork chambers can be seen at the base of the furnace structure. Figure 19 shows the arrangement of ducts

and valves needed to effect the switching and hence to maintain the transfer of heat.

W.R. Ingalls (1903) said that the system of regenerative gas firing lent itself easily to the Belgian form of distillation furnace, resulting in the 'Siemens-Belgian' pattern. However, it seems likely that over the following years larger numbers of regenerative furnaces of Rhenish pattern were built and worked.

At Overpelt in Belgium in 1893 there was erected the prototype of a regenerative furnace which used the original Siemens' plan of gas and air reversing back and forth in the combustion chamber, parallel with the longitudinal axis. This Welzer furnace proved popular. Shortly before 1900 it was copied by the US Zinc Company at Pueblo in Colorado, and numbers were erected in other parts of Europe between 1895 and the 1930s.

In Upper Silesia the proportions of Siemens' furnaces used in the zinc industry rose from 1/8 in 1891 to over 1/4 in 1901 (Ingalls 1903). An experiment carried out in 1895 at the Paulshütte near Rosdzin and reported by Schnabel and Louis in 1907 compared the fuel-coal consumptions for zinc made in furnaces fired directly by coal and on the Siemens'

system: direct firing consumed 10.2kg for 1kg of zinc while the Siemens' furnace took 7.8kg for 1kg. Presumably the Upper-Silesian retort charge contained only some 20% of zinc, a low value by world standards. Using a retort charge containing a higher proportion of zinc the coal consumption could be lowered substantially; for a charge carrying 50% of zinc, consumption might be 3-4kg per 1kg of metal. Indeed in 1950 Morgan quoted a producer-coal consumption of only 1.50kg for 1kg of zinc.

One further form of regenerative zinc furnace was associated with patents of 1891 and 1905. Called the Dor-Delattre, during the first quarter of the twentieth century it found favour in at least five works in Belgium, Holland and France. It had two distinctive features, one being the siting of the regenerative chambers at the ends of the furnace at working level rather than beneath it. The other characteristic was that the gas and air for combustion were led into the furnace along ducts in the roof, above the six rows of retorts. The gases were injected into the combustion chamber through a number of ports spaced along its length. The flaming gases followed a U-shaped path downwards over the

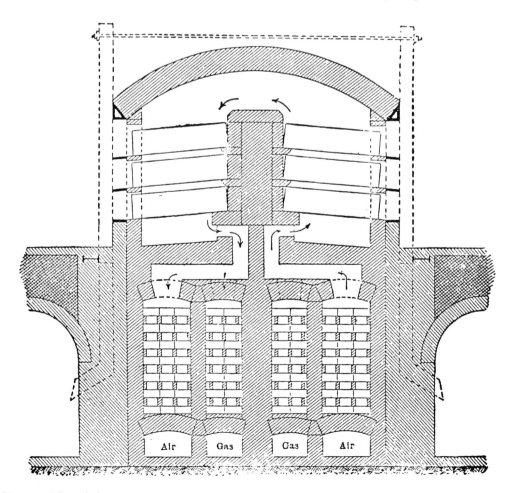

Fig. 20 Siemens-Rhenish furnace, transverse section showing the working floor and, below it, the chequer-brick heat-exchange chambers for heating both producer-gas fuel and combustion air. (Gowland and Bannister 1930, 485)

retorts on one side, through a communicating passage in the hearth and upwards on the second side to reach the ducts leading out to the regenerator chambers. The design was intended to ease access to the air and gas passages, to enable the supplies of gas and air to the burners to be regulated satisfactorily, and to give more-uniform heating to the retorts (Lones 1919).

In 1936 Gyles gave details of the four furnaces installed at Avonmouth near Bristol some years earlier. The pattern of gas flow was broadly similar to that shown in Figure 20. Combustion took place as the gases rose up past the retorts on one side, swept over the bridge along the centre, and descended past the second tier of retorts to pass out through the regenerators on that side of the furnace. The actual combustion chamber is illustrated in Plate 9. Each of the Avonmouth furnaces had a daily output of 12.25 tonnes of metallic zinc, produced in 384 retorts, mounted 192 on each side in four rows of 48. The furnace was divided into four sections, each provided with separately-controlled gas and air systems but coupled with only two regenerators as no attempt was made to preheat the fuel gas. After passing

through the regenerator chequerwork the air entered the combustion chamber at 980°C. The maximum temperature attained was 1400-1430°C; the waste gases left the regenerators at 570°C and were passed on to boilers to provide steam. The air supplies were reversed at intervals of 20 minutes. Average furnace life was quoted as 4-5 years.

The various ways in which heat transfer was arranged in furnaces fired by producer gas are summarised in Table 4.

Despite the considerable improvements in reliability that were achieved with the regenerative method of heat exchange during the period between 1890 and 1930 there were some who thought that heat recuperation possessed more overall advantages. K.A. Phillips (1959) stated that the last American regenerative furnaces were abandoned in 1953. Although such furnaces had the highest thermal efficiency they also had the highest construction cost. Phillips commented that regenerative furnaces were difficult to fire uniformly, and could be operated competitively only where an ample supply of skilled, conscientious workmen was cheaply available.

Table 4 Summary of the chief paths followed by combustion gases in furnaces fired by producer gas

1. Gas and air ascend through canals in the middle of the furnace and then are deflected to each side by the roof arch to travel downwards over the two banks of retorts
(Belgo-Silesian style).

2. Gas and air travel longitudinally more-or-less horizontally through the combustion chamber
(original Siemens' system for steel furnaces;
Hegeler (La Salle) pattern in USA;
Welzer (Overpelt) design in Europe).

3. Gas and air travel up one side of a double furnace with two combustion chambers back-to-back, and down the other
(first Siemens' furnace used for zinc at Auby;
common pattern of Rhenish furnace where heat exchange was practised).

4. Gas and air are injected into the upper part of the combustion chamber at one side, and burn as they travel downwards and round to pass upwards on the second side
(Dor-Delattre design of twentieth century).

Supplying the Heat for Vertical Retorts from Chemical Fuels

Where reduction and distillation were carried out continuously in vertical retorts in the second quarter of the twentieth century by the New Jersey Zinc Company's process, the firing was by producer gas. At Avonmouth near Bristol from 1934 the gas was generated from anthracite coal and introduced to the top of the combustion chambers on each side of the retorts at a temperature of 300°C. As the gas passed down the combustion chambers it met preheated air introduced at a number of levels in order to provide uniform firing. Morgan (1950) described how the hot waste gases leaving the bottom of the combustion chambers passed to aluminous-brick recuperators in which the air was preheated to about 650°C while the waste gases left at 800-900°C. The gases were then made to do more useful work, firstly by serving to heat the briquetted retort charge to about 750°C in a series of heat-exchange vessels called 'cokers', and secondly by passing to waste-heat boilers to generate steam. The producer gas fed as fuel to the retort settings was augmented by gas from the condensers, rich in carbon monoxide, which provided more than one fifth of the total heat requirements (Fig. 14).

Halfacre and Peirce (1959) observed that to achieve good life from the retorts it had been found vital to provide and to maintain a uniform temperature in the combustion chambers. This required the supply of a high-grade fuel gas; natural gas, where available, was suitable. When using producer gas it was reinforced by mixing with it cleaned carbon-monoxide gas from the retorts, following condensation of the zinc and scrubbing. The fuel-gas generated from either anthracite coal or coke breeze was likely to be sufficiently clean for immediate use, but where the gas was derived from bituminous coal it required to be passed through a cleaning system.

Morgan in 1950 compared the fuel-coal consumption for zinc made by the horizontal process, 1.50kg per 1kg of metal, with that by continuous-vertical retorting, 0.64kg. In both cases the charge would have been of high grade.

Electric Heating

From the 1880s attempts were made to apply electrical energy to obtain the high temperature, and to supply the large thermal demand, required for zinc reduction and distillation. One of the attractions of electrical energy for this purpose was its ability to heat the charge directly, inside the reaction vessel, thereby offering the prospect of improved energy efficiency with extended life for the containing vessel.

The Cowles brothers in 1885 designed and patented a scheme by which a zinc-bearing charge, mixed with granular carbon of appropriate resistivity and contained in a tube like a Belgian retort, would be heated by the passage of a current between graphite blocks which closed the ends of the tube. It was proposed that one of these blocks should be fashioned into a crucible to serve as a collecting receptacle for the zinc. Many subsequent proposals were publicised. A more substantial development arose from experiments made during the 1890s by the Swedish engineer Dr C.G.P. de Laval, who suggested using a furnace heated by an open arc set up between carbon electrodes. Gustav de Laval's proposal received financial backing and produced metallic zinc in 1904 and for several years afterwards. Using hydro-electric energy de Laval could continuously smelt roasted blende, preheated to some 800°C, employing coke breeze as reducing agent and lime as flux, and his process yielded a fluid slag. More than 100 patents were taken out, world-wide, to cover this Trollhättan process. However, one of its weak points was that the product from the electrically-heated mass was the troublesome non-coherent 'blue powder' rather than unoxidised metallic zinc, and thus involved further elaborate treatment to yield a marketable product. Explosions within the equipment were common. During the 1920s the potentialities of the derelict Trollhättan plant were thoroughly investigated by the American Cyanamid Company, and reported on by Landis in 1936, but without any further commercial activity resulting.

Already by this date in the USA there had taken place several other electrically-heated trials for zinc, such as C.H. Fulton's scheme in which the zinc mineral, together with coke and pitch, was pressed into columnar briquettes through which electric current was passed to raise the temperature sufficiently for the desired reactions and distillation to occur.

In 1926 another idea, credited to E.C. Gaskill, was the subject of tests undertaken by the St Joseph Lead Company at its Herculaneum lead smelter. Following some persistent experimental work the decision was taken by the company in 1929 to build a commercial electrothermic plant, and this was erected in 1930 near the Ohio River at what became Josephtown. At first, as intended, the new electrically-heated

equipment produced zinc oxide but in 1936, following the development of a novel condenser system, commercial metal began to be made. In subsequent years the plant's capacity came to be greatly expanded. By 1959, according to one of the pioneers of the technique, George F. Weaton, electrothermic zinc-smelting units also existed in Peru, Argentina and Japan.

The St Joseph's electrothermic furnace consisted of a cylindrical shell, 14-15m tall and 1.75-2.40m in diameter, lined with firebrick (Fig. 15). Carbon electrode rods inserted into the shaft at a vertical spacing of 8m provided means for leading current into and out of the charge column. The charge consisted of a mixture of sinter containing 55% of zinc and ranging in size between 6 and 19mm with similarly-sized coke in proportions of 70 sinter: 30 coke by weight (50: 50 by volume), the large proportion of coke contributing to electrical stability in the resistive column. Charging was continuous, through a rotating feed distributor which closed the top of the cylindrical vessel, while discharge of solid residues from the bottom was also performed continuously by a convex rotating table. An individual component of charge took some 18 hours to travel downwards through the shaft by gravity. The charge was preheated to 750°C before it entered the shaft, the source of fuel being carbon monoxide gas recovered from the zinc condensers (i.e. indirectly the source was the coke present). With an emf of around 240 volts applied between the upper and lower sets of electrodes a total current of 10,000-20,000 amperes would flow through the charge column, raising its temperature to 1200-1400°C, with the highest temperature occurring in the centre. One shaft, with a diameter of 2.5 m, could yield 50 tonnes of zinc daily.

By contrast with the St Joseph Lead Company's electrothermic process in which the reactions in the hot zone were essentially between solids and gases, with the residue remaining rigid and 'dry', around the middle of the twentieth century another USA producer succeeded in using the heat provided by open electric arcs to produce a fluid slag as well as a gas containing zinc. This procedure, engineered by The New Jersey Zinc Company primarily to treat zinc-bearing material from its Sterling Hill mine, was firmly based upon the Trollhättan experiences of earlier years. One of the several factors which led to this new installation being considered successful was the application of improved condensers, the New Jersey engineers being able to draw upon the pattern of zinc-splash condensers already used for the

company's vertical-retort process. Mahler and Peirce reported in 1959 that two similar furnaces had been built at Oroya, Peru.

(d) Ways of Condensing Zinc from the Reactor Gases

Introduction

The collection of liquid zinc from the hot gases leaving the high-temperature reactor involved condensation. In several respects this was the most crucial aspect of high-temperature zinc production. The gaseous zinc leaving the retort or other reaction chamber had to be well 'covered' by a high proportion of carbon monoxide gas (composition of the gases was commonly about 50/50 Zn/CO) with the exclusion of anything more than trace proportions of carbon dioxide, steam or air. The purpose of the high potential of carbon monoxide was to discourage the occurrence of reactions such as

$$Zn(g) + CO_2(g) = ZnO(s) + CO(g)$$

that is, the formation of zinc oxide from gaseous zinc by reaction with carbon dioxide. As the temperature fell below 1000°C so the thermodynamic feasibility of such an undesirable reaction increased.

At one atmosphere pressure zinc would condense from gas to liquid at 907°C, at the same time giving out latent heat. At smaller partial pressures the condensation temperature was lower. Thus theoretically a retort gas carrying 50% of zinc by volume would start to condense at around 840°C. Once the zinc had been converted into the liquid state, the opportunities for unwanted oxidation reactions were considerably lessened, for it was only where the liquid surface was in contact with gases that such reactions could take place.

European zinc producers at the beginning of the nineteenth century would have been able to draw upon the experience of mercury makers, for this was the other metal liberated from its ore minerals as a gas. Compared with zinc, the chemical restrictions involved in mercury production were fairly lax and the prevailing temperatures less severe. The gases emanating from the high-temperature mercury reactor could be safely mixed with, and diluted by, the fire gases. The gases containing mercury were passed through cooling chambers and, in the case of the Bustamente furnaces used at Almaden in Spain, through long lines of 'aludels' or clay condensing tubes in which the liquid mercury collected. These bottle-shaped ceramic tubes, glazed on the outside, may have inspired the new zinc extractors in Silesia and Belgium. As described by Schnabel and Louis in 1907, the aludels were some 400-450mm long,

275mm in diameter at their widest part and 120-150mm at the extremities, the openings being so made that the end of one aludel would fit inside the opposite end of its neighbour, thereby creating a long line of receivers.

Practical Condensation

In both the English and the Carinthian methods of zinc production the zinc and carbon-monoxide gases had to leave the hot reactor by travelling downwards along vertical tubes, during which journey cooling took place with the result that liquid zinc would drip from the lower ends. The Carinthian process was the European one which came nearest to the earlier Indian method of extraction (see pp.37-41). Not only were large numbers of vertical reaction vessels placed together in one heating chamber, but the droplets of zinc emerging from the bottom of each tube were run together into a collecting sump, under the protective atmosphere of high carbon monoxide concentration.

In what became the more important methods of batch distillation, the Silesian and Belgian processes, the gases left the long, more or less horizontal reactors through openings situated at one end, and throughout the nineteenth century in almost all cases the zinc outputs were collected separately. Exceptionally, the outputs from two muffles were combined for common collection. Early Silesian practice favoured the use of elbow-shaped, right-angled, fireclay tubes to lead the gases out of the muffle and into the cooler region at the side of the furnace where the temperature could be adjusted to suit condensation to liquid zinc (Figs 11,12). The vertical limb, of clay and cast or wrought iron, echoed in contracted form the condensing tube of the Carinthian and English patterns. The resulting metallic zinc was originally allowed to solidify in chambers situated at the ends of the condensing tubes, so that subsequent remelting and casting were required before marketing. The elbow-shaped (or knee-shaped) member contained a hole, normally covered by a plate luted on with clay, through which fresh charge could be introduced into the muffle. Residues were removed from the muffle by taking away a second plate, or tile, closing the end below the condensing joint. In the Silesian style of working the condensers were contained within the outer part of the furnace structure, in arched recesses or 'chapels'. This arrangement kept the clay condensers close to the 500°C that favoured the efficient formation of liquid zinc and thus discouraged the production of partially-oxidised 'blue powder'.

In the third quarter of the nineteenth century Silesian practice swung to the use of conical condensing tubes of clay, sticking out more or less horizontally from the muffles in similar way to those employed in Belgian working. The tubes were commonly up to 1m in length, and they might be bellied out to provide a bowl-like receiver for the liquid zinc. Generally, the diameter of the condensers used in both Silesian and in Belgo-Silesian working was sufficiently large, say 150 mm, to permit the charge to be introduced into the muffle or retort by long-handled spoon-shaped implements which could be passed through the condenser, and then turned over to release their contents. This requirement restricted the length of condenser that could be fitted.

As stated, the Belgian zinc makers used fireclay condensing tubes which were stuck out horizontally from the open ends of the retorts. However, by comparison with Silesian practice, these tubes were of only 55-130mm in inside diameter. Lengths ranged from 0.3 to 0.5m with walls 5-15mm in thickness. While some condensers were of cylindrical form, others were conical; others again were more elaborately made, with an enlarged diameter in the middle portion to create a 'pouch' for holding liquid zinc. Some conical condensers were made with elliptical cross-sections (Fig. 21).

The fireclay condensers posed a substantial logistic problem in working the batch distillation process. The charge to be treated had to be inserted into the reaction pot through a relatively small opening in its one end accessible from outside the furnace. Later the solid residue from the treated charge had to be removed through the same opening in the pot. In between these operations condensers were needed to cover the opening. Thus two alternative schemes of working were possible: one was to attach, and subsequently detach, every individual condenser during each batch treatment; the other method was to arrange for the size of the condensers to be sufficiently large to permit charging to be done through them. This second alternative was the standard procedure with the Belgo-Silesian method. It was also reported by Reid in 1913 to be in use at Port Pirie in South Australia, where the condensers were formed from retorts cut to half length.

However, in Belgian practice it was the former alternative that was adopted. Each day, after the furnace combustion had been abated to allow temperature to fall somewhat at the end of a batch treatment, the liquid zinc would be drained from the condensers into a ladle, the condensers themselves

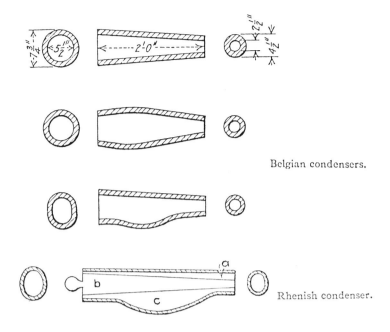

Belgian condensers.

Rhenish condenser.

Fig. 21 Sections through some fireclay condensers.(Hofman 1922, 154, 155)

would be removed from the ends of the retorts, and the hot residues raked - and barred - out. After the pots had been inspected for soundness they would be charged with new feed mix and then the condensers would be refitted to their mouths, using clay luting to seal up cracks and small cavities, supplemented where necessary by fragments of tile. This procedure, occupying 3-5 hours, comprised the 'manoeuvre'. The furnace heat supply would then be opened out and the reaction process started. The number of times that liquid zinc would be drawn from the condensers during the 19-21 hours of treatment varied from once to four times (Pl. 10).

The life of a clay condenser was only 6-15 days. Large numbers were made in the pottery and the simple conical shape was favoured because it could be produced semi-automatically with machinery and straightforward moulds. The dried-and-fired weight would be 8-11kg. In use the condensers became heavily encrusted and impregnated with solid zinc and/or zinc oxide so that when they cracked or broke it was worthwhile to sort through the fragments to recover zinc.

To be efficient as a collector of liquid metallic zinc the condenser needed to have an adequate internal-surface area maintained at an appropriate temperature, and to be airtight. In some Silesian plants elaborate, multi-chambered, condensers were tried in the nineteenth century, but such arrangements were difficult to apply when the furnace contained more than a single row of pots. In USA batch-retort working in the first part of the twentieth century a common stratagem was to partly close the outlet hole of the condensing tubes with clay so that the gas escaped through a small orifice and the ingress of air was restricted.

An alternative procedure used to improve performance and introduced at some European distilleries in the middle of the nineteenth century was to extend the action of the condenser by fitting onto its outlet a *prolong* or *nozzle*. (Note: the word 'nozzle' is sometimes used to mean the prolong, and sometimes the condenser itself.) In its simplest form the prolong was a sheet-iron tube or drum of a suitable size to fit snugly over the end of the clay condenser and with its discharge opening partly covered to keep out the air (Fig. 22, Pl. 4).

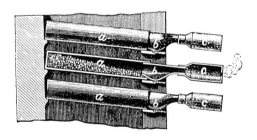

Fig. 22 Diagram of nineteenth-century horizontal-distillation arrangement using Belgian retorts (a), bellied condensers (b), and sheet-metal prolongs (c). (Phillips and Bauerman 1887, 516)

During the latter half of the nineteenth century some great elaborations of prolongs were designed with the joint aims of increasing efficiency of zinc extraction and deflecting the outlet gases away from the working platform in front of the bank of retorts

199

in the furnace. Some of these were illustrated for example, by Ingalls (1903) and Schnabel and Louis (1907). The effluent gases consisted largely of the highly-toxic carbon monoxide. Where this was channelled into a recovery system it could be used to augment the fuel supply to the furnace; in other cases it was burnt, with a blue flame, at the mouths of the prolongs or condensers.

In circumstances where the gaseous zinc did not condense readily and completely out of contact with oxidising influences, a surface coating of zinc oxide would be formed on the liquid droplets. Once such a coating had been created there would be great difficulty in achieving coalescence between the many individual small drops; the result was 'blue powder'. Part of the art of successful zinc distillation was to ensure that, while the overall extraction of metal from the charge was high, the proportion reporting as blue powder was small. The zinc that collected in the prolongs was in the form of blue powder and might amount to some 2% of the whole.

As an aid to better working conditions forced-air ventilation might be provided in the vicinity of the furnace. During the twentieth century at some plants sheet-iron curtains were installed. These were suspended on wire ropes from overhead pulleys so that they could be drawn into place in front of the condensers and prolongs (if fitted) once the distillation part of the cycle got under way. For the periodic tapping of liquid zinc from the condensers any such metal curtain had to be drawn away. In later years the ladles into which the zinc was tapped were themselves sometimes suspended from overhead trolleyways running along in front of the furnace (Pl. 10).

Improvements made in condensation after 1925
The limitations and the high labour costs of the small individual condensers were well understood but it proved difficult to provide any satisfactory alternatives as long as the distillation pots themselves were small and worked in batches. Even so, in the middle of the twentieth century the Belgian Overpelt process achieved a commercial solution to the problem by incorporating the whole of the furnace front into a single closed condensing chamber (Fig. 23). Following the charging of the retorts, a sheet-metal curtain was lowered in front of them to make a gas-tight compartment into which the open ends of the retorts had unrestricted access (Brenthel 1966). Zinc condensing in this compartment could collect as a liquid pool in a brick trough running along at floor level, while the heat evolved by the condensation process was partly dissipated by radiation from the metal curtain and partly absorbed in a water boiler. An economic advantage of this common condenser was that the carbon monoxide gas which left the chamber could be collected. After cleaning, the gas was returned to the furnace to supplement the fuel supply, thereby leading to a saving in consumption of some 20%.

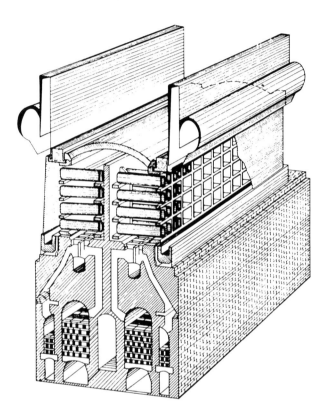

Fig. 23 Mid-twentieth-century horizontal-distillation furnace showing position of large open-ended retorts and arrangement for one common condensing chamber formed by sheet-metal curtain placed in front of furnace. Trough in floor (just below retorts) is to collect condensed zinc. (Brenthel 1966, 48)

The difficulty of achieving efficient condensation was encountered around 1930 by the innovators of both the new continuous distillation methods that appeared at that time: the St Joseph Lead Company's electrothermic process and the New Jersey Zinc Company's vertical-retort process. In the former case, although the primary justification for building a completely new electrothermic plant in 1930 was the production of zinc oxide, which posed no condensation problems, even in 1929 the developers had attached conventional fireclay condensing tubes to an experimental unit to obtain metallic zinc. Some success was achieved in the tests, but efficiency was low and an excessive proportion of blue powder (oxidised zinc) formed. In addition, the prospect of

designing a condenser capable of handling large volumes of gases and 12-15 tonnes of metal daily was daunting.

One of those most closely involved, H.K. Najarian, in 1944 recorded how his team was struck by the 'oft-repeated statement by earlier experimenters, that the most efficient way to condense metallic vapours ... was to bring ... (them) into "intimate contact" with molten metal'. Presumably, among the proposals in mind was that of J. Armstrong, contained in British patent no. 3462 of February 1900, in which the zinc-containing gases from a high-temperature reactor would be made to pass through a trough of molten zinc in order to condense and collect the metal. Najarian also explained how the manager of the new Josephtown smelter, George F. Weaton, 'had long experience with steam-jet condensers and would reiterate his belief at every opportunity that the logical and most efficient way to condense zinc would be with a jet-type condenser.' Consequently, over the five years 1931-6 development work was done to produce from these ideas a practical realisation. The result was the Weaton-Najarian vacuum condenser (Fig. 24). In this the gases of zinc and carbon monoxide from the reactor were drawn through a 50-ton bath of liquid zinc by means of suction applied to the outlet side, the liquid zinc being contained in a U-shaped vessel. As George Weaton recounted in 1959, the zinc content of the gas stream was condensed and absorbed into the liquid bath with high (98%) efficiency while the carbon monoxide, emerging on the outlet side, could be recovered and used for fuel. Water cooling maintained a steady temperature in the bath of liquid zinc, from which portions could be tapped periodically. This novel approach to condensation and its successful engineering application played vital parts in the economic establishment of the electrothermic process for metallic-zinc production.

In the case of the New Jersey Zinc Company's vertical-retort process there arose the same problem of dealing with large and continuous volumes of gases. The company's initial solution was a simple one: the gases leaving the retort were led along a brick-lined downcomer and through a baffled brickwork chamber in which zinc condensed (Fig. 25). The efficiency, however, was poor. During the 1940s an improved condensation scheme was introduced. Like that of the St Joseph Lead Company, this involved the input of mechanical energy in order to achieve efficient condensation; it also involved contacting the gases with a large bulk of liquid zinc. Here the necessary contact was brought about by a 'splash condenser' in which an electrically-driven impeller threw up a continuous shower of molten-zinc drops (Fig. 26). This coarse 'rain' supplied a large surface area of liquid metal

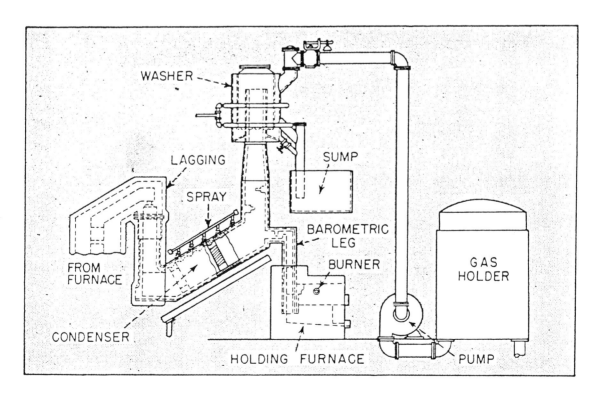

Fig. 24 The Weaton-Najarian apparatus for aspirating retort gases through molten zinc, as developed at St Joseph Lead Company, USA, to condense zinc continuously. (Bunce and Peirce 1949, 58)

upon which the gaseous zinc could condense, and further area was provided by the zinc streaming down the chamber's walls. Temperature of the liquid was maintained at about 500°C by water-cooled coils immersed in the bath which abstracted appropriate quantities of heat. In 1959 it was claimed by Halfacre and Peirce that this condensing device captured about 95% of the gaseous zinc leaving the retort, with 3-4% more reporting as blue powder. The gases leaving the condenser were scrubbed with water to leave the carbon monoxide ready for use as fuel. Like the vacuum condenser developed by the St Joseph Lead Company, the splash condenser of the New Jersey Zinc Company was essential to the success of the whole zinc-distillation process. Around 1950 splash condensers were installed on the vertical-retort plant at Avonmouth, England.

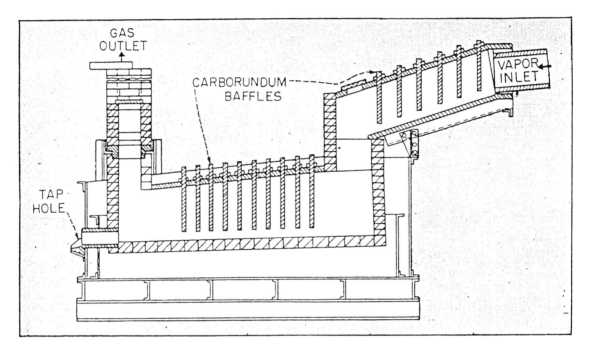

Fig. 25 New Jersey Zinc Company's condenser used on continuous vertical retorts in the 1930's. To absorb and dissipate heat it relied on high-conductivity baffles which extended through the roof (Bunce and Peirce 1949, 58)

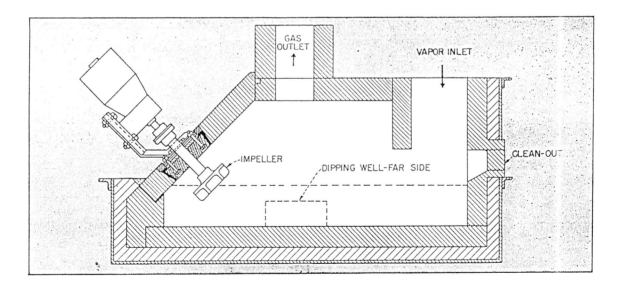

Fig. 26 Splash condenser developed for use with New Jersey Zinc Company's vertical-distillation retorts *c.* 1940. The impeller, partly immersed in a pool of liquid zinc, threw up a spray of droplets which encouraged condensation of zinc from the gases. (Bunce and Peirce 1949, 61)

IMPROVING QUALITY: REFINING THE METAL

General Comments

The metal resulting from distillation ranged in purity from about 97 to 99% of zinc. Particularly in the early years, but persisting to some extent into the twentieth century, substantial quantities of metal were marketed as slabs or plates cast directly from ladlesful of condenser product. Before 1850 it was recognised by some producers that worthwhile improvements in zinc quality could be obtained by treating the condenser metal in a refining furnace. For many uses constant product quality might be more important than high purity; rollers of zinc and brass sheets and galvanisers of sheet-iron articles demanded consistency. Around the beginning of the twentieth century, and especially during the Great War of 1914-18, the virtues of brasses made from high-purity zinc were acknowledged, the resultant alloys possessing better ductility and other properties. Thus metal containing at least 99% of zinc came to be wanted. In the following decade, and more strongly in the 1930s, zinc began to be used for high-pressure diecastings so that a demand was created for metal of 99.9% purity to avoid disastrous and embarrassing failures. To meet these changing market demands zinc producers had to modify their techniques. After about 1916 some electrolytic zinc was available (see pp.210-16) and all of this had a purity of at least 99.9%, thus posing a serious challenge to those who obtained their metal by distillation. The challenge was met soon after 1930 by the innovation of fractional distillation.

The purity of the zinc that resulted from primary distillation depended upon a number of factors, including the kinds and quantities of impurities present in the material charged to the reaction vessels and the part of the distillation cycle from which the particular metal was drawn. Lead, iron and cadmium were the three metallic elements to accompany the charge and to give rise to significant impurity levels in the metal. A clean reduction charge of zinc oxide, free from lead and iron compounds, would yield high-purity metal. Thus the nature of the mineral deposit worked for ore affected the metal product; so did the extent to which dressing sorted out clean zinc minerals for smelting. The distinct limits to this task were set not only by the available technology but by the fineness of the individual mineral components in the ore and by the fact that some zinc minerals contained iron and/or cadmium within their crystal structures. The zinc-iron sulphides (marmatites) of Australian Broken Hill and Trail in Canada were just two notable examples. Nearly all cadmium occurred in this way, in solid solution in zinc minerals. Roasting – and more especially sintering – treatment could remove significant proportions of cadmium, and even lead, from the zinc-bearing material. During the reduction-distillation process cadmium, having a lower boiling temperature than zinc, tended to come over with the zinc early in the operation, while lead with its higher boiling temperature accompanied the later fractions of zinc. At some plants the early-drawn zinc was cast and sold separately from the remainder.

Stratification of liquid phases – 'liquation'

From around the third quarter of the nineteenth century it became fairly common for European zinc-extracting plants to include a coal-fired reverberatory furnace for refining the crude metal resulting from distillation. Furnace capacity might be 20-30 tonnes so that useful blending and equalising would occur in addition to segregation of a purer zinc fraction from less pure ones containing iron and lead. The principle (not necessarily appreciated by nineteenth-century operators) upon which the refining was based was the fact that, while at 500°C liquid zinc could contain about 1.5% of lead in solution and 0.07% of iron, as the temperature fell close to the freezing point of zinc at 419°C the proportions of both lead and iron which could be held became appreciably less. The zinc-rich liquid had lower specific gravity than the other phases present and so formed an upper layer within the furnace well.

The refining process therefore consisted of carefully heating solid zinc to just above its melting temperature and allowing the bath to stand for perhaps 24 hours. This long quiet period provided time for oxides and other non-metallic impurities to rise to the surface where they formed a dross that could be skimmed off. The metallic components would stratify into three layers, the upper stratum consisting of liquid zinc with about 1% of lead, which would be withdrawn for casting. Below the predominant bulk of refined zinc would lie an intermediate layer consisting of iron and zinc, pasty and partly solid at the working temperature, and below this again a dense liquid layer rich in lead ('zincy lead' containing at least 1.3% of zinc). Robson (1950) gave a statement of the analyses of the metals fed into and drawn from such a refining step:

Material	Zinc	Lead	Iron	Cadmium
			(Percent)	
metal input	97.8	2.0	0.10	0.05
refined metal	98.8	1.1	0.025	0.05

This method could do nothing to change cadmium levels. Besides careful temperature regulation it required a source of heat with the minimum of oxidising atmosphere to prevent undue oxidation of zinc at the surface of the bath.

Filtration

What seems to have been a seminal idea was patented in Germany by Kleeman, and equipment embodying it was introduced in 1879 in Upper Silesia. It was used for some time at a number of works, but by 1901 had become almost entirely superseded for its original purpose.

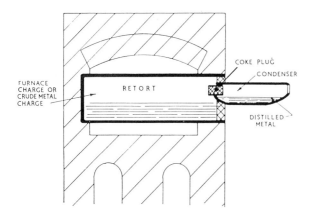

Fig. 27 An early twentieth-century method of improving the quality of the zinc collected in the condenser by causing the gases to pass through a filter of granular coke or firebrick. (Robson 1950, 332)

Kleeman's scheme related to the condensation of zinc from distillation and it sought to improve the recovery of metal while ameliorating the harmful effects on the human system of the gases leaving the condensers. In pursuit of these aims Kleeman caused the gases from each condenser to pass through a bed of red-hot coke. Some of the metallic particles in the gas stream were caught by the coke while the carbon monoxide issuing from the bed burnt on it. In the first two decades of the twentieth century several British producers adopted filters either of quiescent coke or of broken firebricks, to improve the grade of liquid zinc obtained in the condenser. In these cases the entry to the condensers from the retorts was

plugged by porous coke or brick (Fig. 27). This arrangement allowed the gases of zinc and carbon monoxide to pass into the cooler condensers but impeded the carryover of dust or fume particles likely to be rich in lead and/or iron. The method was used by the Delaville Spelter Company of Bloxwich near Walsall and by Brand's Pure Spelter Company at Irvine in Ayrshire, described by J.S.G. Primrose of the Technical College in Glasgow (1910). The normal product contained over 99% of zinc, while occasionally, though unfortunately not predictably, it reached 99.9%. The porous-plug filters were tried also in the redistillation of zinc metal, to prevent droplets of impure zinc from being carried over into the condenser.

Simple Redistillation

A reasonably effective, but costly, way of obtaining zinc of superior purity was redistillation of the initial metal. The need for such extra processing was rarely justified prior to the twentieth century, and in the USA it was the demand for more zinc of better quality created by the war of 1914-18 which in several plants led to a fraction of the total distillation capacity being diverted to such work. Redistillation exploited the difference in boiling temperatures of zinc and its impurities. Belgian-type retorts, sometimes reset so that their open mouths pointed upwards rather than slightly downwards, would be charged through their condensers with either liquid metal or solid bars. Sometimes flask-shaped vessels were used as retorts, held in specially-built furnaces. By the addition of coke filter plugs to prevent drops of impure metal from being carried over into the distillate it was possible to obtain zinc of better than 99% purity, and occasionally, but not consistently, of 99.9%. Gowland and Bannister (1930) quoted an example of the results obtainable by simple redistillation:

Material	Lead	Iron	Cadmium
		(Percent)	
feed	1.5-3.0	0.03-1.0	0.03-0.07
redistilled zinc	0.03-0.12	0.008-0.012	0.03-0.07

Ingalls in 1936(a) noted that in the USA during the war of 1914-18 large quantities of Prime Western spelter were redistilled at works in Kansas and Oklahoma to yield metal of about 99.9% purity which was wanted for cartridge brass. During the inter-war years after 1918 interest in simple redistillation faded.

Fractional Distillation – Refluxing (Fig. 28)

Around 1930 a novel method of removing impurities from zinc was introduced by the New Jersey Zinc Company, based on work by W.M. Peirce and other staff. Experiments extending the idea of Kleeman led initially to a small vertical distillation column packed with broken firebrick in which gaseous zinc from a retort partially condensed, that is, zinc-laden gases entered the bottom of the column and travelled upwards, with part of the zinc leaving the top of the column in gaseous form, while the remainder condensed. The condensed zinc trickled back down the column carrying with it a substantial proportion of the contaminants (Robson 1950). From this was developed an elegant, continuous, process for purifying zinc from lead, iron, and cadmium using a series of two or more refluxing columns to exploit the different values of gas pressure shown over a range of temperature by the various elements. The success of this application of fractional distillation to metallurgical industry was helped by the use of refractory silicon carbide ('carborundum') to construct the large number of horizontal trays, 40 to each refluxer, with which the tall columns were packed (Fig. 28, Pl. 11).

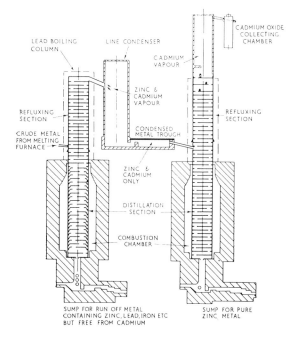

Fig. 28 New Jersey Zinc Company's refluxing (fractional-distillation) columns for refining zinc in the 1930s. From the top of the first (left-hand) column only zinc and cadmium left as gases, while in the second column the temperature was adjusted to yield zinc as liquid with cadmium as gas. (See also Plate 11 and Figure 15.) (Robson 1950, 337)

In action, crude liquid metal was fed into the first ('lead') column, about halfway up and just above the top of the heated part. The temperature gradients in both columns were carefully controlled by furnaces surrounding their lower portions. In the first column conditions were such that only zinc and cadmium reached the top exit as gases, all lead and iron passing down the column in liquid form, to be run off from the bottom together with liquid zinc. In the second column cadmium as a gas was separated from zinc as a liquid, again achieved by adjustment and control of the temperature gradient throughout the height of the column. The capacity of one refluxing unit ranged from 10 to 30 tonnes a day.

The New Jersey Zinc Company's fractional-distillation refining process was intended to complement the same company's vertical-retort method of primary distillation. It was adopted by several operators during the 1930s, including the National Smelting Company at Avonmouth in Britain, where initial production began in 1934. It was also installed at Duisburg in Germany by the Berzelius Metall Hutten GmbH before 1936. For performance figures for Avonmouth (Cocks and Walters 1968) see below.

Material	Zinc	Lead	Iron	Cadmium
		(Percent)		
vertical-retort product	min.99.7	0.2	0.01	0.03–0.06
refluxed vertical-retort metal	min.99.99	0.003	0.003	0.003

About 96% of the zinc in the refluxer feed reported directly in the zinc product.

Electrolytic Refining of Zinc

Crude zinc was electrolytically refined at Baltimore in the USA during the war of 1914–18 but, as Ingalls commented (1936a), the process was too costly to survive once the demand for high-grade metal fell away.

PRODUCTION OF ZINC OXIDE – 'BURNING' AND 'FUMING'

General comments (See editor's note p.216 below.)

The makers of calamine brass for centuries enjoyed the benefits bestowed by the presence of zinc without actually using the element in metallic form: they wanted the compound zinc oxide. Not only is it easier to produce zinc oxide than to make metallic

zinc but the quantity of fuel needed to do so is considerably less. There thus existed before 1800, and there continue to be up to the present, circumstances in which there could be strong economic justification for producing zinc oxide. These circumstances are of two different kinds:

1. where the zinc oxide is to be used either directly as white pigment or for 'chemical' purposes; and
2. where the production of oxide is a means of concentrating and segregating the zinc contained in a low-grade material, as one step towards obtaining metal.

Broadly, the material for (1) is achieved by 'burning', whereas (2) is the object of 'fuming'. For producing pigment or chemical zinc oxide, the starting material may be either an impure zinc-oxide mineral, or zinc carbonate (calamine), or zinc metal itself. On the other hand, where the purpose of treatment is to concentrate the zinc content, the material is likely to be either a complex ore or a slag or other residue.

In the simplest arrangement to obtain zinc as oxide from a material which contains the element, strong heating with a reductant present will yield metallic zinc which then joins the other gases rising from the hot zone. The fact that the gaseous zinc oxidises when the temperature falls and a source of oxygen is present is here applied advantageously. Unlike zinc itself, the resultant oxide is solid at temperatures below 1400°C and appears as fume or smoke which must be encouraged to settle out from the gases. If the particles of resultant zinc oxide are free from impurities they are white, but if contaminated the mixture is coloured.

In contrast with the metal, which melts at 419°C and boils at the comparatively low temperature of 907°C, zinc oxide is solid at much higher temperatures, at 1400°C exhibiting a gas (vapour) pressure of only about 0.13 kPa (1mm of mercury). The thermodynamics involved in the reduction-oxidation reactions are of relevance. To reduce zinc oxide to metal requires the input of energy; on the other hand, the oxidation of zinc is associated with the output of energy. It is this difference which can justify the production of oxide as a concentrating step. Moreover, in marked contrast with the situation that prevails when metal is the desired product, to yield oxide the charge can be in direct contact with the heating flames, and consequently the process can be carried out with considerably lower cost.

Burning for Zinc Oxide

As noted by Bunce and Haslam (1936), the basic process of 'burning' was described in British patent no.2094 of 1796 assigned to John Atkinson and entitled 'Manufacture of white paint'. This described the mixing of either roasted blende or calcined calamine with charcoal and the heating of the mixture in a muffle to liberate gaseous zinc which was then burned to give oxide fume. However, for making commercial zinc oxide in the 1840s the method adopted, and associated with Leclair, consisted of placing metallic zinc in a horizontal retort heated by a fire. By the later part of the nineteenth century the circular- or oval-sectioned retort differed from the standard pattern used for reduction and distillation by having small openings left at both ends, the major portions of the section

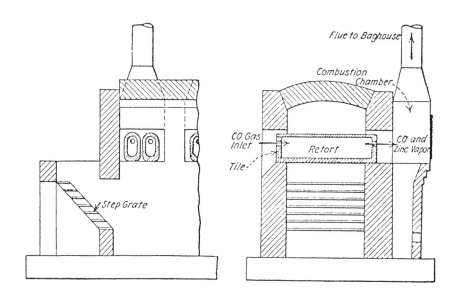

Fig. 29 Furnace and arrangement for making zinc oxide, Port Pirie, South Australia. (Hofman 1922, 285)

being closed by fireclay dams to contain the liquid metal (Fig. 29). When the zinc had attained a temperature of 1000°C a stream of carbon monoxide gas from a hot-coke generator was introduced at one end of the vessel. As this stream of reducing carbon monoxide left the other end of the retort it carried with it gaseous zinc. However, when the gases were directed into a system of settling chambers they came into contact with air, and as a result the zinc quickly reacted or 'burned', producing a brilliant yellow-white flame and yielding fine-sized particles of solid zinc oxide. This technique, which became known as 'the French process' and 'the indirect process' (because it first required the production of metal), remained in wide use in Europe until after 1950. It was capable of giving products of high purity and good whiteness.

Around 1850 in the USA the New Jersey Zinc Company tried, unsuccessfully, to make zinc oxide by treating a mixture of zinc minerals and coal in a reverberatory furnace. However, shortly afterwards, in 1852, Samuel Wetherill, a zincmaker at the company's Newark New Jersey plant, was granted a patent for a technique in which zinc oxide was obtained by heating suitable zinc minerals; this became 'the American process' and 'the direct process'. One of the chief elements in the success of this technique was the 'Wetherill grate', of cast-iron plates perforated with conical holes which were laid with their smaller 3mm diameters uppermost, inside a brick containing vessel. A bed of coal some 50mm thick was spread over the grate and ignited into a uniform burning layer. On top of this fire was placed a layer of mixed oxide-zinc mineral and crushed coal to a depth of 150 mm. An air current was then blown up through the holes in the grate. When the high-temperature reactions were well underway the exit gases from the chamber were directed into a system of collecting ducts and muslin filter bags or tubes. The use of such woven-cloth bags to collect the fume was introduced by Samuel T. Jones at much the same time as Wetherill produced his grate and the combination proved fruitful. As with the 'indirect' method, the zinc left the hot reaction bed as gaseous metal, but it oxidised in the space above the bed as temperature fell and air was encountered.

This 'direct' process was adopted by several USA plants in the 1850s. In the following decade it was taken up in the Middle West, while in the 1880s it became important in the Rocky Mountain zinc region. It was also used in Europe at Liège and other places. In 1919, in the USA 18 plants produced 107,000 tonnes, according to Hofman (1922).

George Darlington conjectured in 1863 that at that time 'perhaps the only valuable contribution which the Americans have made to the science of metallurgy' had been in producing zinc white, which they had brought 'to a high degree of perfection'. The importance of the Wetherill grate was reiterated by W.R. Ingalls during the twentieth century.

Despite the simple nature of the techniques involved, it was generally acknowledged that to produce a high yield of white zinc oxide required considerable skill as well as a restricted choice of charge materials. Cadmium and/or lead in the feed would give a yellow colouration to the product; unburnt or deposited carbon (soot) would darken it.

Around 1920 a mechanised, continuous, zinc-oxide furnace was introduced at the Palmerton plant of the New Jersey Zinc Company. This embodied two novel features: a travelling-grate furnace on which the reactions were carried out; and a briquetted charge, which overcame the problems encountered with loose, powdered beds. Bunce and Haslam gave details of this process in 1936. As with the well-established batch method, the bed was made up with two distinct layers, the lower one consisting of coal fuel and the upper one of mixed zinc-bearing materials (80%) and reductant (20%). The materials for both layers were formed into pressed pillow-shaped briquettes 50mm by 38mm through the thickest part, with waste sulphite liquor from a paper-pulp mill incorporated as binder. Fine-sized anthracite coal was used both as fuel and reductant.

While the primary development of 'zinc-burning' techniques took place in order to yield zinc-oxide products marketable for pigment and other purposes where whiteness was important, a secondary application in the USA during the war years 1914-18 was to extract zinc values from distillation residues. Wetherill grates were pressed into service for the purpose, the retort residues containing sufficient carbon to be self-burning.

Around 1910 distinct interest was shown in Europe in methods which could recover zinc-oxide values from slags by 'burning'. One of the more successful schemes was applied to Oker (Lower Harz) ore containing 9% of lead and 20% of zinc which was first subjected to blast-furnace smelting to yield metallic lead and a slag assaying 17-21% of zinc. The slag was ground to 0.3mm size, mixed with coal dust, briquetted, and then treated in a reverberatory furnace to drive off the zinc into the flue gases. After cooling, the gases were passed through bag filters to collect the solid zinc oxide. In this way, as reported by Gowland and Bannister (1930), in 1910 42,000

tonnes of zinc-bearing slags were processed to yield nearly 10,000 tonnes of 'metal'.

Slag Fuming

In 1917 Frederick Laist, working on the extraction of zinc by leaching and electrolysis at Anaconda in the USA, built upon the European pre-war work to obtain zinc from the leach residues by 'burning' in a reverberatory furnace. This method proved to be uneconomic, particularly when impurities such as arsenic and antimony concentrated in the fume product with the zinc. However nine years later, Laist was involved with experimental work for the Anaconda Company which aimed to extract zinc from lead-furnace slags at Tooele, Utah, and which had a successful outcome. In 1927 a slag-treatment plant was designed and built at East Helena in Montana to process slag derived from the American Smelting and Refining Company's lead furnaces; this contained 12-15% of zinc. The plant consisted of three units: the slag-fuming furnace; a system of flues and tubes for cooling the resultant stream of gas and fume; and the fume-collecting filters, comprising 576 woollen bags, each 0.45m in diameter and 9m long and contained within the 'baghouse'. The distinctive feature of this pioneer 'slag-fuming' plant was the liquid state of the slag feed. The technique adopted was to blow a mixture of air and coal through the fluid slag. The fuming vessel itself consisted of a water-jacketed box, rectangular in plan, with a hearth area of 2.4m x 3.6m; into this the fluid slag was poured to a depth of about 0.9 m, giving a charge weight of some 27 tonnes. Above the hearth the vessel was closed by a rectangular water-jacketed canopy provided with a large flue into which regulated quantities of air could be admitted. Along each of the two longer walls of the furnace hearth, 1m above the bottom, was arranged a row of 11 tuyeres through which a mixture of air and powdered coal could be blown into the slag charge. The weight of coal consumed was 20-35% of the slag weight, and blowing was continued for 100-160 minutes, during which time 80-90% of the zinc present would be reduced to elemental form and join the rising gas stream. As the gases escaped from the bath surface they created violent action. When the gases encountered the air in the flue at the top of the vessel, the zinc was converted to oxide, and carbon monoxide and solid carbon particles oxidised. This equipment had a capacity of some 270 tonnes a day of molten slag, according to Alexander Laist (1929).

Zinc elimination from the bath was reasonably brisk once the temperature exceeded 1050-1100°C.

When the zinc content of the fused slag had been lowered to 3%, increasing proportions of injected coal were required to achieve further reduction by fuming. In the 1940s the fume product was stated to contain 70% of zinc and 6-7% of lead (Pure zinc oxide contains 80%, by weight, of zinc). The method could also be used to melt, and treat, cold slag.

Within a short time of the successful start up of the Anaconda Company's fuming plant at East Helena, the Consolidated Mining and Smelting Company of Canada built a plant at Trail, British Columbia, to extract zinc from fluid lead-furnace slag containing 16% of zinc, a working temperature of 1200°C being the aim (Pl. 12). Another installation in North America was made at Kellogg, Idaho, by the Bunker Hill Company in 1943, which intended to treat 300-400 tonnes a day of hot slag. Ingalls in 1945 reported that in the previous year the fuming plants in the USA treated about 0.5×10^6 tonnes of slag, yielding 75,000 tonnes of oxide fume containing over 50,000 tonnes of zinc.

Although the earlier slag-fuming plants processed material derived from lead-smelting furnaces the scope was extended to include slags from copper treatments. At Flin Flon in Manitoba the Hudson Bay Company built a fuming plant in 1951 to recover zinc from the copper reverberatory-furnace slag. Here the fuming furnaces had hearth areas of 2.4m x 6.35m which gave capacity for 70-tonne charges.

In the third quarter of the twentieth century interest in slag fuming continued and several new installations were made. By the late 1950s there were at least eight plants on the American continent alone.

Waelz Treatment (Fig. 30)

In contrast with the treatment of fluid slags, the waelz process (Wälzverfahren) sought to extract zinc by reactions taking place within a charge that remained solid even though the temperature might locally exceed 1250°C. Indeed, the working limit was set by the softening temperature of the charge. It was claimed for the waelz process that the solid material was easier to handle than a fluid, both inside the reaction vessel and as a discharged product, and that it provided a cheap way to treat residues and other granular materials. The waelz process used as reaction vessel a rotating near-horizontal drum or cylinder (Fig. 30).

According to Johannsen (1927), in 1881 George Druyee suggested the use of a rotating tubular furnace for volatilising zinc, and in May 1910 Eduard Dedolph of British Columbia obtained US patent

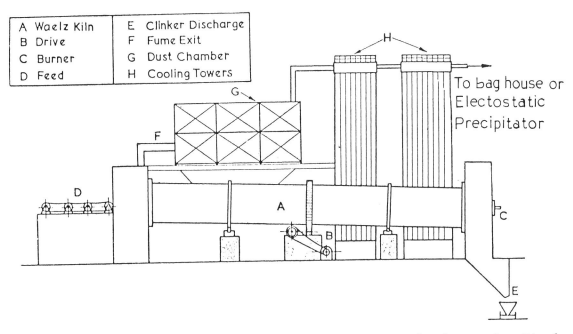

A Waelz Kiln E Clinker Discharge
B Drive F Fume Exit
C Burner G Dust Chamber
D Feed H Cooling Towers

To bag house or Electostatic Precipitator

Fig. 30 Diagram to show arrangement of a waelz plant to extract gaseous zinc from hot granular solid and to collect it as solid particles of zinc oxide, with relatively low thermal demand. (Dennis 1949, 80)

959 924 for 'Extracting lead or zinc as oxide in the form of fume'. Despite the fact that near-horizontal rotating drums had been used as reactors in the chemical and metallurgical industries during the nineteenth century it appears that it was only after the end of the 1914-18 war that further fruitful developments occurred. W.E. Harris in 1936 recorded how Krupp-Grusenwerk of Magdeburg-Buckau instituted research work which led in 1923 to the waelz process, in collaboration with Metallgesellschaft of Frankfurt-on-Main which had been interested in Dedolph's patent. The new technique was the subject of DR (i.e. German) patent 473 016 of December 1923, when F. Johannsen (1948), subsequently professor at Clausthal, was closely associated with the development, having made trials at the Bergakademie in Clausthal in the summer of 1923.

The name 'waelz' (Wälzverfahren) referred to the supposed action of the solid charge, trundling and cascading through the slowly revolving drum. The long cylinder in which the reactions took place had a length of 12-48m with an internal diameter of 1.7-3.5 m, and was mounted on rollers in such a way that there was a fall of 3-4% between one end and the other. The drum, or kiln, a shell of steel plates lined with refractory firebrick, rotated at a peripheral speed of 5.5m per minute (i.e. 0.5-1.5 rpm) so that the solid materials fed in at the slightly-higher end gradually progressed through its length to be discharged at the lower end some 2.5 hours later.

Besides the zinc-bearing material to be treated, the charge contained at least 20% by weight of anthracite coal or coke to provide the reductant and part of the heat supply and, in cases where partly-fused clinker or reactions with the refractory lining were problems, a small proportion of a 'conditioner' such as limestone, quartz or irony mineral as appropriate. Retort residues might already contain sufficient carbon to make a self-burning charge. Unlike most writers on the waelz process, C. W. Morrison (1959) maintained that a definite and critical degree of stickiness within the charge at working temperature was desirable in order to increase the slope of the tumbling heap to close to 40° from the horizontal; the degree of stickiness could be modified by the conditioner. Feeding to the kiln was continuous. At the opposite (discharge) end of the drum a burner injected gas, oil or powdered coal, with air, to generate heat; the combustion gases, with some excess air, were drawn through the drum to leave at the feed end. There was thus a good measure of favourable counter-current flow occurring between the solid charge and the hot gases. One large drum could handle 150 tonnes or more of feed in 24 hours.

Within the high-temperature zone of the rotating cylinder, reducing conditions were created inside the bed of moving granular material and these led to the release of gaseous metallic zinc which joined the stream of other gases. In the space above the bed the climate was oxidising so that a fume of solid zinc-oxide particles resulted, and the endothermic

reduction reaction in the bed was succeeded by the exothermic oxidation process above it, the latter contributing substantially to the overall heat supply. In this way two thirds of the carbon present was consumed, and with careful working the temperature over a major proportion of the drum's length could be maintained at 1100-1150°C. The alternating reducing and oxidising conditions promoted the liberation from the charge of zinc, lead and cadmium values. During the 1950s the waelz method was tried as a way of working up to commercial levels the proportions of germanium contained in residues from zinc treatments.

The gases from the waelz kiln were withdrawn from the charging end and led into ducts by a suction fan. Gas temperature ranged between 500 and 800°C, and long flues were needed to lower the temperature to only 120°C before the gases were filtered through woven-canvas bags in which the oxidised metal fume collected. A large installation would require a 50-hp motor to drive the exhaust fan handling the gases.

Typically, a waelz plant treating a feed of residues from either retorting or leaching, running at 8-30% of zinc, would extract up to 90% of the zinc as oxide fume to leave only 2% of zinc in the solid material discharged. This solid product, leaving the reactor at high temperature, could be cooled by quenching in water. If its contents justified further treatment it could be processed to extract non-volatile metals.

In some instances the primary-kiln oxide product, or the oxide product from slag fuming, was re-processed in a second rotating drum in which the proportion of coke present was limited to only a few percent by weight so that the climate inside the vessel was not strongly reducing. In these conditions, at a temperature of 1200-1260°C, lead oxide would be removed from the charge in gaseous form while the zinc oxide remained relatively unaffected. Thus a fume feed containing 7-10% of lead could be changed to a product with about 1% of contained lead. Lee and Isbell (1959) pointed out that, besides upgrading the zinc content of the material, such re-fuming had a beneficial physical effect in increasing the low bulk density of the fume, perhaps by a factor of four.

Ingalls (1930) reported that at a convention held in Germany the previous year, it was claimed that operating waelz plants were then treating 1×10^6 tonnes of raw materials annually, to account for at least 5% of world zinc production. He observed that such processing was especially useful both for burning zinc out of low-grade silicate ores which were not amenable to concentration by flotation, and for obtaining zinc from distillation residues. In the USA, installations to treat residues had been made at Donora and Palmerton. Harris (1936) noted that between the installation of the first waelz kiln at Luenen in Germany in 1925 and the year 1936 no less than 41 drums were erected at 21 plants, eight of them in Germany, five in the USA, and one in Japan. Their combined capacity was about 1.5×10^6 tonnes, and they were capable of producing 200 000 tonnes of zinc oxide and 25 000 tonnes of lead oxide each year. Almond (1977) described how in Britain a small plant using a single kiln measuring 29.5m by 2.2m was erected in 1930 to treat residues at a nineteenth-century zinc-smelting site at Tindale in East Cumbria. In that instance the aim, unfortunately, was to produce zinc oxide for pigment purposes for which the collected fume proved too dirty. The kiln was heated by an oil burner and it had a rated daily capacity of 100 tonnes of residues plus 20 tonnes of coke breeze. After standing idle from 1931, in 1937 the plant was used by the National Smelting Company of Avonmouth for experiments into the extraction of cadmium from 'sinter rappings'. It was claimed that some 95% of the cadmium in the feed was recovered, but the build-up of accretions inside the drum caused severe damage to the brick lining and consequent plant closure. Such difficulties were fairly common in waelz plant. That particular rotary kiln was later incorporated into an experimental plant at Avonmouth. At Silvermines in Ireland waelz treatment was tried in the 1950s to extract zinc from residues of nineteenth-century mine working. Some later installations have also been made.

ZINC EXTRACTION BY HYDROMETALLURGY AND ELECTROLYSIS

General comments

In the last quarter of the nineteenth century great interest was shown in the application of water-based chemistry for dissolving wanted metals from their crushed ores, i.e. 'leaching'. This was a method used increasingly to extract copper and silver from the residue left after cupriferous pyrite had been employed as a source of sulphur dioxide for making sulphuric acid. Coupled with leaching came interest in the promotion of chemical processes by electricity: during the 1880s and 1890s electrolytic copper refining became important. The extravagant quantities of fuel and labour required to produce zinc

by high-temperature reduction and distillation provided strong incentive for the development of alternative extraction methods.

Some early schemes

Patents were filed in the 1860s relating to techniques for extracting zinc by chemical reactions carried out at 20°C, but it was in the 1880s that serious practical attempts were made to take zinc into aqueous solution by use of dilute sulphuric acid, and subsequently to deposit metallic zinc from the acid solution by electrolysis. Around 1880 Edward A. Parnell of Swansea went a little way towards establishing a successful path by treating calcined zinc ore with weak sulphuric acid to yield an aqueous solution of zinc sulphate. However, Parnell went on to convert his soluble sulphate into insoluble oxide by reaction with powdered blende, a step which left unresolved the problem of forming metallic zinc by an alternative to retorting. In France Léon Létrange in 1881 proposed that sulphide ores be roasted at a low temperature to convert the zinc content into sulphate. The roasted material was then to be treated in weak aqueous sulphuric acid to obtain a solution for electrolysis: not only was zinc to be deposited at one electrode during electrolysis but sulphuric acid was to be liberated for re-use in the process. Although this treatment method proved impractical at the time, 35 years later Létrange's proposal was found to contain all the elements for a successful process.

Activity intensified in the 1890s. At the Silesia-hütte at Lipine in 1893 George Nahnsen electrolysed aqueous zinc sulphate and potassium sulphate, introducing zinc-dust purification and prescribing the degree of solution purity and the current density likely to yield coherent zinc deposits (Ingalls 1903, 1936a). His purpose, however, was to refine by electrolysis solid anodes cast from crude zinc rather than to produce 'new' metal. The cathode product contained 99.93% of zinc and the cell emf was 0.5-1.0 volt. Electrolytic refining of zinc was to remain of extremely limited application. Experimental plants were worked in places as far apart as Duisburg in Germany, Cockle Creek in New South Wales, and Britain. At Hayle in Cornwall, Sherard Cowper Cowles (of the sheradising process for depositing a zinc coating onto other metals), in his search for a deposition process operated a test plant in which aqueous zinc was electrolysed onto aluminium cathodes using lead anodes. Twenty years later this electrode combination was to be adopted in commercial units depositing zinc electrolytically.

In the late 1890s, in a desperate attempt to produce zinc from Australian Broken Hill material, Edgar A. Ashcroft and James Swinburne spent more than £200,000 on an experimental plant at Cockle Creek in New South Wales. Both sulphate and chloride solutions were used in vain efforts to find an economic method. Richard Threlfall witnessed the Australian work and, working for Albright and Wilson at Oldbury near Birmingham in England between 1903 and 1916, he extended it. Starting

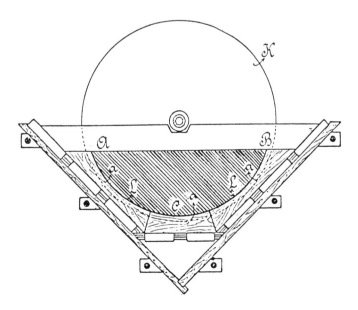

Fig. 31 Transverse section through electrolytic vat for deposition of zinc from aqueous chloride, promoted by Carl Hoepfner in the 1890s. The cathodes (K) were discs of zinc or iron, rotated in the electrolyte, and mounted between stationary carbon anodes. (Guenther 1903, 75)

with galvanisers' refuse ('ash'), Threlfall sought high-purity metallic zinc by electrolysis of fused anhydrous zinc chloride. Threlfall in 1929 explained that the working temperature required was close to 500°C, and as with all techniques involving chlorine gas, containment was a major problem. During 1915-16 an experimental multi-polar cell was kept in continuous production for 15 months with the anode chlorine used to make carbon tetrachloride. This kind of electrolytic cell, an elegant theoretical solution, was many years ahead of its time and doomed to failure by the heavy corrosion caused by the hot chlorine compounds. Successful electrolysis of fused zinc chloride was to remain an unrealised goal, up to the time of writing.

In the only commercially successful application of leaching and electrolysis for zinc before 1913, the metal was obtained as a co-product, or even as a by-product, of chlorine production in Britain and Austria. In Britain two men were closely involved with this method, Dr Carl Hoepfner and Dr Ludwig Mond. It was applied at Brunner Mond and Company's Winnington Works in Cheshire between 1896 and 1924 on a scale of 5-10 tonnes a day. At Winnington zinc ores were first carefully roasted to yield zinc oxide and sulphate; the calcined material was mixed with waste calcium-chloride liquor from Solvay ammonia-soda production and then blown with carbon dioxide gas to give a solution of zinc chloride and a precipitate of calcium carbonate. The aqueous zinc chloride, after purification, was fed to V-shaped wooden electrolysis cells (Fig. 31). The cell anodes were composed of either hard-baked carbon or iron, while the cathodes were discs of zinc which dipped into the electrolyte and constantly moved as they rotated on shafts. The anodes were surrounded by diaphragms of treated cotton canvas to contain the chlorine gas that was liberated, similar weights of chlorine coming from the anodes as zinc at the cathodes. The commercial viability of the process was considered to depend upon the sale of chlorine. At Winnington the gas was used to make bleaching powder, $Ca(OCl)_2$

Associated with Mond in the early years of the Winnington process was Hoepfner who, according to Cohen in 1956, had been hired to recover chlorine from the waste chloride of the works. During 1895-8 Hoepfner supervised a trial of the same technique in Germany, made at the Chemische Fabric's works in Führfurt am Lahn where the raw material was cinder containing about 10% of zinc, derived from Meggen zinciferous pyrite used for making sulphuric acid. Here the zinc was converted to soluble chloride by roasting with sodium chloride.

Some years earlier, in 1888, Hoepfner had proposed a similar scheme to yield copper by electrolysis. However, after his untimely death at Denver, Colorado, in December 1900, the Führfurt production was abandoned. Schnabel and Louis (1907) noted that in Austria, as at Winnington, zinc and bleaching powder were produced from chloride solutions in a Hoepfner-style plant in an alkali works at Hruschau, near Oderberg.

The Great War and Sulphate Systems

The onset of the war in 1914 greatly increased British demands for zinc, while at the same time output from the formerly prolific Belgian smelters was curtailed and no longer available to Britain. While in Britain research into zinc production by electrolysis had been concentrated among chemical manufacturers, in North America investigations were pursued by vitally concerned mining companies and, instead of chloride, aqueous sulphate was the favoured medium. The war brought demand not simply for larger quantities of zinc but for metal of higher purity. Electrolysis could yield metal containing 99.95% and this 'fine' zinc gave brasses with the high ductility desired for making cases for cartridges and shells by deep-drawing. Britain turned to North America for zinc supplies, so giving a powerful stimulus to producers there.

During 1913-14 the Anaconda Copper Company in Montana, USA, and the Consolidated Mining and Smelting Company of Trail in British Columbia both worked at the problem. Following initial success, the Anaconda Company in 1915 built a 35,000 tonnes-a-year plant situated close to hydro-electric power at Great Falls, Montana (later enlarged to 300 tonnes of slab zinc a day). At Trail a plant with a nominal capacity of 9000 tonnes per year (25 tonnes per day) started production in 1916, aided by the government (Fig. 32). The Sullivan ore treated at Trail contained 20% zinc and 14% lead. By 1981, and by using the same basic method, zinc production at Trail had grown to 600 tonnes per day. Mouat (1990) has outlined some of the background to the establishment of the plant at Trail, and its relationship to experiments made c. 1910 by A.G. French.

Australian interests were not slow to join the electrolytic-zinc producers. After experiments in 1917, a first commercial unit, built primarily for treatment of Broken Hill flotation concentrate, entered production in 1918 at Risdon, near Hobart in Tasmania. This used newly-constructed hydro-electric facilities, and the original scale of 10 tonnes a day was soon considerably increased.

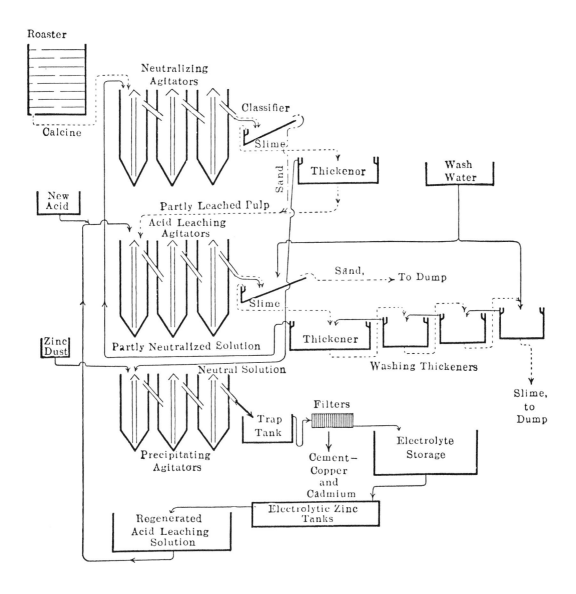

Fig. 32 Idealised flowsheet of early sulphate leach-electrolysis plant for zinc at Trail, British Columbia. (Ralston, 1921, 68)

These three – the Anaconda Company in Montana, the Consolidated Mining and Smelting Company at Trail, and the Electrolytic Zinc Company of Australasia –were the pioneers in the long-term commercial application of the sulphate leach-electrolysis zinc process, and all used the same basic techniques. Frederick Laist was the prime mover at Anaconda, with S.G. Blaylock taking the lead at Trail. Neither of the North American producers had previously been a smelter of zinc. Ingalls (1936a) paid tribute to the boldness of (Sir) Herbert Gepp in establishing the Australasian plant at Risdon, involving a 1,900-km sea journey for Broken Hill concentrate shipped from Port Pirie.

In 1921 Oliver C. Ralston's book *Electrolytic Deposition and Hydrometallurgy of Zinc* was published. Besides giving many details of the various proposals

made, this listed a total of 28 electrolytic-zinc plants which had been in existence at some part of the period 1907-19, although most of these were only experimental and short-lived. In 1927 Ralston briefly reviewed the progress that had been made. Field (1932, 79) noted that in 1929 electrolytic metal accounted for 28% of the 1.4×10^6 tonnes of world zinc production, consuming 1800×10^6 kWh of electrical energy in the process, equivalent to 4,600 kWh (and 16.56 GJ) per tonne.

It became apparent that, compared with a high-temperature distillation plant, one using leaching and electrolysis incurred high capital cost and occupied a large ground area. To show relative economic advantages it needed to be large. Ingalls in 1936 (a) considered that to be competitive in North American conditions an output of at least 20,000 tonnes a year

was required. It was recognised that one economic constraint was the large quantity of electrical energy needed to deposit unit weight of zinc. For zinc electrolysis to be successful, cheap electricity was essential. Most plants depended upon hydro-electric schemes, although in the 1930s three situated in Poland and Germany used coal as their energy source.

Despite the difficulties and the expense inherent in extracting zinc by hydrometallurgy and electrolysis, as the second quarter of the twentieth century progressed the method continued to grow in importance. The trend has continued during the second half of the century. In 1937 the 550,000 tonnes of electrolytic zinc accounted for about one third of the total. Before 1960 the proportion had reached one half. In subsequent years the contribution made by electrolytic metal has expanded in both quantity and proportion. In 1975, for instance, it amounted to 3.8×10^6 tonnes, or 68% of the total (Morgan 1977). The same author gave some comparative figures for the energy and labour required to produce one tonne of zinc: the horizontal-retort process took 1.8 tonnes of coal and 20 man-hours, while leaching and electrolysis demanded 4200-5000 kWh (15.1-18.0 GJ) of energy and 7-8 man-hours.

During the second quarter of the twentieth century leach-electrolysis plants were built in the USA at Kellogg in Idaho and at East St Louis in Illinois. Elsewhere, plants came into production at Flin Flon in Manitoba, Cerro de Pasco situated high in the Peruvian Andes, in Europe and Japan, and at Broken Hill in Northern Rhodesia (now Kabwe in Zambia).

Some Technical Details of the Sulphate System

In common with the high-temperature extraction processes, the first chemical treatment step in the leaching-electrolysis of zinc is roasting, to convert sulphide ore mineral to a mixture of oxide and sulphate. The sulphur dioxide gas evolved during roasting provides a convenient source of the aqueous sulphuric acid with which the product 'calcine' is treated.

To achieve economic production many practical difficulties had to be surmounted. The presence of iron could cause low zinc solubility and also filtration problems; silica could similarly give rise to difficulty with filtration. Rigg, in 1925 commented that the gelatinization of silica was one of the most distressing things met with in the whole range of hydrometallurgy; he had seen entire tanks turned into

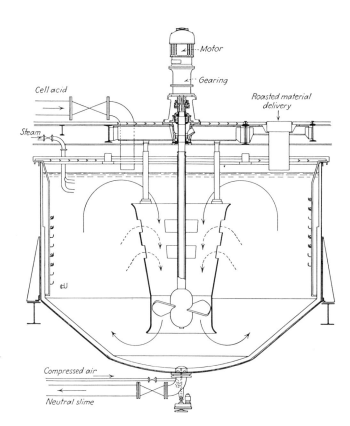

Fig. 33 Zinc-leaching tank of 100m³ capacity, fitted with propeller agitator. Magdeburg, Germany. (Bach 1936, 475)

jelly which had to be dug out with a shovel. Two kinds of agitated tanks used for the leaching step are illustrated in Figure 33 and Plate 13. The presence of many impurities, including chlorine, fluorine and cobalt, caused low electrolytic efficiencies. Other impurities commonly present and requiring removal included copper, cadmium, nickel, arsenic and antimony. Even in the most favourable conditions the electrolytic deposition of zinc from aqueous sulphate was attended by problems and, compared with copper, large quantities of electrical energy were consumed. Figure 34 and Plate 14 show views of typical electrolytic installations. The resultant sheet deposits of solid zinc required to be stripped or 'skinned' (i.e. peeled apart) from the cathode sheets, which were commonly of aluminium, in readiness for melting and casting to slabs for market. The metal product possessed high purity e.g. of 99.97% of zinc, and thus required no further refining.

The kind of technology used during the second quarter of the twentieth century may be illustrated by practice at the Rhodesia Broken Hill Development Company around 1950 when the output was 20,000 tonnes a year or about 60 tonnes of cathode zinc a day. The company had been formed early in the century to exploit deposits containing lead, zinc and

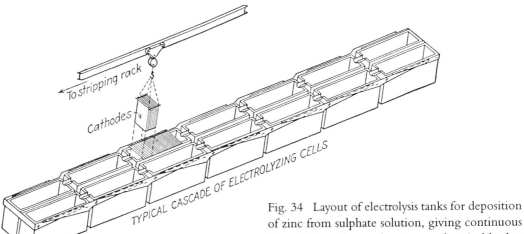

Fig. 34 Layout of electrolysis tanks for deposition of zinc from sulphate solution, giving continuous flow of electrolyte and optimum electrical busbar connections. (Last, Caple and Wever 1945,411)

vanadium. Although some lead was produced, it was not until 1928 that zinc began to be made, using hydrometallurgy coupled with electrolysis. Then the company was a pioneer in the treatment of zinc-silicate ores, which caused difficulties in achieving a separation between solution and residue on account of the soluble silica. The necessary electrical energy was obtained from a specially constructed hydroelectric installation situated at Mulungushi, 40-50km from the mine and treatment works.

The zinc flotation concentrate, containing 55% of zinc and 5% of iron, was oxidised in a four-hearth flash roaster of the Trail pattern to give 100 tonnes daily of product. This material was combined with about the same quantity of weathered dump residues containing more than 20% of zinc, and mixed with 91 m^3 (20,000 gallons) of spent electrolyte fortified by addition of fresh sulphuric acid. The mixing was carried out in one of several cylindrical wooden-stave tanks, lined with lead and acid-resisting bricks and equipped with mechanical impellers and air-lift columns (Pl. 13). The leaching and subsequent purification were done in batches. Other operators, e.g. the Anaconda Company and the Consolidated Mining and Smelting Company, used continuous systems, and some employed a two-stage leaching method intended to minimise the proportions of certain impurities entering solution. After several hours' agitation the acidity of the liquor was adjusted to give a pH of around 5 with consequent precipitation of iron, silica, and other unwanted components. Steam heating was then used to granulate the precipitate so that it could be economically filtered. The resultant zinc-bearing liquor was subjected to several stages of purification, achieved by adding suitable reagents coupled with

filtration to separate the solid reaction products. These steps removed copper from solution by displacement with solid zinc, nickel with sodium arsenite, and chloride ions by a combination of reaction with silver sulphate and cooling. The purified solution, now carrying 130 gl^{-1} of zinc, and only a trace of free acid, entered the electrolytic cell room continuously, where it flowed through a series of rectangular cells (Fig. 34, Pl. 14).

Each electrolytic tank contained two units of 21 lead-plate anodes interleaved with 20 aluminium-sheet cathodes. During electrolysis zinc deposited on the cathodes while sulphuric acid was generated from the anode reaction. Thus the electrolyte leaving the cells carried 30-40 gl^{-1} of zinc and 150 gl^{-1} of free acid. Because the deposition of zinc became unfavourable at high temperatures, lead water-cooling coils occupied part of the volume of each cell in order to maintain an electrolyte temperature of 38-40°C. Every 48 hours the cathodes were lifted from the tanks, transported by overhead hoist to the end of the building, and there stripped of their adherent zinc deposits. While the aluminium cathodes were returned to the electrolytic tanks, the thin sheets of metallic zinc were sent forward to a melting furnace in preparation for casting as slabs (Pl. 15). Heath, in 1960-1, recorded that after 48 hours' electrolysis each cathode carried about 22.7kg of metallic zinc, or 11.3kg as a sheet on each side. The current density used was 280 A m^{-2} and the emf across each cell was close to 3.6 volts. Current efficiency in the late 1950s was 86-87%, the balance of 13-14% representing current expended uselessly. In nearly all electrolytic operations a prime aim is to achieve the highest possible current efficiency.

ONCE...*a laboratory wonder,*

NOW..*consumed
in quantity*

ZINC
99.99⁺% pure

Fig. 35 High-grade slab zinc, the electrolytic product (from a 1930s magazine)

ACKNOWLEDGEMENTS

In compiling this review several libraries have been most helpful, that of the North of England Institute of Mining and Mechanical Engineers in Newcastle-upon-Tyne giving access to its valuable stock, and the library of the University of Teesside (formerly Teesside Polytechnic) in Middlesbrough obtaining numerous items from the British Library at Thorp Arch near Wetherby, Yorkshire. Mr I. D. Allen of Swansea kindly provided the photographs reproduced in Plates 1 and 2.

Editor's note (see p.205 above)

In addition zinc oxide has a very long history of medical usage as a salve and ointment. Pliny speaks of *lauriotis* which was scraped off the flues of lead/silver furnaces where the ore, as at the mines of Laurion itself, were rich in zinc.

In India zinc oxide for medicinal purposes was provided by burning zinc probably from at least the fifth century BC, and the Iranian Abū Dulaf, writing in the ninth century AD, comments on the superiority of the Indian *tutty* or zinc oxide, as it was made by burning their 'tin' rather than from the mineral (see p.30).

SOURCES

Three works contain numerous relevant articles:

Trans. Am. Inst. Mining Metallurgical Engrs. Vol. **121**: *Metallurgy of lead and zinc.* (sponsored by the Rocky Mountain Fund). New York 1936

Trans. Am. Inst. Mining Metallurgical Engrs. Vol. **159**: *Reduction and refining of nonferrous metals.* New York 1944

Zinc: The science of the metal and its alloys and compounds, ed. C.H. Mathewson. New York, Reinhold, 1959; republ. by Hafner, 1970 (Hereunder referred to as *Zinc...*)

Almond, J.K. 1952. A technical report on metallurgy at Broken Hill mine, Northern Rhodesia, prepared for the trustees of the Nuffield Foundation (unpublished typescript).

Almond, J.K. 1977. Zinc production at Tindale Fell, Cumbria. *Jrnl. Hist. Metall. Soc.* **11** 1, 30-8.

Austin, L.S. 1926. *The metallurgy of the common metals...*, Wiley, New York. 1906; 6th edn 1926, 549-79.

Bach, H. *et al.* 1936. The Magdeburg zinc works of the Georg von Giesche's Erben Mining Company. *Trans. AIMME* **121**, 465-81.

Bauerman, H. 1865. *A descriptive catalogue of models in the Museum of Practical Geology*, 177.

Borgnet, G. 1877. Zinc production in Swansea. *Revue Universelle des Mines,* **2** (Nov. and Dec.), 567-634, plates 27-30.

Brenthel, G. 1966. Die Zinkhütte Nordenham (the Nordenham zinc smelter) *Berg-und Hüttenmännischer Tag, Bergakademie Freiberg*, 43-60.

Bray, J.L. 1941. *Non-ferrous production metallurgy.* John Wiley, New York, 352-96.

Bruderlein, E.J. 1936. Manufacture of silicon carbide retorts. *Trans. AIMME* **121**, 441-4.

Bunce, E.H. and Handwerk, E.C. 1936. New Jersey Zinc Company vertical retort process. *Trans. AIMME* **121**, 427-40.

Bunce, E.H. and Haslam, H.M. 1936. Direct-process zinc oxide. *Trans. AIMME* **121**, 678-92.

Bunce, E.H. and Peirce, W.M. 1949. New Jersey Zinc develops a new condenser. *Engng. Mining Jnl.* **150**, no.3 (March), 56-62.

Chadwick, R. 1958. New extraction processes for metals. In *A history of technology.* Vol. 5: The late nineteenth century *c.*1850 to *c.*1900. Singer, C. *et al.* (eds). Clarendon Press, Oxford.

Cocks, E.J. and Walters, B. 1968. *A history of the zinc smelting industry in Great Britain.* George Harrap, London.

Cohen, J.M. 1956. *The life of Ludwig Mond.* Methuen, London. 287-8.

Darlington, G. 1863. On the manufacture of white oxide of zinc direct from the ore. *Mining Smelting Mag.* **3** (June), 335-40.

Dennis, W.H., 1949. Zinc volatilisation. *Mining Mag.* **80** (February), 80-5.

de Sinçay, St P. 1883. On the manufacture of zinc in Belgium. *Proc. Instn. Mech. Engrs.* **3**, 345-61.

Dumas, M. 1847. *Traité de Chimie Appliqué.* Liège, Pls 38-40, pp. 15-17.

Dutrizac, J.E. 1983. The end of horizontal zinc retorting in the US. *Canad. Inst. Mining Bull.* **76**, no.850 (Feb.), 99-101.

Dwight, A.S. 1945. Roasting and sintering. In *Handbook of nonferrous metallurgy.* Vol. 1: *Principles and processes*, ed. D.M. Liddell. McGraw-Hill, New York. 2nd edn., 276-323.

Electrolytic Zinc Company of Australasia Limited. *c.* 1960. *Risdon works Tasmania, description of activities.* Melbourne.

Engineering Mining Journal (editorial) 1915. Zinc smelters' roasting furnaces. *Engng. Mining Jnl.* **99**, no.9, (27 Feb.), 420.

Field, S. 1932. The metallurgy of zinc. *The metal industry,* 15 Jan., 79.

Gaudin, A.M. 1932. *Flotation.* McGraw-Hill, New York.

Gordon, A.R. 1977. Improved use of raw material, human and energy resources in the extraction of zinc. In *Advances in extractive metallurgy 1977*, ed. M.J. Jones. Instn. Mining Metallurgy, 153-60.

Gowland, W. and Bannister, C.O. 1930. *The metallurgy of the non-ferrous metals.* Charles Griffin, 4th edn., 458-507.

Greenwood, W.H. 1875. *A manual of metallurgy. Vol.2: Copper, lead, zinc.* Collins, London.

Guenther, E. 1903. Electrolytic zinc extraction by the Hoepfner process. *Engng. Mining Jnl.* 16 May, 750-2.

Gyles, T.B. 1936. Horizontal retort practice of the National Smelting Company, Limited, Avonmouth, England. *Trans. AIMME* **121**, 418-26.

Halfacre, G.F. and Peirce, W.M. 1959. The vertical retort process. In *Zinc...*, ed. C.H. Mathewson, 252-64

Hanley, H.R. 1933-4. The story of zinc (in four parts). *Jnl. Chem. Edn.* (USA) (Oct.) 600-4, (Nov.) 682-8, (Jan.) 33-9, (Feb.) 111-13.

Harbord, F.W. and Hall, J.W. 1904. *The Metallurgy of Steel.* Charles Griffin, London.

Harlow, F.J. 1918. The new American Spirlet roaster. *Engng. Mining Jnl.* **106** no.7 (17 Aug.), 293-9.

Harris, W.E. 1936. The Waelz process. *Trans. AIMME* **121**, 702-20.

Heath, K.C.G. 1960-1. Mining and metallurgical operations at Rhodesia Broken Hill – past, present and future. *Trans. Instn. Min. Metallurgy* **70**, 681-736.

Hebert, L. 1836. *Engineer's and mechanic's encyclopaedia...* Vol. **2**, 926-8.

Hey, H. 1949. The electrolytic zinc industry. *Proc. Fourth Empire Mining Metall. Congress* **2**, 809-23.

Hofman, H.O. 1922. *Metallurgy of zinc and cadmium,* McGraw-Hill, New York.

Hunt, R. and Rudler, F.W. (eds) 1878. *Ure's dictionary of arts, manufactures, mines.* Vol. **3**. Longman, Green, 7th edn, London, 1187-93.

Hunt, R. (ed.), 1879. *Ure's dictionary of arts, manufactures, mines*. Vol. **4** supplement. Longman, Green, 7th edn, London, 1000-14.

Industrial Chemist. 1947. Production of "Crown Special" zinc. *Industrial Chemist* **23** (Dec.), 806-16.

Ingalls, W.R. 1902. *The production and properties of zinc*. Engng. Mining Jnl., New York.

Ingalls, W.R. 1903. *The metallurgy of zinc and cadmium*. Engng. Mining Jnl., New York.

Ingalls, W.R. 1916. Comments and speculations on the metallurgy of zinc. *Engng. Mining Jnl.*, 7 Oct. 621-6.

Ingalls, W.R. 1930. *Mining Mag.* **43**, 248-51; summary from *The Mineral Industry* **38**, for 1929.

Ingalls, W.R. 1936a. History of the metallurgy of zinc. *Trans. AIMME* **121**, 339-73.

Ingalls, W.R. 1936b. Intermittent zinc distilling from ore. *Trans. AIMME* **121**, 610-35.

Ingalls, W.R. 1945. Pyrometallurgy of zinc. In *Handbook of nonferrous metallurgy*, volume 2, ed. D.M. Liddell. McGraw-Hill, New York. 2nd edn, 444-72.

Johannsen, F. 1927. Die Fortschritte in der Entwicklung des Wälzverfahrens (the advance in the development of the waelz process). *Metall und Erz* 24 no.17, 425

Johannsen, F. 1948. Die Technik des Wälzverfahrens (the technique of the waelz process). *Erzmetall* **1**, 235-9.

Jüptner, H. von (trans.) Nagel, O. 1908. Apparatus for the production of fuel gases. In *Heat energy and fuels.....* McGraw-Hill, New York. 292-301.

Kent, C.H. 1951. The production of high purity zinc at Flin Flon. *Chemistry in Canada* **3**, 11, 31-9.

Laist, A. 1929. Fuming off zinc from lead slags at East Helena. *Engng. Mining Jnl.* **128**, 8 (24 Aug.).

Laist, F. 1929. Modern metallurgical miracles. *Engng. Mining Jnl.* **128** 8, 287-90.

Laist, F., Caples, R.B. and Wever, G.T. 1945. The electrolytic zinc process. In *Handbook of nonferrous metallurgy*. Vol.**2**: ed. D.M. Liddell, McGraw-Hill, New York. 2nd edn, 379-443.

Landis, W.S. 1936. The Trollhättan electrothermic zinc process. *Trans. AIMME* **121**, 573-98.

Lee, H.E. and Isbell, W.T. 1959. Extraction from slag. In *Zinc ...*, ed. C.H. Mathewson, 307-14.

Liddell, D.M. 1945. *Handbook of nonferrous metallurgy*. Vol.**1**: *Principles and processes*; Vol.**2**: *Recovery of the metals*. McCraw-Hill, New York. 2nd edn.

Lones, T.E. 1919. *Zinc and its alloys*. Pitman, London.

McBean, K.D. 1959. Roasting, sintering, calcining and briquetting. In *Zinc ...*, ed. C.H. Mathewson, 136-73.

McNaughton, R.R. 1936. Slag treatment for the recovery of lead and zinc at Trail, British Columbia. *Trans. AIMME* **121**, 721-36.

Mahler, G.T. and Peirce, W.M. 1959. The Sterling process. *Zinc...*, ed. C.H.Mathewson, 265-70.

Mathewson, C.H. 1959. *Zinc: The science and technology of the metal, its alloys and compounds*. Reinhold; republ. Hafner New York. 1970.

Mining and Smelting Magazine. 1862. Calcining furnace for calamine. *Mining Smelting Mag.* **2**, 9-11; based on a drawing in the *Revue Universelle*.

Morgan, S.W.K. 1950. The zinc smelting industry in Great Britain. *Proc. 4th Empire Mining Metall. congress... 1949*, part 2, ed. F. Higham, 784-808.

Morgan, S.W.K. 1959. Recent developments in the zinc industry in Great Britain. *Chem. Industry*, 16 May, 614-20; third Robert Horne memorial lecture.

Morgan, S.W.K. and Woods, S.E. 1971. Application of the blast furnace to zinc smelting. *Metall. Reviews*, **16** 156, 161-74.

Morgan, S.W.K. 1977. *Zinc and its alloys*. Macdonald and Evans, Plymouth.

Morrison, C.W. 1959. The waelz process. *In zinc...*, ed. C.H. Mathewson, 298-306.

Morrow, Bayard S. 1929. Both copper and zinc ores treated by selective flotation in concentrators at Anaconda, Montana. *Engng. Mining. Jnl.* **128**, 8, 295-300.

Mouat, J. 1990. Creating a new staple: capital, technology, and monopoly in British Columbia's resource sector, 1901-1925. *Jnl. Canadian Histor. Assocn.*, new series **1**, 215-37.

Najarian, H.K. 1944. Weaton-Najarian vacuum condenser. *Trans. AIMME* **159**, 161-75.

Parnell, E.A. 1880. A new process for the metallurgic treatment of complex ores containing zinc. *Iron*, **16**, 474; account of paper read at British Assocn. Swansea meeting, 1880.

Peirce, W.M. and Waring, R.K. 1936. New Jersey Zinc Company process for the refining of zinc by redistillation. *Trans. AIMME* **121**, 445-52.

Percy, J. 1861. *Metallurgy and fuels; fire-clays; copper; zinc*. John Murray, London.

Phillips, J.A. and Bauerman, H. 1887. Elements of metallurgy. A practical treatise on the art of extracting metals from their ores. Charles Griffin, London. 2nd edn.

Phillips, K.A. 1959. Horizontal retort practice. In *Zinc ...*, ed. C.H. Mathewson, 225-51.

Pickard, T.R. 1935. Recovery of zinc and vanadium at the Rhodesia Broken Hill plant. *Engng. Mining Jnl.* **136** 10, 489-93.

Power, F.D. 1903. Merton's calcining furnace. *Engng. Mining Jnl.* 21 Nov., 775-6.

Primrose, J.S.G. 1910. Fume filtration for production of pure spelter. *Engng. Mining Jnl.* 27 Aug., 415-18.

Prost, E. 1912. *Metallurgie des metaux autres que le fer*. Paris and Liège, Librairie Polytechnique Ch. Béranger.

Ralston, O.C. 1921. *Electrolytic deposition and hydrometallurgy of zinc*, McGraw-Hill, New York.

Ralston, O.C. 1927. Twenty-five years' progress of electrolytic zinc. *Trans. Amer. electrochem. Soc.* **51**, 129-38.

Ralston, O.C. 1961. *Electrostatic separation of mixed granular solids*. Elsevier, London.

Rambush, N.E. 1923. *Modern gas producers*. Benn Brothers, London.

Read, T.A., Thomas, C.W. and Parsons, K.P.W. 1961. The development of flotation for the treatment of lead-silver-zinc ores at Broken Hill, New South Wales, Australia. *Quarterly Colorado School Mines* **56**, no. 3, part 2, 419-42.

Reid, F.W. 1913. Zinc smelting at the Broken Hill Proprietary Company's works, Port Pirie, South Australia. *Mining Engng. Rev.* (Melbourne), 6 October, 7-12.

Richards, A.W. 1969. Zinc extraction metallurgy in the UK. *Chem in Britain* **5**, no. 5, 203-6.

Richards, J.W. 1908. *Metallurgical calculations*, part 3. McGraw Hill, New York, 595-7.

Ridge, H.M. 1917. The utilisation of the sulphur contents of zinc ore. *Jnl. Soc. Chem Industry* **36**, 13, 676-85.

Rigg, G. 1916. Notes on spelter plant and practice. Unsigned typescript report in the possession of the author of this review.

Rigg, G. 1925. Possible improvements in metallurgical practice relating particularly to the zinc industry. *Trans. Instn. Mining Metallurgy* **35**, 3-38.

Robinson, L.B. 1937. The British zinc and cadmium industry; developments in smelting practice. *Metal Industry (London)*, 15 Jan., 111-13.

Robson, S. 1929. The roasting of zinc concentrates in Great Britain. *Soc. Chem. Industry Chem. Engng. Gp. Proc.* **11**, 58-71.

Robson, S. 1950. Refining of zinc. In *The refining of non-ferrous metals proceedings of symposium … 1949* Instn. Mining Metallurgy, 327-46.

Schmitz, C.J. 1979. *World non-ferrous metal production and prices, 1700 - 1976*. Frank Cass, London.

Schnabel, C. (trans. Louis, H.) 1907. *Handbook of metallurgy*. Vol. **2**. Macmillan, 2nd edn. London.

Scoffern, J., Truran, W., *et al.* 1861. *The useful metals and their alloys*. Houlston and Wright, London.

Smith, E.A. 1918. *Zinc and its alloys*. Longman Green, London.

Temple, D.A. 1986. Zinc - from mine to market: Some views on the industry. *Trans. Instn. Mining Metallurgy* **95**, A33-40.

Threlfall, R. 1929. The electrolysis of molten zinc chloride. *Jnl. Soc. Chem. Industry,* 26 July, 210T-223T.

Truscott, S.J. 1923. *A textbook of ore dressing*. Macmillan, London.

Walker, E. 1907. The zinc smelting works of Swansea, Wales. *Engng. Mining Jnl.* **84**, 161-3.

Weaton, G.F. 1959. The electrothermic process of the St Joseph Lead Company. In *Zinc …*, ed. C.H. Mathewson, 270-86.

Young, A.B. and McKenna, W.J. 1929. Selective flotation of lead-zinc ores at Tooele, Utah. *Engng Mining Jnl.* **128** 8, 291-300.

Zentner, Arthur, 1936. World survey of electrolytic zinc. *Trans. AIMME* **121**, 453-64.

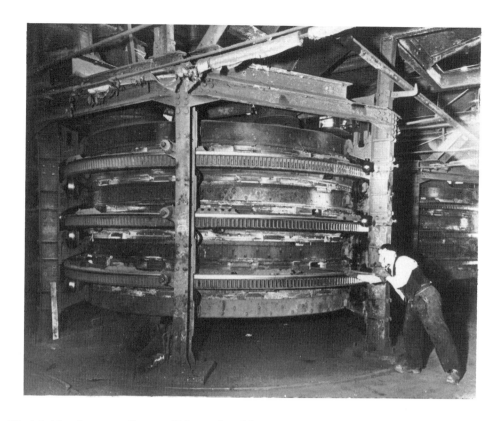

Plate 1 Modified Spirlet furnace at Swansea Vale works of the National Smelting Company, South Wales. (Courtesy of D.I. Allen)

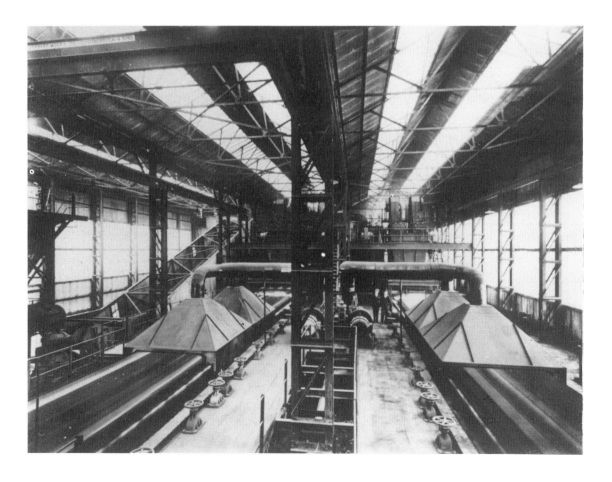

Plate 2 Travelling-grate sintering equipment of the National Smelting Company, Britain. (Courtesy of D.I. Allen)

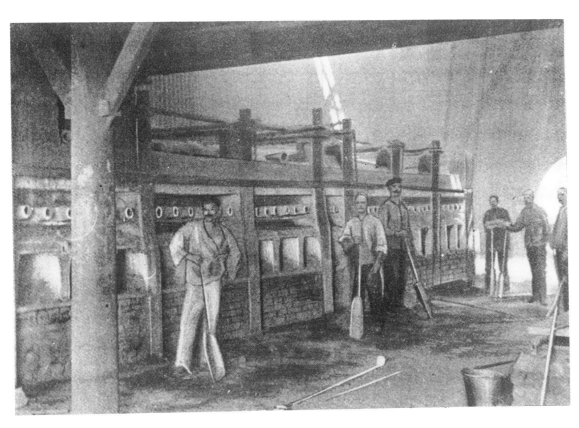

Plate 3 Illustration of a distillation furnace at a Swansea works captioned 'charging the retorts' and showing some of the tools used. The upper row has condensers in place. Compare with Plate 4. (Walker 1907)

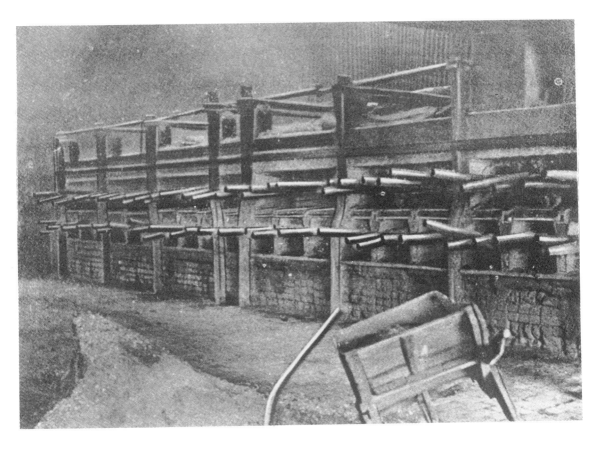

Plate 4 Double row of retorts at Swansea immediately after charging, apparently with prolongs attached to the condensers. (Walker 1907)

Plate 5 New Jersey continuous process: partly-completed vertical retort in furnace setting (Bunce and Handwerk 1936)

Plate 6 Charging continuous vertical retorts at Avonmouth with coked briquettes (*Industrial Chemist*, 1947, 813)

Plate 7 Mid-nineteenth century Belgian zinc-distillation furnace (model). Forty cylindrical retorts were arranged in several horizontal rows inside the chamber, which had a semi-cylindrical roof and a fireplace below. The flame, after heating the retorts, passed through a smaller chamber in which new clay tubes were 'baked' preparatory to use. (Bauermann 1865; photograph: Science Museum neg. 21,461)

Plate 8 Horizontal-distillation plant of the Cherokee-Lanyon Spelter Company at Pittsburgh, USA, on the Kansas-Missouri border, before 1901. This was one of several plants fuelled by natural gas which had their heyday around 1900 (Ingalls 1902).

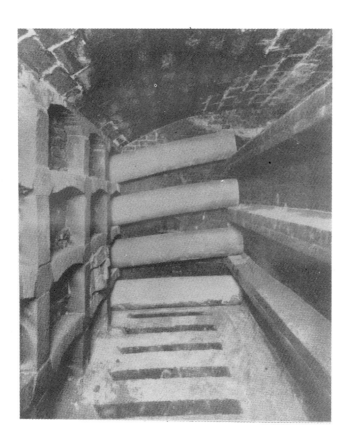

Plate 9 Interior of one side of a Rhenish furnace, showing some retorts in position. This furnace had four rows of 48 retorts on each of its two sides, giving a total of 384 retorts; it yielded about 12 tonnes of metal per day (Gyles 1936).

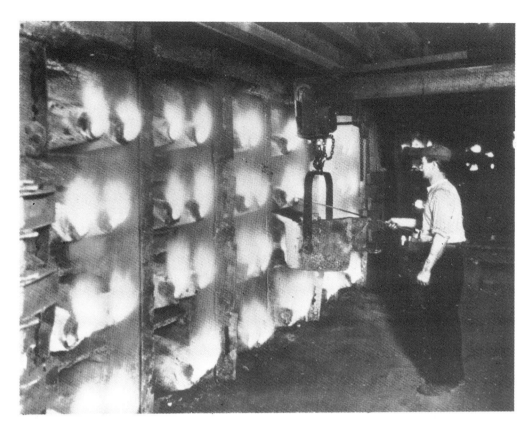

Plate 10 Horizontal-distillation equipment in action at Avonmouth, Britain, with tapping of liquid zinc from the condensers in progress (Robinson 1937, 111)

Plate 11 View of refluxing columns for refining zinc, with intermediate condenser for the zinc-cadmium fraction from the 'lead' column. See Fig. 28. (Peirce and Waring 1936, 450)

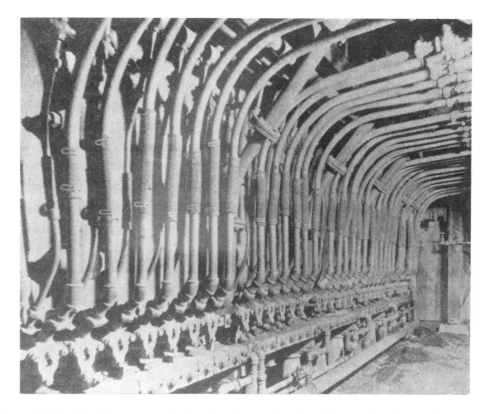

Plate 12 Line of 35 double-inlet tuyeres feeding air and powdered coal into a slag-fuming furnace at Trail, British Columbia, to recover zinc as oxide (McNaughton 1936, 723)

Plate 13 Four brick-lined leaching tanks for dissolving zinc in dilute sulphuric acid. Each tank had a capacity of $90m^3$ and was fitted with a launder to collect overflow. Rhodesia Broken Hill Development Company, 1951 (Almond 1952)

Plate 14 Groups of cathodes and anodes raised from an electrolytic cell. The aluminium-sheet cathodes (suspended in foreground) would be stripped of their deposited zinc coating every 48 hours. Lead pipes were connected to coils immersed in tanks to carry cooling water. Rhodesia Broken Hill Development Company, 1951 (Almond 1952)

Plate 15 Casting Sablon-brand zinc slabs at Rhodesia Broken Hill Development Company (Almond 1952)

DEVELOPMENT OF THE ZINC-LEAD BLAST-FURNACE AS A RESEARCH PROJECT

S.W.K. Morgan

Bristol, England (formerly Imperial Smelting Processes Ltd., Avonmouth, Bristol, England)

SYNOPSIS

The zinc-lead blast-furnace was developed at the Avonmouth plant of the Imperial Smelting Corporation. Although small-scale work in 1943 had shown the possibility that liquid zinc could be condensed from exit gases from a shaft furnace, by the use of molten lead as a shock chilling agent, intensive work on the project did not begin until 1947 when a pilot furnace with a nominal productive capacity of 2 tons per day zinc was built. In 1950 a furnace that, so it was hoped, would produce 20 tons per day zinc was built and began operation, and in 1952 a slightly larger unit followed. These were intended to be the first commercial units and the existing horizontal retort capacity was shut down. Production, however, was still plagued by a number of basic problems and an intensive period of development work was necessary to solve them. By 1960 it was considered that sufficient success had been attained, and a furnace that had a shaft area of 17.2 m^2 and a nominal production capacity of 53,000 tons per year zinc and 12,000 tons per year lead was erected at the Swansea Vale works of the company. The operation of this furnace was sufficiently successful to justify its adoption as a prototype for the 13 other units that have been built. By 1980 these units had produced together more than 10,000,000 tons of zinc and 5,000,000 tons of lead.

An outline is presented of the course of the work and how the main problems were overcome. The problems were made more difficult by the fact that much of the development had to be carried out on production furnaces that were struggling to reach an economic level of operation. Success was achieved because of the existence at Avonmouth of a number of favourable factors: a first-class research team with experts in all relevant disciplines; close and continuous liaison with an excellent engineering department that could design and build rapidly the various modifications as plant trials showed them to be necessary; an operating staff that was usually prepared to accept innovation and interruption; and a Board that throughout the development controlled the company with vision and tenacity.

The operation of the zinc blast-furnace has been described in a considerable number of publications and the development work that led up to its commercial acceptance has also been reported in some detail (Cocks and Walters 1968, Temple 1980). An attempt is made here to consider the work as a major research project in the field of extractive metallurgy and to point out where errors were made and delays caused, so that others who attempt similar developments may perhaps be assisted.

EARLY HISTORY OF ZINC DEVELOPMENT AT AVONMOUTH

Of relevance to the development of the zinc blast-furnace project were the economic state and objectives of the National Smelting Company (which operated the Avonmouth plant when the work began) since throughout the long gestation period before success was achieved, the research work was financed entirely by grants from a sometimes reluctant Board.

Before the first world war the zinc industry in the United Kingdom consisted of some eight small works that operated the horizontal retort process in a relatively inefficient way and compared unfavourably with the larger, more modern works in continental Europe and the USA. In 1913 the total annual zinc production in the country was of the order of only 50,000 tons (imports were approximately 145,000 tons). In 1917 the National Smelting Company was formed under Tilden Smith with the object of stimulating the industry so that the country would become less dependent on imports, and could use the output of zinc concentrates from the Australian Broken Hill field, which the British Government has agreed to purchase for the duration of the war and for ten years after.

The company secured land alongside the Ministry of Munitions mustard gas and oleum plant at Avonmouth and work was started on an ambitious scheme to build 24 furnaces with a design capacity of 70,000 tons per year zinc and 100,000 tons per year of 98% sulphuric acid. Little more than the foundations for this plant had been completed before the war ended and work on the site ceased. The company had received a grant of £500,000 from the Government to complete the plant, but there appears to have been some difficulty in accounting for the expenditure of all of this money, and questions were asked in the House of Commons.

In 1923, with an entirely new Board under the chairmanship of the Australian, W.S. Robinson (to whom the British zinc industry is considerably indebted), rebuilding work began in earnest. Two hand-rabbled Delplace roasting furnaces were built and commissioned, and four of the horizontal retort furnaces that had been designed by the original company in 1917 were completed, but, as a consequence of the coal strike in 1926 and the depression that followed, these were not operated until 1929.

The company was forced reluctantly to use the horizontal retort process (Robson 1933, Gyles 1936). In 1923 this process, which had been developed in Belgium at the beginning of the nineteenth century, was still the only established method of zinc production. The electrolytic process, which had begun commercial life in the first world war, was still suffering acute teething troubles and it demanded large quantities of cheap power, which this country could not provide.

As a consequence of the British Government's rather extraordinary commitment to buy annually a large proportion of the zinc concentrates from the Broken Hill field until ten years after the war (which it had undertaken in 1916 at the instigation of W.S. Robinson and W.M. Hughes, Prime Minister of Australia), the feed to the proposed new horizontal retort plant at Avonmouth had to consist largely of Australian concentrates. This was a considerable disadvantage in that the concentrates had a high iron content (9-10%), which tended to cause severe corrosion in the retorts.

Forced to use the retort process, the Board was convinced from the outset that two major problems required solution. To improve heat transfer and general distillation conditions, it was essential that the retorts be charged with more granular roasted oxide than the Delplace furnaces could provide and some form of sintering had to be developed. The other major problem to be solved was application of the contact sulphuric acid process to the treatment of the gases containing sulphur dioxide, that were evolved from the sintering machine. In the zinc industry until then only chamber process plants had been used, but they could produce only weak (70% H_2SO_4) acid. General belief held that the high content of impurities (mainly arsenic) in zinc roaster gas precluded the use of the contact process. To solve these two problems the Board engaged Gilbert Rigg to design a sintering plant on the basis of experience that he had gained in Australia and also Stanley Robson, who had been employed on the acid plant

of British Dyestuffs, Ltd, where he had installed two of the newly developed Lodge Cottrell electrostatic precipitators for gas purification.

After difficulties had been overcome these two problems were solved. Mechanically operated furnaces were installed to reduce the sulphur content of the blende (and, therefore, the heat load to the sintering machines) from 30% to 8%, and the Delplace furnaces were closed. Two sintering machines had also been installed to complete the roasting operation and early in 1929 four of the distillation furnaces were at last started up, thereby providing a total metal production of approximately 40 tons per day, even though the depressed economic conditions were almost at their worst -for a few days before the end of 1929 the price of zinc dropped below £10 per ton.

Although the Board had attained its first objectives and the Avonmouth plant -and, also, the associated unit at Swansea Vale - was producing zinc, probably in as efficient a way as any other zinc plant in the world, there was widespread dissatisfaction with the horizontal process, primarily because of the arduous and skilled work demanded of the furnace men.

Between 1926 and 1929 the Board spent money in attempts to develop processes that offered some hope as alternatives to the horizontal retort process. In Germany claims were made for a furnace known as the Remy-Roitzheim (Liebig 1916), the retorts of which were constructed of large, oval clay sections placed one upon the other. A series of baffles in the centre of the retort provided access to a rectangular tank condenser. It was claimed that zinc could be distilled from a charge of roasted ore and coke fed continuously down the retort. A Remy-Roitzheim unit was erected at the company's expense at Avonmouth, but it was a complete failure. The retorts were made of clay and were built up of oval sections approximately 1.5m long x 0.5m wide x 0.5m high. The wall thickness was 10 cm. The heat conductivity of both retort wall and charge was so poor that to obtain economic rates of production it was necessary to apply high temperatures, which the retorts could not stand, and wholesale collapse occurred.

The second attempt in this period to develop a new process was more ambitious (and more costly). A unit that operated by what was known as the Lacell process -after the chemist who designed and operated the plant - was built. The process proposed was revolutionary in that it involved the direct chlorination of dried blende at a temperature of about 350° C. Molten zinc chloride was formed, and

elemental sulphur volatilized and condensed. After purification the zinc chloride was electrolysed in the molten state in electrolytic cells, the electrodes of which were formed of graphite cones separated by silica spacers. At the temperature of cell operation, 450°C, the zinc that formed was molten and could be removed from the cells. Chlorine was produced stoichiometrically, and it was hoped that this would be recycled to chlorinate a fresh batch of blende. The concept was elegant, elemental zinc and sulphur being produced from the incoming blende in one operation. In practice the process failed comprehensively, the main reason being that although zinc was produced, the electrode assemblies in the cells collapsed rapidly. The cause of this was thought to be that it was not possible to produce oxygen-free zinc chloride melts and that the oxygen that was liberated at the anodes during electrolysis attacked the graphite of which the electrodes were composed.

By 1929 the New Jersey Zinc Company, after an extraordinary period of development work, had solved most of the problems of the vertical retort process and had production units operating successfully at Palmerton in Pennsylvania (Bunce and Handwerk 1936). Having sent a team to study this process, the Board entered into a license agreement with the New Jersey Zinc Company and built at Avonmouth a 16-retort plant that was to be capable of producing 50 tons of zinc per day. This plant came on line in 1933 and supplied a substantial proportion of the company's output of zinc for the next 30 years.

By 1929, therefore, in spite of severe economic difficulties, the new company had established zinc production at Avonmouth and had also modernized its Swansea Vale plant, but there seemed little possibility of overcoming the limitations of the already venerable horizontal process. Although the vertical retort process offered the hope of some improvement, since it did not require such heavy physical work under hot conditions, its fuel costs were high, as were maintenance and capital charges. Notwithstanding the failure of the two attempts to develop a new method, the company continued to maintain a belief in the value of development work - a belief then not widespread in British industry - and in 1929 a research department was formed at Avonmouth under P. Stacey Lewis, a biochemist. Later in the same year the present writer joined the department to form a metallurgical section. The annual budget of the newly fledged department, which also included a section for the study of

sulphuric acid, was limited for the first few years of its existence to £6,000. Nevertheless, conditions were auspicious in that the Board of the company was determined to build an efficient zinc industry in the United Kingdom, and had a vague belief in the value of research -though this belief faltered more than once in the difficult years that followed.

ZINC BLAST-FURNACE - EARLY HISTORY AT AVONMOUTH

Before the 1930s, when serious consideration was first given to the possibility of developing at Avonmouth a radically new process for zinc production, several attempts had been made elsewhere to produce the metal in a blast-furnace. All had failed through inability to produce from the vapours that left the furnace anything other than a blue powder so oxidized by the reverse reaction, $Zn + CO_2 \rightleftharpoons ZnO + CO$, that it was unusable. In 1930 Maier published the first thermodynamic study of zinc oxide reduction (Maier 1930) which was a major contribution to metallurgical knowledge. He gave no encouragement, however, to the belief that blast-furnace production of zinc was possible. By implication he claimed that it was not feasible to condense liquid zinc from the gases leaving the top of the furnace. To produce liquid metal from the bottom of the furnace demanded the use of pressures far beyond the limits of practical possibility. In experimental work to determine the activity of zinc oxide Maier used molten tin to absorb zinc vapour. The significance of this was not appreciated at Avonmouth at the time.

A further adverse opinion regarding the possibility of shaft furnace production came from Professor M.W. Travers. Travers had worked with Ramsay when the rare gases were discovered and had himself isolated neon. He was a consultant to the company and in 1932 was asked by Robson, then the works director, to study the possibility of blast-furnace production of zinc. In a report dated 21 October, 1932, he concluded 'I have thought of the problem from all angles and do not see anything in it'. From the evidence then available most people would have come to the same conclusion.

Nevertheless, despite the many previous failures to produce zinc in a blast-furnace and the general view in the industry and among the pundits that it was impossible to do so, the research department at Avonmouth, where a certain amount of irreverence existed, returned periodically to an examinations of

the problem. The potential advantages were considerable. If feasible, the method would offer the benefits of large-scale production and the possibility of continuous operation with improved fuel economy. No direct experimental work, however, was carried out at that time.

Some significant evidence that the reaction $Zn + CO_2 \rightleftharpoons ZnO + CO$ in the cooling of blast-furnace gases might be circumvented was obtained in 1935. Robson, who was a prolific source of projects for development work, suggested that sintered zinc ore, which was then a relatively new product in the industry, might make an improved charge for the production of pigmentary zinc oxide on Wetherell grates. This was a process that had been developed in the USA (Mathewson 1959) and in which the furnaces consisted essentially of moving pallets on the chain-grate principle. A mixture of roasted zinc ore and anthracite was fed on to the pallets and ignited, and air was blown through the bed from below. The zinc oxide was reduced in the charge and zinc vapour formed, which was volatilized and then reoxidised immediately by air above the bed.

To examine whether sintered blende would be superior to the hearth-roasted material previously used, a small experimental unit was built, but the results were not promising in that the oxide that was produced tended to be grey in colour. This was found to be due largely to the presence of metallic zinc. During examination of the problem the secondary air that was added above the bed was deliberately reduced, and it was found that under these conditions the metallic zinc content of the oxide could be considerably increased - at one time beads of zinc metal were recovered from the flue.

The optimism that this observation inspired was reinforced in 1937 during a visit to the Vieille-Montagne plant at Baelen to examine the operation of a shaft furnace that had been built there to produce zinc oxide from electrolytic plant residues. Although air was added to the gases after they had left the furnace to burn them deliberately, it had been found necessary also to add some steam inside the furnace to prevent the formation of accretions that were partially cemented together by lumps of metallic zinc. Further encouragement was derived from the fact that slags with high iron contents could be run from the furnace bottom, where there was relatively little zinc, without the formation of metallic iron.

In spite of this practical evidence in support of the view that blast-furnace production of zinc was not necessarily impossible, no experimental work was carried out until 1942. In pre-war Germany the Thede furnace had been developed, which consisted of a closed drum made of carborundum that could be rotated while being heated externally. Claims were made that zinc dust could be melted in this furnace and a high yield to molten metallic zinc obtained. The decision was taken to perform some preliminary tests in which the shaft-furnace principle would be applied and zinc dust would be deliberately produced in the hope that it could be converted into liquid metal in a subsequent stage by use of a furnace similar to the Thede.

In was obviously essential to minimize the reoxidation of zinc vapour in the exit gases from the furnace to produce the highest possible grade of dust. To cool the gases rapidly after they left the furnace a condenser was constructed that was water-jacketed and contained pipes carrying water on which the gases could impinge (Fig. 1).

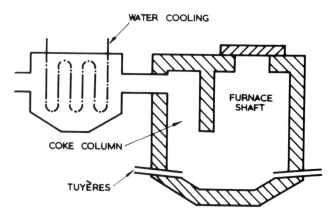

Fig. 1 Water-cooled condenser: 1942 first attempt

It was also considered essential that the gases leaving the furnace should have a sufficient CO/CO_2 ratio to allow some leeway before reoxidation began on cooling, according to the reaction $Zn + CO_2 = ZnO + CO$. For this there were thought to be two requirements: that the gas should be withdrawn below the level of the charge and that it should then pass through a coke column before leaving the furnace. These beliefs were erroneous, but they were firmly held at the time and the complication in furnace construction that they caused dogged much of the early experimental work.

The work at that time was unofficial and not blessed with a grant from the research budget. The equipment was, therefore, built within the department almost entirely from scrap material. The furnace was 'blown' for a few hours at a time, and some zinc dust of reasonable quality was obtained.

Before melting tests could be carried out, however, L.J. Derham put forward the lead chilling suggestion - which opened up entirely new possibilities.

LEAD SPLASH CONDENSER

Derham proposed as a replacement for the water-cooled condenser, which was obviously inefficient, that the gases leaving the furnace (at a temperature of about 900°C) should be quenched by a spray of molten lead droplets (c. 450°C). The cooling effect on the gases would be so rapid that there would be little opportunity for reoxidation. As the temperature of the gases dropped rapidly below the dew-point molten zinc would be formed that would dissolve in the molten lead. This zinc could be recovered by withdrawing some of the lead and cooling it, outside the condenser, to a temperature just above the melting point of zinc (419°C).

The suggestion was so brilliant that testing was begun at once. The water-cooled condenser was replaced by a tank that could hold a layer of molten lead. At the exit end of the tank a horizontal paddle wheel was fitted, which would be rotated from outside the tank to throw a spray of molten lead into the path of the gases as they entered (Fig. 2). Since money was not available to provide a mechanical drive for the wheel, it was rotated by hand.

Immediately, a remarkable vindication of the principle was obtained. When the furnace was on blast with no rotation of the paddle the gases burnt at the stack with a dense zinc flame, forming copious clouds of zinc oxide. As soon as rotation was started and the lead spray formed the flame of the stack gases became almost colourless and metallic zinc began to build up in the condenser lead. In the writers experience no other experimental work has been so convincing or exciting.

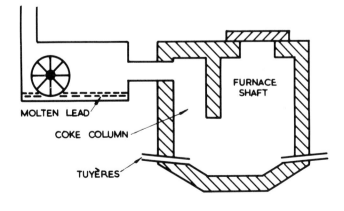

Fig. 2 First lead splash condenser: 1947 second attempt

ORIGINS OF LEAD SPLASH CONCEPTION

The use of shock chilling to avoid reoxidation was not new. Immediately before the war, in an attempt to augment the country's production of magnesium metal, the Magnesium Metal Corporation had been created to operate the process recently developed in Radenthein in Austria. That company had been formed jointly by the National Smelting Company and the British Aluminium Company, and it had taken over a site in Swansea. E.C.R. Spooner was works manager.

In the Radenthein or Hansgirg process magnesium oxide was reduced by carbon in an arc furnace. The gases that left the furnace, which were at a temperature of 1800°C, were immediately quenched by jets of cold hydrogen. The cold mixture of gases, consisting of a preponderance of hydrogen and a small proportion of carbon monoxide and very finely divided magnesium metal dust, was passed through a cyclone, where the magnesium dust was collected. In theory, the carbon monoxide was then to be removed chemically and the hydrogen recirculated through the quenching sprays.

The process was ill-fated and the plant was soon shut down. Metallic dust was made and some ingot cast, but the dust was extremely fine and pyrophoric. Mixed, as it was, with a large volume of hydrogen, it was lethal. A number of fatal explosions occurred, the last of which killed six men. A brief account of the process had been given by T.A. Duncan, in the preface to his review of a later adaptation at Permanente (Duncan 1944). The research department at Avonmouth was, fortunately, not involved in the operation - though it did have a contract from the Magnesium Metal Corporation to develop a process for the extraction of magnesium oxide from sea water. Nevertheless, research workers from Avonmouth visited the plant and were interested in the success of the shock chilling operation.

Another type of condenser, of which Avonmouth researchers were well aware, was that which had been developed by the St. Joseph Lead Company at Monaca, Pennsylvania, and was fitted to its electrothermally heated retorts (Najarian 1944). The gases leaving each retort were sucked through a tube that was filled with molten zinc and the zinc vapour in the gases were cooled and absorbed, the efficiency of condensation and collection being quite high. A suction of about 0.5 atmospheres was required, however, and the power consumption of the vacuum pumps was considerable. Since the gases were

produced under retort conditions with a zinc content of some 45%, the volume to be handled per unit of zinc was much less than that of a blast-furnace gas, the zinc content of which was expected to be 6-8%. It was obvious, therefore, that the St. Joseph condenser would not be applicable to blast-furnace practice, but it did demonstrate that zinc vapour could be condensed and absorbed in liquid metal. As was previously mentioned, Maier had realized this prior to 1930 and had used molten tin for the purpose.

The efficiency of shock chilling in restricting the back reaction and, also, the value of molten metals in the condensation and absorption of zinc were, therefore, already known in the research department at Avonmouth. The brilliance of Derham's suggestion lay in his choice of molten lead as the shock chilling medium.

Lead was almost ideal for the purpose. It could be readily handled in steel, with the result that steel rotors could be used to produce the spray inside the condenser and steel pumps could be used to circulate it through an external cooling system. Even more important was that while it chilled the vapours inside the condenser its own temperature rose and it dissolved the zinc as it formed. The hot lead could be withdrawn from the condenser and passed through an external cooling system (later, water-cooled launders). The zinc as it cooled became less soluble and separated as a liquid phase on top of the molten lead. The zinc could be removed and the cooled lead, by then stripped of some of its zinc, could be returned to the condenser to repeat the shock chilling effect. A continuous process was thus possible.

DEVELOPMENT OF THE PROCESS

The crude tests carried out in 1943 had shown that much of the zinc vapour in the gases from a zinc blast-furnace could be safely condensed to liquid metal by shock chilling with a spray of molten lead droplets: what was undoubtedly the main obstacle to the development of a blast-furnace process seemed, therefore, to have been overcome. Unknown was the number of other difficulties that would require solution before a fully comprehensive operating process could be developed. A series of pilot-plant trials with more sophisticated equipment was required to examine and solve these problems.

Owing to other pressures little further work was carried out on the process until the end of the war,

but in 1946 the design was commenced of the 'Experimental Blast Furnace' (EBF) with a nominal capacity of 2 tons per day zinc. The furnace was to be rectangular in section and have measurements of $0.7 m^2$ internal area by 4m in height. It would be fitted with two tuyeres at the bottom, through which air, heated to 450°C in a tubular preheater, could be blown. A mechanical hoist was to be used to elevate the charge - which consisted of lump sintered blende together with coke that had been preheated in an internally fired shaft - and it was fed through a manually operated bell. At first, the gases were withdrawn half way up the furnace, passed through a column of hot coke of the column into a condenser, which consisted of a rectangular chamber fitted with a horizontal paddle wheel that was partially immersed in a pool of molten lead. When the wheel was rotated a shower of lead droplets was formed through which the gases leaving the furnace had to pass. If the indications from the earlier work were confirmed, this spray would chill the gases and condense and dissolve the contained zinc. A vessel that was fitted with air-cooling apparatus through which lead drawn from the pool could be circulated and cooled was built alongside the condenser. As it cooled molten zinc floated out of solution and could be removed from the top of the lead. The cooled lead was then returned to the condenser. The furnace was completed by mid-1947 and operations commenced, though it was several years before it reached the target production of 2 tons per day.

The project was complex and expensive from the start. Each shift had to be manned by ten operators and controlled by technical staff. Almost every part of the equipment gave trouble. Stoppages were frequent and progress was slow, but, even in the first days of operation, metallic zinc was made and it seemed that the basic principles were sound. What was in question was whether the many operating difficulties could be overcome and a process that was capable of commercial operation evolved.

ORGANIZATION OF THE WORK

From the start it was realized that to solve the many problems a first-class team of metallurgists, physical chemists and chemical engineers had to be established so that all relevant disciplines could be used. Whereas full use of the principles of physical chemistry and, particularly, of thermodynamics had already been made in the steel industry, Avonmouth, under the guidance of S.E. Woods and J. Lumsden, can claim

to be among the first to apply them rigorously in non-ferrous extraction metallurgy. The work also broke new ground in the application of the principles of chemical engineering (which had been developed mainly in the oil industry) to the reactions at the much higher temperatures that were involved in zinc smelting. Invaluable contributions were made by chemical engineers particularly in the design of rotors to create the lead spray in the condensers, the condenser design itself and, also, that of tuyeres and cooling jackets. Further valuable contributions were made by members of the team who did not have formal qualifications.

The project was fortunate in that to put the design of the plant and the many modifications into effect a section of the chief engineer's department, under B.G. Perry and A.A. Clark, could always be called on, and almost all of the considerable amount of constructional work that was required was carried out with enthusiasm by the engineering services on the site. This effective liaison between the research department (which operated the plant) and the engineering section was one of the most important factors in the success of the project: modifications could be made quickly and mistakes rapidly rectified. During the early days of the project G.K. Williams from Bunker Hill Associated Smelters, Port Pirie, whose work on continuous desilverization was well known, was seconded to Avonmouth and his contribution was considerable, particularly in the problem of lead handling. During the whole of the main development period the research department was under the direction of the present writer.

When furnaces 1 and 2 were built, since it was hoped that they would be commercially viable, they were operated by the production staff. The project benefited greatly from the fact that the operation of these furnaces was put under the charge of Mr W.M. Robertson who combined great operating skills and experience with an unusual willingness to accept - once convinced of the necessity - innovation and alteration.

FINANCING OF THE WORK

As soon as work on the EBF began, expenditure on the project became heavy. Running costs of the furnace were more than £2,000 per week and rose to £3,000 when an experimental machine, which was built to prepare special sinter for the furnace, was operated. It is estimated that the cost of the work that was performed between 1946, when the EBF started, and 1950, when no. 1, the first commercial furnace, began operating, was of the order of £100,000/year (equivalent to £660,000 at the 1980 value of sterling).

To justify expenditure of this order over a long period and to obtain it from the sometimes reluctant Board, was not easy. The confidence of a board of directors in the research department that carries out the work is obviously essential, and this can only be maintained if, when demanded, a full factual assessment of the state of the work is always given. Cries of 'eureka' must be muted and carefully rationed. On the other hand, it is essential that the enthusiasm of the research department is not unduly stifled, since this is the driving force of the project. It was fortunate that in those early days the Board of the Imperial Smelting Corporation under the chairmanship of Digby Neave was prepared to accept the very considerable risks that were involved and to grant the money that was required. It is doubtful whether the project would have gone ahead without the support that it received from Neave at that critical time.

CHRONOLOGY OF DEVELOPMENT OF THE BLAST-FURNACE PROCESS

The chronology of the early experimental development of the zinc blast-furnace is summarized in Table 1. Its development has been described briefly in two previous publications (Cocks and Walters 1968, Temple 1980): the purpose of the present account is to consider the overall course of the work and to attempt to indicate when and why progress was unduly delayed.

Because of the war the tests that were carried out with the crude lead splash condenser in 1943 could not be followed up until the small experimental blast-furnace (shaft area 0.7 m^2) was built and blown in May, 1947, and continuous investigational work began. In September, 1950 the scale of the work increased greatly when no. 1 furnace (shaft area 5.25 m^2; nominal capacity 20 tons per day zinc) was blown in. It was hoped that no. 1 furnace would be commercially viable, but it was too small, and beset with operating problems. The first furnace to be commercially acceptable (shaft area 17.2 m^2; nominal capacity 170 tons per day zinc) was built at Swansea and blown in on 9 March, 1960. The period of initial development can be taken, therefore, albeit somewhat arbitrarily, as having lasted from 1943, when the possibility of the condensation of zinc by

Table 1 Zinc Blast-furnace: Chronology of Development

1943 May 21	First demonstration of efficiency of lead splash condenser
1947 May	Experimental blast-furnace blown in (shaft area, 0.7 m^2; shaft height, 4 m; gases withdrawn half way up shaft and passed through column of coke *en route* to paddle wheel type lead condenser; initial cost £13750; nominal capacity, 2 t/day zinc output)
1948 January	Design commenced of no. 1 furnace, expected to be first commercial furnace (shaft area, 5.25 m^2; gases to be withdrawn half way up shaft; nominal capacity, 20 t/day zinc output)
1948 December	Design commenced of no. 2 furnace, to be built alongside no. 1 (shaft area, 6.5 m^2; nominal capacity, 25 t/day zinc output)
1950 September	No. 1 furnace blown in
1952 April	No. 2 furnace blown in
	Tunnel flue discarded
1955 May	Decision taken to convert sinter machine from down- to up-draughting
	No. 1 furnace converted to chair jackets at furnace bottom, giving increased shaft area with same hearth area; output rose to 60 t/day zinc
1959	No. 1 furnace shut down permanently since no. 2 producing sufficient zinc
1960 March	First furnace blown in at Swansea (shaft area, 17.2 m^2); two condensers - one each side of furnace
1967	No. 2 furnace (producing 90 t/day zinc and 50 t/day lead) shut down to make way for no. 4 furnace (shaft area, 27.1 m^2)

shock chilling was first demonstrated, to 1960, when the process was accepted commercially. It can be argued that the essentials of the process were contained in the experimental furnace that was built in 1947 and that no basic changes have since been made. Practically all the intensive development work that has taken place since 1947 has been directed towards ensuring continuity of operation and obtaining maximum output from furnace capacity.

SIMPLIFICATION OF FURNACE DESIGN

From the start of the experimental work in 1947 the overriding problem was continuous interference with furnace operation through the build-up of accretion in the furnace, the furnace top, the inlet to the condenser and the condenser itself. This was particularly serious since it soon became apparent that, for the process to be competitive, the productive capacity of the units had to be much greater than had been originally envisaged, and that allowances had to be made for high gas velocities through both furnace and condenser. Accordingly, when no. 2 furnace was designed in 1948 it had been assumed that it would produce 25 tons per day zinc. Before it was shut down in 1967 to make way for the larger no. 4 (shaft area 27.1 m^2) it was producing 80-90 tons per day zinc and 40-50 tons per day lead, the hearth area being unchanged. Even at these higher outputs the unit was too small to be economic.

In the early days of the work the serious effect of accretion build-up on continuity of production was compounded by the mistaken belief that it was essential to withdraw the gases from the furnace below the level of the charge. It was argued that by so doing the gases would exceed equilibrium and that this would give some leeway before reoxidation, due to reversion, commenced. The argument was erroneous, and although various constructional modifications were tried - the EBF was rebuilt some eight times - little improvement was made. The best solution was found to be the use of a tunnel flue - an inverted 'U'-shaped channel of heat-resistant metal that ran across the furnace below charge level and from one end of which the gases could be withdrawn into the condenser. Even at best this was unsatisfactory in that it seriously limited the blowing rate.

In 1950 the belief that it was necessary to withdraw the gases below charge level was challenged - almost in desperation - and a trial was run on the EBF in which the tunnel flue was discarded and the gases were taken off from the top of the furnace directly into the condenser. Results were promising and it was obvious that a major simplification had been made. No. 2 furnace at Avonmouth had been designed and built with a tunnel flue, but it was removed and the gases were withdrawn from the furnace top. This allowed a welcome increase in blowing rate and improved continuity of production, but zinc oxide accretion continued to restrict the inlet to the condenser and

frequent shutdowns for clearance were still required. The cause of the problem was not in doubt: the gases that left the furnace top were close to their equilibrium and, even though the distance between furnace top and condenser inlet was kept to the minimum, it was impossible to prevent some contact with cooler surfaces on which reversion took place - as the result of which reformed zinc oxide built up progressively.

ADDITION OF AIR TO GASES LEAVING FURNACE

In an attempt to counter accretion formation a heat-resistant metal flue was inserted to carry the gases between the furnace top and the condenser. This flue could be heated externally to 1000°C, and it was argued - quite correctly - that if the gases were not cooled, reversion would not take place and zinc oxide build-up would be avoided. The heated flue was effective in that it remained free from accretion, but the complication in construction and operation that was imposed by its firing system made it impractical.

The situation was saved by a somewhat revolutionary solution that was proposed by S.E. Woods. He argued that if a volume of air equivalent to 12-14% of that blown in through the tuyeres was added to the furnace top, sufficient carbon monoxide would be burnt to raise the carbon dioxide content of the gases from 8% to 11%. The adverse effect of this extra CO_2 on the Zn-ZnO equilibrium would, however, be more than offset by the rise in temperature of the gas (250°C) that would result from the combustion; some cooling in the critical zone between exit from the furnace top and contact with the shock chilling lead could then be tolerated.

Tests with air addition proved almost immediately to be very successful and it at once became a standard part of the furnace operation. Whereas the use of top air additions did not eliminate the formation of accretions entirely, it greatly reduced the rate of build-up and the smoothness and continuity of operation were much improved.

DEVELOPMENT OF UPDRAUGHT SINTERING

Although the introduction of top air addition to reduce accretion formation brought, with other improvements in furnace design, a welcome increase in furnace output, the seriousness of another deficiency became apparent - that of poor charge quality. At the high blowing rates that had to be used to give profitable operation it was obvious that maximum uniformity in both composition and sizing of the sintered blende and coke that formed the charge was essential, and it was also necessary to ensure that both constituents were evenly distributed across the furnace.

Mention has already been made of the development at Avonmouth in the early 1930s of downdraught sintering for the roasting of zinc blends. This was satisfactory for production of the small granular material that was suited to the horizontal and vertical retort processes, but the blast-furnace required a harder, more lumpy product. The hardness of the sinter that was produced on the machine could be increased by the addition of silica (if the quantity present in the ore were insufficient) and lead. One of the earliest encouraging factors in the development of the process was that lead could be recovered from the bottom of the furnace at high efficiency and, since lead oxide was reduced by carbon monoxide high up in the shaft, the treatment of lead-containing materials required little extra coke consumption, with the consequence that lead output from the furnace could be increased with practically no reduction in zinc production. An additional attraction was that the lead that was tapped as bullion from the furnace bottom contained any copper, silver or gold present in the charge, which enabled these values to be recovered. Accordingly, the inducement to increase lead production from the furnace by the treatment of mixed lead and zinc ores and of other lead-containing material was strong.

It became increasingly obvious that the downdraught sintering machines were unable to cope with the growing furnace demand for hard sinter with high lead content. At the high bed temperatures that were necessary to produce sinter hardness fusible lead compounds were carried downwards, and attack on the pallet bars that formed the grate became intolerable. This period was one of the most difficult of the whole project.

Similar problems had been experienced with the sinter machines at the lead smelter at Port Pirie, Australia, and had been overcome by reversal of the air flow and blowing up through the bed. Ignition was achieved by first feeding a thin layer of special charge on the bed, which then passed under an igniter box, combustion being started by the pulling of air downwards through the bed. The pallet then moved over a 'dead' pallet and the main charge was

fed on to the ignited layer. It passed next over the main wind-boxes, air being blown upwards and roasting being completed from below, as the pallet passed along the rest of the machine. The gases that left the top of the bed were collected by hoods.

The development of this method of updraught sintering had cured many of the problems at the roasting plant at Port Pirie, where orthodox lead concentrates were treated (Hopkins 1958). It had not been applied to the roasting of zinc concentrates, which are more difficult to ignite, and at Avonmouth an additional complication arose in that for hygiene reasons all the gases that left the bed had to be collected and treated in a contact sulphuric acid plant. Nevertheless, there was no doubt that the success of the blast-furnace project could be assured only if the change to updraught sintering could be made - even though it involved a major reconstruction of production units, and there was little time to carry out small-scale work to examine problems that were expected. The difficult decision to make the change was taken in 1955 and the roasting units were shut down and modified.

On the whole, the conversion was successful. It was found that with updraught sintering the physical state of the charge and the method of feeding it on to the pallets were more critical than with downdraught roasting, and it was necessary to install drum-type mixers and more sophisticated proportioning devices. Special seals had to be fitted to the hoods over the machines, but when the necessary equipment became available it was found that the updraught sinter could be made harder and with a higher lead content than was available from the downdraught machines and furnace performance improved considerably

OTHER DEVELOPMENTS

Whereas the introduction of air at the top of the furnace and the conversion to updraught sintering were, perhaps, the two advances that contributed most to the development of the project, intensive work that was carried out on other problems was also successful. A detailed examination of the physical chemistry of the furnace showed the advantage of using coke with a low reaction to carbon dioxide. A study of the SiO_2-CaO-FeO system indicated the optimum range of slag composition within which to work. The latter investigation was valuable in showing the feasibility of operating with slags of high iron content, which enabled the volume of slag produced to be kept to a minimum (Richards 1981).

Watercooled Cooling Launders

An essential part of the process concerned the need for continuous extraction outside the condenser of the heat from the molten lead. After having performed its shock chilling function lead left the condenser at 560°C to be cooled externally to 450°C, during which a proportion of its zinc content separated and was removed to the condenser. The heat to be removed was considerable, amounting to 6 GJ per tonne of zinc produced.

Initially, the cooling was carried out in steel vessels, Avonmouth practice being modelled on the method employed in the continuous desilvering process that had been developed at the lead smelter at Port Pirie (Williams 1932). The amount of lead to be handled at Avonmouth, however, was much greater than that at Port Pirie, and for some time the limited cooling capacity of the kettles seriously restricted production.

The problem was solved by replacement of the kettles with lengths of cooling launders. The launders were troughs lined with water-cooled jackets along which flowed the molten lead. The required amount of cooling could be obtained by varying the depth of liquid lead in the launder, so there was an in-built flexibility in the system, which worked well. Later, immersion coolers, which consisted of coils of steel pipe carrying cooling water, were developed. By raising or lowering these the depth of immersion in the lead could be varied (and automatically controlled) and the desired cooling capacity could thus be achieved. The development of the launder cooling system and, later, the immersion coolers removed a major restraint on increases in furnace capacity.

REASONS FOR DELAY IN DEVELOPMENT WORK

The very considerable amount of development work that took place in the initial research and development period between 1943 and 1960 was mainly concerned with improvements to the engineering of the equipment to obtain continuity of operation at high production rates. Certainly, delay was caused initially by the belief that to operate at all it was necessary to withdraw the gases below charge level. This was rectified in 1952, but success still had to await the development of top air additions, the conversion to updraught sintering, the introduction of water-cooled launders and the solution of a number of other problems. From the nature of the

problems little work could be carried out in the laboratory, though considerable use was made of model techniques. Almost all of the investigational work had to be carried out on the furnaces.

In the early days, from 1947, the EBF was used, but despite the availability of excellent engineering facilities for both design and construction, which enabled modifications to be made rapidly, the furnace capacity of 2 tons per day zinc was too small for it to give other than general indications. The decisions to build no. 1 furnace with a design capacity of 20 tons per day zinc and no. 2 furnace to produce 25 tons per day were taken on political grounds (in 1948 and 1950 respectively). The company was still operating horizontal distillation furnaces at both Avonmouth and Swansea and they were becoming increasingly uneconomic. The hope was that if two furnaces were operating at Avonmouth, the horizontal distillation furnaces could be shut down. From a technical point of view the decisions were premature -too many problems still required solution - but it can be argued that had the company not become so involved with the new process, and dependent on its success, the project might well not have survived the difficulties that still lay ahead, and work on it might have been abandoned. The increased commitment once the two larger furnaces were built put considerable strain on the development work that was still outstanding, magnifying the cost of the modifications that had to be made and placing a heavy premium on correctness of diagnosis of problems and proposals for their solution: such conditions slowed the rate of progress.

In spite of these and other difficulties, progress continued to be made – albeit somewhat erratically. The concentration of research effort on the project was maintained. Continuity of furnace operation improved, as did the efficiency of elimination of zinc from the charge in the furnace and its recovery as metal in the condenser. As a result, output from the furnaces increased considerably, and confidence in the process grew to such an extent that in 1958 the decision was taken to build a larger furnace at the Swansea Vale works of the company. This was to have a production capacity of 53,000 tons per year zinc and was to replace the Swansea horizontal distillation furnaces, the last in the United Kingdom, which were shut down.

Commercial Development

Although problems remained and a number of important improvements were made subsequently, the early performance of the Swansea furnace was sufficiently promising to generate interest in several smelting companies abroad. Imperial Smelting Process had been formed under B.G. Berry - who with A.A. Clark had been responsible for much of the engineering - as a company to license and design the equipment for the new process. Since 1960 13 other furnaces have been built abroad, with the same shaft area at Swansea (17.2 m^2), but fitted with only one condenser. By the end of 1979 more than 10,000,000 tons of zinc and 5,000,000 tons of lead had been made by the process. In 1984 these furnaces produced 733,000 tons of zinc and 368,000 tons of lead, being 12% and 8% respectively of world production.

The articles of Imperial Smelting Process contained a number of novel features. All operating companies exchange through ISP operating data and details of changes in technique so that all licenses can benefit from experience that has been gained and improvements that have been made on all the furnaces. Operating men from the companies concerned attend regular conferences so that all aspects of production and development on any of the furnaces can be fully discussed by all. These arrangements have had a significant influence on the expansion of the process since 1960.

Costs and Balance Sheet

An attempt has been made by the present author to determine the cost of the project and to balance it against the revenue that has accrued since the process was first licensed in 1963 so that it can be seen whether the case that was put to the Board in 1946, when heavy expenditure began, was justified. Of necessity, the estimates are approximate, since as a result of changes in management complete cost records of the early days of the project are no longer available. On the other hand, the author himself was mainly responsible for the proposals that were submitted to the Board for expenditure on research and equipment that was required in the period 1946-60 and, also, for justification of the development expenditure. Several of the figures, particularly those which cover operating costs, have been estimated by extrapolation and lack precision, but it is believed that the inaccuracies are largely self-cancelling and that the final totals are sufficiently accurate to enable broad conclusions to be drawn.

The total that is obtained comprised the cost of that section of the research department which has worked on the project since 1943 and the costs of Imperial Smelting Processes, which was formed in 1956 to develop the process commercially, since the staff of this company have been responsible for the

design of the equipment used at Avonmouth and abroad and have made many major contributions to the overall development. Also included are the capital and operating costs of the EBF and furnaces 1 and 2 at Avonmouth, since these never became commercial units, and the costs (including loss of production) of the conversion of no. 1 sintering machine from down to updraught operation. The considerable cost of applying for and servicing the patents that were taken out to protect the process is also included.

Since the estimates cover the period 1946-79, an attempt has been made to compensate for the effect of inflation by expressing all costs in terms of the 1946 value of the pound. In this form the total cost of the work to date has been approximately £4,000,000. Expressed in the same way, the return from royalties, license fees, service charges, etc., has been of the order of £8,000,000. The development of the project has also brought benefit to British engineering firms, which have supplied much of the equipment that is used by licenses.

Although an accountant might not be unduly impressed by these figures, technically the blast-furnace project can be considered a success. The furnaces that are now operating produce some 10% of the world's zinc and 7% of its lead. In his 1962 report the Chief Alkali Inspector (not one generally given to hyperbole!) refers to the development at Avonmouth as 'perhaps the most considerable achievement in non-ferrous metallurgy of the century'.

In the author's opinion it is doubtful whether other processes will be developed to displace the electrolytic or the blast-furnace process for the treatment of current types of high-grade concentrates. The consumption of energy and of manpower in both processes has been reduced to such an extent that it is difficult to see where a radically new method could offer cost savings sufficient to justify the heavy expenditure that would be required to launch it commercially. New techniques for zinc production will undoubtedly be developed in the future, but they will satisfy different criteria. They will no longer be restricted to the treatment of relatively high-grade sulphide concentrates, but will be able to treat lower-grade materials, which will become a source of growing importance as the supply of conventional concentrates draws near to exhaustion.

ACKNOWLEDGEMENTS

The author thanks the Board of RTZ Corporation PLC for permission to publish this paper. This paper originally appeared in *Transactions of the Institute of Mining and Metallurgy* (Section C: Mineral process, extraction; metallurgy. Dec. 1983) and is reprinted here with permission.

Current (1996) Position of the Process

Since 1983 when the previous paper describing the experimental work which led to the development of the Zinc-Lead Blast Furnace Process was described, significant developments have been made. These and future developments are described in a paper by R. Lee given to the International Lead Zinc Study Group in Beijing during the meeting on 20-22 May 1996.

Lee's figures show that in 1995 there were twelve furnaces operating in 11 countries, producing 875,000 tons of zinc and 382,000 tons of lead. This amounts to approximately 12% and 7% of the total world production of the two metals. In India the plant at Chanderiya near Chittaurgarh, in Rajasthan, designed to treat ores from the new mine at Rampura-Agucha was opened by Hindustan Zinc in 1993 (see above p.53), and a new second furnace at Shaoguan in China has just been blown in.

A variety of zinc- and lead-containing residues are now forming a significant proportion of the feed to most furnaces. Waelz oxides, electric steel furnace oxide and electrolytic plant residues are now being treated to an increasing degree. Some enter the charge via the sintering plant, some as hot briquettes. In this process, developed at Avonmouth, the fine oxide material is briquetted at a temperature of about 600°C. Under these conditions a certain amount of incipient crystallisation occurs, forming a strong bond.

Most furnaces show considerable increase in production since installation. Some of this has been attained by enlargement of the shaft in some cases, but with most it has arisen by increasing the intensity and control of the operation.

The introduction of additional charge, fuel and oxygen through the tuyere has been tried with some success.

Increasing use is being made of the ability of the furnace to produce lead and zinc simultaneously. With a number of ore bodies it is difficult (if not impossible) to separate the sulphides by flotation and form high grade concentrates without losing a considerable amount of the values. Under these

circumstances making a bulk concentrate gives increased recovery at the mine, and after roasting makes an excellent feed to the furnaces.

It is doubtful whether the implications of bulk concentrate produce has yet been fully realised by the industry and its application seems certain to grow.

At the present time there is excess production capacity in the industry and it is unlikely that new units will be built in the immediate future. However, world zinc demand continues to grow. In 1995 it rose by 5.1% (ILZGS figures) and it should not be long before demand for new smelting capacity arises. The blast furnace process, although a relative newcomer in the field, would seem to have a promising future.

REFERENCES

Bunce, E.H. and Handwerk, E.C. 1936. New Jersey Zinc Company vertical retort process. *Trans. Am. Inst. Min. Engrs.* **121**, 427-40.

Cocks, E.J. and Walters, B. 1968. *A History of the zinc smelting industry in Great Britain*. Harrap, London.

Duncan, T.A. 1944. Production of magnesium by the carbothermic process at Permanente. *Trans. Am. Inst. Min. Engrs.* **159**, 308-14.

Gyles, T.B. 1936. Horizontal retort practice of the National Smelting Company Limited, Avonmouth, England. *Trans. Am. Inst. Min. Engrs.* **121**, 418-26.

Hopkins, R.J. 1960. Short history of sintering development at Port Pirie. In *Sintering symposium*, Port Pirie. Melbourne, Australasian Institute of Mining and Metallurgy, 3-20.

Lee, R. 1996. Paper given to the International Lead-Zinc Study Group, Beijing, May 20 1996.

Liebig, M. 1916. The Roitzheim-Remy continuous zinc distillation process. *Metall. Chem. Engng.* **14**, 625-8.

Maier, C.G. 1930. Zinc smelting from a chemical and thermodynamic viewpoint. *Bull. U.S. Bur. Mines* **324**, 93.

Mathewson, C.H. (ed.) 1959. *Zinc: the science and technology of the metal: its alloys and compounds*. Reinhold, New York (Am. Chem. Soc. Monograph no. 1423.

Najarian, H.K. 1944. Weaton-Najarian vacuum condenser. *Trans. Am. Inst. Min. Engrs.* **159**, 161-75.

99th Annual Report on Alkali etc. Works by the Chief Inspectors 1962. 1963. London, HMSO, 26.

Richards, A.W. 1981. Practical implications of the physical chemistry of zinc-lead blast furnace slags. *Can. Metall. Q.* **20**, 145-51.

Robson, S. 1933. Metallurgy and uses of zinc. An address given to the London Section of the Institute of Metals, January 2.

Temple, D.A. 1980. Zinc-lead blast furnace - the key developments. *Metallurgical Transactions* **11B**, 343-52.

Williams, G.K. 1932. Description of continuous lead refinery at the works of the Broken Hill Associated Smelters Proprietary Limited, Port Pirie, *South Australia. Min. Metal.* **87**, 75-134.

INDEX OF PEOPLE

INDEX OF SUBJECTS, PROCESSES AND COMPANIES